From Fingers to Digits

Leonardo

Roger F. Malina, Executive Editor

Sean Cubitt, Editor-in-Chief

See http://mitpress.mit.edu for a complete list of titles in this series.

From Fingers to Digits

An Artificial Aesthetic

Margaret A. Boden and Ernest A. Edmonds

The MIT Press
Cambridge, Massachusetts
London, England

This book was set in Stone Sans by Westchester Publishing Services. Printed and bound in the United States of America.

Library of Congress Cataloging-in-Publication Data

Names: Boden, Margaret A., author. | Edmonds, Ernest A., 1942- author.
Title: From fingers to digits : an artificial aesthetic / Margaret A. Boden
 and Ernest A. Edmonds.
Description: Cambridge, MA : The MIT Press, 2019. | Series: Leonardo book
 series | Includes bibliographical references and index.
Identifiers: LCCN 2018029639 | ISBN 9780262039628 (hardcover : alk. paper)
Subjects: LCSH: Computer art. | Art--Philosopohy.
Classification: LCC N7433.8 .B62 2019 | DDC 700.1--dc23
LC record available at https://lccn.loc.gov/2018029639

10 9 8 7 6 5 4 3 2 1

To our dear friend Jasia Reichardt

Contents

Series Foreword
Leonardo/International Society for the
Arts, Sciences, and Technology (ISAST)

Leonardo, the International Society for the Arts, Sciences, and Technology, and the affiliated French organization Association Leonardo, have some very simple goals:

1. To advocate, document, and make known the work of artists, researchers, and scholars developing the new ways in which the contemporary arts interact with science, technology, and society.

2. To create a forum and meeting places where artists, scientists, and engineers can meet, exchange ideas, and, when appropriate, collaborate.

3. To contribute, through the interaction of the arts and sciences, to the creation of the new culture that will be needed to transition to a sustainable planetary society.

When the journal *Leonardo* was started some fifty years ago, these creative disciplines usually existed in segregated institutional and social networks, a situation dramatized at that time by the "Two Cultures" debates initiated by C. P. Snow. Today we live in a different time of cross-disciplinary ferment, collaboration, and intellectual confrontation enabled by new hybrid organizations, new funding sponsors, and the shared tools of computers and the Internet. Sometimes captured in the "STEM to STEAM" movement, new forms of collaboration seem to integrate the arts, humanities, and design with science and engineering practices. Above all, new generations of artist-researchers and researcher-artists are now at work individually and collaboratively bridging the art, science, and technology disciplines. For some of the hard problems in our society, we have no choice but to find new ways to couple the arts and sciences. Perhaps in our lifetime we will see the emergence of "new Leonardos," hybrid creative individuals or teams that will not only develop a meaningful art for our times but also drive new agendas in science and stimulate technological innovation that addresses today's human needs.

For more information on the activities of the Leonardo organizations and networks, please visit our websites at http://www.leonardo.info/ and http://www.olats.org/. Leonardo

Books and journals are also available on our ARTECA art-science-technology aggregator, http://arteca.mit.edu/.

Roger F. Malina
Executive Editor, Leonardo Publications

I

1 Introduction

Margaret A. Boden and Ernest Edmonds

This book is about computer art and its relations to art of a more traditional kind. Specifically, the book focuses on generative art, in its various forms, but particularly on art for which the artists use programming, computer code, as a significant element of their work. We also deal with the context of such art, so some chapters consider much of what is often called digital art, but the focus remains on the generative. Much has been written about digital art in general, and we do not repeat what is easily read elsewhere except when understanding the context requires it. At the core of computing is software—computer programming and code. Perhaps rather strangely, the role of code in computer art has received relatively little attention; hence it is our primary focus. We aim to highlight important continuities as well as the many exciting differences.

A wide range of questions is discussed, for the book is a collection of chapters—most newly written for this volume—by authors with different backgrounds. Margaret Boden is a philosopher, with a special interest in creativity and in how concepts drawn from artificial intelligence (AI) can help us understand it. Ernest Edmonds is a pioneering computer artist and a professional computer scientist. Although each chapter can stand alone, they are unified by the authors' shared interest in the history and philosophy of computer art.

In preparing the book we interviewed a range of artists and curators and had more informal conversations with many people engaged in the art world, most with a specific interest in computing. Perhaps it is not surprising that we have found significant differences among generations. Whereas older people, including many of those who form the art establishment, see computer technology as almost disturbingly new, and not infrequently question the possibility of computers contributing to art at all, young people take it for granted that computers are an integral part of almost all aspects of life, including art. Senior artists may talk about the new opportunities that the computer gives them, whereas young artists were often writing computer programs years before

they ever thought about becoming an artist. For them, using a computer to make art is as natural as using paint.

Notwithstanding the comfort that the young have with computers and computer software, we still find that computer art is largely presented and viewed with suspicion in the conventional and established art gallery world. In this respect, it seems that visual art is behind music in adopting the new technologies. A good deal of modern music involves the use of computers in one respect or another. Apart from the major digital art events that are staged around the world, internationally a small number of commercial galleries specialize in computer art and a small number of public galleries or special wings or units in public galleries also present such work. Venues are certainly growing, but even when the growth is strong, more often than not the computer art is not integrated into traditional art exhibitions. So we find that the problem of computer art (is it *really* art?) is very much a current problem, even though the young may not agree and even though almost every film, much theater, and a great deal of music is today made with the aid of computers. When we come to chapter 14 and hear directly from artists themselves we do not find any doubts at all. However, there is often difficulty in dealing with the established visual art world.

We see, then, that the question of whether computer art should rightly be called art at all is still with us. Are the continuities that link it to older forms of art strong enough to settle that question? Or can it be settled merely by pointing out that several major art galleries have exhibited examples of this work? Is it relevant that other modern technologies (photography and film) have been welcomed by influential art critics, such as Walter Benjamin (1968), as ways of doing—and democratizing—art? Or does the use of computers compromise this field's aesthetic credentials in ways that the use of cameras does not? If so, how? In particular, is the compromise even greater in cases of *generative* computer art, in which the program is left to produce the artwork by itself, with little or no input from a human being? And if not, why are so many members of the general public skeptical about the very idea of computer art? In addressing these questions we show that some of the links with older art forms are quite strong even though they may not often be noted. We also give examples of very strong public interest in interactive art, although the naming of the work as art may not always be particularly evident.

Some closely related questions concern its history. Besides reviewing how the various types of computer art developed, we say something about how they have been met—or rejected—by denizens of the mainstream art world.

Mainstream art comes in many forms: painting, sculpture, ceramics, music, dance, poetry, drama, and more. So too does computer art. But these chapters highlight the *visual* arts. Certainly, the philosophical points made in the more analytical chapters

apply to art in general. Moreover, one chapter is largely about music, and several mention examples from other genres, such as literature. Nevertheless, most of the discussion draws on art (whether mainstream or computer based) in the form of painting or graphics.

The six chapters in part II, by Margaret Boden, are broadly philosophical in tone. The first two set the scene for what follows—by identifying distinct types of computer art and by describing how creativity has been studied (or ignored) in AI. The other four focus on links between computer art and traditional views in philosophical aesthetics. Part III—comprising six chapters by Edmonds—considers some historical questions from the point of view of someone who has been a practitioner of this genre right from its start. In addition, his chapters touch on what the experience of creating computer art is like and how it differs from straight painting or musical composition. Part IV contains a single chapter that comments on many of the questions raised in the previous chapters in a set of interviews (conducted by Edmonds) with well-known computer artists, all of whom write code. We present many of the issues discussed in the book in the artist's voice: what it means to make art today using the media of today.

Chapter 2 provides a taxonomy of computer art. This analysis distinguishes different types within the broad genre of computer-based art and outlines some of its links with more familiar forms.

The term "computer art" is sometimes defined more narrowly. For instance, Dominic Lopes (2009) considers only the interactive examples. By contrast, the taxonomy offered here highlights the *variety* of approaches that can reasonably be included under this name. For example, it distinguishes generative art (G-art), computer-generated art (CG-art), interactive art (I-art and CI-art), robotic art (R-art), evolutionary art (Evo-art), computer-assisted art (CA-art), and live coding art (LC-art). As we will see, these subgenres are not mutually exclusive but sometimes overlap.

In addition, chapter 2 indicates what philosophical questions and problems are related to this or that subgenre. In this context, the most important distinction is between CA-art and CG-art.

CA-art, in which the computer is used by the human artist as an aid in the art-making process, raises no philosophical problems that do not also arise given the use of paintbrushes or chisels. That is not true of CG-art, in which a computer program is left to run by itself, with minimal or zero interference from a human being. Here, the relative autonomy of the computer threatens to usurp (aspects of) the role of the human artist. Our main interest, in all the chapters that follow, is in the generative examples. That is partly because Edmonds is himself a CG-artist and partly because CG-art presents many more philosophical puzzles than CA-art does.

Different types of CG-art, moreover, suggest different philosophical worries. So the taxonomy is followed by a sketch of the relevant philosophical landscape. Some of its peaks and valleys are considered more fully in later chapters.

Next, chapter 3, "Explaining the Ineffable," outlines the history of AI research on creativity.

Much as people often raise philosophical doubts about whether AI systems are really intelligent, so they often doubt whether they can really be creative. Some even question whether AI can offer the *appearance* of creativity. Taking those questions seriously requires one to consider the research mentioned here.

AI research on creativity has blossomed in the last twenty years. But although creativity was identified very early as a key goal for the field, it was not seriously studied for several decades. Insofar as creativity was modeled at all, it was exemplified as verbal or logical problem-solving—hardly ever as music or graphics. Even scientific creativity had to wait many years before becoming an explicit focus for AI.

As it happened, the two people who were most influential in bringing art into the AI arena were both computer artists: the painter Harold Cohen and the composer David Cope. However, AI work on artistic creativity should not be confused with computer art. Often, there is no specifically artistic intention, still less any attempt to exhibit the results in galleries or concert halls. Rather, the interest lies in trying to model the types of thought processes that go on in the minds of human artists when they create. Indeed, Cohen himself, when already a highly acclaimed painter, turned to AI largely because he thought it would help him understand his own creativity. By the time of his death, in 2016, he had come to believe that human and AI creativity are fundamentally different. Even so, he felt that his computer-based work had helped him appreciate this.

That point leads to the key message of the chapter, which is that—contrary to the still-influential Romantic myths—creativity is a psychological capacity that can be understood by science. Specifically, it involves computational processes comparable to those defined in AI.

Three types of psychological mechanisms can produce new thoughts: combining familiar ideas in unfamiliar ways, exploring accepted styles of thinking or making so as to generate novel structures of the relevant kind, and transforming the style to come up with structures of a novel kind (Boden 2004). Each of these three kinds of creativity can be seen in the work of mainstream human artists and in computer art too. And each, as explained in chapter 3, has been modeled in—and clarified by—AI research.

There is an important caveat here, which applies also to several other chapters (e.g., chapter 5). Whether a computer artwork or AI program can *appear* to be creative is a factual question—to which the answer is often yes. Whether it is really creative is

a philosophical question, not a factual one. According to many philosophers, the answer must be no. Irrespective of its actual performance, they say, no computer can provide real creativity.

The reasons advanced for this view are diverse and involve some of the deepest problems in philosophy—including the nature of meaning, consciousness, and moral community. They will be ignored in this book (unless mentioned by any of the artists interviewed in chapter 14), whose focus is on what computer art can achieve in fact. For the record, however, questions about whether computers can be really creative cannot be given a definitive answer, precisely because the philosophical issues involved are so deeply disputed (Boden 2004, chap. 11; Boden 2014).

Chapter 4 considers the broadly accepted assumption that art appreciation normally involves recognition of the making skills concerned. This assumption dates from the predigital age. Indeed, John Ruskin—whose nineteenth-century views on aesthetics are still hugely influential—*defined* art largely in terms of the human skills that it employs (see chapter 7). Even Robin Collingwood, who (as explained in chapter 6) drew a sharp distinction between art and skill, allowed that we often do admire the skill of the person who made the work of art and that we typically value the artifact all the more accordingly. In short, it is nowadays broadly accepted as common sense that art appreciation normally involves recognition of the making skills concerned.

This fact, with its implications for the appreciation of computer art, is the theme of chapter 4. The appreciation of computer art is even more dependent on knowledge of the making process than is the case for traditional (or anyway, non-Constructivist) forms of art.

CG-artists not only *use* the computer but *celebrate* its potential as a medium. Similarly, oil painters may celebrate the colors and textures of their paints and jazz clarinetists the potential of their instrument. Moreover, the different forms of CG-art use the computer in very different ways. It is not merely that individual CG-artworks look (or sound) very different from each other but rather that they can exhibit very different aspects of the indefinitely varied generative potential of the digital computer.

That is all very well, and the multifariousness offered by computers is a genuine cause for celebration. But it raises a problem for the art audience, most of whom have never done any programming and have little or no intuitive sense of what it involves (see chapter 10). Even people who (like most members of industrial societies) use computers very frequently indeed may have no such understanding, because they experience computer programs ready-made. The complex skills that underlie user-friendly applications such as spreadsheets and the commercial search engine are invisible, even unsuspected, by their users. As the computer artist Harold Cohen has put it (personal

communication), most of us are *consumers* of programs, not *producers* of them. Thus, we are not well placed to appreciate, criticize, or even compare individual works of CG-art with respect to the programming achievements involved in them.

Up to a point, computer artists and curators can arrange to make these technical achievements more accessible. Several methods of doing this are suggested in chapter 4. But even in a culture whose children are introduced not only to computers but also to simple programming, the extent to which this can be done is strictly limited. The unfamiliar, elitist skills of computer artists are even less imaginable to the general public than the specialist skills of traditional artists are. We can all remember using a paintbrush, and we can all imagine forging wrought iron. Whether we can picture how to program computers to generate interesting graphics or music or to operate robots is another matter entirely.

The conclusion of chapter 4, then, is decidedly downbeat. Computer art can be enjoyed by anyone. Some examples can engage virtually everyone. But it can never be as fully appreciated as the more familiar types of art. It will always carry an aura of magic: awesome, perhaps, but largely unintelligible.

Chapter 5 explores the potential for creativity in one particular form of computer art, evolutionary art (Evo-art in the taxonomy of chapter 2). The key question is posed by its title: "Can Evolutionary Art Provide Radical Novelty?" In other words, is the creativity of Evo-art forever limited in a way that human creativity is not?

As remarked earlier (and in chapter 3), one of the three types of creativity is transformational creativity. In this, some initial style is transformed with the result that structures of a novel kind can arise. In general, the more radical the stylistic transformation, the more it is valued. Although if the change is too radical, it may be rejected. If computer art cannot offer us transformational creativity, then it is less worthy of our appreciation than human art is.

The computer artists who practice Evo-art hope, by using genetic algorithms, to effect stylistic mutations that vary the resulting artifacts (e.g., images) in highly unpredictable ways, perhaps even jumping out of one style into another. If the second style is not just new but radically new, so much the better.

But is that, in principle, possible? Many critics argue that it is not, because the computational potential of any program—including one equipped with rule-changing genetic algorithms—is fixed. It may be huge, even infinite (a point that is important in chapter 4). But there are always some conceivable structures that are excluded. Evo-art, on this view, simply cannot provide *truly radical* transformations.

Such transformations do sometimes happen, but only (so this objection runs) outside cyberspace. For instance, they occur in biological phylogenesis, in which fundamentally

new organs (e.g., light sensors) can arise—and once arisen, can then evolve into highly differentiated forms. The explanation given for this is that biological evolution takes advantage of the physical contingencies in the environment. Because cyberspace involves no such contingencies, no opportunity for an evolving computational system to engage with the physical world, this spur to stylistic novelty is forever absent.

Robots, however, do not inhabit cyberspace. They not only take in perceptual data from the real world but are material objects moving around in a material, often cluttered, environment. Chapter 5 describes some work in evolutionary robotics wherein radical (anatomical or perceptual) transformations have happened as a result of previously unconsidered physical conditions, even accidents. It also mentions ongoing research by a leading computer artist who hopes to evolve drawing robots that, as a result of physical interactions, generate fundamental, but aesthetically valuable, stylistic changes.

Biology is not the only noncomputerized forum for radical transformation: history-book artistic (and scientific) creativity in human minds and societies counts too. But here, *physical* contingencies are only rarely relevant. Usually, the relevant environment is psychological or cultural. These factors can be modeled in computer systems. And they do not have to be specifically provided beforehand by the programmer: some (non-Evo) computer artists already allow their programs to take current data—words or images—at random from the Internet. One such example is *The Living Room*, an installation built by Christa Sommerer and Laurent Mignonneau.

In short, the message of chapter 5 is that Evo-art could provide radical transformations. Some of them would doubtless be rejected by us, but that is another matter. It could do this even if its artifacts were situated not in the real world but in cyberspace. The fact (repeatedly cited by skeptics about computer art in general) that *a computer program can do only what it is set up to do* does not exclude this possibility. Certainly, if an Evo-art installation were to benefit from the cultural contingencies available on the Internet, the web's contents would have to be accessed by some instruction in the program. But that is just to say that creativity—even radically transformational creativity— does not happen by magic. Evo-art has an open, and intriguing, future.

The remainder of part II turns to key topics in philosophical aesthetics. Many competing accounts of art have been offered by philosophers, including various modernist and postmodernist positions—not to mention the still-influential views of Plato, Aristotle, and Kant. This rich body of literature is touched on in several chapters but is foregrounded in chapters 6 and 7.

Fashions in theoretical aesthetics change. Constructivism, for instance—which led most of the pioneers of computer art to experiment with the new medium (see

chapters 9 and 14)—stressed aspects of the art-making process, and of the finished art-work, that had not been valued before the early twentieth century.

The conceptual art of the 1960s went even further, for it challenged most of the then-accepted assumptions about what counts as art and even what sort of thing an artwork can be (Boden 2007). According to that viewpoint, *many* computer artworks are not art at all—or anyway, not of an interesting kind. Even CG-art, wherein the core of the artwork is often held to be the *process* of art making (see chapter 15), does not necessarily qualify. It does not normally offer a conceptual outrage—a shocking conceptual combi-nation (see Boden 2007)—to the audience. Or rather, it does not offer any *specific* shock to the audience—as when the conceptual artist Walter de Maria, for instance, buried a perfectly crafted and very expensive object (a two-inch-thick steel cylinder, one kilo-meter long) so as to make it invisible.

For some audiences, however, CG-art *in general* is irredeemably suspect, just because its artworks are made by computers not by human hands. Are those audiences wrong? Perhaps so, but this cannot be taken for granted: the point needs arguing.

In particular, one needs to consider the aesthetic theories—or rather, the largely unexamined philosophical assumptions—that are most widely held by the general pub-lic (and within the art world; see chapter 8). These concern the role of *emotion* in art and the role of the art maker as *a human individual*—the topics of chapters 6 and 7.

The theme of chapter 6 is the relationship between computer art and Collingwood's theory of art. Why Collingwood? Well, not because either of us accepts his views on art; we do not. Rather, because it is a common—perhaps the most common—criticism of computer art that *there can be no such thing*, because of the importance of emotions in art. Because computers cannot have emotions, it is said, they cannot be artists either. And Collingwood (1958) is among the most influential of the many philosophers who have claimed that art necessarily involves emotion.

Prima facie, then, his account challenges those who claim that CG-art is, truly, art. Indeed, his ideas underlie much of the hostility to computer-generated art that is found in our culture—not least its uneasy position vis à vis the art world (see chapter 8). If it could be shown that CG-art is not quite as inimical to Collingwood's theory as it appears to be at first sight, the widespread resistance to it would be weakened.

Chapter 6 argues that his approach does indeed threaten the status of computer art as art. But that is not because of any reference to emotions in general. There is no reason in principle why computer art could not express or arouse emotion, and some of it—especially computer music—actually does. Rather, it is Collingwood's extreme *particu-larism* that prevents CG-art from being (on his view) art proper.

He defined art in terms of the expression—and the detailed construction—of some highly particular emotion in the artist's mind, with an equivalent process occurring

also in the mind of the audience. He even said that to regard a novel as depicting "the feelings of women, or bus-drivers, or homosexuals" is not to treat it as *art* at all but rather as psychology (Collingwood 1958). As a work of art, it must construct or express the particular experiences of the individual novelist—who may happen to be a woman, a bus driver, or a homosexual but whose work cannot be regarded (qua art) as representative of the group.

Collingwood's view goes against the spirit of most computer art. That is because a large part of the point of CG-art—especially when the originating human artist has a relatively hands-off role—is to explore, and to exhibit, a certain *range* of possibilities. Each CG-artwork is unique, to be sure. But those generated by a given computer program are unified—both perceptually and historically—by it. The audience is expected to notice that unity and to appreciate it. Whether this appreciative response requires knowledge of computing, as well as sensitivity to observable stylistic variation, is discussed in chapter 4.

Given this conflict, the question arises whether we should say "So much the worse for computer art!" or rather "So much the worse for Collingwood!" The alternative chosen in chapter 6 is the latter. For besides undermining the rationale of CG-art, Collingwood's position also conflicts with common intuitions about traditional art.

Shakespeare's plays, for example, are not art proper for Collingwood—although his sonnets may be. They do not, except perhaps occasionally, construct and express some highly specific emotional experience of Shakespeare himself. On the contrary, they often aim at depicting the emotions of some general class of people—monarchs, for instance ("Uneasy lies the head that wears a crown"). Similarly, a painting that aims to make a political point—such as Pablo Picasso's *Guernica*, or Gustave Courbet's *Peasants of Flagey Returning from the Fair*—is seen by Collingwood as propaganda rather than art unless it happens to capture the painter's particular experience and arouses an equivalent emotion in the audience.

The last chapter in part II, like chapter 6, engages with a writer in traditional aesthetics: Ruskin. His approach is prima facie even more inimical to computer art than Collingwood's is—which makes it even more interesting as a philosophical challenge to the field. That is primarily because it stressed the personal individuality, and the creative freedom, of the human artist-craftsman.

Much as we do not share Collingwood's theory of art, we do not share Ruskin's either. But we do admit to having some sympathy with his view, for it has entered deeply into our culture.

In particular, Ruskin's chapter on Gothic architecture in *The Stones of Venice* (1853) was hugely influential. It molded people's ideas about art in general, remaining "the greatest influence on taste" until the early twentieth-century doctrine of pure form

(Clark 1949). For instance, it insisted on the aesthetic importance of the artist's cultural (e.g., religious) motivation and on his chosen methods of hand-working. By inspiring William Morris, it led indirectly to the Arts and Crafts movement. And, again largely via Morris, it also affected the development of socialism in England.

The ideas expressed in that famous essay are still widely current. Many of us today share, or anyway sympathize with, Ruskin's stress on the individuality and fallibility of the working artist and on the importance of the cultural interests that imbue the artwork. Indeed, the suspicion of computer art in the mainstream art world today is largely grounded in aesthetic values inherited from him. Ruskin's essay was an impassioned complaint against the industrial age and especially against the effects of machine technology on the workman's role in art and craft.

High-tech computer art is very different from the medieval masonry so admired by Ruskin. There is no question but that it fails to satisfy his criteria for superior art. However, chapter 7 argues that this new approach is not quite so beyond Ruskin's pale as one might think.

For example, the individuality of the originating artist still shines through, even given the mediation of the computer (see also chapter 10). Ideological values, such as religion and politics, are not typically involved in CG-art—although, in principle, they could be. They are often prominent in other forms of what chapter 2 terms electronic art, or Ele-art: video-art, for instance. But if CG-art normally eschews ideology, it allows plenty of room for infelicities and failures on the part of the originating human artist. And computer-*assisted* art (CA-art), of course, leaves even more room for mistakes by the human individual. It may seem strange to laud mistakes and infelicities as criteria of art: surely they are to be avoided if at all possible? That was not Ruskin's view. And we need to understand his legacy to understand much of the resistance (especially in England) to this new way of art making.

Ruskin identified six principles of the Gothic, which he used to evaluate all forms of art. More accurately, perhaps, he identified twelve such principles: two parallel sets, concerning the form or content of the artwork itself and the moral climate expressed in it by the artist. We will see that computer art can satisfy his six, or twelve, principles only up to a point. To the extent that it fails to do so, computer art would be regarded by him as an inferior type of art.

Or rather, he would have regarded it as inferior *if* he had accepted it as being art in the first place. The final section of chapter 7 shows that he would not have done that. And his reasons for not classifying computer art as art are shared by many people today, some of whom even cite Ruskin in making their argument. In brief, his nineteenth-century ideas remain very relevant to our twenty-first-century concerns.

The six chapters in part III touch on many of the philosophical points already mentioned. But because of Edmonds's long experience as a computer artist, they are more practical and historical in tone.

Chapter 8 explores the sociological relations between computer art and the art world and considers the changes in these relations that have taken place over the last half century. The attitudes of the major art galleries, for instance, are relevant—and, as we will see, deeply ambivalent.

Sociology and history, in these respects, are closely linked to philosophy. One influential account of what it is for something to count as art is that it be accepted as such by the art world (Danto 1964, 1981; Dickie 1974, 1997). On that view, what counts as art depends on the collective response of the socioeconomic network comprising artists, critics, museum curators, gallery owners, dealers, and collectors—and, where relevant, publishers too (Becker 1986, 1995).

Acceptance or rejection by the art world, of course, rests largely in the application of a range of familiar aesthetic criteria (autonomy and authenticity, for instance; see Boden 2010b, 2010c). But it depends also on judgments, and even prejudices, of other types.

For example, one historian of computer art has remarked that, although "artists throughout history have appropriated new technology and manipulated it to serve their own purposes," the technology used in computer art "has tended to be viewed by the art world as deriving from military applications" and that "perhaps this is [one] reason why the art world has been reluctant to embrace it" (Mason 2008, xii). A related source of skepticism is the role played by computer technology in modern methods of mass production (see chapter 14).

Yet another prejudice against this new art form arises (as remarked previously, in relation to chapter 6) from the widespread assumptions that art and art making must involve emotion and that this can have nothing whatsoever to do with computers.

Even social snobbery has played a part. Computer art in Britain was pioneered predominantly in the newly formed polytechnics (although the Slade School of Fine Art is an important exception), which did not endear it to artists and scholars identified with the major art schools and the universities (Mason 2008, chaps. 7 and 8).

Not least, of course, is the always-present arts-science divide. Despite having been included in the first international exhibition of computer art in 1967, and despite having been nominated for an Arts Council of Great Britain award by the chairman of the Institute of Contemporary Arts, an early kinetic sculpture by Edward Ihnatowicz was rejected by the relevant committee because "the Committee took the view that…there was not really enough evidence of its prospects of success as a work of art as distinct from a piece of electronic ingenuity" (Mason 2008, 96).

So in chapter 8, Edmonds recalls some of his experiences vis à vis the art world over the last fifty years and reports on interviews with individuals situated in different parts of this variegated curatorial and commercial world. Some very recent and—to both of us—inappropriate responses to computer art are discussed. Encouragingly, at least a few of the experts had positive and constructive visions to share.

The next two chapters are not only historical but also partly autobiographical. In chapter 9, "Formal Ways of Making Art: Code as an Answer to a Dream," Edmonds provides a historical context for computer art and describes how, as a young man and already a committed painter, he welcomed the new technology of computing as a way of advancing certain artistic concerns that had been informing his work.

The new concepts and capabilities that the computer introduced were very appropriate in a particular art-making tradition that preceded the invention of computers. It can be seen in the discussions of the General Working Group of Objective Analysis in 1921 in Moscow. This was the beginning of the art movement generally known as Constructivism.

The group drew a distinction between composition and construction in making their art. Briefly, composition was seen to be about arranging perceptible forms according to relationship rules, and construction was about making a work according to a plan for its production. The key point was the introduction of the notion of making a visual artwork according to a plan, or underlying structure, that took creative precedence over the final object. Satisfying the goals or constraints guiding the art-making process was considered to be more important than concentrating on the visual (or audible) composition of an art object.

In 1921, of course, the plans were executed by the artists themselves, but in CG-art they are executed by computers. Constructivist work continued through Systems group art and other groupings, leading on to generative art. What art historians term "generative art" includes any approach wherein the realization of an underlying plan, or abstract structure, is highlighted. Full appreciation of the work therefore depends on knowledge of the creative processes involved (see chapter 4). Early examples, although rarely discussed in this context, include the dice music of Haydn and Mozart. With the arrival of computers, the generative artists found the answers to the prayers that their constructivist predecessors had been making.

Chapter 9 goes on to give the particular example of the developments in Systems art in the United Kingdom, influenced by Max Bill, for example. It explores how making art with software grew out of that movement. The UK's Systems artists both directly and indirectly informed recent software-based art in the UK.

If programming can aid art, as declared in chapter 9, it can also count as art—or so Edmonds argues in chapter 10. Here, he draws on his long-standing personal experience of computer programming, for both artistic and nonartistic purposes, to emphasize the significance of software in art. The concerns of software-based art include a significant conceptual element. The computer enhances the artist's ability to shape the underlying structures of artworks and art systems. In some artists' hands the software goes well beyond the role of a manufacturing tool. It is also a thinking aid or inspiration and increasingly must be seen as a new medium in itself.

The art in software is increasingly recognized. Software in art has been underrated, however. Even many of the books on digital or computer art pay little attention to the computer code that drives and largely defines such art. That is largely because most people, including most art critics, have little or no experience of programming; to use a computer is not necessarily to program one. The artist's challenge is software, not because it is difficult but because it is the conceptual representation of the new art.

Chapter 11, "Diversities of Interaction," discusses the increasing concern with the active role of the audience that has been encouraged by computer art. The audience can interact with an artwork in many ways. We have long understood that perception is an active process so that even contemplating a Mark Rothko painting involves interacting with it in a certain sense. In that example, of course, there is no material change in the painting when it is looked at. But many artworks do, in fact, materially interact with their environment—for example, with shadows changing as the sun moves round a sculpture or with a breeze changing the configuration of a mobile. With the advent of computers in art, however, there has been a significant growth of interest in observable interactions with artworks.

In these cases, we can see members of the audience move in some way and can also see the artwork change as a result. Such observable interaction can be considered in the light of action-response models. In other words, the causal effects of the gallery visitor's behavior on the artwork are relatively direct. They may even be open to intentional direction by the audience members, in which case the audience actively participates in the creation of the final artwork (see also Boden 2010a; Edmonds 2011).

A further development is based on a systems view, in which the audience and the artwork are seen as collections of systems that exchange information. Stroud Cornock and Edmonds (1973) presented the concept of seeing the artwork, the object itself, and members of the participating audience as interacting systems and suggested that the art system might be seen as the collection of all these things. Going one stage further, Sean Clark and Edmonds showed *ColourNet* at the CHI (Computer-Human Interaction) conference

in Paris in 2013 (Clark and Edmonds 2013). This art system allowed separate, possibly mobile, artworks by others to be included within the distributed system. The version demonstrated at CHI 2013 consists of two digital artworks—the core *Shaping Form* component by Edmonds and the *Transformations* component by Sean Clark. *Shaping Form* is projected on a large screen. Participants access *Transformations* on their smartphones. Both components are able to interact with multiple users simultaneously and can work independently. However, they are also able to interact with each other by exchanging color information via the Internet and using that information to influence the colors used.

In works such as *Shaping Form*, an action does not necessarily produce an immediate response. It may change the internal state of the other system and so influence its behavior later in time. The causal influence from audience to artwork is no less real but is much less direct—and often unfathomable.

As for chapter 12, "Correspondences: Uniting Image and Sound," this is the only one that focuses on or beyond nonvisual art. An important form of interaction that has developed considerably as the result of computer programming is interaction between different media. For instance, artworks that integrate visual displays with sound are common today. Such work is often linked with an interest in synesthesia. However, the link is more one of artistic inspiration than science, because the condition (color-and-sound mapping, for example) does not seem to be consistent across individuals.

The key point explored in the chapter is that the computer enables real-time dynamic linking between the generative production of sound and of image. For instance, software technology can analyze live music as it is played, detecting pitch and amplitude (for example) and feeding that information into a computer-based art system that responds to or transforms those sounds—producing music, images, or forms in many other media. A tight integration of media is thus made possible in ways that were imagined but not realized in earlier times.

Chapter 13 "Diversities of Engagement," describes how computer-based interactive art has encouraged a concern for better understanding of audience engagement. At the simplest level, this is a measure of how long someone looks at something: maybe a painting or a sculpture or a video. In the museum world, such simple measures are used to judge how attractive an exhibit is—or perhaps more accurately, how attracted to an exhibit the members of the public are.

The concept of engagement can be elaborated, however. For instance, at least three kinds of engagement can be identified. These are attraction (the work drawing attention to itself), sustainability (the length of time that someone finds it engaging), and repeatability (the extent to which someone wants to experience the work again and again).

Artists who make digital works that take engagement into account become involved in strategies for drawing the audience in and retaining their interest in quite explicit ways. This process can be one that includes an element of audience education. The artwork can be designed so as to attract the public and interact with them in ways that develop interest and engagement. Specific aspects encourage that result. Examples of this can be seen in the curated program of interactive art exhibits and their evaluation in *Beta_Space*, a joint venture of the Powerhouse Museum in Sydney and the Creativity and Cognition Studios at the University of Technology, Sydney (Candy and Edmonds 2011).

The artworks that are made for the new audiences for whom these artists are aiming can be ambient. That is, they may exist in the environment without any specific signals indicating that they should be seen as art. Of course, the context itself can be seen as a strong indicator in this sense. So we might want to distinguish between such art in a museum and art in the street, for instance. Engagement and ambient art are concepts that are important in the digital art world, but they have good continuity with the nondigital world. Dynamic and interactive artwork that is an integral part of an ordinary environment, such as a meeting space, bar, or city square, and that is made by use of computer systems is growing.

Finally, part IV, consisting of only the substantial chapter 14, provides a series of conversations with eleven computer artists. Most focus primarily on the visual arts, although a few of them sometimes integrate or combine vision and music in their work. All the artists are established, even long-established, professionals in the field, although some are known only in very specialized communities. This section of the book presents the artist's voice: the concerns of the book as seen from the point of view of the practicing artist.

In leading these conversations, Edmonds presents the artists with the key questions raised in the previous chapters. As one might expect, there was little or no comfortable consensus on many of these. On some, however, there was a significant measure of agreement. One obvious difference was closely related to age. The older, pioneer artists discovered computers and programming when already into their career and, for various reasons, became engaged in ways that extended or changed their artistic practice. At the other extreme, younger artists report having used computers, including programming them, before they dreamed of becoming artists. For them, the computer did not change their art, because it was always there.

The artists interviewed here work in the visual domain, in performance, and in sound and some work across these media. A strong theme is the importance of programming. The computer code is significant in several ways. For at least one of them, the code *is* the art. For several, writing it is a vital part of the thinking process. They

would never make the kind of art that they do without going through the thinking process required by programming. For them, software is a way of both making art and thinking about art. One of the artists puts a significant amount of effort into constructing the technology that is used in making the art. At least two others even find the need to make their own software tools. A performance artist finds that the specification of dance movements can be inspired by and even determined by the code.

Several artists, particularly those involved in live coding art (LC-art, in the taxonomy of chapter 2), are very interested in to what extent the audience should see the code and to what extent it is desirable that they understand it. One of these is designing a programming language with the very purpose of facilitating audience understanding of the software that drives the work.

It is clear from the interviews in the final chapter that computer artists' aims, methods, and beliefs differ significantly and also that they have often changed over the years. We hope that this book will inspire its readers to consider computer art from both historical and philosophical perspectives and, perhaps, also move their thinking on in valuable ways. We must acknowledge that our own thinking has been partly influenced by many conversations with the late Harold Cohen, who sadly died during the later stages of this book's preparation. Stroud Cornock, who also sadly died during these late stages, inspired much of Edmonds's work. Ernest Edmonds also thanks Linda Candy for endless valuable conversations and tireless support.

Perhaps, while considering computer art, some readers might also get involved in doing it. Or at least in hanging a CG-piece on their living room wall. Impractical? Not necessarily: some small wall-mounted interactive displays show dynamically changing images and sounds, triggered by passersby. Let us help bring computer art into the wider art world!

References

Becker, H. S. 1986. *Doing Things Together: Selected Papers*. Evanston, IL: Northwestern University Press.

Becker, H. S. 1995. "A New Art Form: Hypertext Fiction." In *How to Read a Hypertext*, edited by M. Bernstein. Cambridge, MA: Eastgate Systems.

Benjamin, W. 1968. "The Work of Art in the Age of Mechanical Reproduction." Publ. in German in 1936, trans. 1968. Reprinted in R. Kearney and D. Rasmussen (eds.), *Continental Aesthetics: A Reader* (Oxford: Blackwell), pp. 166–181.

Boden, M. A. 2004. *The Creative Mind: Myths and Mechanisms*. 2nd ed. London: Routledge.

Boden, M. A. 2007. "Creativity and Conceptual Art." In *The Philosophy of Conceptual Art*, edited by P. Goldie and E. Schellekens, 216–237. Oxford: Oxford University Press. Reprinted in M. A. Boden, *Creativity and Art: Three Roads to Surprise*, chap. 5. Oxford: Oxford University Press, 2010.

Boden, M. A. 2010a. "Aesthetics and Interactive Art." In Boden, *Creativity and Art*, chap. 11.

Boden, M. A. 2010b. "Authenticity and Computer Art." In Boden, *Creativity and Art*, chap. 10.

Boden, M. A. 2010c. "Autonomy, Integrity, and Computer Art." In Boden, *Creativity and Art*, chap. 9.

Boden, M. A. 2014. "Artificial Intelligence and Creativity: A Contradiction in Terms?" In *The Philosophy of Creativity*, edited by E. S. Paul and S. B. Kaufman, 224–246. Oxford: Oxford University Press.

Candy, L., and E. A. Edmonds. 2011. *Interacting: Art, Research and the Creative Practitioner*. Faringdon, Oxfordshire: Libri Press.

Clark, K. 1949. "Roger Fry." In *The Dictionary of National Biography 1931–1940*, edited by L. G. Wickham Legg, 298–301. London: Oxford University Press.

Clark, S., and E. A. Edmonds. 2013. "ColourNet: A System of Interactive and Interacting Digital Artworks." In *CHI '13 Extended Abstracts on Human Factors in Computing Systems*. New York: ACM Press: 2911–2914.

Collingwood, R. G. 1958. *The Principles of Art*. New York: Oxford University Press.

Cornock, S., and E. A. Edmonds. 1973. "The Creative Process Where the Artist Is Amplified or Superseded by the Computer." *Leonardo* 6:11–16.

Danto, A. 1964. "The Artworld." *Journal of Philosophy* 61 (19): 571–584.

Danto, A. 1981. *The Transfiguration of the Commonplace: A Philosophy of Art*. Cambridge, MA: Harvard University Press.

Dickie, G. 1974. *Art and the Aesthetic: An Institutional Analysis*. Ithaca, NY: Cornell University Press.

Dickie, G. 1997. *Art Circle: A Theory of Art*. Chicago: Spectrum Press.

Edmonds, E. A. 2011. "The Art of Interaction." *Digital Creativity* 21 (4): 257–264.

Lopes, D. M. 2009. *A Philosophy of Computer Art*. London: Routledge.

Mason, C. 2008. *A Computer in the Art Room: The Origins of British Computer Arts 1950–80*. Hindringham: JJG Publishing.

Ruskin, J. 1853. "On the Nature of Gothic Architecture: And Herein of the True Functions of the Workman in Art." In *The Stones of Venice*, chap. 6. Vol. 2 of *The Sea-Stories*. London: Smith Elder. (Published separately, with an introduction by William Morris, in 1854, by Smith Elder.)

II

2 A Taxonomy of Computer Art

Margaret A. Boden and Ernest Edmonds

2.1 Introduction

Since the late-1950s, an ever-diversifying set of novel art practices has arisen that is still little known or discussed in aesthetics and art theory. (For examples of these practices, see Krueger 1991; Wilson 2002; Candy and Edmonds 2002; Whitelaw 2004; Woolf 2004; Popper 2007.) As Jon McCormack, one of the artists concerned, has put it, "Much of the innovation today is not achieved within the precious bubble of fine art, but by those who work in the industries of popular culture—computer graphics, film, music videos, games, robotics and the Internet" (McCormack 2003, 5).

The "precious bubble" of fine art is a (shifting) socially accepted norm. But artists often work outside the norm of their day as famously illustrated by Marcel Duchamp and his ready-mades or John Cage's use of silence. And sometimes the bubble eventually expands so as to engulf the previously maverick efforts. The Impressionists, for instance, no longer have any need for a *Salon des Refuses*. They do not even need a salon: their images assail us every day on calendars and chocolate boxes. Whether the innovations mentioned by McCormack will one day be included in the expanding bubble remains to be seen. Their fate, in this regard, depends partly on how people—both curators and the general public—respond to the controversial aesthetic and philosophical questions raised in section 2.4.

The novel approaches involved here are closely interrelated, both theoretically and methodologically. So much so, indeed, that they are often all lumped together under

This chapter is based on M. A. Boden and E. A. Edmonds, "What Is Generative Art?," *Digital Creativity* 20 (1–2) (2009): 21–46. The research for that earlier paper was supported by AHRC Grant no. B/RG/AN8285/APN19307, Computational Intelligence, Creativity, and Cognition: A Multidisciplinary Investigation and also by the Australasian CRC for Interaction Design, established under the Australian Government's Research Centres Programme.

a label, such as computer art, electronic art, process art, or generative art. This chapter aims to clarify how they can be distinguished.

2.2 Origins and Interrelations

From the theoretical point of view, this new art originated in cybernetics and general systems theory. The young painter Roy Ascott, later to be highly influential in the field, identified the novel activity as "a cybernetic vision" in 1966 (Ascott 2003b, chap. 3; see also Mason 2008, chap. 4). And the exceptionally creative cybernetician Gordon Pask was a key influence. Besides producing or imagining some of the first artworks of this general type (in the 1950s), he provided much of the theoretical impetus that inspired the more philosophically minded artists in the field (Boden 2006, 4.v.e; Mason 2008, chap. 2).

Very soon, the "cybernetic vision" was bolstered by ideas about structure and process drawn from computer science. Ernest Edmonds, for instance, turned from paintbrush and easel to the computer in the 1960s; he thought he could produce more interesting art in that way (see Boden and Edmonds 2009, sect. iii). At much the same time, music and visual art was produced that reflected the computational theories of mind of artificial intelligence (AI). Indeed, Harold Cohen, a renowned abstract painter in 1960s London, deserted his previous working practices largely because he felt that doing computer art would help him understand his creative processes better (McCorduck 1991; Boden 2004, 150–166, 314–315).

Over the last twenty years, this artistic field has been inspired also by ideas about emergence, evolution, embodiment, and self-organization. These concepts are borrowed from cognitive science and in particular from artificial life (A-Life). However, the theoretical roots (and the pioneering experiments) of A-Life reach back to midcentury cybernetics and automata theory (Boden 2006, 4.v.e, 15.iv–v). In short, the theoretical wheel has turned full circle.

The methodological wheel, meanwhile, has climbed an ascending spiral. Art practices outside the fine-art bubble are grounded in technologies for communication and information processing whose power and variety have burgeoned over the last half century. Often, this means that the customary lone artist is replaced by a team, some of whose members may be computer scientists or tele-engineers.

Most of them rely heavily on digital computing and in particular on methods drawn from AI and A-Life. Specifically, they have employed symbolic and connectionist computation and, more recently, cellular automata, L-systems (automatically branching structures that botanists use to study plant form and physiology), and evolutionary

programming too. This is an ascending spiral, not a linear ascent, because two of those recent methods were foreseen (by John von Neumann) in 1950s cybernetics, and all three had been mathematically defined by the 1960s (Boden 2006, 15.v–vi). But none could be fruitfully explored, by artists or by scientists, until powerful computers became available much later.

The resulting artworks are highly diverse. They include music, sonics, the visual arts, video art, multimedia installations, virtual reality, kinetic sculpture, robotics, performance art, and text. And whereas some of these outside-the-bubble activities place ink or paint onto a surface, others involve desktop visual display units (VDUs) or room-scale video projection. Yet others eschew the virtuality of cyberspace, constructing moving physical machines instead.

The labels attached to these new art forms vary and have not yet settled down into a generally accepted taxonomy. The names preferred by the artists involved include generative art, computer art, digital art, computational art, process-based art, electronic art, software art, technological art, and telematics. All these terms are commonly used to denote the entire field—and although distinctions are sometimes drawn, they are often treated as synonyms.

With respect to the labels computer art and generative art, that was true right from the start. These terms have been used in tandem and more or less interchangeably since the very earliest days. The first exhibition of computer art, held in Stuttgart in February 1965, was called "Generative Computergraphik" (Nake 2005). It showed the work of Georg Nees, who wrote the first doctoral thesis on computer art, giving it the same title as the exhibition (Nees 1969). That thesis was widely consulted by the small but growing community, harnessing the words "generative" and "computer" together in its readers' minds.

Their near equivalence was reinforced in November 1965, when an exhibition (again in Stuttgart) included both Nees's work and the early computer graphics of Frieder Nake. Both men applied the term "generative" to their work and used it to identify art that was produced from a computer program and, hence, at least in part produced automatically. Others who were pioneering the activities outside McCormack's bubble also adopted the term. For example, when Manfred Mohr started producing drawings with a computer program in 1968 he termed it "generative art" (Mohr 1986). And the philosopher Max Bense—who had composed the manifesto for the original Stuttgart exhibition of 1965—was writing about "generative aesthetics" (Nake 1998).

The label generative art is still current within the relevant artistic community. Since 1998 a series of conferences have been held in Milan with that title (see http://www .Generativeart.com/), and Brian Eno has been influential in promoting and using

generative art methods (Eno 1996). The use of the term has now converged on work that has been produced by the activation of a set of rules (determined by the artist) *and* in which the artist lets a computer system take over at least some of the decision making.

With the recent appearance of art using methods drawn from A-Life (for examples, see Whitelaw 2004; Tofts 2003; 2005, 80–103; Popper 2007, 118–129), the label generative art, as used in the community concerned, has acquired biological overtones. In biology, "generative" is common in discussions of morphological development, of growth in plants and animals, and in references to reproduction. One or both of those meanings are sometimes explicitly stressed by self-styled generative artists whose work focuses on emergence, self-organization, or evolution. McCormack himself is one such example (e.g., Dorin and McCormack 2001; McCormack, Dorin, and Innocent 2004). Even so, the formal mathematical sense remains a core aspect of the label's meaning.

Despite the continuing assimilation of the terms "generative" and "computer" art, one should not assume that these are exactly the same thing. According to the taxonomy given in section 2.3, not all generative art involves computers. To the contrary, the generative processes involved vary widely in type—some of which were already used by artists hundreds of years ago.

Even in the 1960s, however, alternative tags for this general area were already being offered, and more have been suggested since then. An influential discussion by the art historian Jack Burnham (1968), for instance, identified the new work, overall, as process art—a label that is still in use fifty years later.

Since Burnham's discussion, the processes involved in process art have diversified hugely. As a result, and in addition to varying labels for the entire extrabubble field, there are today many names for subfields. These more discriminating categories include interactive art, evolutionary art, video art, media (and new-media and multimedia) art, holographic art, laser art, virtual art, cyborg art, robotic art, telerobotics, and net art. Again, however, the extension of these labels (the scope of the subfields) is not always clear.

It is partly for that reason that "a satisfactory critical framework of new forms in art technology has yet to be developed" (Candy and Edmonds 2002, 266). The distinctions made in this chapter should help toward such a framework.

There is a caveat, however. The definitions given in section 2.3—for instance, of computer art, generative art, evolutionary art, robotic art, and interactive art—use words that are already being used by the artists in question. Indeed, this analysis may help readers interpret these artists' discussions of their own work. But the aim is not to offer a report of common usage: such usage is not consistent. Rather, this new taxonomy

is intended as a theoretical tool to highlight certain distinctions that have aesthetic or philosophical interest. As we see in section 2.4, judgments concerning creativity, authorial responsibility, agency, autonomy, authenticity, and (sometimes) ontology are even more problematic outside the precious bubble than inside it.

2.3 The Taxonomy

Fourteen types of art are distinguished in the taxonomy given here. They are Ele-art, C-art, D-art, CA-art, G-art, CG-art, Evo-art, R-art, Net-art, I-art, CI-art, VR-art, LC-art, and 3DP-art.

Some of these activities, having been located within the classification, are then ignored. In other words, certain types of computer art are identified in the taxonomy but not further discussed in this chapter or elsewhere in this book. Most of the attention is paid to the forms of CG-art, because these raise the most interesting philosophical issues.

This taxonomy is a decidedly non-Linnaean structure. For one thing, the definitions given in this chapter, like most definitions, admit borderline cases and even anomalous counterexamples. And for another, there is no neat and tidy hierarchy of genus and species within which these twelve types can be located. Although there are some part-whole relations here, there are also untidy overlaps.

One type of overlap concerns links with more traditional, or familiar, categories of art. Most cases of such art do not fall under this new classification at all. But some of the classifier concepts—namely, G-art, I-art, Evo-art, and R-art—cover artworks both inside and outside McCormack's "precious bubble." Admittedly, those that lie inside the bubble are relatively maverick examples, as we will see. Indeed, some of them (produced by the conceptual artists) were specifically intended to undermine the commonly accepted notion of fine art in terms of which the bubble is defined. In McCormack's usage, however, *all* examples of noncomputer art are located inside the bubble.

A list summarizes the definitions at the end of this section.

Let us start with electronic art, or Ele-art. This wide concept covers *(df.) any artwork whose production involves electrical engineering or electronic technology.* So it ranges from simple analogue devices of the 1950s and 1960s such as Pask's *Musicolour* and *Colloquy* (Pask 1971; Mallen 2005) and Edward Ihnatowicz's kinetic sculpture *SAM* (Zivanovic 2005, 103)—all pioneering examples of interactive art, or I-art—to the highly sophisticated man-robot integrations embodied by the performance artist Stelarc (Smith 2005). And along the way it covers the whole of computer art and media art, including examples that exploit the advanced computational techniques of virtual reality.

Ele-art does not include art that is *produced* only by humans but *published* by electronic means. So it excludes Japan's Keitai novels, for instance. These are stories published online for download to mobile phones. Some are so popular—more than two million downloads in their first week—that they are issued in book form by traditional publishers. In 2007, half of Japan's top ten fiction best sellers originated in this way. By contrast, some of the Manga-art comics now being published for mobile phones do count as Ele-art—namely, those involving animated graphics or interactivity. In some cases, the phone buzzes when the reader comes to a tense moment in the action depicted on the screen. A Keitai novel could of course be adorned with such buzzes and would then count as a marginal example of Ele-art—only marginal because these buzzes are superficial, and their loss (if the text were later published in book form) would minimally alter the reader's experience.

Unlike mechanical art, such as Leonardo da Vinci's metal lion, who "after he had a while walked vp and downe, stoode still opening his breast, which was all full of Lillies and other flowers of diuers sortes" (Marr 2003, n66), electronic art could not appear until the mid-twentieth century. But as the previous paragraph implies, the technologies concerned have diversified richly since then. Accordingly, the highly inclusive label Ele-art is not very interesting for our purposes.

Surprisingly, perhaps, neither is the concept of computer art, or C-art: *(df.) art in whose productive process computers are involved.* This concept is apt for general art-historical purposes, because it covers every example that anyone might want to call computer art—including many that are commonly given other labels. It is less useful for us here, however, for two reasons.

First, it includes analogue as well as digital computers. Some of the earliest C-art work combined digital methods with specially built analogue devices. Ihnatowicz's giraffe-like kinetic sculpture *Senster* is a case in point (Zivanovic 2005; Mason 2008, chap. 5). As for analogue computers, these were used in the early days in, for example, visual arts such as Ben Laposky's work of the 1950s (Laposky 1969) and electronic music at the same time, famously encouraged by the invention of the Moog synthesizer (Pinch and Trocco 2002).

Today, a few computer artists sometimes employ analogue *processes*— namely, electrochemical reactions like those pioneered by Pask. Some of their work, including Pask-inspired "sculptures" by Richard Brown (2001, 2006) and Andy Webster (2006), featured in the 2007 Edinburgh exhibition *Gordon Pask and His Maverick Machines*. In addition, a video on this theme titled "Tuning Pask's Ear" has been shown in several European art galleries (Webster and Bird 2002). But analogue *computers* are another matter—and are very rarely used by artists today. Because of the huge flexibility that is afforded by the general-purpose nature of digital computers, it is those machines that

underlie most C-art. Indeed, to speak of computer art is typically to assume that digital computers are being used.

In other words, computer art is tacitly classed as digital art, or D-art. D-art *(df.) uses digital electronic technology of some sort.* It includes not only artworks generated by computers but also digitally manipulable (but human-produced) music and video. Common usage sometimes treats "digital art" and "computer art" as near synonyms. In this taxonomy, however, they are analytically distinct with most but not quite all, C-art being included within D-art. If the word "electronic" were removed from our definition, the nineteenth-century Pointillists would count as D-artists; their pictures were composed not of continuous brushstrokes or color washes but of myriad individual spots of paint.

D-art is more wide ranging than may appear at first sight. For instance, some C-artists use visual software that is *intuitively* analogue and so relatively natural to work with. One example is continuous vector mapping, used instead of pixel editing (Leggett 2000). But they are relying on methods and hardware that are digital at base. In fact, most people who today say that they are using an analogue method (i.e., an analogue virtual machine) would actually be working on a digital computer, used to simulate an analogue computer.

Similarly, most neural networks, or connectionist systems, whether used by cognitive scientists or by computer artists, are simulated on von Neumann machines. That is true, for instance, of Richard Brown's interactive *Mimetic Starfish*, a millennial version of *Senster* that was exhibited around the world and was described by *The Times* (2000) as "the best bit of the entire [Millennium] dome." The starfish was built by engineering visual imagery, not metal: it is a purely virtual creature (an image projected onto a marble table) that responds in extraordinarily lifelike ways to human movements. And it is generated by a self-equilibrating connectionist system (programmed and built by Igor Alexander). In short, digital technology reaches further than one might think.

The second reason the definition of C-art given is too catholic for our purposes is that it includes cases in which the computer functions merely as a tool under the close direction of the artist, rather like an extra paintbrush or a sharper chisel. Artists in the relevant community sometimes speak of this as computer-aided or computer-assisted art, contrasting it with what they call computational art—where the computer is more of a participant, or partner, in the art making (e.g., P. Brown 2003, 1). Let us call this CA-art, wherein *(df.) the computer is used as an aid (in principle, nonessential) in the art-making process.*

Consider video art and music videos, for instance. These popular outside-the-bubble activities qualify as CA-art in this sense. The human-originated images and music are digitally stored and (usually) manipulated or transformed by the artist, using the

computer as a tool. Other cases of CA-art include someone's doing a line drawing by hand on the computer screen and then calling on a coloring program such as Photoshop to produce a limited edition of identical prints—or a unique image. This is an upmarket form of paint by numbers, wherein the hues for each area are chosen by the individual artist. Yet other examples include visual collages composed from image libraries and computer music that is so called because it uses electronic synthesizers and virtual instruments.

In practice, the computer aid may be necessary for the art making. It is impossible, for instance, to alter video images in certain ways except by using a computer. Similarly, some visual effects delivered by Photoshop could not have been produced by using oils, water colors, or gouache. The renowned artist David Hockney accordingly described Photoshop as "a fantastic medium" (Hockney 2009). And synthesized computer music exploits sounds that had never been heard before synthesizers were developed. Nevertheless, the computer is not essential *in principle*. The relevant visual or sonic effects are specifically sought by the human artist and might conceivably have been produced in some other way. Much as a species with iron-hard fingernails would not need chisels, so our vocal cords (or wood, metal, or cats' sinews) might have been able to produce the sounds produced by synthesizers.

The subclass of C-art that is of interest in the present context is the type in which the computer is not used as a tool to effect some preexisting idea in the artist's mind but is in a sense (just what sense is explored in section 2.4) partly responsible for coming up with the idea itself. In other words, the computer art that is most relevant here is a form of generative art, or G-art. In G-art, *(df.) the artwork is generated, at least in part, by a process not under the artist's direct control.*

This is a very broad definition. It does not specify the minimal size of the part. It does not lay down just what sort of generative process is in question. It does not say what counts as being outside the artist's direct control. And it is silent on whether the processes concerned were deliberately molded by the artist before losing direct control. In short, this definition of G-art is largely intuitive. In general, it picks out cases of art making in which personal control is deliberately diminished, or even wholly relinquished, and relatively impersonal processes take over.

Those impersonal processes vary greatly. They may be physical, psychological, sociocultural, biological, or abstract (formal). And if abstract, they may or may not be implemented in a computer.

For example, in the dice music written by Haydn and Mozart, the exact order of the precomposed phrases was decided by throwing a die. Although a human threw the die voluntarily, he or she could not influence, still less determine, just how it fell. That was due to purely physical forces.

Such forces also influenced some visual generative art that predated computers. One clear example is Kenneth Martin, whose 1949 abstract painting used basic geometrical figures (squares, circles, diagrams) and rules of proportion (Martin 1951). Later, his *Chance and Order* and *Chance, Order, Change* series combined rule-driven generation with random choice. Although the basic forms were laid down by the rules that Martin had deliberately devised, chance physical events—such as picking a number out of a hat—determined the actual course of the work.

As for generative literature, this too may involve chance events dependent on physical processes. The various versions of Bryan Johnson's (1969) novel *The Unfortunates* are produced in this way. The novel was published as twenty-seven separate sections in a box: all but the first and last were to be read in a random order, decided by shuffling or dice throwing. Many other examples of interactive stories, partly narrated by the reader, have been produced since then (Montfort 2003). Most of these depend not on physical processes but on deliberate voluntary choices by the reader-author; however, some are partly generated by dice throwing and the like.

Arguably, G-art produced by physical forces can be found *inside* McCormack's bubble, too. Given the phrase "at least in part," used earlier to describe a computer's share in Nees's and Nake's work, one might say that Jackson Pollock's paintings exemplified G-art grounded in physics. Although he certainly was not throwing (still less choosing) paint at random, he did not have direct control over the individual splashes as he would have had over marks made with a paintbrush.

Even more control was lost, or rather deliberately sacrificed, when Hans Haacke, in the 1960s, began to exploit and even to highlight the physical behavior of water, vapor, and ice; of waves; and of weather conditions. He wanted to make "something which experiences, reacts to its environment, changes, is nonstable…, always looks different, the shape of which cannot be predicted precisely" (Lippard 1997, 38, 64–65). He saw these works not as art *objects* but as "'systems' of interdependent processes" that evolve without the viewer's interaction or "empathy" so that the viewer is a mere "witness." A few years later, Jan Dibbets placed eighty sticks in the sea, a few inches below the surface, and watched them oscillate in the water from fifty feet above: "That," he said, "was the work" (Lippard 1997, 59).

The Surrealists of the 1920s, by contrast, had exploited *psychological* processes—but their work counts as G-art because these were of a relatively impersonal kind. Inspired by Freud, they engaged in automatic writing and painted while in trance states to prioritize the unconscious mind, which Andre Breton declared to be "by far the most important part [of our mental world]." Indeed, Surrealism was defined by Breton as "pure psychic automatism [*sic*] by which one proposes to express…the actual functioning of thought, in the absence of any control exerted by reason, exempt from all aesthetic or

moral preoccupations" (Breton 1969). The unconscious thought was taking place in a person's mind, to be sure, but voluntary choice and personal "preoccupations" (i.e., the reality principle and ego ideals) were not directing it.

The conceptual artist Sol LeWitt was also recommending G-art when he said that art should be designed by some formulaic rule. The crucial idea, he said, "becomes a machine that makes the art," in which "all of the planning and decisions are made beforehand and the execution is a perfunctory affair" (LeWitt 1967, 824). Once the plan has been chosen, "The artist's will is secondary to the [art-making] process he *initiates* from idea to completion" (LeWitt 1969, item 7; italics added). He even added that the artist's "wilfulness may only be ego." That art-making process was nevertheless psychological, in the sense that the implications of his abstract rules were discovered not by computers but by conscious reasoning.

Sociocultural processes—in the form of the US postal system—produced Douglas Huebler's artwork called *42nd Parallel*. Items were posted from fourteen towns spanning 3,040 miles on latitude 42° north, all sent to Truro, Massachusetts. The work, according to Huebler, was not the conception in his mind, or the posted items, or even the acts of posting. Rather, it was the widespread pattern of activity within the US postal system. But, he said, the work was "brought into its complete existence" through documents: the certified postal receipts (for sender and for receiver), and a map marked with ink to show the geographical relations of the fifteen towns. Its nature as G-art is evident in his remarks that "an inevitable destiny is set in motion by the specific process selected to form such a work, freeing it from further decisions on my part," and "I like the idea that even as I eat, sleep, or play, the work is moving towards its completion" (Lippard 1997, 62).

The artist Hubert Duprat turned to biology for constructing a work of art. He put dragonfly larvae into an aquarium containing not pebbles and pondweed but tiny flakes of gold and a few small pearls, opals, and sapphires and left them to sculpt opulent little protective cases, held together by caddis silk (Duprat and Besson 1998). Some thirty years earlier, Haacke too had turned to biology. He experimented with the growth of grass and the hatching of chickens (as well as with water and weather) to make something "natural," which "lives in time and makes the 'spectator' experience time" (Lippard 1997, 38). Mavericks though they were, both Duprat and Haacke were working inside McCormack's bubble.

Others have even exploited physical and biological *degeneration* to produce their G-art. The environmental sculptor Andy Goldsworthy sometimes highlights effects caused by undirected physical change, in his gradually melting ice sculptures, for example. And in Gustav Metzger's "auto-destructive" art (notorious for an overnight gallery cleaner

innocently throwing Metzger's bag of rotting rubbish into the dustbin), the point of the exercise is to remind us of the deterioration that awaits all human constructions—and human beings, too (Metzger 1959, 59; 1965). He was thinking not only of biological decay but also of the terrible destructive power of the Cold War arms race. The artwork is usually assembled by a human artist (or sometimes, Metzger said, by machines in a factory). But it attains its final form, and its significance, through the natural processes of damage and decay.

Such inside-the-bubble (albeit unorthodox) cases, however, are not what the new artists normally have in mind when they refer to generative art. Their phraseology is borrowed from mathematics and computer science, with which the maverick artists just named were not concerned. These disciplines see generative systems as sets of abstract rules that can produce indefinitely many structures or formulae of a given type and that—given the Church-Turing thesis (Boden 2006, 4.i.c)—can *in principle* be implemented in a computer. The G-art community outside the bubble put this principle into practice. That is, their art making rests on processes generated by formal rules carried out by computers—as opposed to physical, biological, or psychological processes or abstractions personally discovered by conscious thought.

In other words, the instances of G-art that most concern us here are those that are also instances of C-art. They are computer-generated art, or CG-art.

A very strict definition of CG-art would insist that *(df.) the artwork results from a computer program being left to run by itself, with zero interference from the human artist.* The artist (or a more computer-literate collaborator) writes the program but does not interact with it during its execution. In effect, the artist can go out for lunch while the program is left to do its own thing.

Such cases do exist. Cohen's AARON program (described later) is one well-known example. Nevertheless, that definition is so strict that it may be highly misleading. Most people working in, or commenting on, generative art allow a compromise in the core concept so as to include interactive art. That is such a prominent subclass of what is called generative art that, even though the taxonomy given here does not aim to capture common usage, it would be highly anomalous to exclude it.

To be sure, the definition of CG-art does cover most interactive art, because it insists on zero interference from the human artist rather than from *any* human being, whether artist or audience. However, it would be very easy for readers to elide that distinction, which in any case makes a questionable assumption about authorial responsibility (discussed in section 2.4). Moreover, the overly strict definition of CG-art excludes those cases (whether inside the bubble or outside it) wherein artists rely on their intuitive judgment to make selections during an artwork's evolution.

It is preferable, therefore, to define CG-art, less tidily, as art wherein *the artwork results from some computer program being left to run by itself, with minimal or zero interference from a human being.* "Minimal," of course, is open to interpretation. It necessitates careful attention to *just what* interference goes on and *by whom* in any particular case.

Most of what people call computer art is CG-art, in this sense. Indeed, the phrases "computer art" and "generative art" are often regarded as synonyms. Notice, however, that in our terminology not all C-art is CG-art. CA-art is not, because the computer is used as a tool subject to the artist's hands-on control and is of no more philosophical interest than a paintbrush or a chisel.

Admittedly, the distinction between CA-art and CG-art is not always so clear-cut as in the CA-art examples mentioned earlier. We see in chapter 6, for instance, that a program for simulating various painting materials and styles can be run either *more* or *less* autonomously (Colton, Valstar, and Pantic 2008). More, and it counts as CG-art; less, and it is better seen as CA-art—although even so, it relies heavily on CG-processes. In general, CA-art may involve AI agents: programs called on by the human artist to aid in specific ways during the production of an artwork (Boden 1994; 2006, 13.iii.d). The more that the ongoing direction is assumed by the computerized agents, not by the human being, the closer the project is to CG-art.

CG-art is intriguing on two counts. First, the generality and potential complexity of computer programs means that the possible space of CG-artworks is huge, indeed infinite. Moreover, most of the structures in that space will be images or music that the unaided human mind could not have generated or even imagined as the artists themselves admit. CG-literature can be ignored here: unless it is heavily interactive, it is much less successful, because the relevant knowledge of language and of the world is too rich to be implemented in computers.

A skeptic might object that much the same is true of a trumpet or a cello: not even the most skilled stage impressionists could mimic these instruments plausibly. In short, human artists often need help from machines. Trumpets, computers—what is the difference? Well, one important difference has just been mentioned: the generality of digital computers. In principle, these machines can (and do) offer us an entire symphony orchestra and an infinite set of visual images and sculptural forms—indeed, an infinite range of virtual worlds. McCormack (2003, 7) goes so far as to compare this infinite space of possibilities, way beyond our comprehension, with the Kantian sublime.

The second point is even more pertinent. Whereas there is no interesting sense in which a trumpet or a cello can be left to do its own thing, a computer certainly can. And it is part of the definition of CG-art that this happens. As we see in section 2.4, this

aspect of CG-art raises some tricky problems concerning concepts such as autonomy, agency, creativity, authenticity, and authorial responsibility.

Especially well known cases of CG-art are the successive versions of AARON. This is a drawing-and-coloring program developed over the last forty years by the one-time abstract painter Cohen (1995, 2007) and whose works are exhibited at venues all around the world—including the Tate Gallery. It has shown clear progression along aesthetic dimensions. Indeed, Cohen (personal communication) describes the 2006 version as a "world-class" colorist, whereas he himself is merely a "first-rate" colorist: "I wouldn't have had the courage to use *those* colours," he has said. Earlier versions of AARON mixed liquid dyes and used painting blocks of five different sizes to place them on paper; a later version printed out colors instead of using liquids, but these colors too were mixed at the program's behest. And the current implementation of AARON shows the development of the images in real time, projected onto an electronic screen.

An almost equally famous example is Emmy, a computer musician developed over much the same period by the composer David Cope (2001, 2006). This generates music in the styles of many renowned composers and very convincingly, too (see Hofstadter 2001, 38–39). Cope has recently abandoned it, because of the prejudiced reactions of audiences (see section 2.4).

Both of those programs were based on methods drawn from what the philosopher John Haugeland (1985) dubbed GOFAI, or good old-fashioned AI (see Boden 2006, chaps. 10 and 13). However, the mature Emmy also uses connectionist AI (Boden 2006, chap. 12). More recent methods for constructing CG-artworks, as remarked in section 2.2, include cellular automata, L-systems, and evolutionary programming, all widely used in A-Life research (Boden 2006, chap. 15).

Cellular automata are systems made up of many computational units, each following a small set (usually the same set) of simple rules. In such systems, surprising patterns can emerge from the simple, anodyne base. Further variations ensue if another level of rules is added to the system. Examples in CG-art include the tessellated visual constructs within Paul Brown's *Sandlines* and *Infinite Permutations* and his other works (Whitelaw 2004, 148–153; Tofts 2005, 85–86; and see http://www.paul-brown.com).

L-systems are automatically branching structures, used by botanists to study plant form and physiology (Lindenmayer 1968; Prusinkiewicz and Lindenmayer 1990; Prusinkiewicz 2004). In the hands of CG-artists, they have led to McCormack's *Turbulence* installation (McCormack 2004; Tofts 2005, 80ff.). This generates images of unnatural yet lifelike vegetation growing in front of one's eyes and in response to one's actions (thus qualifying as interactive art). Another example is the use of a "swarm

grammar," based on L-systems generating structures in (simulated) 3-D space, comparable to the decentralized yet organized constructions of social insects such as termites (Jacob and von Mammen 2007).

As for evolutionary programming, this has given rise to an important subclass of CG-art: evolutionary art, or Evo-art. Examples include Karl Sims's *Genetic Images* and *Galapagos* (Sims 1991, 2007), plus many others (Whitelaw 2004, chap. 2). In Evo-art, the artwork is not produced by a computer program that has remained unchanged since being written by the artist. Rather, the artwork is *(df.) evolved by processes of random variation and selective reproduction that affect the art-generating program itself.*

Evo-art relies on programs that include self-modifying processes called genetic algorithms. To begin, a population of near-identical artworks—or to be more precise, the miniprograms that generate them—is produced by the computer. There can be any number, nine or sixteen or even more. In aesthetic terms, these first-generation artworks are boring at best and chaotic at worst. Next, each of these first-generation programs is altered (mutated) in one or more ways by the computer, at random. Usually, the alterations are very slight. Now, a selective procedure—the fitness function (decided by the artist-programmer)—is applied to choose the most promising candidate for breeding the next generation. And this process goes on repeatedly, perhaps for hundreds of generations. Provided that the mutations allowed are not too fundamental (see section 2.4), what ensues is a gradual evolutionary progress toward the type of structure favored by the artist.

Occasionally, the fitness function is fully automatic, being applied by the computer itself. If so, there may be scores, or even hundreds, of siblings in a given generation. This is a prime example of the computer's being left to do its own thing. More usually, the selection is made by the artist or a gallery visitor, for instance, using intuitive, and often unverbalized, criteria. In such cases, the population size rarely rises above sixteen because people cannot take in more than a limited number of patterns at once. In other words, and for reasons touched on in section 2.4, there is usually no *programmed* fitness function. In such cases, the Evo-art also counts as interactive art, or I-art.

One might argue that the suggested definition of Evo-art is faulty on the grounds that evolutionary art need not involve a computer. It is certainly true that the very earliest G-art works of the sculptor William Latham, who later became famous as a computer artist, were drawings generated by repeated dice throwing and hand sketching. At that time, he had no idea that computers might be able to do the job for him—and do it better (Todd and Latham 1992, 2–6). But that is highly unusual: virtually all art that is produced by an iterative process of random variation plus selection is computer based. Indeed, there may be no noncomputerized examples besides early Latham. Someone

might suggest Claude Monet's water lily series, but although these showed gradual improvement by way of small changes, those changes were far from random. Even Richard Dawkins's simple biomorphs, which were hugely seminal for Evo-artists, were computer generated (Dawkins 1986, 55–74). It is therefore acceptable to define Evo-art as a subclass of CG-art, even though this excludes the early Latham efforts.

Another subclass of CG-art is robot art, or R-art, which is *(df.) the construction of robots, for artistic purposes, that are physical machines capable of autonomous movement or communication.* This (happily!) is not the place for attempting to define "artistic purposes." As for "autonomous," the word may be understood intuitively here. At some point, however, it should be considered carefully, not least because the concept of autonomy is closely connected also with agency and creativity (see section 2.4).

This definition covers all cases of C-art wherein robots are involved. However, robots may be constructed for artistic purposes when the focus of aesthetic interest is not—as is usual—on the robots themselves but on drawings done by them (see chapter 5). A narrower definition that excludes such maverick cases would be that R-art is *the construction of robots that are regarded as objects of aesthetic interest and that are physical machines capable of autonomous movement or communication.*

Clearly, not all R-art is Ele-art. Indeed, R-art covers examples built many centuries ago. A few of these ancient machines could move as a whole from one place to another—such as Leonardo's mechanical lion that "walked vp and downe" the room or Daedalus's mercury-filled Venus that (according to Aristotle's *De Anima*) had to be tethered to prevent it from running away. Most, however, could move only their body parts—like the moving statues of nymphs and satyrs in the grotto fountains at Saint Germain, which enthused Rene Descartes as a young man (Boden 2006, 2.ii.d), or Jacques de Vaucanson's mechanical flute player (Boden 2006, 2.iv).

Electronic R-art is highly varied (Whitelaw 2004, chap. 4). It includes Ihnatowicz's eerily hypnotic *Senster*, Stelarc's thought-provoking man-robot hybrids, and Ken Goldberg's early 1990s *TeleGarden*—wherein living plants are watered by a robot that is controlled by Everyman via the Internet. (For an archive of photos and videos, see http://www.telegarden.org/tg/; see also Popper 2007, 379–393).

The *TeleGarden* was an early example of net art, or Net-art, in which *(df.) the artwork is generated on the Internet, by multiple human interactions with the computer and indirectly with each other.* So a Net-artwork is not just a computer-generated artwork that happens to be put onto the web by its human artist, not even if it can then be modified by other people. Rather, it is one for whose very existence the Internet is an essential condition. As Thor Magnusson has put it (personal communication), the immaterial property of interconnectedness is almost an artistic material, as clay is.

Artwork that was comparable, to some extent, existed forty years ago (Edmonds 1975). In 1971, Edmonds exhibited *Communications Game*, an electromechanical system of switches and lights controlled by six people sitting at individual stations linked by wires into three networks. And in 1972, he exhibited *Rover*, a rotating sphere driven, and partly lit, by three people operating joysticks. The aim was to enable an experience of communication and cooperation to arise, despite the absence of any direct communication among participants. These examples do not fit our definition of Net-art, however. Because no computer was involved, they were not even cases of C-art. Moreover, the Internet was not involved either, so the human participants were few compared with the numbers involved in Net-art today. But one might call them early prototypes, or anyway precursors. Indeed, Edmonds had also experimented with a few more participants and networks (unsuccessfully: people were overwhelmed by the larger number of signals), and he already had in mind the possibility of ARPAnet connections allowing for remote, and much more numerous, interactions.

Ten years later, Ascott conceived a work (*La Plissure du Texte*) that used the ARTEX computer network as the basis for the creation of a worldwide distributed narrative, or "collective global fairy tale" (Ascott 1983). The participants (or small participant groups) were each responsible for improvising the actions of a different character in the story: witch, princess, beast, wise old man, and so on. They were drawn from eleven cities around the world, and the system was continuously online for twelve days at the Musee d'Art Moderne's *ELECTRA* 1983 exhibition in Paris. The versions at different locations actually vary slightly, although they should be identical. (For a Toronto version, see http://www.normill.ca/Text/plissure.txt.)

This was much nearer to Net-art than Edmonds's 1970s examples had been. But true Net-art—generated by the interactions between hundreds or even thousands of people—is significantly different again. The word "multiple" in the definition needs to be interpreted generously. Although Net-artworks are sometimes confined to a relatively small or closed group, the general spirit of the Net-art enterprise encourages not only extensive interconnection but also nearly unlimited openness.

The pioneering *TeleGarden* remains unusual because only relatively few examples of Net-art involve robotics. Most Net-art is literary, visual, or musical (Bolter 1991; Becker 1986, 1995; Ascott 2003a; Greene 2004). The rarity of *robotic* Net-art is hardly surprising, because a robotic installation requires constant on-the-spot monitoring if only to receive the friendly attentions of an oil can. Goldberg's garden, for instance, was kept in operation and exhibition for nearly a decade by a team based in Austria's Ars Electronica museum (see http://www.ieor.berkeley.edu/~goldberg/garden/Ars/).

Whether it should really be called Goldberg's garden is of course debatable (see section 2.4). To be sure, it was his idea in the first place. But as with all Net-art (by definition), its detailed nature at any time has depended on the individual choices of many other human beings. And many, here, really does mean many. The number of participants-artists involved in the *TeleGarden* had already reached nine thousand by the end of its first year online and mushroomed massively thereafter.

Huge numbers apply also to some of the nonrobotic examples. The literary instances—of which Ascott's global fairy tale was a forerunner—are multiauthor hypertexts. They include narratives composed by many hundreds of participants, offshoots of game-playing MUDs and MOOs (Montfort 2003). Their possibility was glimpsed long ago by Vannevar Bush, whose prescient "As We May Think" (1945), originally written as early as 1937, foresaw not only hypertext but search engines such as Google, too (Bolter 1991; Boden 2006, 10.i.h).

In the cases of R-art previously mentioned, only one robot is involved. Sometimes, however, groups of interacting (distributed) robots are constructed. Such groups usually employ the techniques of situated robotics, wherein the machines respond directly to specific environmental cues, including here *the behavior of other robots* (Boden 2006, 13.iii.b and iii.d). Occasionally, they exploit self-organizing techniques whereby the system gradually reaches an equilibrium state. Futuristic though they may seem, both these methodologies were first used by midcentury cyberneticians: Grey Walter and Ross Ashby, respectively (Boden 2006, 4.viii). One example of the latter type is Jane Prophet's *Net Work* installation (Bird, d'Inverno, and Prophet 2007). One might think of this as a high-tech version of Dibbets's oscillating sticks. But instead of eighty isolated sticks placed below the surface of the sea, *Net Work* consists of 2,500 floating, intercommunicating buoys, each of which is color emitting and wave sensitive. More accurately, it *will* consist of 2,500 such buoys: a miniature version has been tested on the Thames, but it is planned to surround the pier at Herne Bay.

Such mutually interacting robot groups *do not* count as interactive art in the definition of I-art given later unless they are also capable of interacting with the human audience. *Net Work* does have that capability: the audience can affect it by shining torchlight on the buoys or by remote control over the Internet. Other examples of interactive (and interacting) robot groups include Kenneth Rinaldo's works in what he calls ecotechnology. His R-art (and I-art) installation called *The Flock* comprises three wire-and-vine robotic arms suspended from the ceiling that interact with each other and with the moving and speaking human audience. Similarly, his *Autopoiesis* has fifteen robot wire-frame arms distributed around the room that sense the observer's

movements and communicate with each other so as to coordinate their behavior in various ways.

This brings us to the tenth category: interactive art, or I-art. In this genre, the human audience, which need not include the artist, is not a passive observer but an active participant. Audiences are never wholly passive, of course, because art appreciation involves active psychological processes. Indeed, Duchamp (1957) went so far as to say, "The creative act is not performed by the artist alone; the spectator brings the work in contact with the external world by deciphering and interpreting its inner qualification and thus adds his contribution to the creative act." Even for Duchamp, however, the spectator's contribution concerns only the work's "inner" qualification (its role, he said, is "to determine [its] weight on the aesthetic scale"). The work's perceptible nature—or, many would say, the artwork itself—does not change as a result. In interactive art, by contrast, it does.

In I-art, then, *(df.) the form or content of the artwork is significantly affected by the behavior of the audience.* And in CI-art (i.e., the computer-based varieties), *(df.) the form or content of some CG-artwork is significantly affected by the behavior of the audience.* Again, I am speaking intuitively here: worries about just what counts as the artwork are left to the next section. The word "significantly" is needed, even though it is a hostage to interpretative fortune, so as to exclude performance art, because performance is usually subtly affected by audience reception. As for the word "behavior," this must be interpreted with generosity. In CI-art it covers voluntary actions (such as waving, walking, touching the computer screen, or choosing a plot line within a story), largely automatic yet controllable actions (such as the direction of eye gaze), and involuntary movements (such as breathing). It even includes arcane physical factors such as the radiation of body heat.

Occasionally, the interaction involves not the audience but the physical environment: aspects of the weather, for example, or wave movements. Some installations in city squares respond to the ambient temperature and rainfall, a gentle drizzle causing changes different from those seen in a downpour; others focus on the changing patterns caused by waves on the sea. Strictly speaking, such cases fall outside CI-art as it is defined here, unless—which is usually the case—they *also* involve interaction with the human audience.

CI-art is generative art *by definition.* But it is not generative in our strictest sense as AARON is. Although the artist can go to lunch and leave the program to do its own thing, the audience cannot. However, it qualifies as CG-art in the broader sense because the artist has handed over control of the final form of the artwork to the computer, interacting with some other human being. The degree of control attributable to the

audience varies: they may not realize that they are affecting the artwork or (if they do) just what behavior leads to just which changes. We see later that this variability is an important dimension in the aesthetics of CI-art.

I-art is not an entirely recent phenomenon; remember Haydn's dice music, for instance. But it became prominent in the mid-twentieth century. This was often justified in political terms: I-art was seen as offering valuable *human-human* communication, in societies in which the sense of community had been diluted (Bishop 2006). It was made possible largely by cyberneticians such as Pask applying their theory of communicative feedback to art and by the new electronic technology developed in World War II.

That is not to say that all these I-art efforts were examples of Ele-art. Many artists, indeed, eschewed such technology for (countercultural) ideological reasons: it was too strongly linked with the military-industrial complex. Even Ascott's first I-art had nary an electron in sight; it consisted of canvases with items or images on them that could be continually moved around by hand, so that the viewer of the resulting collages was their *maker* too (Mason 2008, 54–58). *SAM* and the *Senster* were early examples of I-art that did use electronics. But as we have seen, they did not involve computers.

Today's I-art, however, is overwhelmingly computer based. That is because the *generality* of digital computers enables them, in principle, to support an infinite variety of human-computer interactions.

The types of interaction explored in CI-art are already widely diverse—hence the inclusiveness of the term "behavior" in the definition. The by-now countless examples range from interactive CD-ROMs viewed on a desktop and altered (for instance) by touching the screen (Leggett and Michael 1996), to room-sized video or virtual reality (VR) installations—such as Christa Sommerer and Laurent Mignonneau's *Trans Plant*. In this case, a jungle gradually appears on the walls as the audience moves around the enclosure: grass grows when the viewer walks, and trees and bushes when the viewer stands still; the plants' size, color, and shape depend on the size and body attitudes of the human being; and the color density changes as the person's body moves slightly backward or forward. *Trans Plant* is driven by the viewer's movements, but some CI-artworks are modified also, or instead, by the sound of human voices or footsteps. This is reminiscent of the *Senster*—but these computer-generated changes are much more varied and complex than those that could be engineered in the 1960s by Ihnatowicz.

Sometimes, the relevant interactions involve online access to the Internet. This is true of Net-art in general, of course, wherein the artwork itself exists only by means of the Internet. But it is also true when the artwork being shown or generated on the walls of a gallery is enhanced by the automatic incorporation of items that happen to

be present on the Internet at that particular moment. One example is *The Living Room*, another installation built by Sommerer and Mignonneau. Unlike *Trans Plant*, this CI-artwork does not undergo changes that depend systematically on what the viewer is doing. Instead, random images and sounds, picked up from the Internet, appear in the room as a result of the viewer's movements and speech.

It is usual, as in that example, for the change in the CI-artwork (whether systematic or not) to be nearly simultaneous with the observer's triggering activity. In much of Edmonds's recent CI-art, however (some of which was presented the 2007 Washington commemoration of the ColorField painters), the effects of the viewer's behavior are delayed in time. In his most recent pieces, delayed changes in the software, introduced by more than one artist and also by members of the public, interact to modify the final artwork. An example, involving interactions between his *Shaping Form* and Sean Clark's *Transformations*, is described in chapter 1.

Partly because of the lesser likelihood that the viewer will realize—and be able to control—what is going on, Edmonds speaks of "influence" rather than "interaction" in these cases. As we see in section 2.4, whether mere influence can be aesthetically satisfying is controversial even *outside* the precious bubble.

Certainly, mere influence, as against instantaneous interaction, would not be enough for the twelfth category, virtual reality art, or VR-art. VR-art is the most advanced version of CI-art (for examples, see Popper 2007, chaps. 4–6). Already foreseen in the mid-1960s by Ivan Sutherland (1965, 2, 506–508, 582–583), it was not technologically possible until the late 1980s (Boden 2006, 13.vi).

In VR-art, interaction leads to illusion—of an especially compelling kind. In other words, *(df.) the observer is immersed in a computer-generated virtual world, experiencing it and responding to it as if it were real*. One cannot pretend that this definition is clear: just what is it for someone to experience and respond "as if it were real"? Some relevant issues are covered in section 2.4. Meanwhile, let us continue to rely on an intuitive understanding of such language.

Someone might want to argue that VR-art was initiated centuries ago. Pseudorealistic mimetic worlds have been depicted in various forms of trompe l'oeil (including realistic panoramas) for many centuries and even appeared in some of the wall paintings and architecture of classical Rome. But there is a crucial difference between the relevant aesthetics in times ancient and modern. As Oliver Grau (2003, 16) has pointed out, the "moment of aesthetic pleasure" in trompe l'oeil comes when viewers consciously realize that they are *not* experiencing reality. In VR-art, by contrast, the enjoyment lies in feeling as though one is really inhabiting, and manipulating, an alternative world. The longer the awareness of its unreality can be delayed, the better. In other words, the

experience of past forms of mimetic art was based only on illusion, not on immersion. Although one can say that the viewers were invited or deceived into responding to the art *as if* it were real, that "as if" was much less richly textured, much less sustained, and therefore much less persuasive than it is now.

Cinema is a halfway house (Grau 2003, chap. 4). It often elicits an emotional or narrative immersion in the filmgoer and sometimes—using special screens and techniques—leads to near-veridical experiences of inhabiting the cinematic world. These tend to exploit our reflex responses to visual images that suggest falling or imminent collision: so roller-coasters, white-water rafting, and tigers leaping toward us out of the screen are familiar favorites. But there is little psychological subtlety in this inhabitation and no detailed interaction with the alternate world, still less any physical manipulation of it.

In general, VR-art aims to make the participants (often called immersants) feel as though they are personally present in the cyberworld concerned. Normally, this world is visual or audiovisual, being presented on a visual display unit or a personal head-set, or projected onto the walls or floor of a real-world room. McCormack's *Universal Zoologies* VR-artwork is an exception: its images and sounds are projected onto two large talking heads in an attempt to provide a realistic illusion of human conversation (Tofts 2005, 81–82). But sometimes VR-art leads also to convincing experiences of touch, pressure, and motion by providing the observer with special gloves and other equipment (Boden 2006, 13.vi). Sometimes, too, the observer experiences utterly *unreal* capacities, such as being able to fly or to activate highly unnatural causal chains within the virtual world.

Even when the viewer is not presented with such shockingly unfamiliar experiences as those, something about the virtual world will be perceptibly *unlike* the real world. And this is deliberate. VR-artists are not aiming to achieve a fully detailed mimesis: what would be the point of that? Rather, they use near mimesis to cast some aesthetically or conceptually interesting light on our usual experiences and assumptions.

Detailed mimesis may be appropriate for other purposes, of course. For instance, a VR brain used in training neurosurgeons provides nicely realistic sensations of touch and vision when the trainee's virtualized surgical tool prods, pinches, or cuts different parts of it (Wang et al. 2007). Given that brains are very soft (compared with hearts, for example), the visual or haptic information at issue here is highly complex. So each of the different types of "touching" (prodding, pinching, cutting) has its own distinctive material and perceptual effects. Such highly realistic effects would be appropriate in an *artistic* VR work only if they prompted thoughts about matters beyond the practical exigencies of brain surgery—the physical vulnerability of all human flesh, perhaps, and (by extension) of human plans.

The thirteenth category, LC-art, covers cases of live coding, wherein *(df.) the art object is generated on the fly by code that is written in real time by the artist.*

Most LC-art is music, but occasionally images or texts are generated instead. The reason is that producing an interesting or attractive artwork is only part of the LC-artist's goal. And appreciating the art object for its own sake is only part of what the LC-audience is intended to do. In addition, they are supposed to read the code (which is displayed in real time, while it is being written) and appreciate how it informs the resulting artwork. Why did *that* instruction lead to *that* observable feature? And *what sort* of music is likely to result from *that* new piece of code? It is even more difficult to do this when both code and result are presented visually than when one is visual and the other auditory. So music is the dominant medium in LC-art. Indeed, very often live coders do not place that much emphasis on the exact manner and detail of the visual presentation of the code, hence indicating indirectly that the music is primary.

Even in the case of music, however, only a highly computer-literate audience can achieve the desired experience. It follows that the problems of art appreciation discussed in chapter 4 are especially great for LC-art. Moreover, it takes a special sort of coding to enable the audience to do so. Some LC-artists use existing programming languages, which may already be familiar to the audience. But others design novel programming languages, so that the successively appearing lines of code can be immediately seen to imply particular musical results.

LC-art is a type of CG-art because it involves programming by the artist and the generation of the LC-artwork by the computer. But it is similar to CA-art in one way: the human artist has direct control over what the program is doing at every moment. It therefore raises fewer philosophical questions than other categories of CG-art as CA-art in general does too (see section 2.4).

The final category is 3DP-art, which involves *(df.) the construction of artworks by means of 3-D printing.* Using this new technology, objects are built by laying down successive levels of some hard-setting fluid. This computer-controlled process is being used to produce toys, jewelry, artificial organs (e.g., ears), and even guns. But it is also beginning to be used by artists (as yet, only very few).

In principle, 3DP-art could be *generative* in the sense required for CG-art. For instance, it is suggested in chapter 6 that some future version of a program like *The Painting Fool* might employ 3-D printing to build brushstrokes in the chosen style, having appropriate 3-D texture as well as the requisite colors.

A team of artists and engineers in the Netherlands is already copying a Rembrandt self-portrait and his painting *The Jewish Bride*, as well as Van Gogh's *Flowers in Blue Vase*, all in three dimensions, not just two. However, that project counts as CA-art rather than CG-art: the desired results were initiated by Rembrandt and Van Gogh, and the

team is reproducing *only* those. Similarly, many 3DP-artists who aim to produce their own, novel artworks are using the technology in much the same spirit as Hockney uses Photoshop. In theory, they could make the works without the technology, but in practice the facility that it offers makes the construction of the sculptures realistic. See, for example, the exhibition *Beyond the Buzz*, shown at the Minneapolis College of Art and Design in 2015 (http://mcad.edu/events-fellowships/beyond-the-buzz).

Achieving truly generative 3DP-art involves added challenges. These challenges do not involve concerns for computation, as such, but concentrate on relationships between the virtual and the physical and the ways that different physical objects can relate to one another through their shared virtual digital models. One of the few examples of attempts to meet such challenges can be found in a 2010 exhibition displayed in Auckland, New Zealand (*Hybrids* at the Media and Interdisciplinary Arts Centre; http://shura.shu.ac.uk/4391/). The key point about this work was its emphasis on the dialogue between 3-D printing and traditional media. One of the curators, Ian Gwilt, has specifically concentrated on hybrid collections of artworks in which 3-D printing forms one aspect and is both influenced by and influences the artwork (see, e.g., Gwilt 2013).

In sum, the fourteen definitions in this taxonomy are as follows:

1. Ele-art involves electrical engineering or electronic technology.
2. C-art uses computers as part of the art-making process.
3. D-art uses digital electronic technology of some sort.
4. CA-art uses the computer as an aid (in principle, nonessential) in the art-making process.
5. G-artworks are generated, at least in part, by a process not under the artist's direct control.
6. CG-art is produced by leaving a computer program to run by itself, with minimal or zero interference from a human being. The stricter definition of CG-art (art produced by a program left to run by itself, with *zero* interference from the human artist) was deliberately rejected.
7. Evo-art is evolved by processes of random variation and selective reproduction that affect the art-generating program itself.
8. R-art is the construction of robots for artistic purposes, in which robots are physical machines capable of autonomous movement or communication. C-art that uses robots but has an artistic focus not on the robots themselves is excluded.
9. Net-art is the generation of the artwork on the Internet, by multiple human interactions with the computer and indirectly with each other.

10. In I-art, the form or content of the artwork is significantly affected by the behavior of the audience or sometimes by purely physical causes.

11. In CI-art, the form or content of some CG-artwork is significantly affected by the behavior of the audience.

12. In VR-art, the observer is immersed in a computer-generated virtual world, experiencing it and responding to it as if it were real.

13. LC-art is generated on the fly by code that is written in real time by the artist.

14. 3DP-art is the construction of artworks by means of 3-D printing.

2.4 Questions for Philosophical Aesthetics

Aesthetic and philosophical problems arise with respect to CG-art in general and others with respect only to particular varieties of it. None of these can be explored at length here. (For fuller discussions, see the other chapters in this volume and also Boden 1999; 2004; 2006, 13.iii.d–e and 16.viii.c; 2007a; 2007b; 2010a; 2010b; Cornock and Edmonds 1973; Costello and Edmonds 2007; Edmonds 2006, 2007; Muller, Edmonds, and Connell 2006.) Instead, here we briefly discuss the wide range of puzzles that attend the consideration of generative art.

One obvious question can be put like this: Is it really the case that a computer can ever *do its own thing*? Or is it always doing the programmer's (artist's) thing, however indirectly?

To answer that question seriously requires both general philosophical argument and attention to specific aspects of particular CG-art examples in the underlying program and in the observable artwork. That sort of attention is not appropriate in cases of G-art that are not computer based. The physical, psychological, or biological processes in which they are grounded are not specifiable in detail—not even by scientists, let alone by artists. Computer programs, in contrast, are so specifiable.

That is why one can make sensible comparisons between the extent to which different CG-art programs are or are not under the artist's direct control and the extent to which, and the points at which, they are subject to interference from a human being. However, one can do this only if one knows something about how the program or installation works (see chapter 4). Merely observing, or even participating in, the resultant artwork is not enough.

Whether it *appears* to participants that the program or installation is independent, or autonomous, is of course another question, one that may not be easy to answer in practice.

Even the programmer may be misled, here. In the earlier paper on which this one is based (Boden and Edmonds 2009), Edmonds pointed out that step-by-step programming (i.e., writing a program as a sequence of explicit instructions) feels more directive than rule-based programming (i.e., defining a set of constraints—for instance, that Z should always be bigger than Y or X must never equal W—that the computer must follow, without stating how this will be effected by the machine). In the latter case, one might say that the artist leaves the computer to do its own thing without knowing *just what it is* that the computer will be doing. The computer-art community usually regards it as important that the artwork is generated from a set of rules, or constraints, rather than from a step-by-step algorithm. But this is more a matter of taste than anything else. Even when programmers have written explicit step-by-step code, they do not necessarily—or even usually—know the outcome. If they did, there would be no bugs (except those due to typing mistakes and punctuation errors). Despite the difference between the feel of the two programming approaches, there is no distinction at the most fundamental level: in all but the very simplest cases, both types of program are unpredictable by their programmer. Rule-driven systems merely *appear* to have a greater degree of autonomy relative to the conscious decisions of the human artist.

Autonomy, of course, is a concept that is closely connected with art making in general. John Ruskin, for example, made much of it in his theory of aesthetics (see chapter 7). But does it ever make sense to ascribe autonomy to a computer?

Some sorts of programs can indeed have autonomy and of several different types (Boden 2007b). But only one of these is similar to the sort of human autonomy that we normally associate with art. Is that ever found in CG-art?

It is certainly-art, in which the human artist's moment-to-moment coding is responsible for the artwork that results. But what about the other categories of CG-art? Irrespective of the artist's phenomenology while writing the program or of the participants' phenomenology when experiencing it, do some of these have more autonomy than others? What of Evo-art, for instance: does the self-modification involved and the automatic selection (in cases in which that happens) mean that evolutionary programs are more autonomous than, say, AARON? With respect to AARON, can we ascribe at least a minimal level of autonomy to the computer, given that Cohen has no hands-on control over what picture will be drawn or how?

Insofar as a program is doing its own thing, does it take on the *authorial responsibility*? Let us ignore the fact that authorial responsibility is often unclear here anyway, because most CG-art is produced by a team, not a lone artist.

For instance, did AARON generate those magnificent "world-class" colored drawings or did Cohen? He admits, after all, that he himself "wouldn't have had the courage to

use *those* colours." On the other hand, he says he is happy that there will be more of "his" original artworks appearing well after his death (Cohen 2002a). Is he right, or is he deluded? The answer will depend not only on one's philosophy of the self but also on one's views as to whether any computer program can be seen as an author or artist. Douglas Hofstadter, for example, interprets the self in such a way that he would be content to ascribe the posthumous works to Cohen himself, and he would even deny that they are in the fullest sense *posthumous* (Hofstadter 2007).

However, if he was emotionally moved by them, he would also resist ascribing authorship to the computer (Hofstadter 2001). In the end Harold Cohen comes down on his, rather than the computer's, side when it comes to taking the credit for the creativity: "I think of autonomy now in terms of that weakly defined but strongly felt future state that manifests itself in the criteria that direct creative behavior. And if I take some satisfaction in being able to formulate it in those terms, I also recognize that the criteria and the creativity in question are mine, not the program's" (Cohen 2002b).

Does Evo-art leave more room, or less, for human authorship than AARON does? That is, does the artist's choice of fitness function suffice to give him or her the authorial credit for whatever artwork emerges after many generations of random (i.e., undirected) change? Is the credit greater, or less, if instead of relying on a programmed fitness function, the artist does the selecting by hand?

One reason for the Evo-artist's choosing to do the selection by hand is to produce only works *in his or her own style*. This is also the reason the mutations that are allowed are usually very slight. An artistic style is a sustained pattern of activity, lasting over time (Boden 2010c). In Evo-art that allows radical mutations (and that does not ration them to once every two thousandth generation, for instance), no pattern can be sustained for long—not even if the human artist is trying to shape the results by making the fitness selection at each stage. On the contrary, huge structural changes can occur in a single generation (see Sims 1991). This leads to fascinated amazement on the part of the gallery audience. Nevertheless, Evo artists do not normally allow such mutations. They prefer to explore a stylistic space that, despite many surprising variations, remains recognizable as theirs to someone with an experienced eye. In other words, they are primarily engaged in *exploratory* creativity, not transformational creativity (Boden 2004).

There are some exceptions. The CG-artist Paul Brown has embarked upon an Evo-art project whose aim is to evolve robots that will make aesthetically acceptable drawings that *do not* carry Brown's general style or personal signature (Bird et al. 2006). Thus far, his hope has not been satisfied. And perhaps that is not surprising; Brown, after all, was setting the fitness functions at all stages of the work. It is not clear whether it is in principle possible for his artistic mark to be lost as this project proceeds

or whether the robots might be able to develop a personal signature of their own (Boden 2010c).

This example raises questions also about the relation between CG-art and *embodiment*. Many philosophers of mind discount AI and A-Life in general (as models of mind or life) for being concerned with virtual, bodiless, systems. However, Brown's R- and Evo-art creatures are robots moving in the real world and are therefore subject to physical forces. It is known that truly fundamental changes—that is, new types of sensory receptors—can evolve in robots as a result of unsuspected physical contingencies (Bird and Layzell 2002). Compare the biological evolution, not of a primitive eye into a better eye, but of a light sensor in which no such sensor existed before. In principle, then, a fundamentally new style might develop in this way, whereas (arguably) that could not happen in a purely virtual, programmed system. (This question is discussed further in chapter 5.)

Similar puzzles about authorial responsibility arise in CI-art in general, of which hand-selected Evo-art is a special case. Just where, in the man-machine system concerned, is the true author?

That worry affects all I-art, of course, but is there any extra difficulty where CI-art is concerned? For present purposes, let us ignore Duchamp's suggestion that *all* art is multiauthored. And what difference, if any, does it make if—as sometimes happens (see chapter 11)—the audience provides feedback during the construction of the CI-work, so that its final form depends not only on the decisions of the artist but also on the reactions of the audiences who encountered it in its prototype stage? Perhaps the distinction between decisions and reactions is crucial here, debarring the audience from earning any extra authorial credit in such cases?

To speak of a worry here, however, is perhaps to counteract what CI-artists are trying to do. Despite its sturdy roots in cybernetics and computer technology, CI-art has attracted favorable notice from postmodernists precisely because of the ambiguity of authorship involved. The pioneering Ascott (2003a, 2003b), in particular, has always seen the value of CI-art as its democratizing ability to engage the viewer or participant *as creator*. In his words, "creativity is shared, authorship is distributed" (1990, 238). If authorship is deliberately distributed, then to worry about its locus (about ascribing the status of *author*) is to miss the point.

For all the heady talk of creative participation, some CI-art is fairly limiting (Kahn 1996). That is so, for instance, when the possible changes in the artwork are explicitly preset by the artist, as opposed to their emerging from the program's doing its own thing. The limitation is especially great when the participant chooses from a menu of selections.

Another way of putting questions about authorial responsibility is to ask where the *creativity* lies. But what, exactly, do we mean by creativity?

It certainly involves *agency*—which is why considerations of autonomy and authorial responsibility are inevitable. But what is agency? The interacting arms and floating buoys identified as examples of R-art are typically described by the artists and technicians concerned as agents—a word borrowed from AI and A-Life research on distributed cognition. But does that research misuse the concept? Even if it does, does it include agents of interestingly different types (Boden 2006, 13.iii.d–e), some of which are more deserving of the name than others? If so, should we at least reserve the term—and the ascription of creativity—for those cases of CG-art in which the agents involved are of the more plausible variety? Again, such questions cannot be answered without careful attention to the details of the programs and communications involved.

It is commonly assumed that creativity—and art, too—involves *unpredictability*. But what is its source? Is it merely lack of computational power on the part of human minds? We have seen that CG-art, like complex programs in general, is indeed unpredictable for that reason. But CI-art and Evo-art are unpredictable for other reasons as well: CI-art, because the artist cannot predict the sequence of interactions that will take place, even if able to predict what would happen at a given moment if *that* audience movement were to occur; and Evo-art, because of the many *random* changes to the program and because of the choices made at successive generations by the artist. Does the unpredictability of traditional art have any deeper source? And if so, is this something that cannot be ascribed to, or even simulated in, computers? Answering these questions requires one to distinguish different types of unpredictability very carefully (see Boden 2004, chap. 9).

Another set of questions concerns *ontology*, or what counts as the *artwork*. How can we identify the artwork when an artist's computer program generates countless unique images or musical compositions, none of which have been seen or heard by the artist? Is each image or musical composition produced by AARON or Emmy an artwork or is the artwork the program that generates it? In Evo-art, does one and the same artwork exist at differing levels of sophistication at different generations? Or does every generation produce a new artwork or, perhaps, a new population of (sibling) artworks?

What counts as the artwork when the uniqueness is due not only to a richly generative computer program but also to the contingent (and ephemeral) behavior of a participatory human audience? Perhaps the familiar concept of artwork is well suited only to the unchanging artifacts that form the overwhelming majority of the cases *inside* McCormack's bubble?

Traditional artists can fully comprehend the painting or sculpture that they have executed so carefully (although whether this applies to the G-art dimension of Pollock's

paintings is questionable), but CI-artists cannot fully know the CI-artwork that they constructed with equal care. This is not merely a matter of the unpredictability of detail: in sufficiently complex cases, it is not even clear that they can recognize the general potential of their own work. With regard to CI-art, then, perhaps we should speak not of the artwork but of the art system, which comprises the artist, the program, the technological installation (and its observable results), and the behavior of the human audience? And perhaps, if the concept of the artwork falls, then that of the artist or author falls too?

Or maybe we should think of each occurrence of CI-art as a performance and the program or installation as the score? If so, then philosophical discussion of what counts as an artwork in music is pertinent (e.g., Goodman 1968). But the performance is more like a jazz improvisation than the playing of classical music, because it can vary considerably from one occasion to another. Even if the form of each particular human-computer interaction can be completely determined by the artist (which is not so, for instance, when the computer's response can be modified by its memory of the history of previous interactions), the *sequence* of such events cannot.

Yet another problematic area concerns *aesthetic evaluation*. Are entirely novel aesthetic considerations relevant for CG-art in general or for some subclass of it? And are some aesthetic criteria, normally regarded as essential, utterly out of place in CG-art—authenticity, for instance?

The devotees of CI-art, in fact, do not use the familiar (inside-the-bubble) criteria to judge different interactive installations. Or insofar as they do, these are secondary to other considerations (Boden 2010a). The criteria they see as most appropriate concern not the nature of the resulting artwork (the beauty of the image projected on the wall, for example, or the melody and harmoniousness of the accompanying sounds), but the nature of the interaction itself. There is general agreement on that point. But there is significant disagreement on just what type of interaction is the most aesthetically valuable.

Some CI-artists, especially those engaged in VR-art, stress the disturbing sense of unreality involved and the participant's new take on everyday experience that ensues. Many value the participant's conscious control of the artwork, others aim to highlight their sense of personal embodiment, and yet others stress the audience's disconcerting experience of unpredictability triggered by their own actions. All those criteria concern the participant's *experience*, but difficulties arise if one asks how that experience can be discerned, or logged, by anyone other than the individual participant. As remarked in section 2.3, if the observers can never come to realize that they are affecting what happens, then the "I" in "CI-art" might better be thought of as "influence," not "interaction."

Some especially jagged philosophical rocks lie in wait for VR-artists. The concept of virtual reality has been defined in various ways (Steuer 1992). Most, like the definition of VR-art given in section 2.3, refer to the participant's experience of being immersed in a real world and reacting accordingly. This notion seems to be intuitively intelligible, especially if one has actually encountered a VR installation. But just what it means, whether in psychological or philosophical terms, is very difficult to say.

It is not even clear that it is coherent (Boden 2006, 16.viii.c). Several leading philosophers of mind have addressed this hornet's nest of questions in writing about the film *The Matrix* (see especially the papers by Hubert Dreyfus and Andy Clark on the Warner Brothers website, http://whatisthematrix.warnerbros.com). That is not to say that *The Matrix* counts as VR-art, for it does not. Nevertheless, it raises some of the same questions that would attend highly plausible instances of VR-art. Whether these would also be highly successful instances is another matter: we have seen that VR in art, as opposed to science or surgery, typically highlights some *unreal* dimension of the experience.

As for *authenticity*, this is a tricky concept. For several reasons, of varying plausibility, someone might argue that it is not applicable to any instance of CG-art (Boden 2007a). And CG-artists have suffered as a result.

For example, Cope (2006, 364) has been continually disappointed by people's failure to take his music seriously—not because they dislike it on hearing it (sometimes they *refuse* to hear it) but simply because it is computer generated. Even when they do praise it, he has found that they typically see it less as music than as computer output—a classification that compromises its authenticity. For instance, even though each Emmy composition is in fact unique, people know that the program could spew out indefinitely many more tomorrow. That human composers die, says Cope, has consequences for aesthetic valuation: someone's oeuvre is valued in part because it is a unique set of works, now closed. As a result of this common reaction, Cope decided to destroy the database of dead composers' music that he had built up over the last twenty-five years and used as a crucial source in Emmy's functioning. Emmy's successor will compose music only in Cope's own style; whether audiences regard this as being significantly more authentic still remains to be seen.

Finally, what of the claims made by many CG-artists to be exploring the nature of *life*? It is clear from Rinaldo's choice of the titles *Autopoiesis* and *The Flock* (plus the rest of his oeuvre; Whitelaw 2004, 109–116), for instance, that his R-art works are not intended as mere fairground toys but as meditations on significant aspects of life. He is not alone in this: many of the CG-artists who have been influenced by A-Life see their work in that way. Concepts such as emergence and self-organization, and of course

evolution, crop up repeatedly in their writings and interviews—as does the key concept of life itself.

One may well agree that their work throws light on, or anyway reminds us of, important—and puzzling—properties of life. But one need not also agree with the claim sometimes made by these CG-artists that purely *virtual* life (or strong A-Life) is possible and that their work, or something similar, might even create it. Indeed, one should not accept those claims, because physical metabolism (which is much more than mere energy dependency) is essential for life but is denied to computers (Boden 1999).

Perhaps the most obvious philosophical question of all is this: Yes, it can help while away a Sunday afternoon, *but is it art, really*?

Whatever art may be (a topic on which gallons of ink have been spilled), many people feel that computers are the very antithesis of it. Indeed, some philosophers argue this position explicitly (e.g., O'Hear 1995). On their view, art involves the expression and communication of human experience, so that if we did decide that it is *the computer* that is generating the artwork, then it cannot be an *art* work after all—no matter how decorative or even beautiful it may be.

A closely related worry (addressed in chapter 6) concerns emotion in particular: if computers are not emotional creatures, then—on this view—they cannot generate anything that is properly termed art (Hofstadter 2001). Another common way of discrediting computer art in general is to argue that art involves creativity and that no computer— irrespective of its observable performance—can *really* be creative (for a discussion, see Boden 2004, chap. 11; 2014). Furthermore, a person's aesthetic approval of an artwork is sometimes instantly renounced on discovering that it is, in fact, a CG-artwork, a reaction that led Cope to destroy the database on which Emmy's—or should one rather say "his"?—CG-music rested.

Despite these (fairly common) views on the relation—or lack of it—between art and computers, there are undeniable continuities between CG-art and noncomputer art. Several of these were mentioned in section 2.3, which showed that some of the fourteen taxonomic categories include examples drawn from both inside and outside McCormack's precious bubble. And those categories that apply only to CG-art cover many individual cases that are aesthetically related to traditional artworks. Even key aspects of Gothic art, seemingly a million miles away from CG-artworks, can be shared by these electronic instances (see chapter 7).

Moreover, the art world itself—however suspicious it may be of computers in general and however dismissive it may be of particular CG-art efforts—does sometimes award these new activities the coveted status of art. Sometimes this happens in a specialized corner of the art world: for instance, London's Kinetica Gallery (opened in 2006) is

devoted to interactive, robotic, and kinetic art. But some major traditional galleries clearly accept that traditional and CG-art are players in the same cultural ballpark.

Two such instances have been mentioned in this chapter: the Tate's one-man show of Cohen's AARON and the Washington exhibition featuring Edmonds's work as a development of that of the ColorField painters (Mark Rothko and the like). The latter example is especially telling, precisely because it was not a show celebrating only CG-art. On the contrary, this sixtieth-anniversary exhibition was putting CG-art alongside the precious bubble—or even inside it. In reply to the skeptical challenge But is it art, *really?* what more persuasive answer could there be?

References

Ascott, R. (1966/1967). "Behaviourist Art and the Cybernetic Vision." *Cybernetica* 9:247–264; and 10 (1967): 25–56. Reprinted as chap. 3 in Ascott 2003b, 109–156.

Ascott, R. 1983. *La Plissure du Texte.* http://alien.mur.at/rx/ARTEX/PLISSURE/plissure.html.

Ascott, R. 1990. "Is There Love in the Telematic Embrace?" *Art Journal* (College Arts Association of America) 49:241–247. Reprinted as chap. 15 of Ascott 2003b.

Ascott, R. 2003a. "Technoetic Aesthetics: 100 Terms and Definitions for the Post-biological Era." In *Telematic Embrace: Visionary Theories of Art, Technology, and Consciousness*, 375–382. London: University of California Press. First published in Japanese, trans. E. Fujihara, in R. Ascott, *Art and Telematics: Toward the Construction of a New Aesthetics* (Tokyo: NTT Publishing Co., 1998).

Ascott, R. 2003b. *Telematic Embrace: Visionary Theories of Art, Technology, and Consciousness.* London: University of California Press.

Becker, H. S. 1986. *Doing Things Together: Selected Papers.* Evanston, IL: Northwestern University Press.

Becker, H. S. 1995. "A New Art Form: Hypertext Fiction." In *How to Read a Hypertext*, edited by M. Bernstein. Cambridge, MA: Eastgate Systems.

Bird, J., M. d'Inverno, and J. Prophet. 2007. "*Net Work*: An Interactive Artwork Designed Using an Interdisciplinary Performative Approach." *Digital Creativity* 18 (1): 11–23.

Bird, J., and P. Layzell. 2002. "The Evolved Radio and Its Implications for Modelling the Evolution of Novel Sensors." *Proceedings of Congress on Evolutionary Computation*, CEC-2002, 1836–1841.

Bird, J., D. Stokes, P. Husbands, P. Brown, and B. Bigge. 2006. "Towards Autonomous Artworks." *Leonardo Electronic Almanac*. Available from jonba@sussex.ac.uk.

Bishop, C. 2006. *Participation.* Cambridge, MA: MIT Press.

Boden, M. A. 1994. "Agents and Creativity." In "Agents," edited by D. Riecken, 117–121. Special issue, *Communications of the Association for Computing Machinery*. Reprinted in Boden 2010b, chap. 8.

Boden, M. A. 1999. "Is Metabolism Necessary?" *British Journal for the Philosophy of Science* 50:231–248. Reprinted in Boden 2010b, chap. 12.

Boden, M. A. 2004. *The Creative Mind: Myths and Mechanisms.* 2nd ed. London: Routledge.

Boden, M. A. 2006. *Mind as Machine: A History of Cognitive Science.* 2 vols. Oxford: Clarendon/ Oxford University Press.

Boden, M. A. 2007a. "Authenticity and Computer Art." In "Creativity, Computation, and Cognition," edited by P. Brown. Special issue, *Digital Creativity* 18 (1): 3–10. Reprinted in Boden 2010b, 193–209.

Boden, M. A. 2007b. "Stillness as Autonomy." In *Proceedings of Computers in Art and Design Education (CADE) Conference, Stillness (Perth), September 2007,* edited by S. Worden, L. Green, and P. Thomas, 175–192. An expanded version is in Boden 2010b.

Boden, M. A. 2010a. "Aesthetics and Interactive Art." In *Creativity and Art: Three Roads to Surprise,* 210–234. Oxford: Oxford University Press.

Boden, M. A. 2010b. *Creativity and Art: Three Roads to Surprise.* Oxford: Oxford University Press.

Boden, M. A. 2010c. "Personal Signatures in Art." In *Creativity and Art: Three Roads to Surprise,* 92–124. Oxford: Oxford University Press.

Boden, M. A. 2014. "Creativity and Artificial Intelligence: A Contradiction in Terms?" In *The Philosophy of Creativity: New Essays,* edited by E. S. Paul and S. B. Kaufman, 224–246. Oxford: Oxford University Press.

Boden, M. A., and E. A. Edmonds. 2009. "What Is Generative Art?" *Digital Creativity* 20 (1–2): 21–46.

Bolter, J. D. 1991. *Writing Space: The Computer, Hypertext, and the History of Writing.* Hillsdale, NJ: Lawrence Erlbaum.

Breton, A. 1969. *Manifestoes of Surrealism.* Translated by R. Seaver and H. R. Lane. Ann Arbor: University of Michigan Press.

Brown, Paul. 2003. "Generative Computation and the Arts." Special issue, *Digital Creativity* 14 (1): 1–2.

Brown, Richard. 2001. *Biotica: Art, Emergence, and Artificial Life.* London: RCA CRD Research.

Brown, Richard. 2006. "The Electrochemical Glass." *Strange Attractor Journal Three.* https://www.falmouth.ac.uk/content/richard-brown.

Burnham, J. 1968. *Beyond Modern Sculpture: The Effects of Science and Technology on the Sculpture of This Century.* London: Allen Lane.

Bush, V. 1945. "As We May Think." *Atlantic Monthly* 176 (July): 101–108. Reprinted in *Multimedia: From Wagner to Virtual Reality,* edited by R. Packer and K. Jordan, 135–153. London: W. W. Norton, 2001.

Candy, L., and E. A. Edmonds, eds. 2002. *Explorations in Art and Technology.* New York: Springer.

Cohen, H. 1995. "The Further Exploits of AARON Painter." In "Constructions of the Mind: Artificial Intelligence and the Humanities," edited by S. Franchi and G. Guzeldere. Special issue, *Stanford Humanities Review* 4 (2): 141–160.

Cohen, H. 2002a. "A Million Millennial Medicis." In *Explorations in Art and Technology*, edited by L. Candy and E. A. Edmonds, 91–104. New York: Springer.

Cohen, H. 2002b. "A Self-Defining Game for One Player: On the Nature of Creativity and the Possibility of Creative Computer Programs." *Leonardo* 35 (1): 59–64.

Cohen, H. 2007. *AARON's World: 20 de Junho–28 de Julho 2007*. Lisbon: Antonio Prates, Arte Contemporanea.

Colton, S., M. Valstar, and M. Pantic. 2008. "Emotionally Aware Automated Portrait Painting." In *Proceedings of the 3rd International Conference on Digital Interactive Media in Entertainment and Arts (DIMEA)*, edited by Sofia Tsekeridou, 304–311. New York: ACM Press.

Cope, D. 2001. *Virtual Music: Computer Synthesis of Musical Style*. Cambridge, MA: MIT Press.

Cope, D. 2006. *Computer Models of Musical Creativity*. Cambridge, MA: MIT Press.

Cornock, S., and E. A. Edmonds. 1973. "The Creative Process Where the Artist Is Amplified or Superseded by the Computer." *Leonardo* 6:11–16.

Costello, B., and E. A. Edmonds. 2007. *Playful Pleasures: A User Evaluation of Three Artworks*. Sydney, Australia: University of Technology, CCS Report 2007-1.

Dawkins, R. 1986. *The Blind Watchmaker*. Harlow: Longman.

Dorin, A., and J. McCormack. 2001. "First Iteration/Generative Systems." *Leonardo* 34 (3): 335.

Duchamp, M. 1957. "The Creative Act." In *The Essential Writings of Marcel Duchamp*, edited by M. Sanouillet and E. Peterson, 138–140. London: Thames and Hudson.

Duprat, H., and C. Besson. 1998. "The Wonderful Caddis Worm: Sculptural Work in Collaboration with Trichoptera." *Leonardo* 31 (3): 173–182.

Edmonds, E. A. 1969. "Independence of Rose's Axioms for M-Valued Implication." *Journal of Symbolic Logic* 34:283–284.

Edmonds, E. A. 1975. "Art Systems for Interactions between Members of a Small Group of People." *Leonardo* 8:225–227.

Edmonds, E. A. 2006. "New Directions in Interactive Art Collaboration." *CoDesign: International Journal of CoCreation in Design and the Arts* 2 (4): 19–194.

Edmonds, E. A. 2007. "Reflections on the Nature of Interaction." *CoDesign: International Journal of CoCreation in Design and the Arts* 3 (3): 139–145.

Eno, B. 1996. "Generative Music: Evolving Metaphors, in My Opinion, Is What Artists Do." http://www.inmotionmagazine.com/eno1.html.

Goodman, N. 1968. *Languages of Art: An Approach to a Theory of Symbols*. Indianapolis, IN: Bobbs-Merrill.

Greene, R. 2004. *Internet Art*. London: Thames and Hudson.

Gwilt, Ian. 2013. Data-Objects: Sharing the Attributes and Properties of Digital and Material Culture to Creatively Interpret Complex Information. In *The Re-materialisation of the Art Object*, edited by D. Harrion, 14–26. Hershey, PA: IGI Global.

Haugeland, J. 1985. *Artificial Intelligence: The Very Idea*. Cambridge, MA: MIT Press.

Hofstadter, D. R. 2001. "Staring Emmy Straight in the Eye—and Doing My Best Not to Flinch." In Cope 2001, 33–82.

Hofstadter, D. R. 2007. *I Am a Strange Loop*. New York: Basic Books.

Jacob, C., and von Mammen, S. 2007. "Swarm Grammars: Growing Dynamic Structures in 3D Agent Spaces." *Digital Creativity* 18:15–64.

Johnson, B. S. 1969. *The Unfortunates*. London: Panther.

Kahn, D. 1996. "What Now the Promise?" In *Burning the Interface*, edited by M. Leggett and L. Michael, 21–30. Sydney: Museum of Contemporary Art. CD-ROM.

Krueger, M. W. 1991. *Artificial Reality*. 2nd ed. Reading, MA: Addison-Wesley.

Laposky, B. 1969. "Oscillons: Electronic Abstractions." *Leonardo* 2 (4): 345–354.

Leggett, M. 2000. "Thinking Imaging Software." *Photofile: Photomedia Journal* 60:28–31.

Leggett, M., and L. Michael, eds. 1996. *Burning the Interface*. Sydney: Museum of Contemporary Art. CD-ROM.

LeWitt, S. 1967. "Paragraphs on Conceptual Art." *Artforum* 5 (10): 79–83. Reprinted in *Theories and Documents of Contemporary Art: A Sourcebook of Artists' Writings*, edited by K. Stiles and P. Selz, 822–826. London: University of California Press, 1996.

LeWitt, S. 1969. "Sentences on Conceptual Art." *Art-Language* 1:11–13. Reprinted in Lippard 1997, 75–76; and in Stiles and Selz, 826–827.

Lindenmayer, A. 1968. "Mathematical Models for Cellular Interaction in Development, Parts I and II." *Journal of Theoretical Biology* 18:280–315.

Lippard, L. R. 1997. *Six Years: The Dematerialization of the Art Object from 1966 to 1972*. London: University of California Press.

Mallen, G. 2005. "Reflections on Gordon Pask's Adaptive Teaching Concepts and Their Relevance to Modern Knowledge Systems." In *Creativity and Cognition 2005: Proceedings of the Fifth Conference on Creativity and Cognition*, edited by L. Candy, 86–91. New York: ACM Press.

Marr, A. 2003. "'He Thought It the Deuil, Whereas Indeede It Was a Meere Mathematicall Inuention': Understanding Automata in the Late Renaissance." Paper presented at the Workshop on

the History of AI/A-Life, Stanford University, CA, October. Also published as A. Marr, "Understanding Automata in the Late Renaissance." *Journal de la Renaissance* 2 (2004): 205–222.

Martin, K. 1951. "Abstract Art." In *Broadsheet No. 1: Abstract Paintings, Sculptures, Mobiles*. London: Lund Humphries. AIA exhibition catalog. Also in *Nine Abstract Artists, Their Work and Their Theory: Robert Adams, Terry Frost, Adrian Heath, Anthony Hill, Roger Hilton, Kenneth Martin, Mary Martin, Victor Pasmore, William Scott*, edited by L. Alloway. London: Tiranti, 1954.

Mason, C. 2008. *A Computer in the Art Room: The Origins of British Computer Arts 1950–80*. Hindringham: JJG Publishing.

McCorduck, P. 1991. *AARON's Code: Meta-art, Artificial Intelligence, and the Work of Harold Cohen*. New York: W. H. Freeman.

McCormack, J. 2003. "Art and the Mirror of Nature." In "Generative Computation and the Arts," edited by Paul Brown. Special issue, *Digital Creativity* 14 (1): 3–22.

McCormack, J. 2004. *Impossible Nature: The Art of John McCormack*. Melbourne: Australian Centre for the Moving Image.

McCormack, J., A. Dorin, and T. Innocent. 2004. "Generative Design: A Paradigm for Design Research." In *Proceedings of Futureground*, edited by J. Redmond, D. Durling, and A. de Bono, 156–164. Melbourne: Design Research Society.

Metzger, G. 1959. "Manifesto Auto-destructive Art." In *A Computer in the Art Room: The Origins of British Computer Arts 1950–80*, edited by C. Mason, 59. Hindringham: JJG Publishing.

Metzger, G. 1965. *Auto-destructive Art*. London: Destruction/Creation.

Mohr, Manfred. 1986. "Divisibility III, Generative Works, Part III, Works from 1985–1986." Galerie D+C Mueller-Roth, Stuttgart, Germany, December 6 1986–January 24, 1987.

Montfort, N. 2003. *Twisty Little Passages: An Approach to Interactive Fiction*. Cambridge, MA: MIT Press.

Muller, L., E. A. Edmonds, and M. Connell. 2006. "Living Laboratories for Interactive Art." *CoDesign: International Journal for CoCreation in Design and the Arts* 2 (4): 195–207.

Nake, F. 1998. "Art in the Time of the Artificial." *Leonardo* 31 (3): 163–164.

Nake, F. 2005. "Computer Art: A Personal Recollection." In *Creativity and Cognition 2005: Proceedings of the Fifth Conference on Creativity and Cognition*, edited by L. Candy, 54–62. New York: ACM Press.

Nees, G. 1969. *Generative Computergraphik*. Berlin: Siemens AG.

O'Hear, A. 1995. "Art and Technology: An Old Tension." In *Philosophy and Technology*, edited by R. Fellows, 143–158. Cambridge: Cambridge University Press.

Pask, G. 1971. "A Comment, a Case History, and a Plan." In *Cybernetics, Art, and Ideas*, edited by J. Reichardt, 76–99. London: Studio Vista.

Pinch, T., and F. Trocco. 2002. *Analog Days: The Invention and Impact of the Moog Synthesizer*. Cambridge, MA: Harvard University Press.

Popper, F. 2007. *From Technological to Virtual Art.* Cambridge, MA: MIT Press.

Prusinkiewicz, P. 2004. "Art and Science for Life: Designing and Growing Virtual Plants with L-Systems." In *XXVI International Horticultural Congress: Nursery Crops; Development, Evaluation, Production and Use*, edited by C. G. Davidson and T. Fernandez, 15–28. Toronto: International Society for Horticultural Science. CD-ROM.

Prusinkiewicz, P., and A. Lindenmayer. 1990. *The Algorithmic Beauty of Plants.* New York: Springer-Verlag.

Sims, K. 1991. "Artificial Evolution for Computer Graphics." *Computer Graphics* 25 (4): 319–328. See also http://www.karlsims.com/papers/siggraph91.html.

Sims, K. 2007. "Galapagos Interactive Exhibit." http://www.genarts.com/galapogos/index.html.

Smith, M., ed. 2005. *Stelarc: The Monograph.* Cambridge, MA: MIT Press.

Steuer, J. 1992. "Defining Virtual Reality: Dimensions Determining Telepresence." *Journal of Communication* 42 (4): 73–93.

Sutherland, I. E. 1965. "The Ultimate Display." *Proceedings of the International Federation of Information Processing Congress*, edited by W. A. Kalenich, 506–583. Washington, DC: Spartan Books. Reprinted in R. Packer and K. Jordan, eds. *Multimedia: From Wagner to Virtual Reality.* New York: W. W. Norton, 2001.

The Times (London). January 8, 2000.

Todd, S. C., and W. Latham. 1992. *Evolutionary Art and Computers.* London: Academic Press.

Tofts, D. 2003. "Avatars of the Tortoise: Life, Longevity, and Simulation." In "Generative Computation and the Arts," edited by Paul Brown. Special issue, *Digital Creativity* 14 (1): 54–63.

Tofts, D. 2005. *Interzone: Media Arts in Australia.* Fisherman's Bend, Victoria: Craftsman House.

Wang, P., A. A. Becker, I. A. Jones, A. T. Glover, S. D. Benford, C. M. Greenhalgh, and M. Vloeberghs. 2007. "Virtual Reality Simulation of Surgery with Haptic Feedback Based on the Boundary Element Method." *Computers and Structures* 85 (7–8): 331–339.

Webster, A. 2006. *Solar Stacking.* (An electrochemical sculpture.)

Webster, A., and J. Bird. 2002. "Tuning Pask's Ear." Video (7:26).

Whitelaw, M. 2004. *Metacreation: Art and Artificial Life.* London: MIT Press.

Wilson, S. 2002. *Information Arts: Intersections of Art, Science, and Technology.* Cambridge, MA: MIT Press.

Woolf, S. 2004. "Expanded Media: Interactive and Generative Processes in New Media Art." PhD diss., University of Sussex.

Zivanovic, A. 2005. "The Development of a Cybernetic Sculptor: Edward Ihnatowicz and the Senster." In *Creativity and Cognition 2005: Proceedings of the Fifth Conference on Creativity and Cognition*, edited by L. Candy, 102–108. New York: ACM Press.

3 Explaining the Ineffable

Margaret A. Boden

Preamble

Creativity was highlighted as a key concern by one of the fathers of artificial intelligence (AI) right at the beginning of his AI career—and right at the end of it, too.

In 1958, Herbert Simon confidently declared in the management journal *Operations Research*, "It is not my aim to surprise or shock you. ... But the simplest way I can summarize is to say that there are now in the world machines that think, that learn *and that create*" (Simon and Newell 1958, 6; italics added). And in an internal RAND memo, "The Processes of Creative Thinking," he had recently outlined some specific ideas about problem-solving in seemingly intractable areas where comprehensive search was impossible (Newell, Shaw, and Simon 1962). These were already being implemented, in the pioneering Logic Theorist and General Problem Solver programs (Boden 2006, 6.iii.c).

Almost forty years later, in 1996, he joined in an informal email discussion among some of the Fellows of AAAI (the American Association for AI, today renamed as the Association for the Advancement of AI) about whether AI is really a *science*—as opposed to a branch of engineering (13.vii.a). In reply, he recommended that his fellow Fellows quell their doubts by reading his paper, "Explaining the Ineffable" (Simon 1995). Its subtitle was rich in intriguing keywords: "Intuition, Insight, and Inspiration." All three

This chapter sketches the history of AI-work on creativity. The many cross-references refer not to other parts of this volume but to Margaret Boden's book *Mind as Machine: A History of Cognitive Science* (2006), from which it is a lightly edited extract (13.iv). The cross-references have been left intact here because they indicate closely-relevant areas of AI and computational psychology that may be of interest to readers of this volume. (The next part of the book—13.v-vi—outlines the history of personal computing and virtual reality, including some brief comments on the rise of computer art in 13.vi.c.) The cross-references to Boden 2006 are structured as chapter.section.sub-section; so 9.xi.d, for example, denotes chapter 9, section xi, subsection d.

were near synonyms for creativity. Because he chose this paper from the entire research literature to show that AI is, indeed, a science, he clearly felt that AI had gone some way toward fulfilling the promise implicit in the title of his 1958 RAND harbinger (for the harbingers of AI, see 10.i.f).

But that promise had not been taken up explicitly until the 1980s. Some of the mid-century readers of *Operations Research* would have been eager to see the still-unpublished RAND memo. But they might have been disappointed. The title mentioned creative thinking, to be sure. But the focus was on problem-solving and game playing: creativity in its everyday sense was ignored. Likewise, Nathaniel Rochester's section on "Originality in Machine Performance" in the proposal for the seminal Dartmouth summer meeting on AI (see 6.iv.b) had not discussed originality in the arts and sciences (McCarthy et al. 2000, 49). In the 1950s, that was not considered a fit topic for AI.

3.1 Creativity Ignored

Creativity was an obvious challenge for AI from the very beginning—or even before it. In the imaginary conversation that launched the Turing test (16.ii), Alan Turing had depicted a computer as interpreting and defending a sonnet, tacitly implying that a computer might compose poetry too. However, once people started writing AI programs, this particular challenge was parked on the sidelines.

When GOFAI was still NewFAI (good old-fashioned AI and newfangled AI; see 10.pre-amble), creativity was a no-go area. To be sure, Donald Mackay (1951) had described a probabilistic system that he said would show "originality" in a minimal sense—but that had been an aside, not the main object of the exercise. Similarly, problem-solving programs were occasionally described as creative. And Simon, in 1957, had mentioned the theory of creativity he and Allen Newell were developing and had praised the pioneering work of Lejaren Hiller and Leonard Isaacson, whose computer-generated Illiac suite (a string quartet, first performed in 1957) was, in his estimation, "not trivial and uninteresting" (McCorduck 1979, 188). Nevertheless, creativity in the layman's sense (i.e., art, music, and science—and maybe jokes) was all but ignored by AI professionals.

Outside the field, this was less true. Konrad Zuse's vision of automatic carpet design, with deliberate weaving errors to add authenticity, was not yet in the public domain (10.iii.a). But visual computer art was getting started in Europe and the United States by 1963, and interactive computer art had already begun in the 1950s (see 13.vi.c).

In the 1950s, too, Hiller—a professional chemist, but also holding a master's degree in music—had initiated the Illiac suite (see Hiller and Isaacson 1959, 182–197). The first three movements were generated from rules defining musical styles (sixteenth-century

counterpoint, twelve-tone music, and a range of dynamics and rhythms), sometimes combined with tone pairs chosen by chance; the fourth movement was based not on familiar styles but on Markow chains (Hiller and Isaacson 1959). Systematic experiments in computer music, including instrumentation, were done at IRCAM (Institute for Research and Coordination in Acoustics/Music) in Paris from the early 1960s. And a competition for computer-composed music was organized at the 1968 IFIP (International Federation for Information Processing) meeting in Edinburgh (and led to the founding of the UK Computer Arts Society).

In general, however, these projects involved the artistic avant-garde with a few art-oriented scientists—not the leaders of GOFAI. Their references to creativity, invention, and discovery in the Dartmouth proposal were not being echoed in AI research (McCarthy et al. 2000, 45, 49–51). Even creative problem-solving was rarely described as such, despite the Logic Theorist team's use of the term in their late 1950s call to arms.

That is why my AI colleagues were bemused when, in the early 1970s, I told those who asked that I had decided to include a whole chapter on the topic in my book on the field (Boden 1977, chap. 11). Several protested, "But there isn't any work on creativity!"

In a sense, they were right. Admittedly, the 1960s had produced an intriguing model of analogy (discussed later), and meta-DENDRAL had touched on creativity in chemistry (10.iv.c). Moreover, much NewFAI work was an essential preliminary for tackling creativity as such. For instance, NLP (natural language processing) researchers had asked how memory structures are used in understanding metaphysics (Wilks 1972, 9.x.d), metaphor (Ortony 1979), or stories (Charniak 1972, 1973, 1974; Schank and the Yale AI Project 1975; Rieger 1975a, 1975b). One brave soul was generating story-appropriate syntax (Davey 1978; 9.xi.c), and another was studying rhetorical style (Eisenstadt 1976).

But apart from a handful of painfully crude poets, story writers, or novelists, there were no models of what is normally regarded as creativity (Masterman and McKinnon Wood 1968; Masterman 1971; Meehan 1975, 1981; Klein et al. 1973). The renowned geometry program, which found a superbly elegant proof about the base angles of isosceles triangles, was only an *apparent* exception (see 10.i.c and Boden 2004, 104–110).

This explains why John Haugeland (1978, 7), when he questioned the plausibility of cognitivism, raised general doubts about GOFAI analyses of "human insight" but did not explicitly criticize any specific models of it. His first worry was that GOFAI systems "preclude any radically new way of understanding things; all new developments would have to be specializations of the antecedent general conditions." But Galileo, Kepler, and Newton, he said, invented "a totally new way of talking about what happens" in the physical world, and "a new way of rendering it intelligible." Even to learn

to understand the new theory would be beyond a medieval-physics GOFAI system, "unless it had it latently 'built-in' all along." He may have chosen this particular example because he had heard of the about-to-be-published BACON suite (described later) on the grapevine. The underlying difficulty, he suggested (following Herbert Dreyfus: see 11.ii.a), was that "understanding pertains not primarily to symbols or rules for manipulating them, but [to] the world and to living in it."

Before the 1980s, then, creativity was a dirty word—or anyway, such a huge challenge that most programmers shied away from it. The most important exception, and still one of the most impressive, was due to someone from *outside* the NewFAI community.

3.2 Help from Outside

Harold Cohen (1928–2016) was a highly acclaimed abstract artist of early 1960s London. Those words "highly acclaimed" are not empty: a few years ago, a major exhibition, *The 1960s*, was held at London's Barbican. Even though this was focused on 1960s culture as a whole, not just on the visual arts, two of Cohen's early paintings were included. He turned toward programmed art in 1968. He spent two years at Stanford University as a visiting scholar with Edward Feigenbaum, in 1973–1975, where he not only found out about AI but also learned to program.

In the four decades that followed, while at the University of California, San Diego, he continuously improved his drawing and coloring program, called AARON (Cohen 1979, 1981, 1995, 2002, 2012; McCorduck 1991; Boden 2004, 150–166, 314–315). Successive versions of AARON were demonstrated at exhibitions in major galleries (and at science fairs) around the world and received huge publicity in the media. An early version is now available as shareware.

Unlike his 1960s contemporaries Roy Ascott and Ernest Edmonds (13.vi.c), Cohen was not using computer technology to found a new artistic genre. Rather, he was investigating the nature of representation. To some extent, he was trying to achieve a better understanding of his own creative processes. But over the years he came to see his early attempts to model human thought as misdirected:

> The common, unquestioned bias—which I had shared—towards a human model of cognition proved to be an insurmountable obstacle. It was only after I began to see how fundamentally different an artificial intelligence is from a human intelligence that I was able to make headway....The difference is becoming increasingly clear now, as I work to make AARON continuously aware of the state of a developing image, as a determinant to how to proceed. How does a machine evaluate pizazz? (personal communication, July 2005)

Cohen asked how he made introspectively "unequivocal" and "unarbitrary" decisions about line, shading, and color. (From the mid-1990s his main focus was on color.) And he studied how these things were perceived—by him and others—as representing neighboring and overlapping surfaces and solid objects. Moving toward increasingly three-dimensional representations, he explored how his/AARON's internal models of foliage and landscape, and especially of the human body, could be used to generate novel artworks. He was adamant that they *were* artworks, although some philosophers argue that no computer-generated artifact could properly be classified as art (O'Hear 1995).

Two examples, dating from either side of 1990, are shown in figures 3.1 and 3.2. Notice that the second, drawn by the later version of the program, has more 3-D depth than the first. Which, in turn, has more than the drawings of AARON's early 1980s acrobats-and-balls period (see figure 3.3).

In particular, jungle AARON did not have enough real 3-D data about the body to be able to draw a human figure with its arms overlapping its own body. His early 1990s

Figure 3.1
An example of AARON's jungle period, late 1980s; the drawing was done by the program, but the coloring was done by hand. *Untitled*. 1988, oil on canvas (painted by Harold Cohen), 54″ × 77″, Robert Hendel collection. (Reproduced with permission of the Harold Cohen Trust.)

Figure 3.2
An example of AARON's early 1990s period; the drawing was done by the program, but the coloring was done by hand. *San Francisco People*. 1991, oil on canvas (painted by Harold Cohen), 60″ × 84″, collection of the artist. (Reproduced with permission of the Harold Cohen Trust.)

San Francisco people could have waved if he had wanted them to, but his late 1980s jungle dwellers could not have crossed their arms instead of waving.

By 1995, Cohen had at last produced a painting-machine-based version of AARON that could not only draw acceptably but also color to his satisfaction, using water-based dyes and five "brushes" of varying sizes. However, his satisfaction was still limited.

By the summer of 2002, he had made another breakthrough: a digital AARON as colorer, whose images could be printed at any size.

The program was regularly left to run by itself overnight, offering up about sixty new works for inspection in the morning. Even the also-rans were acceptable: one gallery curator who exhibited it told Cohen that "he has not seen AARON make a bad one since it started several weeks ago" (personal communication). One might even say that AARON has now surpassed Cohen as a color artist, much as Arthur Samuel's program surpassed Samuel as a checkers player nearly half a century before (10.i.e). Cohen

Figure 3.3
An example of AARON's acrobats-and-balls period, early 1980s. (Reproduced by permission of the Harold Cohen Trust and reprinted from Boden 2004, frontispiece.)

regards this latest incarnation of AARON as "a world-class colorist," whereas he himself is merely "a first rate colorist" (personal communication).

This is no longer the latest incarnation of AARON. By 2009, a version commissioned by the Carnegie Science Center in Pittsburgh, and scheduled to run there continuously for the next ten years, had achieved a yet wider variation of imagery, not least because its images, exhibited electronically on large screens, ceaselessly changed and developed in real time (see Cohen 2012). Cohen in his artistry and in his programming skill was indefatigable.

A comparably spectacular, although later, AI artist was Emmy—originally designated EMI (Experiments in Musical Intelligence). This program was written in 1981 by the composer David Cope (1941–), at the University of California, Santa Cruz.

It was not easy for other people to run, or experiment with, the early version. The now-familiar MIDI, or Musical Instrument Digital Interface, which defines musical notes in a way that all computers can use, was not yet available. Indeed, its inventor Dave Smith first had the idea in that very year and did not announce the first specification until August 1983 (Moynihan 2003). Today, Emmy's successors are based on MIDI and so can be run on any PC equipped with run-of-the-mill musical technology.

This was not the first attempt to formalize musical creativity (neither was the Hiller and Isaacson effort). A system of rules for do-it-yourself hymn composition was penned in the early eleventh century by Guido d'Arezzo, who also invented the basis of tonic sol-fa and of today's musical notation (A. Gartland-Jones, personal communication). But Cope, almost a thousand years later, managed to more than formalize his ideas about music, he actually implemented them. Moreover, his program could compose pieces much more complex than hymns, whether within a general musical style (e.g., baroque fugue) or emulating a specific composer (e.g., Antonio Vivaldi or J. S. Bach). It could even mix styles or musicians, such as Thai and jazz or Bach and Joplin, much as the Swingle Singers do.

Emmy gained a wide audience, although not as wide as AARON's. Part of its notoriety was spread by scandalized gossip: Cope has remarked, "There doesn't seem to be a single group of people that the program doesn't annoy in some way" (Cope 2001, 92). But as well as relying on word of mouth, people could read about it and examine some Emmy scores in Cope's first three books (1991, 2000, 2001). Enthusiasts could even try it out for themselves, following his technical advice, by using one of the cut-down versions, such as ALICE (ALgorithmically Integrated Composing Environment) and SARA (Simple Analytic Recombinant Algorithm), provided on CDs packaged inside his books.

They could listen to Emmy's compositions, too. Several stand-alone CDs were released (by Centaur Records, Baton Rouge, Louisiana) in the late 1990s. In addition, several live concerts of Emmy's music were staged for public audiences. These featured human instrumentalists playing Emmy's scores, because the program did not represent expressive performance: it laid down what notes to play, not how to play them.

However, the concerts were mostly arranged by Cope's friends: "Since 1980, I have made extraordinary attempts to have [Emmy's] works performed. Unfortunately, my successes have been few. Performers rarely consider these works seriously" (Cope 2006, 362). The problem, said Cope, was that they (like most people) regarded Emmy's music as computer output, whereas he had always thought of it, rather, as *music*. Moreover, being output it was infinitely extensible, which, he found, made people devalue it.

In 2004 he took the drastic decision to destroy Emmy's historical database: there will be no more "Bach" fugues from the program (Cope 2006, 364). Emmy's "farewell gift" to the historical-music world was a fifty-page score for a new symphonic movement in the style of Beethoven, which required "several months of data gathering and development as well as several generations of corrections and flawed output" (366, 399–451). From then on, Emmy—or rather, Emmy's much-improved successor—composed in Cope's style, as "Emily Howell" (374).

Douglas Hofstadter, a fine amateur musician, found Emmy impressive despite—or rather, because of—his initial confidence that "little of interest could come of [its GOFAI] architecture." On reading Cope's 1991 book, he got a shock:

> I noticed in its pages an Emmy mazurka supposedly in the Chopin style, and this really drew my attention because, having revered Chopin my whole life long, I felt certain that no one could pull the wool over my eyes in this department. Moreover, I knew all fifty or sixty of the Chopin mazurkas very well, having played them dozens of times on the piano and heard them even more often on recordings. So I went straight to my own piano and sight-read through the Emmy mazurka—once, twice, three times, and more—each time with mounting confusion and surprise. Though I felt there were a few little glitches here and there, I was impressed, for the piece seemed to *express* something.... [It] did not seem in any way plagiarized. It was *new*, it was unmistakably *Chopin-like* in spirit, and it was *not emotionally empty*. I was truly shaken. How could emotional music be coming out of a program that had never heard a note, never lived a moment of life, never had any emotions whatsoever?
>
> [Emmy was threatening] my oldest and most deeply cherished beliefs about...music being the ultimate inner sanctum of the human spirit, the last thing that would tumble in AI's headlong rush toward thought, insight, and creativity. (Hofstadter 2001b, 38–39; italics in original)

Hofstadter was allowing himself to be *over*impressed. Frederic Bartlett's "effort after meaning" (5.ii.b) imbues our perception of music as well as of visual patterns and words.

The human performer projects emotion into the score-defined notes, much as human readers project meaning into computer-generated haikus (9.x.c). So given that Chopin-like scores had been produced, it was not surprising that Hofstadter interpreted them expressively.

What was surprising was the Chopin-like musicality of the compositions. Simon's 1957 prediction that a computer would write aesthetically valuable music within ten years had failed and had been mocked accordingly (Dreyfus 1965, 3). But Cope had now achieved this, although fourteen years late.

Emmy's basic method was described by Cope as "recombinatory" and summarized by Hofstadter as "(1) chop up; (2) reassemble" (Hofstadter 2001b, 44). In fact, Emmy was exploring generative structures as well as recombining motifs. It showed both combinational and exploratory creativity—but not, as Hofstadter (2001a) was quick to point out, transformational creativity (Boden 2004). A new style could appear only as a result of mixing two or more existing styles.

The program's database was a set of signatures (note patterns of up to ten melodic notes) exemplifying melody, harmony, meter, and ornament, all selected by Cope as being characteristic of the composer concerned. Emmy applied statistical techniques to identify the core features of these snippets and then—guided by general musicological principles—used them to generate new structures. Some results worked less well than others (e.g., Cope 2001, 182–183, 385–390).

Strictly, Emmy was not an exercise in "explaining" the ineffable. Cope's motivation differed from Simon's (and Hofstadter's; see later discussion). His aim was not to understand creative thought but to generate musical structures like those produced by human composers. Initially, he had intended EMI to produce new music in *his* style but soon realized that he was "too close to [his] own music to define its style in meaningful ways," so he switched to the well-studied classical composers instead (Cope 2001, 93). A quarter century later, having destroyed the historical database, he switched back to computer compositions in his own style (Cope 2006, 372–374 and pt. 3).

In short, he was modeling music, not mind. The task would not necessarily have been easier had he known the psychological details; for instance, limits on short-term memory rule out the use of powerful generative grammars for jazz improvisation (Johnson-Laird 1993).

Nevertheless, the implication of Cope's writings was that all composers follow some stylistic rules, or algorithms. Sonata form, for example, is a formal structure that was supposed to be rigidly adhered to by everyone composing in that style. This assumption has been questioned. It is known that Haydn, Mozart, and Beethoven (for instance) worked diligently through the exercises given in musical textbooks.

But whether they stuck rigidly to those rules in their more original, creative music is quite another matter. Peter Copley and Andrew Gartland-Jones (2005) argue that they did not.

On their view, the formal rules of style are extracted and agreed post hoc and are then followed to the letter only by musical students and mediocrities. Once sonata form, or any other musical structure, has been explicitly stated, it tends to lose its creative potential. This explains the paradox of sonatas in the Romantic period being *far less* free than in the classical times (Copley and Gartland-Jones 2005, 229). But the rules are flexible enough to evolve in use:

> It would be tempting to view this process as *generally agreed* forms, evolving. But … [it] would be more useful to see the general acceptances of common practice as *present to provide a frame for musical differences, changes, developments etc.* [Footnote: This is the basis for Boden's transformational creativity]. If there is a constraint it comes organically from within a complex network of practitioners rather than [a] set of stated constraints that are accepted until someone decides they need breaking. This is a complex mechanism indeed, and even if we argue that algorithms might explain certain emergent patterns, it is not at all sure that such patterns stem from a simple, if enormously lengthy, set of rules. (Copley and Gartland-Jones 2005, 229; italics added)

Cope's Emmy, they admit, can indeed compose many acceptable pieces. But even if it could generate fully "convincing" examples, "without a model of how [the abstracted rules] change we are capturing an incomplete snapshot of musical practice" (229). In other words, Cope is modeling musical creations—not yet musical creativity.

3.3 In Focus at Last

It is no accident that those two highly successful programs, AARON and Emmy, were written by non-AI professionals. They depended on a reliable sense of how to generate and appreciate structures within the conceptual space concerned (Boden 2004, chaps. 3–4). In general, a plausible computer artist stands in need of an expert in art. Even if (like Hiller) the person is not a professional artist, they need (again, like Hiller) to be a very highly knowledgeable amateur.

Often, artist and programmer are different people (e.g., William Latham and Stephen Todd, respectively; Todd and Latham 1992). But some artists are sufficiently computer literate to design their own systems. Edmonds was a professional computer scientist in the 1960s, as well as being an influential artist. Although he has always used his programs to help him understand creative thinking in general, he was less concerned than Cohen or Cope to talk about *the program as such*: if his viewers needed to realize that

there was a program involved, they did not need to think about just how it worked (see 13.vi.c). Today, fifty years later, many young artists are computer literate even if they are not computing professionals. Whether their computer literacy reaches beyond the *consumption* of (ready-made) programs is another question.

If artist programs need experts in art, much the same is true of programs focused on literature, mathematics, and science. A competent programmer is the sine qua non, but domain expertise is needed too. Because most AI researchers were reasonably proficient in those areas, one and the same person could be programmer and expert. That is why AI work on creativity, once it got started, usually focused on them (rather than on music or, still less, visual art).

The everyday skill of analogy, which features in both literature and science, had been modeled as early as 1963 by Thomas Evans (1934–) at MIT. His program was a huge advance (Evans 1968). Implementing the ideas briefly intimated by Marvin Minsky in his harbinger article "Steps" (see Boden 2006, fig. 10.2), it not only discovered analogies of varying strength but also identified the best.

It could do this because it described the analogies on hierarchical levels of varying generality. Using geometrical diagrams like those featured in IQ tests (see figure 3.4), Evans' program achieved a success rate comparable to that of a fifteen-year-old child. But it was not followed up. This was an example of the lack of direction in AI research that so infuriated Drew McDermott, in his squib "Artificial Intelligence Meets Natural Stupidity" (1981; 11.iii.a).

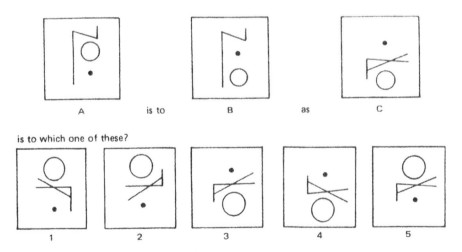

Figure 3.4
Analogy problem tackled by Evans's program (Evans 1968).

By the early 1980s, analogy had returned as a research topic in AI. For instance, an international workshop held in 1983 included five papers explicitly devoted to it, plus several more that could be seen as relevant (Michalski 1983, esp. 2–40).

Evidently, the AI scientists concerned did not read Jerry Fodor's *Modularity of Mind* (1983) or anyway did not accept its pessimism about explaining the higher mental processes. Fodor despaired of any attempt to understand analogy in scientific terms. Despite its undeniable importance, he said, "nobody knows anything about how it works; not even in the dim, in-a-glass-darkly sort of way in which there are some ideas about how [scientific] confirmation works" (Fodor 1983, 107).

And, according to him, they never would: "Fodor's First Law of the Nonexistence of Cognitive Science [states that] the more global … a cognitive process is, the less anybody understands it." He was right in arguing that we will never be able to predict or explain every case of analogy in detail but wrong in concluding that nothing of scientific interest can therefore be said about it (7.vi.h).

Fodor's skepticism notwithstanding, several GOFAI scientists in the 1980s tried to model how conceptual analogies are generated, interpreted, and used (Gentner 1983; Holyoak and Thagard 1989; Thagard et al. 1988; Thagard 1990; Gentner et al. 1997). Like Newell and Simon before them, they sometimes went back to the gestalt psychologists' 1930s work on problem-solving (5.ii.b). For instance, they asked (taking Karl Duncker's example) how the notion of a besieging army could help in discovering how to irradiate a tumor without killing the surrounding tissues.

In general, they wanted to know just how an analogous idea could be identified and fruitfully mapped onto the problem at hand. The answer usually given was to show how distinct conceptual structures could be compared and, if necessary, adapted so as to match each other more closely. Sometimes, the problem solver's goal was allowed to influence the comparison. But the basic process was like that used long before by Patrick Winston's concept learner (10.iii.d): comparing abstractly defined and preassigned structures.

A blistering critique of these "inflexible" and "semantically empty" approaches was mounted by Hofstadter (1995, 55–193). He complained that they were less interesting than Evans's work of twenty years before and radically unlike human thinking. Although both these charges were fair, his stinging critique was not entirely justified (for structuralist replies, see Forbus et al. 1998; Gentner et al. 1997).

But Hofstadter did not share Fodor's gloom about the impossibility of *any* scientific understanding of analogy. To the contrary, he had already spent many years studying it, using a basically connectionist approach. He had been thinking—and writing—along these lines since the early 1970s (12.x.a).

By the mid-1980s, he and his student Melanie Mitchell had implemented the Copycat program (Hofstadter 1985b, chaps. 13 and 24; 2002; Mitchell 1993; Hofstadter and Mitchell 1993; Hofstadter 1995, chaps. 5–7). This was described in several seminars at MIT in 1984, although without attracting much attention at the time (Hofstadter, personal communication).

Intended as a simulation of human thinking, it modeled the fluid perception of analogies between letter strings. So it would respond to questions like these: "If *abc* goes to *pqr*, what does *efg* go to?" or the much trickier "If *abc* goes to *abd*, what does *xyz* go to?" Lacking a circular alphabet, it could not map *xyz* onto *xya*; instead, it suggested *xyd*, *xyzz*, *xyy*, and the especially elegant *wyz*. Its descriptors were features such as leftmost, rightmost, middle, successor, same, group, and alphabetic predecessor or successor. Like Evans's program, Copycat could generate a range of analogies and compare their strength. Unlike Evans's program, it was probabilistic rather than deterministic and could be primed to favor comparisons of one type rather than another. Whereas Copycat worked on letter strings, Hofstadter's Letter Spirit project focused on complex visual analogies. Specifically, it concerned the letter likenesses and letter contrasts involved in distinct alphabetic fonts. An *a* must be recognizable as an *a* no matter what the font; but seeing other letters in the same font may help one to realize that it is indeed an *a*. At the same time, all twenty-six letters within any one font must share certain broad similarities, all being members of *that* font (see figures 3.5 and 3.6).

Hofstadter's early writings on Letter Spirit had outlined a host of intriguing problems involved in interpreting and designing fonts (e.g., Hofstadter 1985a). And in the mid-1990s he described a program capable of recognizing letters in a variety of styles (Hofstadter 1995, 407–496; McGraw 1995; Hofstadter and McGraw 1995). By the new millennium, the design aspect of Letter Spirit had been partially implemented too (Rehling 2001, 2002). The new program could design an entire alphabet font if given five seed letters (*b, c, e, f, g*). Today, the group's aim is to generate an alphabet from only a single seed.

Letter Spirit is the most ambitious AI analogy project and in my view the most interesting. Whether it can readily be applied to other domains, however, is unclear. Even the much simpler Copycat would be difficult to generalize. However, if what one is interested in is how it is possible for human beings to engage in subtle and systematic analogical thinking, then it is a significant contribution. It is no simple matter to generate or appreciate an alphabetic font. So much so, indeed, that hardly anyone other than Hofstadter would have dreamed that anything cogent could be said about the computational processes that may be involved.

Figure 3.5
The letter *a* written in different fonts (Hofstadter 1995, 413). (Reprinted by permission of Basic Books, an imprint of Hachette Book Group, Inc.)

Figure 3.6
Different fonts based on the Letter Spirit matrix (Hofstadter 1995, 418). (Reprinted by permission of Basic Books, an imprint of Hachette Book Group, Inc.)

Turning from analogy to story writing, the best AI storywriter was authored not by a novelist or literary critic but by a computer scientist, now a professional game designer, Scott Turner (1994). He is not to be confused with Mark Turner, a teacher of English at the University of Maryland who turned to cognitive science to illuminate the interpretation and creation of literature (Turner 1991; Fauconnier and Turner 2002).

This program did not produce high-quality literature. Its plots were simplistic tales about knights, princesses, and dragons, and its use of English left a great deal to be desired. But it had three interesting features.

First, it used case-based reasoning (13.ii.c) to create new story plots on the basis of old ones. For example, it generated a concept of suicide (derived from killing) when the story's plot could not be furthered by third-party fighting. Second, it relied on the latest version of the Yale analysis of motivational and planning schemata to decide what might plausibly be done and how (see 7.i.c and 9.xi.d). And third, Scott Turner had realized what previous AI programmers had not (e.g., Meehan 1975), that a story needs not only goals and plans for each character involved in the plot, but also *rhetorical* goals and plans for the storyteller. Accordingly, a character's goals were sometimes rejected by the program or their expression suppressed in the final narrative for reasons of story interest or consistency. (For a sustained critique of Turner's approach, see Bringsjord and Ferrucci 2000.)

By the mid-1990s, AI had even made good on Charles Babbage's suggestion that puns follow principles, including double meanings and similar pronunciation of differently spelled words (3.iv.a). Kim Binsted, at the University of Edinburgh, wrote a program, JAPE, that originated punning riddles fitting nine familiar templates, such as What do you get when you cross an X with a Y? What kind of X has Y? What kind of X can Y? and What is the difference between an X and a Y? (Binsted 1996; Binsted and Ritchie 1997; Binsted, Pain, and Ritchie 1997; Ritchie 2003a). JAPE used a semantic network of over thirty thousand items, marked for syllables, spelling, sound, and syntax as well as for semantics and synonymy. The program would consult the templates (no simple matter) to generate results including these: What do you call a depressed train? A locomotive. What do you call a strange market? A bizarre bazaar. What kind of murderer has fiber? A cereal killer. Babbage's triple pun (cane/Cain, a bell/a belle/Abel) could not have been created by JAPE, but its puns were no more detestable than most. In fact, it is the most successful of today's AI jokers (Ritchie 2001; 2003b, chap. 10).

As for creative mathematics, great excitement (within AI, although not outside it) was caused in the late 1970s by Douglas Lenat's program AM, or Automated Mathematician (Lenat 1977). This was his doctoral thesis at Stanford. Starting from a few simple concepts of set theory, it used three hundred heuristics for modifying concepts and used

criteria of mathematical interestingness (occasionally supplemented by specific nudges from the programmer) to generate many concepts of number theory. These included integer, addition, multiplication, square root, and prime number. It even generated a historically novel concept, which was later proved as a (minor) theorem, concerning maximally divisible numbers, a class that Lenat himself had not heard of. Later, he recalled how he found out about them:

"[I wondered whether any mathematician had thought of such a thing. Polya seemed to be the only one who knew.] He said, 'This looks very much like something the student of a friend of mine once did.' Polya was about 92 at the time. It turned out the friend was [Godfrey] Hardy and the student was Ramanujan" (Shasha and Lazere 1995, 231).

Coming up with something that had been discovered by such a giant as Srinivasa Ramanujan (1887–1920), people felt, was no mean feat.

Whether the excitement was fully justified was another matter. Critics pointed out that Lenat had not made clear just how the interesting concepts were generated and suggested that a heuristic that was crucial for generating the notion of primes had been included, whether consciously or not, so as to make this discovery possible (Ritchie and Hanna 1984). What is more, they said, it may have been used only the once. No detailed trace of the program was available.

Lenat replied that AM's heuristics were fairly general ones, not special-purpose tricks, and that (on average) each heuristic contributed to two dozen different discoveries and that each discovery involved two dozen heuristics (Lenat and Seely Brown 1984). He admitted, however, that writing AM in LISP had given him a tacit advantage because minor changes to LISP syntax were relatively likely to result in expressions that were mathematically interpretable.

A few years later, yet more excitement was caused by Lenat's EURISKO, which—satisfying Drew McDermott's plea for program development (11.iii.a)—incorporated heuristics for modifying *heuristics* (Lenat 1983). Besides being used to help plan experiments in genetic engineering, it came up with one idea (a battle-fleet design) that won a war game competition against human players and another (a VLSI chip design) that won a US patent, which are awarded only for ideas not "obvious to a person skilled in the art." Lenat himself then switched to research on AI en-cyc-lopedia, or CYC (13.i.c). But his AM program led others to focus on how mathematical interestingness could be used in automating creative mathematics (for a review, see Colton, Bundy, and Walsh 2000).

What of Simon himself? His late-century programming efforts were devoted to explaining creativity in science, although he gestured toward the humanities from time to time

(Simon 1994). With Patrick Langley and others at Carnegie Mellon University, he wrote a suite of increasingly powerful programs (BACON, BLACK, GLAUBER, STAHL, and DALTON) intended to model the thought processes of creative scientists such as Francis Bacon, Joseph Black, Johann Glauber, Georg Stahl, and John Dalton. These were initiated in the late 1970s and continually improved thereafter (Langley 1978, 1979, 1981; Langley, Bradshaw, and Simon 1981; Langley et al. 1987).

These inductive systems generated many crucial scientific principles—quantitative, qualitative, and componential. They came up with Archimedes's principle of volume measurement by liquid displacement, the very origin of Eureka! And they rediscovered Ohm's law of electrical resistance, Snell's law of refraction, Black's law of the conservation of heat, Boyle's law relating the pressure and volume of a gas, Galileo's law of uniform acceleration, and Kepler's third law of planetary motion. Occasionally (e.g., with Snell's law), they used a symmetry heuristic to choose between more and less elegant, although mathematically equivalent, expressions. Some could produce hypotheses to explain the observed data patterns, whether mathematical (e.g., Black's law) or qualitative (e.g., the chemical patterns observed by Glauber and componentially explained by Stahl and Dalton). And the later versions could use the real (i.e., messy, imperfect) historical data, not just data doctored to make the sums come out exactly right.

Simon wanted to *explain* the ineffable, not just—as in meta-DENDRAL or Emmy—to mimic it. So his group aimed to keep faith with human psychology.

Their programs, accordingly, respected the details recorded in the laboratory notebooks of the scientists concerned. For example, they used the same data that the long-dead authors had used. Or rather, they used the same verbal and mathematical data: they could not accept visual, auditory, or haptic input from the real world or recognize similarities between sensory patterns (see 12.v–vii). And as well as generating the same scientific laws, they tried to match the heuristics that had been used by the human scientists and the temporal order of their hunches and discoveries—and mistakes. Later work by the Carnegie Mellon group focused, for instance, on the general principles of how to suggest and plan experiments (Kulkarni and Simon 1988) and on the use of diagrams in scientific discovery (Cheng and Simon 1995).

At one level, the BACON program and its siblings were highly impressive. They offered successful models of induction and illuminated certain aspects of the way many human scientists go about their work. Despite the common propaganda, some science is *not* concerned with numbers or with componential structure (7.iii.d). But the creativity involved was exploratory rather than transformational.

In other words, these programs were spoon-fed the relevant questions, even though they found the answers for themselves. What their human namesakes had done was

different, because they had viewed the data in new ways. Indeed, they had treated new features as data. To identify *mathematical* patterns in the visual input from earth or sky had been a hugely creative act when Galileo Galilei first did it. To look for numerical constants was another, and to seek simple linear relationships *before* ratios or products (search priorities that were built into the heuristics used by the BACON suite), yet another. The Carnegie Mellon programs were deliberately provided with the ways of reasoning that Bacon, Glauber, Stahl, and Dalton had pioneered for themselves. They were roundly criticized by Hofstadter as a result (Hofstadter 1995, 177–179; see also Collins 1989).

This, of course, recalls Haugeland's principled objection to GOFAI-based models of insight. It also relates to the worries about open-ended evolution (discussed later in this chapter and in chapter 5, and in 15.vi.d). We will see in chapter 5 that *totally new types* of sensor have been evolved in artificial systems but only by unexpectedly taking advantage of the contingencies of the physical environment or hardware. Compare these biological examples with Haugeland's psychological claim that understanding pertains to "the world and to living in it."

In short, Saul Amarel's (1968) hope that an automated system might come up with a radically new problem representation remained unfulfilled. And not only Amarel's, for Simon himself had expressed much the same hope in the 1950s. The Logic Theorist team's harbinger memo had listed four characteristics of creative thought, of which the last was this: "The problem as initially posed was vague and ill-defined, so that part of the task [is] to formulate the problem itself" (Simon and Newell 1958).

That is *still* beyond the state of the art. Langley (1998) reviewed seven cases of AI-aided discovery that were sufficiently novel and interesting to be published in the relevant scientific journals. He pointed out that, in every case, the programmers had been crucial in formulating the problem or manipulating the data or interpreting the results. So Ada Lovelace's futuristic vision of science by machine has been realized: many new answers have been found automatically and some new questions too (e.g., new experiments). But *fundamental reformulations of old problems*, still less *radically new* ones, have not. Lovelace would not have been at all surprised by that. On the contrary, it is just what she expected (3.iv.b).

In one sense, it is what Simon himself expected, too. Machines, at present, lie outside the cooperative loop (2.ii.b–c). Simon described scientific discovery as a matter of "social psychology, or even sociology" (1997a, 171). His main reason was that open scientific publication provides a "blackboard" that hugely extends the individual scientist's memory (172). Machine discovery systems "are still relatively marginal participants in the social system of science." We might be able to hook them up to data-mining

programs to reduce their reliance on human beings for providing data and problems. However, "even this is a far cry from giving machines access to the papers, written in a combination of natural, formal and diagrammatic language, that constitute a large part of the blackboard contents" (173).

As for negotiations about the value of supposed "discoveries" (1.iii.f; Boden 1997), Simon's view was that "the machine (augmented now by the computer) has already, for perhaps a hundred years, been a member of the society of negotiators" (Simon 1997b, 226). Here, he cited the prescient Henry Adams, who had been so deeply troubled by his visit to the dynamo hall in an industrial exhibition (Adams 1918). Future AI programs, said Simon, might persuade us to value their discoveries above our own previous judgments (1997b, 225). He added that this was already happening in the area of mathematical proof (but that is not straightforward; see MacKenzie 1995).

Disputes about what counts as a discovery are especially likely in cases of transformational creativity, in which previously valued criteria are challenged. This type of creativity *was* eventually modeled, up to a point, by evolutionary programs. Some were focused on art (Sims 1991; Todd and Latham 1992), some on music (Gartland-Jones and Copley 2003; Hodgson 2002, 2005), and some on science or engineering (Goldberg 1987; Ijspeert, Hallam, and Willshaw 1997).

To some extent, genetic algorithms (Boden 2006, 15.vi; and see chapter 5) could transform the conceptual space being explored by the program. For example, Paul Hodgson, an accomplished jazz saxophonist, wrote several programs designed to improvise Charlie Parker–style jazz in real time. The first two, IMPROVISER and VIRTUAL BIRD, used brief melodic motifs as primitives (these were not statistically culled, as in Cope's work, but were based on a systematic theoretical analysis of music (Narmour 1989, 1992). VIRTUAL BIRD played well enough, early in the new century, that the world-famous Courtney Pine was willing to perform alongside it. Another, an evolutionary version called EARLY BIRD, used only dyadic (two-note) primitives (Hodgson 2005). It explored Bird space even more adventurously than its predecessor, partly because of the transformations it generated and partly because its primitives were less highly structured. Even so, it was not transformational in the sense of generating a recognizably different musical style. Hodgson felt that this would be possible but only if he himself added a great deal more musical information to constrain the changes allowed (Hodgson, personal communication).

That is hardly surprising, for in all such evolutionary programs the fitness function was due to the human being, whether built into the program or provided interactively. Peter Cariani (1997) has criticized current genetic algorithms accordingly, arguing that they are incapable of the sort of open-ended creativity seen in biological evolution.

Wholly new sensory organs, however, *have* been evolved in artificial systems, by a combination of genetic algorithms and environmental or hardware contingencies (15.vi.d). Perhaps future research on psychological creativity will take a leaf out of this biological book.

Biological evolution is not only open ended but unpredictable. And most creative ideas are unpredictable, too. There are various reasons why that is so (Boden 2004, chap. 9; see also Boden 2006, chap. 17). But that does not mean that AI creativity researchers were wasting their time. One may be able to explain something—to show *how it is possible*—without also being able to predict it (7.iii.d). Much as a theoretical psychology could never predict every passing fancy or every suicidal thought within Joe Blow's mind, so it could never predict every creative idea. It might be able to say a great deal, however, about the general types of ideas that were likely or unlikely and why. That, you will remember, had been Cohen's aim when he embarked on AARON in the first place; and it was Simon's aim, too.

By the turn of the millennium, then, AI research on creativity had at last become respectable. Several books on the topic had appeared, written or edited by long-standing members of the community (Michie and Johnston 1984; Boden 2004; Shrager and Langley 1990; Partridge and Rowe 1994; Hofstadter 1995). The interest was spreading way beyond a few enthusiasts. The *Stanford Humanities Review* published two book-length special issues on AI and creativity, especially in relation to literature (Guzeldere and Franchi 1994; Franchi and Guzeldere 1995).

The respectability suddenly snowballed into a range of professional meetings. IJCAI-97 (International Joint Conference on Artificial Intelligence) commissioned a keynote presentation on the topic (Boden 1998). And a flurry of creativity conferences and workshops were mounted by AI and artificial-life researchers. These included the continuing series Discovery Science, which complemented the Creativity and Cognition meetings on computer art that had been organized in the UK for many years past by Edmonds (13.vi.c).

If the ineffable had not yet been fully explained, *that it was truly ineffable* was now highly doubtful.

References

Adams, H. 1918. "The Dynamo and the Virgin." In *The Education of Henry Adams*, 379–390. Boston: Houghton and Mifflin.

Amarel, S. 1968. "On Representations of Problems of Reasoning about Actions." In *Machine Intelligence 3*, edited by D. M. Michie, 131–172. Edinburgh: Edinburgh University Press.

Binsted, K. 1996. "Machine Humour: An Implemented Model of Puns." PhD diss., University of Edinburgh.

Binsted, K., H. Pain, and G. D. Ritchie. 1997. "Children's Evaluation of Computer-Generated Punning Riddles." *Pragmatics and Cognition* 5:305–354.

Binsted, K., and G. D. Ritchie. 1997. "Computational Rules for Punning Riddles." *Humor: International Journal of Humor Research* 10:25–76.

Boden, M. A. 1977. *Artificial Intelligence and Natural Man.* New York: Basic Books.

Boden, M. A. 1997. "Commentary on Simon's paper on "Machine Discovery." In *Machine Discovery*, edited by J. Zytkow, 201–203. London: Kluwer Academic.

Boden, M. A. 1998. "Creativity and Artificial Intelligence." *Artificial Intelligence* 103:347–356.

Boden, M. A. 2004. *The Creative Mind: Myths and Mechanisms.* 2nd ed. London: Routledge.

Boden, M. A. 2006. *Mind as Machine: A History of Cognitive Science.* 2 vols. Oxford: Clarendon/ Oxford University Press.

Bringsjord and Ferrucci. 2000. *Artificial Intelligence and Literary Creativity: Inside the Mind of BRUTUS, a Storytelling Machine.* Mahway, NJ: Lawrence Erlbaum.

Cariani, P. 1997. "Emergence of New Signal-Primitives in Neural Systems." *Intellectica* 2:95–143.

Charniak, E. 1972. *Toward a Model of Children's Story Comprehension.* AI-TR-266 Cambridge, MA: MIT AI Lab.

Charniak, E. 1973. "Jack and Janet in Search of a Theory of Knowledge." *Proceedings of the Third International Joint Conference on Artificial Intelligence.* Los Angeles, 337–343.

Charniak, E. 1974. *"He Will Make You Take It Back": A Study in the Pragmatics of Language.* Castagnola, Switzerland: Istituto per gli Studi Semantici e Cognitivi.

Cheng, P., and H. A. Simon. 1995. "Scientific Discovery and Creative Reasoning with Diagrams." In *The Creative Cognition Approach*, edited by S. M. Smith, T. B. Ward, and R. A. Finke, 205–228. Cambridge, MA: MIT Press.

Cohen, H. 1979. *Harold Cohen: Drawing.* San Francisco: San Francisco Museum of Modern Art. Exhibition catalog.

Cohen, H. 1981. *On the Modelling of Creative Behavior.* RAND Paper P-6681 Santa Monica, CA: RAND.

Cohen, H. 1995. "The Further Exploits of AARON Painter." In "Constructions of the Mind: Artificial Intelligence and the Humanities," edited by S. Franchi and G. Guzeldere. Special issue, *Stanford Humanities Review* 4 (2): 141–160.

Cohen, H. 2002. "A Million Millennial Medicis." In *Explorations in Art and Technology*, edited by L. Candy and E. A. Edmonds, 91–104. New York: Springer.

Cohen H. 2012. "Evaluation of Creative Aesthetics." In *Computers and Creativity*, edited by J. McCormack and M. d'Inverno, 95–111. New York: Springer.

Collins, H. M. 1989. "Computers and the Sociology of Scientific Knowledge." *Social Studies of Science* 19:613–624.

Colton, S., A. M. Bundy, and T. Walsh. 2000. "On the Notion of Interestingness in Automated Mathematical Discovery." *International Journal of Human-Computer Studies* 53:351–375.

Cope, D. 1991. *Computers and Musical Style*. Oxford: Oxford University Press.

Cope, D. 2000. *The Algorithmic Composer*. Madison, WI: A-R Editions.

Cope, D. 2001. *Virtual Music: Computer Synthesis of Musical Style*. Cambridge, MA: MIT Press.

Cope, D. 2006. *Computer Models of Musical Creativity*. Cambridge, MA: MIT Press.

Copley, P., and A. Gartland-Jones. 2005. "Musical Form and Algorithmic Solutions." In *Creativity and Cognition 2005: Proceedings of the Fifth Conference on Creativity and Cognition*, edited by L. Candy, 226–231. New York: ACM Press.

Davey, A. C. 1978. *Discourse Production: A Computer Model of Some Aspects of a Speaker*. Edinburgh: Edinburgh University Press.

Dreyfus, H. L. 1965. *Alchemy and Artificial Intelligence*. Research Report P-3244. Santa Monica, CA: RAND.

Eisenstadt, M. 1976. "Processing Newspaper Stories: Some Thoughts on Fighting and Stylistics." *Proceedings of the AISB Summer Conference*. Edinburgh, July, 104–117.

Evans, T. G. 1968. "A Program for the Solution of Geometric-Analogy Intelligence Test Questions." In *Semantic Information Processing*, edited by M. L. Minsky, 271–353. Cambridge, MA: MIT Press.

Fauconnier, G. R., and M. Turner. 2002. *The Way We Think: Conceptual Blending and the Mind's Hidden Complexities*. New York: Basic Books.

Fodor, J. A. 1983. *The Modularity of Mind: An Essay in Faculty Psychology*. Cambridge, MA: MIT Press.

Forbus, K. D., D. Gentner, A. B. Markman, and R .W. Ferguson. 1998. "Analogy Just Looks like High Level Perception: Why a Domain-General Approach to Analogical Mapping Is Right." *Journal of Experimental and Theoretical AI* 10:231–257.

Franchi, S., and G. Guzeldere, eds. 1995. "Constructions of the Mind: Artificial Intelligence and the Humanities." Special issue, *Stanford Humanities Review* 4 (2): 1–345.

Gartland-Jones, A., and P. Copley. 2003. "The Suitability of Genetic Algorithms for Musical Composition." *Contemporary Music Review* 22 (3): 43–55.

Gentner, D. 1983. "Structure-Mapping: A Theoretical Framework for Analogy." *Cognitive Science* 7:155–170.

Gentner, D., S. Brem, R. W. Ferguson, A. B. Markman, B. B. Levidow, P. Wolff, and K. D. Forbus. 1997. "Conceptual Change via Analogical Reasoning: A Case Study of Johannes Kepler." *Journal of the Learning Sciences* 6:3–40.

Goldberg, D. 1987. "Computer-Aided Pipeline Operation Using Genetic Algorithms and Rule Learning. Part I: Genetic Algorithms in Pipeline Optimization." *Engineering with Computers* 3:35–45.

Guzeldere, G., and S. Franchi, eds. 1994. "Bridging the Gap: Where Cognitive Science Meets Literary Criticism (Herbert Simon and Respondents)." Special issue, *Stanford Humanities Review* 4 (1): 1–164.

Haugeland, J. 1978. "The Nature and Plausibility of Cognitivism." *Behavioral and Brain Sciences* 1:215–226.

Hiller, L. A., and L. M. Isaacson. 1959. *Experimental Music: Composition with an Electronic Computer.* New York: McGraw Hill.

Hodgson, P. W. 2002. "Artificial Evolution, Music and Methodology." *Proceedings of the Seventh International Conference on Music Perception and Cognition* (Sydney), 244–247. Adelaide, Australia: Causal Productions.

Hodgson, P. W. 2005. "Modeling Cognition in Creative Musical Improvisation." PhD diss., University of Sussex.

Hofstadter, D. R. 1985a. "Metafont, Metamathematics, and Metaphysics." In *Metamagical Themas: Questing for the Essence of Mind and Pattern*, edited by D. R. Hofstadter, 260–296. New York: Viking.

Hofstadter, D. R. 1985b. *Metamagical Themas: Questing for the Essence of Mind and Pattern.* New York: Viking.

Hofstadter, D. R. 2001a. "A Few Standard Questions and Answers." In *Virtual Music: Computer Synthesis of Musical Style*, edited by D. Cope, 293–305. Cambridge, MA: MIT Press.

Hofstadter, D. R. 2001b. "Staring Emmy Straight in the Eye—and Doing My Best Not to Flinch." In *Virtual Music: Computer Synthesis of Musical Style*, edited by D. Cope, 33–82. Cambridge, MA: MIT Press.

Hofstadter, D. R. 2002. "How Could a COPYCAT Ever Be Creative?" In *Creativity, Cognition, and Knowledge: An Interaction*, edited by T. Dartnall, 405–424. London: Praeger.

Hofstadter, D. R., and FARG (The Fluid Analogies Research Group). 1995. *Fluid Concepts and Creative Analogies: Computer Models of the Fundamental Mechanisms of Thought.* New York: Basic Books.

Hofstadter, D. R., and G. McGraw. 1995. "Letter Spirit: Esthetic Perception and Creative Play in the Rich Microcosm of the Roman Alphabet." In *Fluid Concepts and Creative Analogies: Computer Models of the Fundamental Mechanisms of Thought*, edited by D. R. Hofstadter and FARG, 407–466. New York: Basic Books.

Hofstadter, D. R., and M. Mitchell. 1993. "The Copycat Project: A Model of Mental Fluidity and Analogy-Making." In *Advances in Connectionist and Neural Computation Theory.* Vol. 2, *Analogical Connections*, edited by K. Holyoak and J. Barnden, 31–112. Norwood, NJ: Ablex.

Holyoak, K. J., and P. Thagard. 1989. "Analogical Mapping by Constraint Satisfaction." *Cognitive Science* 13:295–356.

Ijspeert, A. J., J. Hallam, and D. Willshaw. 1997. "Artificial Lampreys: Comparing Naturally and Artificially Evolved Swimming Controllers." In *Fourth European Conference on Artificial Life*, edited by P. Husbands and I. Harvey, 256–265. Cambridge, MA: MIT Press.

Johnson-Laird, P. N. 1993. "Jazz Improvisation: A Theory at the Computational Level." In *Representing Musical Structure*, edited by P. Howell, R. West, and I. J. Cross, 291–326. London: Academic Press.

Klein, S., J. F. Aeschlimann, D. F. Balsiger, S. L. Converse, C. Court, M. Foster, R. Lao, J. D. Oakley, and J. Smith. 1973. "Automatic Novel Writing: A Status Report." Technical Report 186. Madison: University of Wisconsin Computer Science Dept.

Kulkarni, D., and H. A. Simon. 1988. "The Processes of Scientific Discovery: The Strategy of Experimentation." *Cognitive Science* 12:139–175.

Langley, P. W. 1978. "BACON.1: A General Discovery System." *Proceedings of the Second National Conference of the Canadian Society for Computational Studies in Intelligence*. Toronto, 173–180.

Langley, P. W. 1979. "Descriptive Discovery Processes: Experiments in Baconian Science." PhD diss., Carnegie Mellon University.

Langley, P. W. 1981. "Data-Driven Discovery of Physical Laws." *Cognitive Science* 5:31–54.

Langley, P. W. 1998. "The Computer-Aided Discovery of Scientific Knowledge." In *Discovery Science, Proceedings of the First International Conference on Discovery Science*, edited by S. Arikawa and H. Motoda, 25–39. Berlin: Springer.

Langley, P. W., G. L. Bradshaw, and H. A. Simon. 1981. "BACON.5: The Discovery of Conservation Laws." *Proceedings of the Seventh International Joint Conference on Artificial Intelligence*. Vancouver, 121–126.

Langley, P. W., H. A. Simon, G. L. Bradshaw, and J. M. Zytkow. 1987. *Scientific Discovery: Computational Explorations of the Creative Process*. Cambridge, MA: MIT Press.

Lenat, D. B. 1977. "The Ubiquity of Discovery." *Artificial Intelligence* 9:257–286.

Lenat, D. B. 1983. "The Role of Heuristics in Learning by Discovery: Three Case Studies." In *Machine Learning: An Artificial Intelligence Approach*, edited by R. S. Michalski, J. G. Carbonell, and T. M. Mitchell, 243–306. Palo Alto, CA: Tioga.

Lenat, D. B., and J. Seely Brown. 1984. "Why AM and EURISKO Appear to Work." *Artificial Intelligence* 23:269–294.

Mackay, D. M. 1951. "Mindlike Behaviour in Artefacts." *British Journal for the Philosophy of Science* 2:105–121.

Mackenzie, D. 1995. "The Automation of Proof: A Historical and Sociological Exploration." *Annals of the History of Computing* 17 (3): 7–29.

Masterman, M. M. 1971. "Computerized Haiku." In *Cybernetics, Art, and Ideas*, edited by J. Reichardt, 175–183. London: Studio Vista.

Masterman, M. M., and R. McKinnon Wood. 1968. "Computerized Japanese Haiku." In *Cybernetic Serendipity*, edited by J. Reichardt, 54–55. London: Studio International.

McCarthy, J., M. L. Minsky, N. Rochester, and C. E. Shannon. 2000. "A Proposal for the Dartmouth Summer Research Project on Artificial Intelligence." In *Artificial Intelligence: Critical Concepts*. Vol. 2, edited by R. A. Chrisley, 44–53. London: Routledge.

McCorduck, P. 1979. *Machines Who Think: A Personal Inquiry into the History and Prospects of Artificial Intelligence*. San Francisco: W. H. Freeman.

McDermott, D. V. 1981. "Artificial Intelligence Meets Natural Stupidity." In *Mind Design: Philosophy, Psychology, Artificial Intelligence*, edited by J. Haugeland, 143–160. Cambridge, MA: MIT Press.

McGraw, G. 1995. "Letter Spirit (Part One): Emergent High-Level Perception of Letters Using Fluid Concepts." PhD diss., Indiana University, Bloomington.

Meehan, J. 1975. "Using Planning Structures to Generate Stories." *American Journal of Computational Linguistics* 33:77–93.

Meehan, J. 1981. "'TALE-SPIN' and 'Micro TALE-SPIN.'" In *Inside Computer Understanding: Five Programs plus Miniatures*, edited by R. C. Schank and C. K. Riesbeck, 197–258. Hillsdale, NJ: Lawrence Erlbaum.

Michalski, R. S., ed. 1983. *Proceedings of the International Machine Learning Workshop*. June, Monticello, Illinois.

Michie, D. M., and R. Johnston. 1984. *The Creative Computer: Machine Intelligence and Human Knowledge*. London: Viking-Penguin.

Minsky, M. L., ed. 1968. *Semantic Information Processing*. Cambridge, MA: MIT Press.

Mitchell, M. 1993, *Analogy-Making as Perception*. Cambridge, MA: MIT Press.

Moynihan, T. 2003. "The Sweet Sounds of MIDI." May 21. Available at http://www.g4tv.com/screensavers/features/44197/The_Sweet_Sounds_of_MIDI.html.

Narmour, E. 1989. *The Analysis and Cognition of Basic Melodic Structures: The Implication-Realization Model*. Chicago: Chicago University Press.

Narmour, E. 1992. *The Analysis and Cognition of Melodic Complexity: The Implication-Realization Model*. Chicago: Chicago University Press.

Newell, A., J. C. Shaw, and H. A. Simon. 1962. "The Processes of Creative Thinking." *Contemporary Approaches to Creative Thinking*, edited by H. E. Gruber, G. Terrell, and M. Wertheimer, 63–119. New York: Atherton Press.

O'Hear, A. 1995. "Art and Technology: An Old Tension." In *Philosophy and Technology*, edited by R. Fellows, 143–158. Cambridge: Cambridge University Press.

Ortony, A., ed. 1979. *Metaphor and Thought*. Cambridge: Cambridge University Press.

Partridge, D. A., and J. Rowe. 1994. *Computers and Creativity*. Oxford: Intellect Books.

Rehling, J. A. 2001. "Letter Spirit (Part Two): Modeling Creativity in a Visual Domain." PhD diss., Indiana University, Bloomington.

Rehling, J. A. 2002. "Results in the Letter Spirit Project." In *Creativity, Cognition, and Knowledge: An Interaction*, edited by T. Dartnall, 273–282. London: Praeger.

Rieger, C. J. 1975a. "Conceptual Overlays: A Mechanism for the Interpretation of Sentence Meaning in Context." *Proceedings of the Fourth International Joint Conference on Artificial Intelligence*. Los Angeles, 143–150.

Rieger, C. J. 1975b. "The Commonsense Algorithm as a Basis for Computer Models of Human Memory, Inference, Belief, and Contextual Language Comprehension." *Theoretical Issues in Natural Language Processing (Proceedings of a Workshop of the Association of Computational Linguistics*. June, Cambridge, MA, 199–214.

Ritchie, G. D. 2001. "Current Directions in Computational Humour." *Artificial Intelligence Review* 16:119–135.

Ritchie, G. D. 2003a. *The JAPE Riddle Generator: Technical Specification*. Informatics Research Report EDI-INF-RR-0158. Edinburgh: University of Edinburgh, School of Informatics, February.

Ritchie, G. D. 2003b. *The Linguistic Analysis of Jokes*. London: Routledge.

Ritchie, G. D., and F. K. Hanna. 1984. "AM: A Case Study in AI Methodology." *Artificial Intelligence* 23:249–268.

Schank, R. C., and the Yale AI Project. 1975. *SAM: A Story Understander*. Research report 43. New Haven, CT: Yale University, Department of Computer Science, August.

Shasha, D., and C. Lazere. 1995. *Out of Their Minds: The Lives and Discoveries of 15 Great Computer Scientists*. New York: Copernicus.

Shrager, J., and P. Langley, eds. 1990. *Computational Models of Discovery and Theory Formation*. San Mateo, CA: Morgan Kaufmann.

Simon, H. A. 1994. "Literary Criticism: A Cognitive Approach." In "Bridging the Gap: Where Cognitive Science Meets Literary Criticism (Herbert Simon and Respondents)," edited by G. Guzeldere and S. Franchi. Special issue, *Stanford Humanities Review* 4 (1): 1–27.

Simon, H. A. 1995. "Explaining the Ineffable: AI on the Topics of Intuition, Insight, and Inspiration." *Proceedings of the Fourteenth International Joint Conference on Artificial Intelligence*. Vol. 1, 939–948.

Simon, H. A. 1997a. "Machine Discovery." In *Machine Discovery*, edited by J. Zytkow, 171–200. London: Kluwer Academic.

Simon, H. A. 1997b. "Machine Discovery: Reply to Comments." In *Machine Discovery*, edited by J. Zytkow, 225–232. London: Kluwer Academic.

Simon, H. A., and A. Newell. 1958. "Heuristic Problem Solving: The Next Advance in Operations Research." *Operations Research* 6:1–10.

Sims, K. 1991. "Artificial Evolution for Computer Graphics." *Computer Graphics* 25 (4): 319–328.

Thagard, P. 1990. "Concepts and Conceptual Change." *Synthese* 82:255–274.

Thagard, P., K. J. Holyoak, G. Nelson, and D. Gochfeld. 1988. "Analog Retrieval by Constraint Satisfaction." Research paper, Cognitive Science Laboratory, Princeton University, November.

Todd, S. C., and W. Latham. 1992. *Evolutionary Art and Computers*. London: Academic Press.

Turner, M. 1991. *Reading Minds: The Study of Literature in an Age of Cognitive Science*. Princeton, NJ: Princeton University Press.

Turner, S. R. 1994. *The Creative Process: A Computer Model of Storytelling and Creativity*. Hillsdale, NJ: Lawrence Erlbaum.

Wilks, Y. A. 1972. *Grammar, Meaning, and the Machine Analysis of Natural Language*. London: Routledge and Kegan Paul.

4 Art Appreciation and Creative Skills

Margaret A. Boden

4.1 The Problem

Traditionally, our appreciation of art depends in part on our appreciation of the process of art making. In evaluating a painting, for instance, we commonly consider the skills involved in producing it and the specific difficulties overcome in so doing. We appreciate the finesse with which these methods are applied and respect the dedication needed to acquire them. If we know that the painter had to grind his (usually his) own lapis lazuli and mix his own oils, we admire him somewhat more than we admire someone who could squeeze his colors out of a tube. And if we want to know *just how* a certain canvas was painted, we are interested to know whether the process involved pestle and mortar or labor-saving plastic tubes.

We are impressed, in particular, by the creative application of familiar skills in surprising but effective ways, and—even more—by the generation of new ones. Indeed, advances in artistic technique form a large part of what art critics study—and of what gets individual artists into the history books.

Arguably, such knowledge about the skills of art making does not affect our evaluation of the picture itself. Suppose we were to discover that Leonardo had bought his paints from some fifteenth-century Winsor and Newton art supplier: would the aesthetics of the *Mona Lisa* be any less compelling or any less mysterious? Or suppose we found out that he had painted the canvas holding the brush between his teeth; what then? In other words, knowledge of the art making is generally thought to be secondary to strictly aesthetic appreciation. But even so, it is regarded as a valuable part of our experience of art.

This presents a problem for computer art in general—which involves skilled and creative *computing* as the basis of the creative *art*. The art making here is typically invisible, leaving no obvious footsteps in the artwork itself. Even when brushstrokes,

for instance, are specifically represented in the final artifact (as by The Painting Fool, described in chapter 6; Colton 2012), these are not the footsteps of the program, but quasihuman footsteps generated by the program.

What is more, even if the relevant art-generating program were to be explicitly presented to the audience, it would (for most people) be unintelligible. As for assessing the creativity—the novelty, elegance, and ingenuity (and even the integrity; Boden 2010a, 187–190)—of the program considered *as* a program, that is beyond all but the technocognoscenti.

Admittedly, only relatively few people can fully understand the technical achievements of traditional artists. Many of us have no more than a primitive knowledge of how they use paint on canvas—for example, providing a white primer (to heighten the final colors), as the Pre-Raphaelites did. One might want to say, then, that artists of computer-generated (CG) art with hidden skills are in a position similar to that of their predecessors. However, although few of us know about the white primer, everyone can remember (or imagine) wielding a paintbrush, mixing colors, and using watercolors, pastels, or even oils. The same is not true of CG-skills. CG-artists do not simply do better what we all did clumsily as children or even what we saw our elders do well; they do something of which most of us have no experience at all.

If the CG-artist's skill is invisible or mysterious, this does not rule out the possibility that the resulting artwork may interest, disturb, or even enthrall us. And that, of course, is all to the good. It means that no one is completely prevented from appreciating CG-art. Novelty, surprise, and value—in a word, creativity—can be recognized in CG-artworks. But it seems that this type of art cannot command our respect for its creativity, or even its competence, considered as a product of technical skill. At best, it can amaze us much as a magician does who conjures a rabbit out of a hat: *that* he does this can arouse our awe, but *how* he does so cannot. Only other magicians can recognize the nature and creative value of the conjuror's skills. In short, where computer art is concerned, one key dimension of art appreciation seems to be missing.

One might put this point even more strongly. One might say that the program itself is the real artwork. In that case, what I have been calling computer artworks are merely the program's *performances*. Analogously, consider the *Eroica* symphony. One may regard the true artwork as Beethoven's score. Any actual performance of it is an ephemeral event, unique—and perhaps marvelous—in its details but fundamentally derivative of the written score. Some CG-artists take a closely comparable position, regarding the generative process, or programmed procedure, as the real artwork. If we take either of these views, in which the true artwork is the program or procedure itself, then the problem presented here becomes even more taxing. The nature of the program

is now—or should be—the crux of aesthetic attention, not (as previously implied) something of secondary importance worthy of attention only because of our general interest in human artists' skills.

I continue to refer to the performances (the results) of CG-art programs as the actual *artworks* concerned, as most people, including many CG-artists themselves, usually do. Accordingly, I continue to treat the writing of the program as an aspect of the CG-artist's skill—how he or she mixes and manipulates the CG-oils, one might say. But the strong claim of the underlying program to be regarded as the definitive artwork should not be forgotten.

Whichever horn of that philosophical dilemma one chooses to take, CG-artists face a significant barrier to aesthetic appreciation. This obstacle arises not only in the minds of the general public but also in those of most professional art critics and curators, too. Is there anything that CG-artists can do to remove it or at least to minimize it?

4.2 Perhaps Skills Are Irrelevant, after All?

One thing that CG-artists might conceivably do is try to convert us all to the views of the art theorist Robin Collingwood. Collingwood, as explained in chapter 6, insisted that our common assumption about the aesthetic worth of the artist's skills is radically mistaken. He believed that such skills are utterly irrelevant to the status of the object considered *as art*.

On his view, the essence of a work of art is its power to elicit a certain emotional experience in the viewer or listener. Strictly speaking, he saw the true artwork as being not the physical artifact itself but the experience constructed in the observer's mind. The artifact has aesthetic value only insofar as it enables this mental construction to take place. He acknowledged, of course, that artists need certain skills to be able to fashion artifacts that will reliably prompt the relevant experiences. And those skills, like any other hard-won and effective technical practices (plumbing, for instance), are worthy of our respect. But they do not merit specifically *aesthetic* admiration.

For Collingwood, then, the artist's skills could in principle remain wholly unknown to the audience without in any way diminishing the value of the artwork as art. If it leads us to construct a particular emotional experience in our minds, that is enough. Just how artifacts having that psychological effect are made by the artist is a technical question—one of some historical and professional interest, no doubt, but not of any aesthetic importance.

Someone might suggest, accordingly, that CG-artists should adopt Collingwood as their patron saint and try to persuade the rest of us to follow him, too. In that case, the

invisibility and unintelligibility of their skills would not matter. Ignorance of their tech-niques would not undermine people's aesthetic appreciation of their work in any way.

That would not be a sensible suggestion, however. For one thing, Collingwood's stress on emotion as the key to art raises some difficulties for computer artists, although not nearly so many as is commonly assumed (see chapter 10). For another, his sidelining of skill in art appreciation sits uneasily alongside computer artists' justifiable pride in their highly unusual skills (see chapter 10).

But there is a third reason that suggestion should be resisted—and this reason is not confined only to CG-art. Namely, Collingwood's position on the aesthetic irrelevance of artistic skills, although not his prioritizing of emotion, strikes most people as bizarre.

It strikes us as bizarre because, as already remarked, we normally take it for granted that admiration of the artist's skill is part of art appreciation. Indeed, the art critic John Ruskin (discussed at length in chapter 7) saw *recognition of the processes of skilled art making* as central to aesthetic valuation. Ruskin was even more widely influential than Colling-wood. He still is; countless people who have never even heard his name have adopted Ruskin's key ideas within their attitude to art.

4.3 Of Course Skills Matter! But Which Ones?

So perhaps CG-artists with a proper pride in their own creative processes should choose Ruskin, instead, as their patron saint?

Well, no. Ruskin—despite his emphasis on the importance of skills—is no more suit-able as a champion for CG-art than Collingwood is. Ruskin did not merely say that skills are crucial in genuine art making. He said that skills *of a certain kind* are essential.

In a nutshell (for more detail, see chapter 14), these are the skills of individual crafts-men, working by hand with brush or chisel, knife or needle, and leaving visible footsteps (or fingerprints?) in the resulting artwork. To respond to a work *as art*, for Ruskin, was to recognize it as a handmade product of a freely engaged human individual.

One might try to include CG-artists within Ruskin's deeply admired class of skilled craftsmen by pointing out that programming itself is a highly skilled activity and some-times also (as explained in chapter 10) a highly creative one. Moreover, although pro-gram code does not carry physical traces of the craftsman's hand, as Ruskin's beloved medieval gargoyles do, it may well bear stylistic traces of the individual programmer. A person's programming may be as distinctive as the other personal signatures recog-nized by connoisseurs of art (Boden 2010b).

The problem, of course, is that only a tiny handful of people are knowledgeable enough to be able to identify the creativity, still less the personal authorship, of the code underlying

a CG-artwork (which, in any event, is not usually made available). As an attempt to persuade the general public that such art really is *art*, the close analysis of programming skills is a lost cause. Not-so-close analysis can sometimes be helpful, however; see sections 4.3–4.4. Nor can this approach enable just anybody to try to produce some CG-art themselves: programming, no matter how simple, does not come as naturally as using a paintbrush or needle and thread. As Ruskin might have put it, computer art cannot satisfy his demand that art "should both admit the aid, and appeal to the admiration, of the rudest as well as the most refined minds" (Ruskin 1854, 34).

Furthermore, Ruskin was fiercely critical of the then-new machine age, whose factory technologies he saw as insidiously dehumanizing. Were he alive today, he would regard computers in general and computer art in particular as further steps on this dehumanizing road and, as such, to be deplored.

He would not even have accepted computer-aided art—such as David Hockney's recent work, for example. But why not? If chisels are allowed as art-making tools, why not computers? And if the individual human artist is making all the important art-making decisions, as Hockney certainly is, why cavil at the use of digital technology rather than the blacksmith's hammer and tongs? The answer (see chapter 7), is that Ruskin explicitly outlawed the use of instruments that hugely increase our physical or mental powers. Titian or Michelangelo, he said, would have rejected "electricity" or "steam-hammers." In general, great artists would "imperatively and scornfully refuse, either the force, or the information, which are beyond the scope of the flesh and the senses of humanity" (Ruskin 1875, chap. 2, sect. iv). So computers, clearly, would not be acceptable to him even as convenient *aids* to art making.

As for generative computer art, in which crucial choices are made not by a human being but by the program, that would be even further beyond the pale. He would not have regarded CG-art as true art at all. So notwithstanding his celebration of creative skills, CG-artists would be most unwise to suggest Ruskin as their aesthetic champion.

Our original question, then, remains: If art appreciation is largely the recognition of artistic skill, how can the arcane, elitist skills of computer artists become widely recognized and respected? How can they be made accessible to the rudest as well as the most refined minds?

4.4 Making CG-Artists' Skills Directly Visible

Making CG-skills accessible could mean making them more directly visible in the artwork itself, or it could mean making them more intelligible. Both strategies are highly problematic, as we will see. But the latter is more likely to be attempted than the former.

In principle, a CG-artist could try to make his or her CG-graphics or CG-music bear some visible or audible footsteps of the underlying program. But because such traces would affect the perceptible nature—the aesthetics—of the artwork itself, the artist very likely would not want to do this. Only if the footsteps formed part of the original aesthetic intent would they be artistically acceptable.

Artistically acceptable footsteps could arise in those cases of evolutionary art (see chapters 2 and 5) in which part of the artist's prime intent is to celebrate evolution as such. There, visible traces of the history of the art making would have some *intrinsic* aesthetic interest. Evidence of the execution of the (evolutionary) program would not merely lie alongside the artwork but would form an integral part of it. The artist concerned might even regard the artwork itself as *a continuing process* or as a *sequence* of displayed images drawn from successive generations.

Where evolutionary art, or Evo-art, is concerned, it is relatively easy to make some aspects of the program visible to the audience (see section 4.4). It is much more difficult to indicate *this* or *that* aspect of the CG-art program to the observer when that program is a traditional symbolic affair (like all but the most recent versions of Harold Cohen's AARON, for instance).

Burdening the gallery visitor with successive images generated by a (symbolic) program that was designed by the artist to produce one or more static artworks seems less aesthetically defensible than doing this for Evo-art. What is more, the earlier stages of the program might not actually produce visible images at all; instead, they might merely make decisions that will affect the visible artwork when it comes to be generated later. Even if (some of) the earlier stages were capable of producing visible images, very few CG-artists of this kind would want to present such preparatory phases *as part of the artwork as a whole*. Nor is it clear how they could succeed in leaving telltale visual traces of the program within the final static artwork even if they wanted to.

A display of some of the preparatory phases in the execution of a symbolic program might indeed help open the audience's eyes to the computational skills involved. For it could show that the CG-artist has created a program that focuses on specific aesthetically relevant problems in arriving at the final artwork. One subprocedure, for instance, might enable occlusion by deleting previously drawn lines, another might seek an empty space of suitable size so as to avoid having to deal with occlusion. Understanding *how* those stages come about would require more technical expertise on the part of the gallery visitor. This presentational strategy is a gamble, however, and one that the CG-artist may not wish to make. For it risks being seen as education rather than art.

In sum, making CG-skills directly visible is easier said than done and, when it is done, may be experienced as pedagogy, not aesthetics.

4.5 Intelligibility through Programming

The tension between pedagogy and art is present in all attempts to heighten people's appreciation of CG-art by teaching them how it is achieved. Such attempts need not involve visible footsteps in the final artwork or even visible traces of the history of the running of the program. They may be very much more abstract than that. And very much more abstract than the formal rules that underlie some famous examples of Conceptual art (see Boden 2007). In a word, they must deal somehow with *programming*. They must convey something about what the program does and also something about how it is doing it.

The dilemma here is that making abstract CG skills more intelligible threatens to turn the gallery into a classroom. The audience's aesthetic experience will be colored (and often diminished?) accordingly. The danger that aesthetics may be elbowed aside to make way for education must be faced, nevertheless. We have already noted that an art lover knowing *nothing* about programming cannot properly appreciate CG-artists' work. Knowing *something*, however, may help. We need to ask just what kinds of "somethings" are relevant and just how they can be communicated to the nonspecialist audience.

Perhaps the first thing to say is that in a country whose schoolchildren are taught information technology (IT) partly by writing miniprograms (in languages like LOGO or BASIC), the potential for the appreciation of computer art will already be heightened. Anyone who has learned to program, even at a Mickey Mouse level, has learned some highly relevant "somethings" that can be acquired in no other way.

They will have realized the clarity and precision required to program successfully. They will have experienced the creativity involved in achieving a desired result in a new way. And perhaps even more important, they will have glimpsed the unsuspected power of superficially simple pieces of code. For these ends, Mickey Mouse programming is enough. There is a greater difference in understanding—and so in the capacity for appreciating CG-artists' skills—between someone who has never programmed and someone who has than there is between the most fumbling amateur programmer and a dazzling artificial intelligence professional.

When IT was first taught in British schools, miniprogramming was the general approach. Nowadays, most IT lessons focus instead on the use of ready-made computing packages—such as financial spreadsheets, or Hockney's CA-aid Photoshop, or the ubiquitous search engine Google. The creative activity of trying to compose a program for oneself simply is not made available. Most children, including (so my artificial intelligence colleagues tell me) some with mold-breaking computer scientists as parents, infer as a result that computing is boring and turn away from it accordingly.

In 2012, a senior executive of Google warned (rightly) that the UK is jeopardizing its preeminence in IT by this approach. For our purposes here, what is relevant is not the effect of a country's IT education policy on its economic potential but the extent to which it prepares its citizens to appreciate computer art or, for that matter, to become CG-artists themselves. Borrowing Ruskin's words: preparing them to give their aid as well as their admiration. With respect to those goals, too, our children need fewer packages and more programming.

I am glad to say that the British school curriculum has just been altered. From 2014–2015 on, all children are learning some programming. But that welcome change has only just begun. Its effects will take years to become apparent.

At present, then, the potential audience for CG-art is overwhelmingly innocent of programming. The topic is not only abstract (as arithmetic is, too), but—to them—utterly abstruse. So presenting the actual code, or even the logical rules, that generated a given work of CG-art will not help more than a handful of people appreciate the creative skills involved.

This situation is especially problematic for live coding (LC) art, in which the audience is required to match the developing artwork with the lines of code being written by the artist as they watch (see chapter 2). Doing this is far from easy. Indeed, the live code is sometimes written in a programming language (such as LISP) that is unknown even to many IT professionals. Admittedly, the artist will usually attempt to code generative processes that are "succinct and quick to type" (Brown and Sorenson 2009, 17). But that does not necessarily help the audience. The LC-musician Alex McLean (personal communication) has tried to construct a special programming language that will be relatively transparent to nonspecialist listeners. But his example is not widespread; it is hugely tempting—for the artist—to rely on familiar languages that are intelligible only to the cognoscenti.

In short, LC-artists assume that their audience is familiar with programming code. Only if that is so will they be able to appreciate the artwork (usually music) being created in front of their eyes except in the most superficial manner. Such familiarity is highly unusual, however. For most members of the public, LC-art is a closed book.

The other forms of CG-art are less demanding. Even so, special measures may be needed to deepen the audience's aesthetic experience.

In the very early days of CG-art, the generative code or set of rules was quite often displayed alongside the final artifact. Ernest Edmonds did this for his late-1960s 3-D canvas *Nineteen*, for instance (Cornock and Edmonds 1973, fig. 2) and so did most of the budding computer artists who presented work in the groundbreaking *Cybernetic Serendipity*

exhibition at London's Institute of Contemporary Arts (Reichardt 1968). But the (tiny) audience at that time was likely to be *au fait* with programming or at least with logic and mathematics. Today, the potential audience is very much wider, so other methods are needed to convey the abstractions concerned.

4.6 Intelligibility through Description

One way of communicating the nature of CG-artists' skills without getting lost in abstractions is to rely on natural language—possibly complemented by visual illustration. So one may try to provide a high-level verbal description of what the program is doing, and how it is doing it, that will be intelligible to virtually any gallery visitor.

The taxonomy of computer art presented in chapter 2 is one attempt to do this, in very general terms. Considering the taxonomy *as a whole* enables one to understand a given (type of) C-art not only by knowing something about how it was made but also by comparing or contrasting it with other types.

It is not a simple matter, however, to communicate such intangible ideas to the gallery visitor—who, in any case, is normally interested in some particular instance of C-art, not merely in a general taxonomic class. The degree of detail, for instance, will be constrained not only by the audience's knowledge (or lack of it) of programming or only by their powers of concentration but also by the physical space or time available.

Occasionally, a CG-artist will write an entire book explaining what his or her programs do and how they work (Todd and Latham 1992). Or perhaps someone else will do so on the artist's behalf—although in this case, the how may be sadly underplayed (McCorduck 1991). But relatively few people will take the time and trouble to read it. More often, the artist has to rely on exhibition catalogs. If the gallery is willing to sponsor a catalog with room for more than a list of names and titles, a written description could be fairly lengthy. If not, then the artist (and the curator) will be limited to what can be realistically presented—and easily read—on the wall nearby. For CG-music, of course, there is no wall; if the description is to be a written one, then some sort of explanatory leaflet is the only way to go.

Sometimes, the CG-art description might be made available not (or not only) in writing but as speech. This would involve an introductory minilecture, presented either at a fixed place and time or (more likely) via a phone app or a portable audiocassette. That project is not straightforward either: the speaker—perhaps a professional actor?—of a prerecorded message would need some understanding of it to communicate it effectively.

The type of CG-art that is easiest to describe in this way is also the one that the general public finds the most surprising: Evo-art. The notion that a program can change itself, as opposed to being rigidly fixed by a human programmer, is highly counterintuitive for many people. But explaining it to them is relatively easy, because the programs that generate Evo-art exploit ideas with which the audience is already familiar. Besides the concept of biological evolution itself, these common ideas include reproduction, generations, siblings, heredity, gene, random mutation, selection, and fitness; and some people will also have come across more technical terms, such as genotype, phenotype, crossover, and point mutation.

As well as describing Evo-art by using words such as these, the CG-artist can provide visible snapshots drawn from different generations of a graphics program's phenotypic performance. This is more difficult with Evo-music, because one cannot perceive several music snippets simultaneously. And some or all of the visual snapshots can even be presented alongside the relevant (genotypic) code snapshots and with explanatory verbal comments to boot.

These parallel snapshots (with the verbal comments) can convey an idea of the sorts of code mutations that are possible and of their potential graphic results. That deeper mutations (such as crossover or concatenation) lead to deeper, and even less predictable, phenotypic changes than simple (point) mutations do can be illustrated in this way. For examples, compare the deep mutations—and utterly unpredictable genotypic or phenotypic results—that are allowed by Karl Sims's evolutionary graphics program with the much less adventurous ones allowed by the sculptor William Latham (Sims 1991; Todd and Latham 1992). Latham was less adventurous not because he was less imaginative and not because he (or his code-writing collaborator, Stephen Todd) was less skilled in computing, but because his artistic interest was in exploring the potential of a more limited, yet aesthetically interesting, space of possibilities.

The skills of the CG-artist in choosing just which types of mutations to allow in the underlying code can be hinted at in this way. Similarly, the fitness function used for selection at each generation can be communicated, up to a point, by displaying sets of snapshot siblings with their differing fitness marked. The artist's skill in deciding to use *that* fitness function rather than *this* one can be gestured at in this way.

Hints and gestures are all that can be provided, of course. A fuller understanding is available only to computer experts. But displaying the bare bones of CG-art as previously suggested can help inform the audience about the Evo-artist's skills both in coding and in making more obviously aesthetic (i.e., fitness or phenotypic) choices.

This limitation on the communication of CG-artists' skills is not necessarily a bad thing. Hints and gestures may be all that the CG-artist actually wants to convey. Admiration

is often increased by mystery. Cohen waited many years before making the code for any version of AARON available on the Internet. And more traditional artists, too, are not always eager to announce their secret skills to the world.

If Evo-art is relatively easy to explain, connectionist-based CG-art is not. One of the most widely admired pieces in London's Millennium Dome was Richard Brown's *Mimetic Starfish*. This was a continuously changing, and extraordinarily lifelike, image of a multicolored starfish, moving its five arms freely while seemingly trapped inside a marble table (Brown 2000). The image (projected downward onto the table from the ceiling) was generated by a neural network, which made a host of detailed visible changes that were triggered by its perception of the movements and sounds made by the audience nearby.

There was an outline explanation on the wall of how the system worked, which made some highly superficial comparisons with the brain. But just what Brown had to do—just how he had to exploit his coding skills—to construct this marvel was hardly touched on. And that is not surprising. Explaining how a parallel-processing neural network functions involves communicating ideas such as weighted connections, excitation or inhibition, equilibrium, distributed representation, and constraint satisfaction. It is not impossible to do that in reader-friendly terms (see e.g., Boden 2004, chap. 6). But it needs more space and more concentration from the reader than a couple of laminated posters on the wall.

The *Mimetic Starfish* was an example of computer interactive (CI) art (see chapters 2 and 7). In CI-art, the program interacts with the outside world—sometimes wind or weather but usually the human audience. Accordingly, the detailed nature of the perceptible result depends on just what the program does in response to the outside influence. I say "perceptible result" rather than "artwork" because many CI-artists would insist that the artwork is not actually the resulting artifact but the interaction itself.

In principle, hints about the skills exploited in CI-art—what the program is doing, and possibly even also how it is doing it—could be conveyed by sampled snapshots without compromising the aesthetic intent. The key point of CI-art is that the changing stages of the artwork are constructed on the fly as program and audience interact. If some of these interactions can be picked out so as to convey a sense of what is going on behind the superficial experience, the artistic integrity of the work would seem to remain intact.

It does not follow, however, that these hints can be provided easily. Quite apart from the audience's general unfamiliarity with programming, there are two further reasons why the CI-artist's skills may be inaccessible.

The first is that the CI-artist sometimes decides to make *what the program is doing* invisible. In other words, the human audience is not expected, still less required, to recognize the nature of the interaction. Sometimes the artist is content if they do not even notice that there is an interaction. In such cases, the question of the audience's appreciation of the CG-artist's skills simply does not arise.

The second is more general. Because of the theoretical generality of the digital computer, infinite types of computer-generated interaction are in principle possible. To be sure, what actually happens will depend on the CI-artist's skills (as also on their aesthetic taste and imagination). But *just what is going on* can vary so much that there is no single answer to the question of what the computer is doing. The programming involved may be of any computational type—evolutionary, connectionist, symbolic GOFAI (good old-fashioned artificial intelligence), cellular automata, hybrid, etc. Even more important, the kinds of interaction involved vary indefinitely. This does not prevent there being a special description of each idiosyncratic system of interaction. But this will have to be prepared anew for every individual case. Whether the CG-artist actually wants to spend his or her time in doing that (an educational task, after all) is a pertinent question.

Suitably experienced curators might be able to help here and in other cases of CG-art as well. They might assist in, or even take over, the task of providing a gallery-friendly description of what the program is doing and how. Specialist curators, constantly showing CG-art, might even amass a collection of items—such as posters—that could be used for several different exhibitions. A curator of a normal gallery, one not dedicated to computer art, is unlikely to be able to fill this role. But there might be roving curators, people able to give advice to artists or galleries when the artists are loath to do the job themselves.

Sometimes computer artists will seek feedback from their gallery audience (see chapter 8). This is usually done in the hope of improving early versions of the artwork, taking the audience's reaction into account—and thereby enabling the audience to be creative participants at one remove (Muller, Edmonds, and Connell 2006). One place where this happens regularly is in the permanent Beta Space section at Sydney's Powerhouse Museum (Turnbull, Connell, and Edmonds 2011; Turnbull and Connell 2014, 221–228).

A rather different type of audience engagement could help the visitors understand, and so better appreciate, the artwork they are experiencing. Much as children visiting galleries or museums are often given printed quizzes or questionnaires designed to encourage them to focus on certain aspects of the artifacts being displayed, so adults

confronted with computer art might be given handouts designed to guide their thoughts to the specific *whats* and *hows* of the art concerned. This could become a routine practice not only in designated Beta Spaces (the answers on the handouts might be helpful to the CG-artists in the future development of their work) but also in CG-art exhibitions in general.

Not all CG-art is displayed in galleries, of course. Some of it, especially the interactive variety, is found in streets and city squares. Usually, such art is commissioned by governmental or commercial institutions (Turnbull and Connell 2014, 228–240). The artists and organizers of CG street art face an added difficulty. Not only may there be no convenient wall available for explanatory material but the whole point may be to give the unsuspecting pedestrian an ephemeral surprise to be experienced in passing, not an art system or artifact to be contemplated at length. Rabbits out of hats, perhaps.

4.7 Conclusion

CG-artists may be forever doomed to elicit only a shallow appreciation of their work, responding strongly to the surface aspects but with little or no recognition of the skills involved in their art making. Certainly, they face that obstacle today.

As we have seen, this tendency can be countered in several ways. But most of them risk confusing art with education—an education full of unwelcome abstractions, at that.

Moreover, education will never release them entirely from having to borrow the mantra of philandering husbands everywhere: "My wife [audience] doesn't understand me!" Traditional artistic skills will always remain more accessible than those underlying CG-art.

All human beings can understand the basic aspects of painting, carving, sewing, and sculpting. Culturally ancient crafts and body arts, as well as the more historically recent (and culturally specific) fine arts, exploit those skills in familiar ways. And all of us can readily learn more about them if we wish, either by practicing them as increasingly competent amateurs or by reading about them in the works of art historians or teachers of art. The skills applied in computer art are different. Even if all children were introduced to programming at an early age, the expertise required would be both less visible and less easily intelligible than the familiar handcrafts that most of us—like Ruskin (and largely following Ruskin)—value so highly.

All is not lost, however. After all, most lovers of traditional art are hugely ignorant of the technical details involved but can respond deeply nonetheless. People faced with CG-art can respond to it deeply too. Indeed, they can be transfixed by it in ways that

simply are not available in traditional art (remember the *Mimetic Starfish*). Knowledge of the computing skills involved can certainly add to the experience, but a valuable aesthetic response can occur without it.

In short, the audience does not *have* to know the recipe. So maybe the most appropriate—or anyway, the most realistic—injunction for CG-art audiences is the one given by cheerful waiters in down-market bistros, simply "Enjoy!"

References

Boden, M. A. 2004. *The Creative Mind: Myths and Mechanisms*. 2nd ed. London: Routledge.

Boden, M. A. 2007. "Creativity and Conceptual Art." In *The Philosophy of Conceptual Art*, edited by P. Goldie and E. Schellekens, 216–237. Oxford: Oxford University Press. Reprinted in M. A. Boden, *Creativity and Art: Three Roads to Surprise*, 70–91. Oxford: Oxford University Press, 2010.

Boden, M. A. 2010a. "Autonomy, Integrity, and Computer Art." In *Creativity and Art: Three Roads to Surprise*, 175–192. Oxford: Oxford University Press.

Boden, M. A. 2010b. "Personal Signatures in Art." In *Creativity and Art: Three Roads to Surprise*, 92–124. Oxford: Oxford University Press.

Brown, A. R., and A. Sorenson. 2009. "Interacting with Generative Music through Live Coding." *Contemporary Music Review* 28 (1): 17–29.

Brown, R. 2000. *Mimetic Starfish*. Video available at www.mimetics.com/starfish.

Colton, S. 2012. "The Painting Fool: Stories from Building an Automated Painter." In *Computers and Creativity*, edited by J. McCormack and M. d'Inverno, 3–38. Berlin: Springer.

Cornock, S., and E. A. Edmonds. 1973. "The Creative Process Where the Artist Is Amplified or Superseded by the Computer." *Leonardo* 6:11–16.

McCorduck, P. 1991. *AARON's Code: Meta-Art, Artificial Intelligence, and the Work of Harold Cohen*. New York: W. H. Freeman.

Muller, L., E. A. Edmonds, and M. Connell. 2006. "Living Laboratories for Interactive Art." *CoDesign: International Journal of CoCreation in Design and the Arts* 2 (4): 195–207.

Reichardt, J., ed. 1968. *Cybernetic Serendipity*. London: Studio International.

Ruskin, J. 1854. "On the Nature of Gothic Architecture: And Herein of the True Functions of the Workman in Art." In *The Stones of Venice*, vol. 2, *The Sea-Stories* (London: Smith Elder): chap. 6.

Ruskin, J. 1875. *Deucalion*. In *The Complete Works of John Ruskin*, edited by E. T. Cook and A. Wedderburn, 26:95–360. London: George Allen.

Sims, K. 1991. "Artificial Evolution for Computer Graphics." *Computer Graphics* 25 (4): 319–328.

Todd, S. C., and W. Latham. 1992. *Evolutionary Art and Computers*. London: Academic Press.

Turnbull, D., and M. Connell. 2014. "Curating Digital Public Art." In *Interactive Experience in the Digital Age: Evaluating New Art Practice*, edited by L. Candy and S. Ferguson, 221–242. New York: Springer.

Turnbull, D., M. Connell, and E. A. Edmonds. 2011. "Prototyping Places: Curating Practice-Based Research in a Museum Context." In *Proceedings of Rethinking Technology in Museums 2011*. University of Limerick, Ireland, 203–214.

5 Can Evolutionary Art Provide Radical Novelty?

Margaret A. Boden

5.1 The Question

Many computer artists engage in evolutionary art, or Evo-art, in the taxonomy of chapter 2. They include Jon McCormack, Karl Sims, William Latham, Ashley Mills, Lise Autogena, and Joshua Portway (for others, see Whitelaw 2004; Romero and Machado 2007). Rather than relying on symbolic artificial intelligence (AI) programming techniques, as Harold Cohen (for example) does, they draw on A-Life (artificial life) methods inspired by evolutionary biology.

A-Life *scientists* employ several very different computational methods, including cellular automata, situated robotics, and genetic algorithms (Boden 2006, chap. 15). And artists inspired by A-Life use all these, as is clear from Mitchell Whitelaw's (2004) wide-ranging interviews with this community. But our interest here is in artworks produced by evolutionary methods. More accurately, our interest is in *the creative potential of that general class* of artworks.

Evo-artists work with programs containing self-altering rules—genetic algorithms, or GAs (Boden 2006, 15.vi). They rely on the GAs to effect random mutations in the code that generated the current artwork. Then, they select the preferred items from the descendants for use as parents of the next generation—continuing, perhaps, for many hundreds of generations.

Although the variations are generated by the program itself, the selection is usually done by the human artist or sometimes by the audience, in the gallery or on the Internet (e.g., Graham Nicholl's *Living Image*). That is because it is not normally possible to express aesthetic values clearly enough for them to be stated as an automatic fitness function.

A few Evo-artists do employ automatic selection, because the evolution is not driven by aesthetic criteria. For instance, Autogena and Portway's *Black Shoals Stock Market Planetarium*, which was exhibited—and evolving—for three months at Tate Britain in

2001, is an artificial ecosystem whose evolving creatures adapt their behavior to real-time financial input from stock markets.

The types of mutation that are allowed vary from case to case and are decided by the human artist. The general types of change, then, are broadly predictable (although *which* type will be seen next is unknown). But the actual variations are not. Often, they surprise even the originating artist. And the more fundamental the types of mutation that are allowed, the more unpredictable the observed results will be.

So much is beyond dispute. What is much more controversial is whether these mutations and variations could ever be *truly* radical. Could they do more than merely tweak the current style (the current program)? Could they ever jump from one style into a fundamentally new one? Could Evo-art go beyond highly unpredictable exploratory creativity to achieve radically transformational creativity (Boden 2004)? Or is that a capacity enjoyed only by human artists?

If it is, then the lack of interest in computer art that is shown by most of the art world, as described in chapter 3, would be largely justified. Besides their skepticism with respect to computers and emotion (see chapter 6), most people think that computers could not come up with anything interestingly new.

It would be possible, of course, for a human artist to transform a style and then express the new (post-transformation) style in an Evo-art program—which could proceed to tweak and explore it. Indeed, a process of successive transformations effected by the originating artist can already be seen in the versions of Cohen's (nonevolutionary) AARON program, each of which draws in a recognizably different style (McCorduck 1991; Boden 2004, 150–166, 314–315). But the question here is whether the program itself could do this. Can computer art and, in particular, Evo-art provide radical creativity *on the part of the computer*?

More accurately: Can computer art at least *appear* to provide radical creativity? As explained in chapter 1, whether this would count as real creativity is a philosophical issue that is here ignored (but see Boden 2004, chap. 11; 2014).

Most people seem to believe that the answer is obviously no. Given a style, they may admit, a computer can explore it. But if you want it to come up with a new style, don't hold your breath! After all, they say, a computer does what its program tells it to do—and no more. The rules and instructions specified in the program determine its possible performance (including its responses to input from the outside world), and there is no going beyond them. Those rules and instructions can change as a result of GAs. But because the initial Evo-program includes specifications of the GAs, those changes themselves lie within its computational power. Going outside the limits set by the program is therefore impossible. So radical creativity simply cannot happen, QED.

We see later that this assumption is too quick. In principle, Evo-art can offer radical transformations. Why it does not do so every day is another question, discussed briefly in section 5.5. First, let us ask why artists choose to do Evo-art in the first place; more specifically, whether they do so in the hope of arriving at radical stylistic change.

5.2 Why Do Artists Choose to Do Evo-art?

There are three main reasons why some computer artists have decided to use this particular A-Life technique. First, they may want to celebrate the marvel of life itself. That this is a common justification is clear from interviews with many Evo-artists (Whitelaw 2004).

A few of these life-celebrating Evo-artists go even further. They have been inspired by the handful of maverick A-Life scientists who hope to create life in computers. They see their own efforts as linked with, even contributing to, this general project. In other words, some Evo-artists believe in the possibility of life in cyberspace: virtual life, or strong A-Life.

However, they are mistaken. Briefly (for a full discussion, see Boden 1999), the reason they are mistaken is that metabolism is a criterion of life, and computers do not metabolize. Metabolism is a form of self-organization that cannot be understood in purely computational terms but only by reference to physical energy. Computers consume energy, of course. But metabolism in living organisms is the self-creation and maintenance of a physical unity (the cell or the body) by means of interlocking biochemical cycles of some *necessary* complexity. There is none of that in computers.

So the idea that Evo-art could be a first step on the road to virtual life is misguided. It does not follow that art inspired by this fond hope is aesthetically worthless. After all, even atheists can appreciate a *Madonna* or a *Pieta*. But one does have to know about these (few) Evo-artists' faith in virtual life—just as one has to know about the Renaissance artists' faith in the scriptures—to understand what they are up to.

The second reason for getting involved in Evo-art is to piggyback on the creative power of biology. Biological creativity, whether in evolution or the developing embryo, differs from what is normally meant by creativity. Unlike artistic (or scientific) creativity, it does not generate ideas or artifacts. Nor is it goal driven—still less consciously monitored. But it does produce structured phenomena that are new, surprising, and valuable.

"Valuable", here, does not mean valuable *to us* but valuable in terms of the likelihood of survival or of finding a mate. Sometimes biological evolution does favor structures that are highly valuable to us—the male peacock's tail, for example. And in that

case, the feathers we find so extraordinarily beautiful are attractive also to the peahen (although not necessarily with respect to exactly the same visual features). But there are many biological structures, evolved because of their value for survival or attracting mates, that most humans find uninteresting or even repulsive. This can act as a reminder that what humans are willing to count as valuable can be highly problematic, not least in art (see section 5.6).

GAs mimic the creative power of Darwinian evolution, being modeled on the sorts of mutations that happen in living organisms. Biological evolution results from many small changes, not sudden saltations. A-Life simulations have proved that the saltations sometimes observable at the phenotypic level—so-called punctuated evolution (Eldredge and Gould 1972)—can be produced by a gradual accumulation of small changes at the genetic level. Very few, if any, of those individual (genetic or phenotypic) changes count as *transformations*. Even small mutations can be damaging for a living organism, and larger ones are very likely to be lethal. Nevertheless, over a vast period of time, the evolutionary process has delivered an unimaginable variety of flora and fauna, many of which we find delightful.

It is not surprising, then, that some computer artists have sought to enrich their work by means of evolutionary programming. Indeed, there is even more likelihood that GAs will produce a fair proportion of acceptable (that is, nonlethal) changes than that biological mutations will do so. The products of Evo-art are not subject to the many fierce constraints posed by metabolism, food supply, climate, and predator-prey ecology.

In short, the second reason for getting involved in Evo-art is well founded. It is entirely reasonable to expect that Evo-art will often produce aesthetically acceptable novelties, including many that could not even have been imagined, still less anticipated, by the human artist concerned. What is more, that expectation has already been satisfied on countless occasions—for instance, in the work of the Evo-artists previously named.

The third reason for doing Evo-art follows on from the second. It is the hope that truly radical stylistic change might result, as has often occurred in the evolution of life. If that were to happen, then computer art would have achieved a strong form of originality: transformational creativity, comparable to that celebrated in histories of art. Not a new style to compare in value with Giotto or Pablo Picasso, perhaps. (Then again, why not?) But not mere run-of-the-mill exploration or even modest tweaking, either.

Not all Evo-artists cleave to that third reason. Indeed, most of them allow only relatively superficial changes. Their seeming lack of adventurousness is grounded in the fact that—like most artists, most of the time—they have found a style that interests them and are content to explore it. Occasionally, they may switch to a different style,

but then they devote their effort to exploring that one. Moreover, as professional artists they are usually happy for their Evo-art work to display their personal signature (Boden 2010) and so consolidate their professional reputation. (An interesting exception is discussed in section 5.5.) The Evo-artist Latham, for instance, generates images that, despite their literally unimaginable variations, are instantly recognizable as *his* (Todd and Latham 1992).

Even if an Evo-artist does start out partly inspired by this third reason—that is, the hope for radical stylistic transformations—he or she will very likely be disappointed. An artistic style is a sustained pattern of activity. If radical mutations, and therefore huge structural changes in the phenotypic image, are possible at every generation, no pattern will be sustained for long. There will often be no visible family resemblance between ancestors and descendants, even if they are separated by only one or two generations. To give a biological analogy, it is almost as though a cat had given birth to a puppy or a fish or even a buttercup.

This is evident in Sims's (1991) work, wherein the mutations include nesting one entire image-generating program inside another or concatenating two such programs. These radical changes can occur on many hierarchical levels and so may produce programs or images of significant complexity. The system has been exhibited at the Pompidou Centre and elsewhere around the world. The gallery visitors are initially amazed and fascinated by the transformations taking place before their eyes. But they soon become bored and frustrated, precisely because of the unsatisfying lack of sustained stylistic exploration. When they try (by choosing the parents for the next generation) to steer the system toward certain colors or shapes, they are rapidly disappointed: sooner rather than later, unwanted features will appear and previous advances will be lost. This is exasperating for anyone seriously interested in the aesthetics of the evolving images. For artistic purposes, the program is *too* transformational. It is surely no accident that Sims is not a professional artist seeking to advance his oeuvre but a computer scientist concerned to show the potential of evolutionary technology.

So the third reason for engaging in Evo-art is something of a poisoned chalice. There is an antidote for this poison, however. Namely, the third-reason Evo-artist could choose to freeze the program on its attainment of an especially interesting or attractive image and then go on to explore the stylistic possibilities inherent in that. Evo-art techniques might still be used, but these *would not* now allow mutations as radical as those that enabled the system to come up with the favored transformation in the first place. This schedule of work would mirror the activity of mainstream artists, who—as suggested earlier—normally follow transformation, if they ever achieve it at all, with

exploratory consolidation of the new style. Consider, for instance, the chronological sequence evident in a retrospective exhibition of a highly transformational painter such as Picasso.

This antidote to the "poison" threatening third-reason Evo-art suggests that our key question can be restated. Instead of asking whether Evo-programs could ever generate radically new *styles*, we can ask whether they could generate radically transformed *structures*, which might then be explored (with or without GAs) so as to found a new, sustained style. Prima facie, this appears to be possible; Sims's work is enough to show that.

One might ask whether it would be possible for Evo-art to achieve *stylistic* transformation directly if radical mutations were allowed that were not as unconstrained as Sims's are but that were more adventurous than Latham's. For example, suppose a GA technique could lengthen the programmed genome (as Sims's system can) but do so more gradually. Lengthening the genome is potentially radical because it enables greater structural complexity in the resulting image. In biology, to be sure, length of genome does not neatly match morphological complexity: some lowly creatures have many more genes than we do. Nevertheless, organisms that are more complex do tend to have more genes, which allows for a greater variety of gene-gene interactions. In other words, longer genomes can provide an explosion in the possibility space.

A GA technique like that just suggested was developed more than twenty years ago. Inman Harvey's (1992) SAGA (Species Adaptation Genetic Algorithm) varies the length of the genome in a gradual—and therefore relatively sustainable—manner, enabling (as he puts it) new "species" as well as new varieties to arise. So perhaps SAGA could lead third-reason Evo-artists to a sustained stylistic transformation, not just to a single structural transformation?

The many SAGA-evolved forms that already exist include some impressive quasibiological examples. One is a simple feature detector in a robot's "brain," broadly comparable to the orientation detectors found in visual cortex (Harvey, Husbands, and Cliff 1994; Husbands, Harvey, and Cliff 1995). This mini-network, which is sensitive to a light-dark gradient at a particular orientation, evolved unexpectedly from a controller network whose connections were initially random.

One can say that it was *evolved by* the GA, not merely (like Sims's surprising images) *generated* by it, because all its robot ancestors were automatically selected by the same fitness function. This was intended by the programmers to result in the ability to navigate within a toy environment. That environment happened to contain a white cardboard triangle, and the feature detector evolved as part of an adaptive visuomotor mechanism. Connections to visual and motor units within the whole network enabled the robot to

use the triangle as a navigation aid. This ability, once it had emerged, was selected and maintained by the fitness function.

At first sight, then, this example proves that GAs can indeed provide radical novelty. But the skeptics whose argument is summarized at the end of section 5.1 may disagree. In particular, those critics who take the biological inspiration for evolutionary programming seriously may still insist that GAs cannot get beyond exploratory creativity. Even varying the length of the genome, they will say, does not avoid the problem. For the possibility space, albeit huge, is still inherently fixed by the program.

Nor is the problem avoided, some objectors say, by human intervention at the stage of selection, as happens in almost all Evo-art. It is true that such intervention can vary the fitness function (which is rarely explicit anyway), whereas an automatic fitness function, like the one used in evolving the orientation detector, is fixed. This is relevant because biological fitness functions change too as evolution proceeds. But even interactive Evo-art, these objectors would insist, is limited by the initial program, so that truly transformational creativity is impossible.

Third-reason Evo-art, on this view, is doomed. In section 5.5, we see that this common objection is misguided and that the significance of the white cardboard triangle in the robots' playpen was not fully appreciated.

But first, we must ask how biology, and also human artistry, manages to produce radical changes. If we understood that, we might—despite the seemingly cogent objection previously outlined—be able to achieve genuinely radical (third-reason) Evo-art after all. We consider biology in section 5.3 and artistry in section 5.4.

5.3 Open-endedness and Openness in Biology

Biological evolution exemplifies transformational creativity whenever it generates forms radically unlike what existed before: vertebrates from invertebrates, for instance. Such morphological changes are deeper, more surprising, than mere iterations such as segmentation, wherein a structure is repeated many times without significant variation; think of millipedes and earthworms or the vertebrae and spinal nerves of human beings. They are also deeper than slight improvements in preexisting functions, such as those that enable creatures to run a little faster or to see a little better than their parents.

For example (as skeptics regarding GAs often point out), biological evolution has resulted many times in fundamentally new types of sense organs. Besides producing *improved* eyes, ears, and noses, it has created *first-time* eyes, ears, and noses. And, of course, it has generated new types of communication and representation, including (in

Homo sapiens) language and thought. These are all examples of what is meant by saying that biological evolution is open ended.

As we have seen, it is not obvious that evolutionary A-Life can do the same sort of thing. Are the transformations produced by GA programs really transformations at all? Or are they merely deceptively impressive cases of exploratory creativity, in which the possibility space being explored has been implicitly predefined by the programmer? This issue worries not only skeptics about Evo-art but also the scientific A-Life community. Indeed, they have identified open-ended evolution as the most important of fourteen grand challenges for the field (Bedau et al. 2000; Rasmussen et al. 2003).

An enthusiast for Evo-art might reply by saying that, likewise, an organism's DNA (plus the mechanisms of meiosis) defines a set of possibilities. So if DNA genomes can create genuine novelties, why not artificial genomes?

The answer often given by critics of GAs is that *embodiment* and environmental *embeddedness* are crucial. That is, biological form does not result only from DNA, which exists in a richly varying physical environment that can affect it in unpredictable, evolutionarily fruitful, and sometimes even transformative ways. It follows, on this view, that purely programmed A-Life (and by implication Evo-art) cannot give us what we want—namely, genuine transformations. Only physical models could do that.

This is now an increasingly popular position within A-Life circles, but it dates back to an A-Life pioneer of the mid-twentieth century (Ashby 1952; Boden 2006, 4.viii.c–d). William Ross Ashby's "law of requisite variety" stated that the variety in a system's regulator must be at least as great as the variety in the system being regulated. So if the system is to outstrip the possibilities inherent in its regulator, it must be *informationally* open. That is, it must be capable of being affected by events that were not specified within the regulator.

There is a potentially confusing pun here. The *open-endedness* of an evolving system is its ability to come up with radical novelties of many different kinds. That is different from its *openness* to information from outside the system itself. Openness to external influences is what the general systems theorist Ludwig von Bertalanffy (1950, 1962) had in mind when he contrasted closed and open systems—although he spoke of openness to energy and physical causation rather than information.

Although the two notions are distinct, they are closely related. The first is made possible by the second. Open-endedness of evolution, as we will see, depends on informational openness in the members of the evolving population. However, the reverse is not true: informational openness need not result in open-endedness. That is why, even though all organisms are open systems, not all biological evolution is transformational. If the external events in question are of a type to which the organism is already

adapted, then evolution is likely to be more a matter of incremental or exploratory improvement than of radical transformation. But if they are not, then open-ended evolution may come into play, and the irrelevant may suddenly become relevant.

To a species without light sensors, for instance, light is irrelevant. Nevertheless, given some fortuitous mutations, it may turn out to be highly relevant, leading to the emergence of sensory capacities of a radically new kind.

Specifically, some mutations must occur within the creature such that new molecules are generated that are sensitive to light and are near enough to the surface of the creature to receive light. However, that is not enough for even the crudest form of vision. In addition, the photochemical changes must affect other molecules, eventually resulting in changes that have survival value for the organism. Suppose, for example, that the molecules generated at some point in the chain of light-triggered chemical reactions were to stimulate the motor organs, causing movement toward or away from the light. This could bring the animal within reach of better food or a safer hiding-place. In that case, natural selection could take over to maintain—and, given further mutations, even to improve—the new sensor. (For fascinating accounts of the evolution of various types of eyes, see Cronly-Dillon 1991; Land and Nilsson 2001.)

In this context, the robotic minicontroller whose evolution is described earlier is an interesting case. Strictly speaking, perhaps, it should not be counted as the evolution of a wholly new sense organ, because it started off with some very simple photoreceptors. But it did evolve a wholly new sensorimotor circuit and an equivalent behavioral capacity. Initially, its light sensor had purely random connections to any motor neurons. The new sensorimotor circuits were able to evolve only because the robots' environment happened to contain a piece of white cardboard, one of whose edges happened to match an angle of light-dark contrast to which the photoreceptors could respond.

So openness is crucial for open-ended evolution. And this applies to evolutionary programs no less than to biology. Indeed, Ashby explicitly applied his law of requisite variety to both natural and artificial systems. Admittedly, he was thinking of physical artifacts (as in his Homeostat), not of computer programs. But the same principle applies.

Where the regulator is DNA (plus natural selection), physical interactions with external events can sometimes prompt radically new senses and forms of behavior, which can then be honed and improved by further adaptations. Where the regulator is a program, informational openness would be satisfied if—analogously—the physical states of the system being regulated by the program were sometimes affected by causal interactions with physical events in the external world. Some of these might appear, beforehand, to be utterly irrelevant to any potentially adaptive change in the system concerned. But if

they satisfied the fitness function being used by the program, they could be maintained (and even improved) likewise.

The problem with (most) artificial evolution, then, is not that the system is artificial but that it is informationally closed. Artificial systems that *are* open to environmentally triggered change may show transformations that are truly radical.

This was exemplified half a century ago by the exceptionally creative cybernetician Gordon Pask (1959; Fernandez 2008; Boden 2006, 4.v.e). One of his evolutionary chemical machines grew threadlike crystalline structures—dynamically balanced between the deposition and re-solution of ions—supposedly analogous to concepts because they could discriminate sounds of different pitch (fifty or one hundred hertz), or the presence or absence of magnetism, or differences in pH level. These chemical threads were not *initially designed* to discriminate pitch (or magnetism or pH) but *naturally arose* in a way that made this discrimination possible. They were a primitive example of the self-organization of *new* perceptual abilities, creating *new* perceptual dimensions, which happens from time to time during phylogenetic evolution (Cariani 1992, 1993, 1997).

In recent decades an A-Life experiment unexpectedly led to a comparable result. Jonathan Bird and Paul Layzell (2002), to their amazement, found themselves confronted with a primitive radio antenna (a radio wave sensor) that picked up and modified the background signal emanating from a nearby PC monitor. They had been using a technique for evolving circuits in hardware (Thompson 1995) to evolve an oscillator, not a radio. But to their surprise, some of their devices exploited unconsidered or accidental aspects of the physical environment to produce radio reception and seemingly irrelevant features of the environment had unexpectedly become relevant.

These aspects would never have been specified in a program that was *intended* to evolve a radio antenna. They included the aerial-like properties of printed circuit boards, the proximity of the PC, the order in which the analogue switches had been set, and a soldering iron left on a nearby workbench that happened to be plugged in.

This is a mixed bag. Bird and Layzell concluded (2002, 1841) that the open-ended evolution of novel sensors requires a physical device, whether natural or artificial, whose primitives are sensitive to a wide range of environmental stimuli; not just light (which in this case remained irrelevant) but many other physical properties too. If the specific physical situation in which this research was done had been slightly different, arcane chemical properties of the paint on the surrounding wallpaper might have played a role.

Informational openness has contributed to transformative biological evolution and to some artificial versions too. In all cases, this evolution has occurred entirely within the *overall* possibility space. But the skeptic cannot therefore argue that there is no genuine novelty involved. Any novel structure, whether biological or not, is made possible

by—and constrained by and confined within—the totality of preexisting conditions, environment included. That is just to say that creativity does not happen by magic. Creation ex nihilo is an illusion, but creativity is not.

We have seen that artificial evolution can sometimes emulate biology's power to originate (e.g., sense organs) as well as to improve. But in the cases described so far, it does so by physical interaction with the environment. That is not normally attempted in Evo-art. Indeed, it is not normally possible, because Evo-art's evolution usually occurs in cyberspace. If Evo-artists really want to generate radical change, will they have to arrange for *physical* interactions too? Will they have to forsake pure programs, turning instead to electronic circuitry or robots?

Before we can answer that question (in section 5.5), we must ask (in section 5.4) whether *art in general* achieves its transformations as a result of physical influences from outside. Have the radical novelties found in painting, music, or literature arisen thanks to serendipitous physical interactions—like those that took place in Pask's glass containers, in Harvey's robot's environment, or on Bird and Layzell's laboratory bench?

If so, then presumably third-reason Evo-art would have to do likewise: Evo-art *only* as evolutionary robotics. But if not, then not. Evolution in cyberspace, with not a robot in sight, could suffice.

5.4 Openness in Art

For members of *Homo sapiens*, the environment is not only physical and biological but sociocultural too. Some of the external factors that affect the organism—or better, the organism's mind, the person—are driven by or cause physical events that implement or are interpretable as *thoughts*. Consider Marcel Proust's memory-triggering madeleine, for instance, or Immanuel Kant's being (as he put it) "awoken from [his] dogmatic slumbers" by reading David Hume.

It may seem unlikely that a *merely physical* stimulus could lead to interesting (valuable) changes in art. But there are some examples. It is fairly common, for instance, for sculptors to be strongly influenced by uncovering hidden veins in a block of marble. In general, art involves stigmergy: changes in the overall plan that are prompted by unexpected events during its execution (Harrison 1978). Those events are sometimes psychological in nature, a remark made by a bystander, perhaps. But often they are intrinsically meaningless physical features (like veins in marble) that are interpreted by the human artist as semantically or aesthetically significant.

Some such cases involve transformational creativity. Proust's madeleine is one example: the ingesting of the cake triggered a host of memories and productive thoughts in Proust's mind, which led in turn to a radically new form of novel writing. Another

concerns a jazz drummer with Tourette's syndrome (Sacks 1985), who was a fine enough musician to be able to use the random noises caused by uncontrollable tics in his hands as the seeds of improvisations that *could not* have happened otherwise. And it is highly probable that some of the deeply surprising (transformationally creative) leaf arrangements and ice sculptures created by the artist Andy Goldsworthy were grounded in his serendipitous perceptions of fallen leaves or melting ice in their natural state.

As for scientific creativity, think of Alexander Fleming's accidentally abandoned petri dish. The unexpected physical stimulus (the clear areas visible in the dish) led him to infer that there might be a bactericidal substance there—the very first to be discovered. Even Friedrich von Kekule's chemically revolutionary benzene ring, according to his own report many years later, was triggered by the specific shapes of flames dancing in his hearth (Boden 2004, 25–28, 62–71).

Clearly, then, the various forms of unpredictability that characterize creative thought (Boden 2004, chap. 9) include some serendipitous events that are physical rather than meaningful. However, we must remember Louis Pasteur's observation that "fortune favors the prepared mind." Only a highly accomplished jazz drummer could see how to relate random taps to musically meaningful schemas for improvisation. Similarly, only an expert chemist, already aware that the relations between neighboring atoms within a molecule are important, could see the potential chemical relevance of a topological change from string to ring. In other words, the physical event must be *understood as* meaningful or *assimilated into* meaningful schemas if it is to have its creative effect.

Typically, however, the unexpected stimuli that lead to creative thought—whether transformational or not—are "thoughts" themselves. (This term is enclosed in quotation marks because it includes thoughtfully produced artifacts, such as paintings or music, as well as purely conceptual examples.) Remember Hume's "awakening" of Kant, again. Or think of Henry Adams's (1918) highly creative response to the contrasting artifacts he encountered in the cathedral and the turbine hall.

Some of these thoughts come into the mind from the external world: other people's remarks, sentences read in books, items heard in concert halls, or sights seen in art galleries or turbine halls or even fireplaces. Their transformational effect in the relevant person's mind may be almost immediate (recall Kekule's reaction "But lo! What was that?" on seeing two flames suddenly linking themselves together). Alternatively, they may be stored away in the recesses of the memory, to be resuscitated only when the relevant creative process (the painting, poetizing, composing, theorizing, and so on) gets under way.

Yet other creativity-triggering thoughts come not from the external (physical or sociocultural) world as such but from that part of the person's internal world that

appears to be *external to the specific task in mind*. They are generated within the person's own mind or brain on the basis of already existing thoughts and mental associations, many of which would previously have been regarded—even by the artist—as utterly *irrelevant* to the artistic project in question.

These thoughts and mental associations include highly general combinational principles (such as synonymy, antinomy, and superordination) and exploratory and transformative heuristics (such as iteration and consider the negative). But even in those cases, previous *outside* influences—the person's past social interactions, education and reading, and cultural experiences in general—are crucial.

In brief, human minds are open systems. And what they are largely open to are thoughts. No man, after all, is an island—and no man's memory, either. Our language and cultural communication are guarantors of that.

5.5 What Sort of Openness Does Radical Evo-Art Need?

The implication of section 5.3 is that if Evo-art were to produce artworks existing in the physical world—robots, for instance (R-art, in the taxonomy of chapter 2)—then it might show true open-endedness. Indeed, critics who take biological embodiment especially seriously would probably say that any truly radical (third-reason) Evo-art *must* be a subclass of R-art.

The implication of section 5.4, however, is that physical openness is not strictly necessary for artistic open-endedness. Radical Evo-art could also result if the program were open to semantically interpretable representations from outside or to internally generated representations (thoughts) that are prima facie irrelevant. And if *nonevolutionary* computer art were open to a semantic environment, it too could avoid being trapped inside the space of possibilities defined by the program.

Let us consider these implications in turn.

It might seem revolutionary to recommend that Evo-art turn toward physical artifacts such as robots, given that R-art is only a small corner within C-art as a whole. It would be better, however, to call it counterrevolutionary. The seminal *Cybernetic Serendipity* exhibition, held in London nearly fifty years ago, was dominated by a bevy of simple robots (Reichardt 1968, 2008; Fernandez 2008). That was before the development of hugely powerful general-purpose computers, not to mention computer graphics. Today, thanks to those technological advances, relatively few C-artworks are robotic.

Even fewer are both robotic and evolutionary. One such example, however, is especially interesting here. The C-artist Paul Brown, who was awakened to the artistic potential

of computers by his visit to *Cybernetic Serendipity*, has been trying for many years to lose his personal signature.

An artist's personal signature is not his or her autograph on the canvas but consists of a range of features, including many of which the artist is not even conscious, that make the artwork recognizable as having been done by *that* individual. Personal signatures exist because of the need for computational efficiency in human minds (see Boden 2010). So Brown is an exception to the generalization made in section 5.2 that professional artists want to preserve, and even highlight, the characteristic individuality of their work. The reason lies in his commitment, as a very young man, to the impersonal program of modernism—which attracted him (and Ernest Edmonds; see chapter 9) to computer art in the first place.

Thus far, he has not succeeded in doing this. To the connoisseur of C-art, Brown's work is still instantly recognizable as *his*. Simply using computers (usually to generate cellular automata) has not enabled him to bypass his own psychology. So he recently decided to set up a project in Evo-art in which—because of the random mutations—the results would not be entirely under his control. Specifically, he hoped to evolve pen-carrying robots to draw aesthetically acceptable marks, drawings that *would not* betray his authorship as the originating artist.

This example counts as R-art, wherein robots are used for artistic purposes. As explained in chapter 2, however, it is an unusual case. The aesthetic interest here is not in the robots themselves but in the drawings made by them.

Of course, he would be the arbiter and designer of the (automatic) fitness function. So it might turn out that even these robot-drawn marks would betray Brown's idiosyncratic style. Then again, it might not. The more that our aesthetic preferences are rooted in very low-level visual features, perhaps even in biologically inherited perceptual mechanisms, the more likely that culturally and personally idiosyncratic preferences are not *necessary* for positive aesthetic valuation. The extent to which this is so is an empirical question, whose answer is unknown (Boden 2010).

The reason Brown used robots, instead of evolving images in cyberspace, was not mere gimmickry or a fascination with intriguing gizmos. Rather, it is the issue explored in section 5.3. The robots would be physical things moving in a physical world and therefore open to factors such as friction (between pen and paper or wheels and floor), temperature (affecting the density of the ink on the pen), and obstacles (causing the robot to stop or to move away from or around the impediment). Thus, seemingly irrelevant physical contingencies (such as a soldering iron's being plugged in) might become relevant, by producing features in the drawings that were then selected by the fitness function. With luck, this openness to external influences might result in a radically

transformed style, wherein—at last—Brown's personal aesthetic preferences were not identifiable.

Thus far, Brown's R-art project has not progressed long enough to see whether he can succeed in losing the mark of his own hand in the robots' drawings. (Early reports on the work are given in Bird, Bigge, et al. 2005; Bird, Husbands, et al. 2008; Bird and Stokes 2006a, 2006b, 2007; Brown et al. 2007; Stokes and Bird 2008.) For present purposes, however, Brown's (modernist) self-negating aim is irrelevant. More to the point is whether the evolved robots will be able to draw aesthetically acceptable marks. If they can, Brown would have shown that an *automatic* fitness function can sometimes suffice for artistic success. Even more to the point, he would have shown that third-reason Evo-art can—as implied by section 5.3—be achieved by focusing on *physical* openness.

Now, let us turn to the implications of section 5.4. The first thing to note is that we do not need to be overly literal in our interpretation of "interpretation." Just as we need not ask whether computers can really be creative, so we need not ask whether they can really interpret representations as having meaning. Indeed, the latter question concerns one of the highly controversial philosophical issues that, as remarked in chapter 1, underlie the former question. For our present purposes, the mere *appearance* of semantic interpretation on the part of the computer will suffice.

A C-art program that was open to semantically interpretable or aesthetically significant representations from outside might take them directly from some human being. That is what happens in interactive computer art (CI-art, in chapter 2 terminology) including virtually all Evo-art, in which the selection at each generation is done by artist or audience. So the objection given at the end of section 5.2 is misguided. Any CI-art program is, by definition, an open system. Although the CI-artworks it generates are indeed limited by it, they do not result from the program alone.

But that does not address the basic worry here, which is that an *unaided* C-art program could never generate radical stylistic transformations. What are we to say about that?

A C-art program that was open to outside (semantic) influences might be able, for instance, to trawl the web, maybe even searching for texts, music, or images that could turn out to be helpful for the task at hand. Some current (nonevolutionary) computer art incorporates items taken randomly from the Internet so as to increase the unpredictability of the artwork. Examples include Christa Sommerer and Laurent Mignonneau's installation *The Living Room* (see chapter 2).

Future C-art programs might also be able to communicate with other programs carrying out broadly comparable tasks but with a different educational or cultural

experience. In addition, to satisfy the implication regarding internally generated representations (thoughts) that are prima facie irrelevant, the C-art program might spend its downtime in generating novel representations in a relatively unconstrained manner for possible use in as-yet-unforeseen creative tasks. Similarly, future versions of the machine-discovery programs described in chapter 3 might, as suggested long ago by the AI researcher Herb Simon, be able to read and learn from scientific papers, as human scientists can (Langley et al. 1987).

This is a tall order. If C-art programs are ever to respond fruitfully—and sometimes transformationally—to serendipitous thoughts rather than predetermined keywords, or to accidentally encountered musical structures or techniques rather than canned note sequences, or to meaningful images rather than simple lines and curves, huge progress will be needed in AI. Specifically, this will require significant advances in research on associative memories, recognition of analogy, natural-language processing, computer vision, musicology and comparable domain-specific studies, and knowledge representation in general.

It is not at all certain that this will be feasible in practice, except in toy and largely preordained examples. Some of the problems are mentioned in chapter 4 (see also Boden 2006, 7.v, 9.x–xi, 10, 12, 13). In fact, there are very good reasons for doubting whether AI will ever attain the full richness and subtlety of human thought and therefore of human creativity (Boden 2006, 7.iii.d, 9.x.e). But it is not impossible *in principle*. This claim assumes that human thought is a matter of complex computation, or information processing (for a host of arguments and evidence to this effect, see Boden 2006).

It follows that radically transformational Evo-art is possible in principle, provided that its programs are (physically or semantically) open systems. But it also follows that success in third-reason Evo-art is highly improbable in the short run. It may even be unlikely in the long run. These caveats are especially apt with respect to *noninteractive* Evo-art, in which the fitness function is applied automatically by the program. In such cases, the artist must express his or her aesthetic preferences as a clearly defined fitness function—which is very much easier said than done.

5.6 Evo-values?

If third-reason Evo-art is ever achieved, it will have to face the problem that is inherent in all radically transformational creativity. Namely, if the change is too radical, it may be rejected outright.

By definition, transformational creativity breaks existing stylistic rules. That transgression has to be accepted, and even appreciated, if the new style is to be valued at

all. If it is not, the change will be seen as chaotic, or at best incompetent, rather than creative.

These matters are difficult enough in the case of human-generated art. Even the community of practicing artists, never mind the commercially influenced art world (see chapter 8), may reject the new creation as valueless. The transformative *Demoiselles d'Avignon*, for example, was scorned even by Picasso's artist friends and languished unseen in his studio for several years.

The idea that an Evo-art program, written prior to 1907, might have produced (a cruder version of) the *Demoiselles*, perhaps after importing some African images from the (anachronistic) Internet, is not utterly absurd. But the idea that its fitness function, programmed to reflect the aesthetic preferences typical of artists (whether avant-garde or Impressionists or Academicians) before 1907, would have allowed the new image to breed future generations is surely fanciful.

For that to happen, a higher-level fitness function would have to be defined that could recognize, and favor, specific continuities and contrasts between the old style and the new one. It is stylistic continuities and contrasts—among other things (such as highly topical cultural themes, the bombing of civilians in war, for example)—to which art critics refer when they try to persuade doubters that the new style, although shocking, is actually valuable.

Again, this is a tall order. Structural continuities and contrasts (including the brush-work employed in applying the paint; see chapter 4) are difficult to identify and still more difficult to define clearly enough for expression in an AI program. As for topical themes, these are a conceptual quagmire. What noncheating fitness function could lead an Evo-art program to select a neo-*Guernica* partly because of its successful depiction of the horrors of war? Even a *cheating* fitness function, written with the political theme of potential neo-*Guernicas* explicitly in mind, is barely conceivable.

Perhaps we shall always need *human* artists, and art critics, to persuade the public to value the new styles. Although, to be sure, a mere increase in familiarity can help. Whether an Evo-art program could ever take on, or even assist, that delicate task is an intriguing question. But to quote from the skeptic imagined in section 5.1, "Don't hold your breath!"

References

Adams, H. 1918. "The Dynamo and the Virgin." In H. Adams, *The Education of Henry Adams*, 379–390. Boston: Houghton and Mifflin.

Ashby, W. R. 1952. "Can a Mechanical Chess-Player Outplay Its Designer?" *British Journal for the Philosophy of Science* 3 (9): 44–57.

Bedau, M. A., J. S. McCaskill, N. H. Packard, S. Rasmussen, C. Adami, D. G. Green, T. Ikegami, K. Kaneko, and T. S. Ray. 2000. "Open Problems in Artificial Life." *Artificial Life* 6:363–376.

Bertalanffy, L. von. 1950. "An Outline of General Systems Theory." *British Journal for the Philosophy of Science* 1:134–165.

Bertalanffy, L. von. 1962. *Modern Theories of Development: An Introduction to General Systems Theory.* New York: Harper.

Bird, J., B. Bigge, M. Blow, R. Brown, E. Clive, R. Easton, T. Grimsey, G. Haslett, and A. Webster. 2005. "There Does Not, in Fact, Appear to Be a Plan: A Collaborative Experiment in Creative Robotics." In *Proceedings of the Symposium on Robotics, Mechatronics and Animatronics in the Creative and Entertainment Industries and Arts*, edited by T. Hirst and A. Green, 58–65. Society for the Study of Artificial Intelligence and the Simulation of Behaviour Hatfield, UK: Study of Artificial Intelligence and the Simulation of Behavior (AISB).

Bird, J., P. Husbands, M. Peris, B. Bigge, and P. Brown. 2008. "Implicit Fitness Functions for Evolving a Drawing Robot." In *Applications of Evolutionary Computing: EvoWorkshops 2008*, edited by M. Giacombini, A. Brabazon, S. Cagnoni, G. Di Caro, R. Drechsler, A. Ekart, A. Esparcia-Alcazar, M. Farooq, A. Fink, J. McCormack, M. O'Neill, J. Romero, F. Rothlauf, G. Squillero, S. Uyar, and S. Yang, 473–478. New York: Springer.

Bird, J., and P. Layzell. 2002. "The Evolved Radio and Its Implications for Modelling the Evolution of Novel Sensors." *Proceedings of Congress on Evolutionary Computation* CEC-2002, May, Institute of Electrical and Electronic Engineering (IEEE), 1836–1841.

Bird, J., and D. Stokes. 2006a. "Evolving Fractal Drawings." In *Generative Art 2006: Proceedings of the 9th International Conference*, edited by C. Soddu, 317–327. Milan.

Bird, J., and D. Stokes. 2006b. "Evolving Minimally Creative Robots." In *Proceedings of the 3rd International Joint Workshop on Computational Creativity (ECAI '06)*, edited by S. Colton and A. Pewase, 1–5. Riva del Garda.

Bird, J., and D. Stokes. 2007. "Minimal Creativity, Evaluation and Pattern Discrimination." In *Proceedings of the 4th International Joint Conference on Computational Creativity*, edited by A. Cardoso and G. Wiggins, 121–128.

Boden, M. A. 1999. "Is Metabolism Necessary?" *British Journal for the Philosophy of Science* 50: 231–248. Reprinted in M. A. Boden, *Creativity and Art: Three Roads to Surprise*, 235–254. Oxford: Oxford University Press, 2010.

Boden, M. A. 2004. *The Creative Mind: Myths and Mechanisms.* 2nd ed. London: Routledge.

Boden, M. A. 2006. *Mind as Machine: A History of Cognitive Science.* 2 vols. Oxford: Clarendon/ Oxford University Press.

Boden, M. A. 2010. "Personal Signatures in Art." In *Creativity and Art: Three Roads to Surprise*, 92–124. Oxford: Oxford University Press.

Boden, M. A. 2014. "Artificial Intelligence and Creativity: A Contradiction in Terms?' In *The Philosophy of Creativity*, edited by E. S. Paul and S. B. Kaufman, 224–246. Oxford: Oxford University Press.

Brown, P., B. Bigge, J. Bird, P. Husbands, M. Perris, and D. Stokes. 2007. "The Drawbots." *Proceedings of Mutamorphosis 2007: Challenging Arts and Sciences*, November, Prague.

Cariani, P. 1992. "Emergence and Artificial Life." In *Artificial Life II*, edited by C. G. Langton, C. Taylor, J. D. Farmer, and S. Rasmussen, 775–797. Redwood City, CA: Addison-Wesley.

Cariani, P. 1993. "To Evolve an Ear: Epistemological Implications of Gordon Pask's Electrochemical Devices." *Systems Research* 10 (3): 19–33.

Cariani, P. 1997. "Emergence of New Signal-Primitives in Neural Systems." *Intellectica* 2:95–143.

Cronly-Dillon, J. R. 1991. "The Origin of Invertebrate and Vertebrate Eyes." In *Evolution of the Eye and Visual System*, edited by J. R. Cronly-Dillon and R. L. Gregory, 15–51. Basingstoke, UK: Macmillan.

Eldredge, N., and S. G. Gould. 1972. "Punctuated Equilibria: An Alternative to Phyletic Gradualism." In *Models in Paleobiology*, edited by T. J. M. Schopf, 82–115. San Francisco: Freeman Cooper.

Fernandez, M. 2008. "Aesthetically Potent Environments, or How Gordon Pask Detourned Instrumental Cybernetics." In *White Heat Cold Logic: British Computer Art 1960–1980*, edited by P. Brown, C. Gere, N. Lambert, and C. Mason, 53–70. London: MIT Press.

Harrison, A. 1978, *Making and Thinking: A Study of Intelligent Activities* Hassocks, UK: Harvester Press.

Harvey, I. 1992. "Species Adaptation Genetic Algorithms: A Basis for a Continuing SAGA." In *Toward a Practice of Autonomous Systems: Proceedings of the First European Conference on Artificial Life*, edited by F. J. Varela and P. Bourgine, 346–354. Cambridge, MA: MIT Press.

Harvey, I., P. Husbands, and D. Cliff. 1994. "Seeing the Light: Artificial Evolution, Real Vision." In *From Animals to Animats 3: Proceedings of the Third International Conference on Simulation of Adaptive Behavior*, edited by D. Cliff, P. Husbands, J.-A. Meyer, and S. W. Wilson, 392–401. Cambridge, MA: MIT Press.

Husbands, P., I. Harvey, and D. Cliff. 1995. "Circle in the Round: State Space Attractors for Evolved Sighted Robots." *Journal of Robotics and Autonomous Systems* 15:83–106.

Land, M. F., and D.-E. Nilsson. 2001. *Animal Eyes*. Oxford: Oxford University Press.

Langley, P. W., H. A. Simon, G. L. Bradshaw, and J. M. Zytkow. 1987. *Scientific Discovery: Computational Explorations of the Creative Process*. Cambridge, MA: MIT Press.

McCorduck, P. 1991. *AARON's Code: Meta-Art, Artificial Intelligence, and the Work of Harold Cohen*. New York: W. H. Freeman.

Pask, G. 1959. "Physical Analogues to the Growth of a Concept." In *The Mechanization of Thought Processes*, edited by D. V. Blake and A. M. Uttley, 2:877–922. London: Her Majesty's Stationery Office.

Rasmussen, S., L. Chen, M. Nilsson, and S. Abe. 2003. "Bridging Nonliving and Living Matter." *Artificial Life* 9:269–316.

Reichardt, J., ed. 1968. *Cybernetic Serendipity: The Computer and the Arts*. London: Studio International.

Reichardt, J. 2008. "In the Beginning…." In *White Heat Cold Logic: British Computer Art 1960– 1980*, edited by P. Brown, C. Gere, N. Lambert, and C. Mason, 71–82. London: MIT Press.

Romero, J., and P. Machado, eds. 2007. *The Art of Artificial Evolution: A Handbook on Evolutionary Art and Music*. New York: Springer.

Sacks, O. 1985. *The Man Who Mistook His Wife for a Hat: And Other Clinical Tales*. New York: Simon and Schuster.

Sims, K. 1991. "Artificial Evolution for Computer Graphics." *Computer Graphics* 25 (4): 319–328.

Stokes, D., and J. Bird. 2008. "Evolutionary Robotics and Creative Constraints." In *Beyond the Brain: Embodied, Situated and Distributed Cognition*, edited by B. Hardy-Valle and N. Payette, 227–245. Newcastle, UK: Cambridge Scholars.

Thompson, A. 1995. "Evolving Electronic Robot Controllers That Exploit Hardware Resources." In *Advances in Artificial Life: Proceedings of the Third European Conference Artificial Life*, edited by F. Moran, A. Moreno, J. J. Merelo, and P. Chacon, 640–656. Berlin: Springer.

Todd, S. C., and W. Latham. 1992. *Evolutionary Art and Computers*. London: Academic Press.

Whitelaw, M. 2004. *Metacreation: Art and Artificial Life*. Cambridge, MA: MIT Press.

6 Collingwood, Emotion, and Computer Art

Margaret A. Boden

6.1 Introduction

Philosophical aesthetics and computer art seem to be miles away from each other. Certainly, the mainstream philosophical literature does not address computer art more than perfunctorily if at all. It is sometimes said, almost as an aside, that "computer art" is a contradiction in terms (e.g., O'Hear 1995). But because there is no universally agreed definition of art in the philosophical community, it is not obvious that that is so. Moreover, because there are distinct varieties of computer art (see chapter 2), it may be that some have more claim on this honorific title than others.

One implication of the lack of an agreed definition of art, of course, is that there can be no knockdown argument about the status of (any type of) computer art *as art* that addresses all the many definitions that have been offered. This chapter examines just one of these accounts of art and asks what its implications are for the various forms of computer art.

Specifically, it considers the philosophical aesthetics of Robin Collingwood (1889–1943).

6.2 Why Pick Collingwood?

The question Why pick Collingwood? has two answers. The first is simply, Why not? Collingwood is recognized as "one of the twentieth century's few outstanding philosophers of art" (Ridley 1998, 1). Only fifty years ago, he was "probably the most widely read and influential aesthetician to have written in English since Addison, Hutcheson, and Hume" (Kemp 2009). Given that he is such an important voice in philosophical aesthetics, it is of interest to ask how his views relate to *any* kind of art.

This chapter is developed from a talk given at the Workshop on Computational Creativity held at the Leibniz Centre for Informatics, Schloss Dagstuhl, Germany, in July 2009.

To be sure, his views are less popular today than they were half a century ago. Indeed, parts of his work are now nearly universally "scorned" (Guyer 2003, 45). Nevertheless, he still has his champions. In 2003, for instance, Aaron Ridley spoke of Collingwood's "wonderful" book *Principles of Art* (1938), while admitting that it is also "wonderfully uneven" (Ridley 2003, 222). Critics who have "scorned" much of his work acknowledge other parts of it as philosophically "valuable" (Guyer 2003, 45). And more generally, current writings on aesthetics abound with passing references to him. In short, Collingwood is still a highly respected name in this area.

However, so are others. For example, Arthur Danto is often cited in philosophical aesthetics. He defined art in relation to the institutions of the art world—something Collingwood would have regarded as essentially irrelevant (Danto 1964, 1981; Carroll 1993, 80). In so doing, he raised many of the issues explored by Ernest Edmonds in chapter 8 of this volume. So why not choose him?

Well, most of the people who are skeptical about the very idea of computer art—and in my experience, that means most people—do not base their skepticism in Danto's approach. Far from it: if the art world were to become more accepting of computer art, their doubts would remain. If a major collector such as Charles Saatchi were to invest in C-art, it would (on Danto's account) become "art" almost overnight. But the general public would very likely not be persuaded.

Danto's institutional theory was developed in part to oppose the skepticism of mid-twentieth-century audiences who, on first encountering much pop art and Conceptual art, reacted in outrage, saying *"That's* not art!" His answer, in effect, was "But the art world accepts it as such, and that settles the matter." Their riposte would generally be "So much the worse for the art world!" They would probably be even more dismissive of computer art than they are of the provocative urinals, Brillo boxes, and buried kilometer rods—and now the diamond-encrusted skulls—that inhabit the computer-free zones in modern art (Boden 2007b).

The reason for this is that people's unwillingness to countenance the possibility of computer art, as real art, is usually based in a strong intuition that goes back well over two thousand years—namely, that *art somehow involves emotion*, something that, they believe, computers could not possibly have.

We need not challenge that belief here: let us grant that computers do not have emotions. Which is not to say that they cannot be used to model emotion in ways that are psychologically illuminating (Boden 2006, 7.i.f). But we do need to question the "how" in that "somehow."

This gives us the second answer to the question "Why pick Collingwood?" As we will see, Collingwood put emotion at the heart of art even more firmly, even more

exclusively, than most philosophers do. It follows that his theory is prima facie an especially strong challenge to the very idea of computer art. In responding to that challenge, the relationship of emotion to C-art must be clarified.

Those philosophers who put emotion in pride of place as a criterion for genuine art do so in several different ways. For instance, Clive Bell (1914, 113), whose writing was hugely influential in the rise of abstract art, insisted that "the starting-point for all systems of aesthetics must be the personal experience of a peculiar emotion"—one aroused, and justified, only by "significant form," which is therefore the "essence" of all visual art. Although this emotion is experienced by the person, its intentional object, on Bell's view, is strictly impersonal. The aesthetic emotion responds not to any human predicament or story, whether joyous or loving or fearful, but only to abstract form. Other (expressionist) philosophers claim that art involves the expression of some more personal emotion and that art appreciation is grounded in the experience of a similar emotion by the audience.

Both these positions, along with all other forms of expressionist aesthetics, were rejected by the modernists and in particular by the conceptual artists of the 1960s (Boden 2007b). One of their leaders contemptuously dismissed claims that art lovers are driven by "the expectation of an emotional kick" (LeWitt 1967, 79).

But art lovers in general, as Sol LeWitt realized full well, are more sympathetic to expressionism. They may doubt whether emotion is actually the *essence* of art—being perfectly willing, for instance, to accept the affect-free drawings of Maurits Escher as genuine art. But they readily accept that art and emotion are typically closely linked. One example of this attitude is mentioned in chapter 4: the artificial intelligence (AI) scientist Douglas Hofstadter, who was surprised by the seemingly emotional content of the music composed by David Cope's Emmy program—"seemingly" emotional because, as explained in chapter 3, Hofstadter was projecting emotion onto the music rather than finding it within it.

Collingwood was a hugely influential expressionist. It is no accident that his position began to be "scorned" with the midcentury arrival of conceptual art. But his version of the thesis was unusual. One of the most prominent differences from other expressionist aestheticians, such as Leo Tolstoy (1899), was his unrelenting particularism. As we will see, computer art fails to satisfy his concept of art, even though it could match some of the alternative emotion-based accounts offered by other expressionist philosophers, largely because he defined it in *that* way.

In this chapter, Collingwood is not regarded as a philosophical guru to be slavishly followed on all points. Rather, he is treated as a worthy intellectual sparring partner. His ideas, whether acceptable or not, can help us explore the relations between computer art and the more traditional denizens of our galleries and concert halls.

6.3 Collingwood's Philosophy of Art

Collingwood offered two quite different philosophies of art, of which only the second, developed in the 1930s, concerns us here. It is that second account, so hugely influential, whose footsteps can be seen in many discussions of art today. That is not because it was the more immediately plausible. To the contrary, it was highly surprising, even challenging.

His earlier writing on aesthetics had been relatively unexceptional (Collingwood 1925). It was based on a long-familiar idea: the appreciation of beauty. Art, he said in the early 1920s, is "the special activity by which we apprehend beauty" (9). He insisted that "the awareness of beauty is at once the starting-point and the culmination, the presupposition and the end, of all art," and "it is simply an enlargement and a sharpening of the [artist's] awareness [of beauty] that constitute, either for him or for anyone else, the value of the picture [or other artwork] when it is done" (1925, 7).

The imagination, he said, enables the appreciation of beauty ("the beautiful is neither more nor less than the imagined" [1925, 19]). And it is crucial to the practice of art, which is "the primary and fundamental activity of the mind, the original soil out of which all other activities grow" (1925, 14). But not all beauty is created by art. He saw Kant's notion of *the sublime* as the "elementary" form of the beautiful: it is "beauty which forces itself upon our mind, beauty which strikes us as it were against our will and in spite of ourselves, beauty which we accept passively and have not discovered" (1925, 35). Human artistry, to be sure, is far from passive. But the most basic aesthetic response occurs "against our will and in spite of ourselves."

The emphasis was less on the artist as originator than on our aesthetic response to the work of art itself. Indeed, there need not be any artist. Beauty could be appreciated in manmade objects designed for nonartistic purposes—or, of course, in nature.

By contrast, Collingwood's (1938) later aesthetics focused on how the work of art reflects certain aspects of the human artist. And this theory was unorthodox, even counterintuitive, in various ways.

Beauty, now, was given no special importance: if present, it could be relished, but it was not necessary in order to give art its aesthetic worth. By implication, significant form—the modernist notion of beauty (which had gained currency since its early century introduction by Bell and by the painter Roger Fry)—was an optional extra, not (as they had said) the very essence of art.

Further unorthodox claims made by Collingwood included his rejection of representation as a criterion of art; what he meant by emotional expression; what he identified

as the work of art; and his distinctions between art and craft, entertainment, and pro-paganda. Each of these, as we will see, is relevant to the interpretation of computer art.

His insistence that art is not a luxury but is crucial for a humane and civilized cul-ture was only slightly less unusual. What he meant by this seemingly trite claim was idiosyncratic. His view was that art has a hugely important practical effect. Emotional self-knowledge, he said (for reasons explained later), is *necessarily* provided (to the art-ist) by good art and is constructed also by the audience who understands it. And such self-knowledge is a necessary, but not a sufficient, condition for a healthy society.

Specifically, the fascist politics sweeping across Europe at the time thrived, he said, largely because the public could not recognize the "corruption of consciousness" involved in what was presented as art but was really emotively manipulative propa-ganda. Lacking emotional self-knowledge (provided only by art proper), people could not recognize or admit—still less criticize and reject—the emotions aroused in them by such effective propaganda. These emotions were not merely (often) socially debased but also crude—that is, lazily unexamined and unchecked. As he put it, "I call this the 'corruption' of consciousness; because consciousness permits itself to be bribed or cor-rupted in the discharge of its function, being distracted from a formidable task towards an easier one" (1938, 217).

Similarly, modern advertising and mass entertainment rely on the skillful use of popular media to arouse emotions that are not examined and so provide no advance in self-knowledge. Thus, a society that is awash with emotions may, in the absence of art, direct these emotions inappropriately. He even went so far as to say that "bad art" is the root of all evil: "the true *radix malorum*" (1938, 285).

None of this implied that artists are a superior class, to be entrusted with the respon-sibility of saving society from itself. On the contrary, said Collingwood, "the effort towards expression of emotions, the effort to overcome corruption of consciousness, is an effort that has to be made not by specialists only but by everyone who uses lan-guage, whenever he uses it. *Every utterance and every gesture that each one of us makes is a work of art*" (1938, 285; italics added).

His emphasis on self-knowledge and emotional honesty, in both artist and Every-man, explains why Collingwood saw bad art as so destructive. By bad art, he did not mean a clumsy cut with the chisel or a carelessly wielded paintbrush or even a syco-phantic portrait or a badly represented landscape. Rather, a bad work of art is "an activity in which the agent tries to express a given emotion but fails" (1938, 282). As for trite popular novels and movies or attention-catching advertisements, these are not bad art so much as quasi art. They do not count as art at all, for they promote

"organized and commercialized day-dreaming" rather than the true expression of emotions (1938, 138).

What is it, then, to express an emotion? For Collingwood, this is not a matter of first having an emotion fully formed and then expressing it faithfully to transmit it to the audience. Rather, to express the emotion is to *construct* it, to *identify* it, and in so doing to *specify and form* it. In his words, "Until a man has expressed his emotion, he does not yet know what emotion it is" (1938, 111).

This may seem absurd: surely I can know that I feel anger or grief or joy without expressing it to myself or to anyone else? Collingwood would not disagree. But he would say that this indefinite feeling is preconscious rather than conscious. The *particular* emotion that you feel, the specific nature of that instance of anger or grief or joy, can be identified and recognized only after it has been developed and sharpened by being consciously, and conceptually, expressed. That is, a particularized emotion is not pure feeling. Rather, it is an intellectual construction—"a feeling...dominated or domesticated by consciousness" (1938, 217).

The act of consciously *constructing* emotion, rather than merely suffering it or even communicating it, is essential in Collingwood's aesthetics. So he compared artistic and emotional expression to the struggle to express what one is thinking (1938, 267–269), which, as we all know from personal experience, helps construct the thought in some newly definite form rather than simply conveying a preexisting conception.

Perhaps the clearest statement of Collingwood's particularism was this: "The artist proper is a person who, grappling with the problem of expressing a certain emotion, says 'I want to get this clear.' It is no use to him to get something else clear, however like it this other thing may be. Nothing will serve as a substitute. He does not want a thing of a certain kind, he wants a certain thing" (1938, 114). It followed, he said, that everyone who reads literature as psychology, as depicting "the feelings of women, or bus-drivers, or homosexuals..., necessarily misunderstands every real work of art with which he comes into contact, and takes for good art, with infallible precision, what is not art at all" (1938, 114–115).

Once the artist's emotion has been expressed in this way, it can in principle be communicated to another person. But again, this communication is not what is often meant by that term. Many people claim that art enables emotion of a certain type to be transmitted from one person to another. It is almost as though the medium (text, painting, musical instrument, and so on) carries the emotion as a carrier-pigeon, picking it up from the mind of the artist and depositing it in the mind of the audience. For Collingwood, this is impossible. Or rather, it is possible, but only in the case of *nonart*, such as entertainment (including, today, TV soap operas) or political propaganda. In

art proper, the audience constructs the emotion afresh in their mind, much as the artist did in her or his, and it is the equivalent, highly particular, emotion that is involved.

Several things follow from this. One is that "there is no distinction of kind between artist and audience" (1938, 119). Collingwood endorsed Samuel Taylor Coleridge's remark that "we know a man for a poet by the fact that he makes us poets" (1938, 118). Granted, the artist is the originator. And the artist is the person who uses hard-won skills to produce the art object: a point taken up at length in chapter 4. But the mental work—the construction of a particular emotion—done by the audience is essentially the same as what went on in the artist's mind.

As Collingwood put it, "Though both [poet and audience] do exactly the same thing, namely express this particular emotion in those particular words, the poet is a man who can solve for himself the problem of expressing it, whereas the audience can express it only when the poet has shown them how" (1938, 119). In other words, Everyman an artist: "The poet is not singular either in his having that emotion or in his power of expressing it; he is singular in his ability to take the initiative in expressing what all feel, and all can express" (1938, 119).

The artist's experience is richer too. "If you want to get more out of an experience, you must put more into it." Painting a picture will necessarily be a richer experience than merely looking at it or looking at its subject in the natural world: "The painter puts a great deal more into his experience of the subject than a man who merely looks at it; he puts into it, in addition, the whole consciously performed activity of painting it; what he gets out of it, therefore is proportionately more" (1938, 308). In sum, "[He 'records' in his picture] not the experience of looking at the subject without painting it, but the far richer and in some ways very different experience of looking at it and painting it together."

Another implication—on which Collingwood insisted repeatedly—was that the "work of art" is not a physical object, such as a painting or sculpture, or a physical phenomenon, such as a series of visual images or sounds. Nor is it a public performance, like ballet or street theater. It is not even an abstract structure recorded in some formal notation, like a musical score or written text. Rather, the work of art is a mental entity: the (fully formed, identified, subtly expressed) emotion in the artist's mind—together with its psychological twin in the mind of the audience. The artist's emotion, albeit mental, is not an essentially private matter. To the contrary, it is expressed—and mediated—by public "languages": words, gestures, and culturally familiar artistic conventions.

In one sense, Collingwood regarded *all* these things, and everything else too, as mental constructs. He was committed to an Idealist metaphysics, developed in his previous writings. For present purposes, however, this fact can be ignored. His contrast

between the constructive mental activity that is involved in understanding art and the absence of this in perceiving things without understanding was independent of his background Idealism (see Ridley 1998, 17–25).

That a work of art is not a physical thing or even an observable phenomenon may seem a strange idea. But remember the conceptual artists of the 1960s and their deliberate "dematerialization of the art object" (Lippard and Chandler 1968, 31; Lippard 1973; Boden 2007b). For them, it was the *idea* in the artist's (and audience's) mind that was the true work of art. There might not be any physical artifact associated with it, and if there was, it might be invisible (e.g., Walter de Maria's buried kilometer rod). Moreover, other philosophers of aesthetics besides Collingwood have offered versions of mentalism. For instance, David Davies (2004, 146) argues that *every* work of art is an action—or in a sense, a performance. Specifically, it is an action on the artist's part, which identifies a "focus of appreciation" whose vehicle may be, but need not be, a physical object. Even if it is, the *work of art* as such is the artist's attention-directing action. So if Collingwood was unusual in being a mentalist, he is not unique.

Collingwood sometimes used the term "work of art" in its more familiar sense (e.g., 1938, 37), applied to a physical artifact—what one might call the art object (and what Danto calls the "vehicle"). But he did so as a sort of shorthand. The artist's emotion is often expressed (particularized) with the help of paint on canvas, chiseled marble, or words on a page. On Collingwood's view, however, the art object should not attract attention for its own sake: for its phenomenal qualities or beauty. It is an "*objet d'art...* only because of the relation in which it stands to the aesthetic experience which is the 'work of art proper'" (ibid.). Its role is to function as a "language" that can prompt the culturally prepared audience to go through the same sort of constructive mental activity as the artist did when making it.

And just as what really matters about a book is not the printer's ink on the paper or the beauty of the typeface but the meanings expressed by way of them, so the physical *art object* is not what art is really about. It is not *the work of art* itself.

By the same token, the medium chosen by the artist is *artistically* inessential. The artist may have found that a certain medium is best, or even in practice necessary, for expressing or constructing the emotions concerned. But in principle, and perhaps in fact, some other medium might do so just as well.

Yet another implication is that art, as such, has nothing to do with usefulness. What Collingwood meant by usefulness did not include the benign social-political effects of art previously mentioned. He granted that "a work of art may very well amuse, instruct, puzzle, exhort, and so forth, without ceasing to be art, and in these ways it may be very useful indeed." Nevertheless, he insisted that "what makes it art is not the same as what makes it useful" (1938, 32).

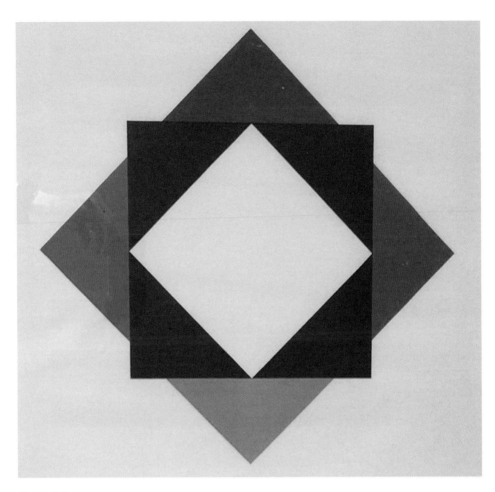

Figure 9.1
Max Bill. *Ardiv III*. 1972, screen print. (Reproduced by permission of Ernest Edmonds.)

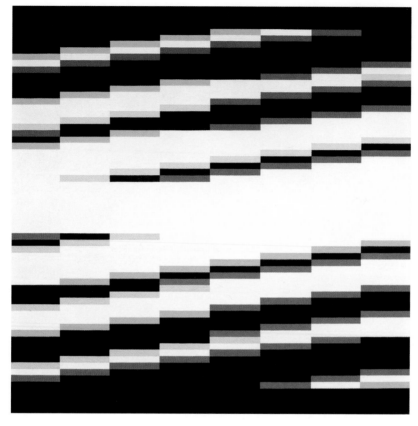

Figure 9.2
Jeffrey Steele. *SYNTAGMA SG III 104*. 1992, oil on linen, 61×61 cm. (Reproduced by permission of the artist.)

Figure 9.3
Ernest Edmonds. *Nineteen*. 1968–1969, multimedia, 183 × 145 × 17 cm. (Reproduced by permission of the artist. Image courtesy of Jules Lister.)

Figure 11.2
Christa Sommerer and Laurent Mignonneau. *Life Spacies*. 1997, screenshot, collection of NTT-ICC, Tokyo, Japan. (Reproduced by permission of the artists.)

Figure 11.3
Sidney Fels and Kenji Mase. *Iamascope*. 2000, in the Millennium Dome Play Zone, London. (Photograph courtesy of Linda Candy.)

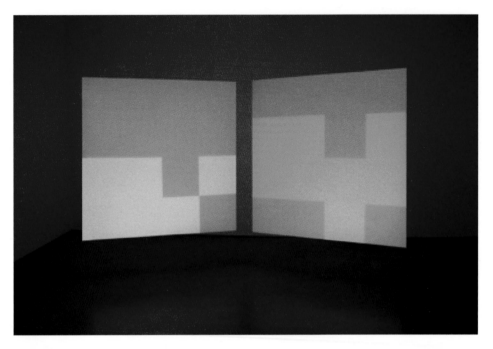

Figure 11.4
Ernest Edmonds. *Shaping Space*. 2012, interactive installation. (Reproduced by permission of the artist. Photograph Site Gallery, Sheffield, UK.)

Figure 13.1
Brigid Costello. *Just a Bit of Spin*. 2007, two views of someone interacting with the work. (Reproduced by permission of the artist.)

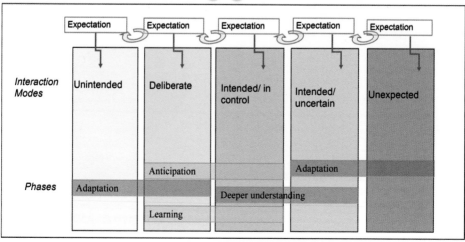

Figure 13.2

Zafer Bilda's creative engagement model. (Reproduced by permission of Zafer Bilda.)

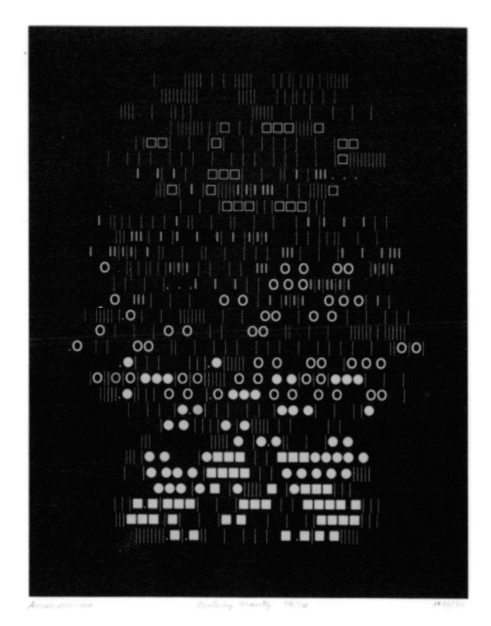

Figure 14.1
Aaron Marcus. *Evolving Gravity*. 1972–1974. (Reproduced by permission of the artist.)

Figure 14.2

Harold Cohen. *Coming Home #2*. 2007, permanent pigment ink on panel, 57.5 × 169.5 cm. (Reproduced by permission of the artist.)

Figure 14.4

Paul Brown. *Builder/Eater*. 1977 (re-created 2014), real-time computational generative artwork, size variable. (Reproduced by permission of the artist.)

Figure 14.5

Roman Verostko. *Flowers of Learning, Black Elk*. 2006, plotter drawing with pen-and-ink, 76×101 cm. One of seven units in a twenty-five-foot installation. Spalding University, Louisville, KY. (Reproduced by permission of the artist.)

Figure 14.6

Julie Freeman. *A Selfless Society*. 2016, online animation with sound. JavaScript with HTML5 canvas element, real-time data from a colony of naked mole rats, variable size. (Reproduced by permission of the artist.)

Figure 14.7
Alex May. *Digital Decomposition*. 2017, interactive digital installation, variable size. (Reproduced by permission of the artist.)

Figure 14.8
Kate Sicchio. *Hacking Choreography*. 2014, performed by Philippa Lockwood and Elissa Hind at Waterman's Art Centre, London. (Reproduced by permission of the artist.)

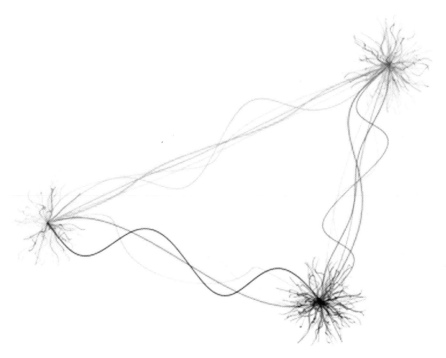

Figure 14.9

Andrew Brown. *Connections*. 2013, developed in the Impromptu environment and exhibited as part of the [d]Generate exhibition of digital generative art at the Gympie Regional Gallery. (Reproduced by permission of the artist.)

Figure 14.11
Alex McLean performing at Algorave Karlsruhe, 2015. (Photograph by Rodrigo Velasco.)

Likewise, art has nothing to do with representation (mimesis), previously thought by many philosophers to be the core aim of art. A work of art may in fact be a successful representation. But for Collingwood, what makes it good art is not the same as what makes it a good representation.

And finally, art has nothing to do with skill (a counterintuitive notion that is challenged in chapters 4 and 10). Certainly, a work of art—or rather, an art object—may be fashioned with prodigious skill. But, he said, the skillfulness qualifies it as a superior work of *craft*, not of art. Skill in working in a particular medium may be essential in practice if an artist wishes to express a particular emotion clearly enough for others to be able to experience it too. Even skill in representation may be necessary if a painted portrait or landscape is to enable the audience to construct the same emotion as it did in the artist. But skill is not the same as art. Far from it: "Art proper, as the expression of emotion, differs sharply and obviously from any craft whose aim it is to arouse emotion" (1938, 113).

Collingwood saw this distinction as "sharp" and "obvious" (which in fact it is not; see Boden 2000) because he saw the aim of craft as very different from the aim of art. On the one hand, craft is not particularist in intent: "The end which a craft sets out to realize is always conceived in general terms, never individualized" (1938, 113). And, on the other hand, he said, craft (skill, technique) is applied to preordained ends.

These ends include making pots from lumps of clay or tables from planks of wood—for which, according to Collingwood, no highly skilled craftsman begins to work without having a clear idea of what it is he wants to make. Similarly, the craftsman may seek to provide magic, entertainment, or propaganda—all involving the foreseeable elicitation of a general type of emotion. But the hard work that is involved in clearly expressing a highly particular emotion is hard largely because its end is not foreseen. Only after it has been successfully expressed does the artist's emotion exist *as an identifiable particular experience.* In that sense, art is not goal directed but open-ended.

Like Danto after him, Collingwood deliberately sought to include the newest art as well as (some of the) more familiar types. Right at the outset of his book he spoke of "a new drama,…a new poetry, and a new way of painting…[and] a new way of writing prose" (1938, 1). He had in mind rising artists such as "Mr. Joyce, Mr. Eliot, Miss Sitwell, or Miss Stein" (1938, 3). The question to be considered now is whether an even newer form of art, computer art, fits within his definition.

There is no short answer. There are diverse forms of computer art, some of which may be better suited to Collingwood's approach than others are. Moreover, there are two ways of thinking about computer art, of any category. One is to think of the computer as an artistic medium; the other is to focus on its generative aspects. These points are explored in the next three sections.

6.4 Computers as an Artistic Medium

Artists tend not only to use their chosen medium but to celebrate it. A composer, for instance, glories in the range of acoustic possibilities offered by the piano or the clarinet as well as in the more abstract musical structures represented in the score. And a skilled pianist or clarinetist exhilarates in coaxing the chosen instrument to reach unexpected heights in performance. Computer artists too—and especially those engaged in computer-generated (CG) art as opposed to computer-assisted (CA) art—tend to celebrate their medium rather than merely using it.

As defined in chapter 2, CG-artworks result when *a computer program is left to run by itself with minimal or zero interference from a human being*; in computer-assisted, or CA-art, by contrast, *the computer is used by the human artist as an aid—in principle, nonessential—in the art-making process.* We see later that this distinction is not always clear-cut: some CA-art relies heavily on CG-processes.

The computer being the chosen medium for all C-art would undermine the possibility of true computer art if something about computers disqualifies them from being an artistic medium. That is especially so if one's theory of aesthetics treats the medium as an essential aspect of the work of art.

The latter condition, although still common, is less widely accepted today than it was in Collingwood's time. The conceptual artists, twenty years after his death, made a point of denying that the medium, and the artist's skill in handling it, is important. For them, and for their current followers, art is about ideas, not artifacts. Nor did this condition apply to Collingwood himself. He too, as we have seen, identified the work of art as a *mental* construct. He regarded the medium in which it is embodied as contingent, not essential.

Yet even Collingwood had to allow that the chosen medium must be one that, as a matter of fact, is capable of helping the artist and audience construct the emotional experience in question. This matter of fact is largely cultural. There may be some physical reason why a putative medium is unable to communicate a certain emotion or even any emotion at all. For instance, paints radiating only ultraviolet light would be imperceptible to humans. The art galleries would be visited only by bees. And collages made of individual mercury droplets would lose their form if the droplets were able to touch each other. But a medium may be unsuitable, instead, because of its cultural associations.

Consider, for instance, Chris Ofili's *The Holy Virgin Mary*, the portrait of a black Madonna that won London's Turner Prize in 1998. Mary's gown was blue, respecting a painterly convention familiar since the Renaissance. But there the traditional aspects ended. Quite

apart from the unconventional (black African) physiognomy, the medium was most unusual. The picture was made with a mixture of oil paints and elephant dung, and the linen canvas bore some small resin-coated balls of dung.

This work of art created a scandal because of what the British audience saw as its scatological, and therefore blasphemous, associations. A similar reaction greeted it in New York, where Mayor Rudolph Giuliani wanted it removed from the walls of the Brooklyn Museum of Art. In the African environment that had inspired it, however, elephant dung is considered highly useful, even near sacred. What is more, it is sometimes used for painting. And in parts of India the dung sells for high prices, so the artist's use of it could be seen as comparable to using gold leaf or precious stones on a medieval religious icon.

In brief, there is no intrinsic property that makes elephant dung physically unsuitable as an artistic medium. The scattered dung balls might have rotted away, to be sure, but they were protected by the resin. As a matter of cultural fact, however, it cannot be used to make works of art that will be widely accepted in the UK or United States.

Of course, Ofili knew very well what he was doing. He was not painting for an audience in Africa or India, and he fully intended to *épater le bourgeois* in the West. He even included some sexually expressive symbols in the painting: several tiny images of buttocks and female pudenda—after all, that is where baby Jesus came from. But those potentially offensive images were not what enraged the public. Perhaps most people did not look closely enough to realize what they were. It was the choice of dung as the artistic medium that caused the furor.

The public's distaste for computers does not quite match its distaste for feces, elephantine or not. Artists aiming to *épater* those beleaguered *bourgeois* have sometimes used human feces too—sealed in ninety small cans in the case of Piero Manzoni's *Merda d'artista* of 1961. But there is no doubt that many people are highly suspicious of computers and are especially averse to their use in what are normally regarded as quintessentially human contexts.

Art is a paradigm case of such a context. And the emotional aspect of art is seemingly the most human aspect of all. If people believe—which most people do—that computers cannot experience emotions and indeed can have nothing whatsoever to do with emotions, then they are likely to think that computers cannot be used to communicate emotions. And for anyone who (like Collingwood) believes that emotion is the very essence of art, computers will probably appear to be utterly unsuitable as an artistic medium.

On that view, what the computer actually does is irrelevant. In addition, how it is actually used by the human artist is irrelevant. Likewise, the Madonna's blue gown and

even Ofili's provocative mini-images were deemed irrelevant by the people scandalized by the medium chosen for his work. No specific C-art project needs to be examined. None merits examination, for "C-art" is a contradiction in terms. Both computer-generated and computer-assisted art are to be dismissed as frauds. Simply because they use computers as their medium, neither CG-art nor CA-art is really art at all.

This position is not rationally grounded. Oil paints cannot feel wonder and humility or marble, grief. But these media can nevertheless be used to fashion an awe-inspiring *Annunciation* or a hugely affecting *Pieta*. So the mere fact that computers cannot feel emotions does not rule them out as an artistic medium. What, if anything, rules them out as a medium is the widespread cultural prejudice that makes it impossible for most people to experience emotions (other than bemusement and frustration) when presented with computer art. This prejudice can even *prevent* people from being presented with computer art: one music critic wrote a savage "review" of a concert of CG-music even though he admitted that it had not yet happened and that he had no intention of turning up when it did (Cope 2006, 345).

If such prejudice is to amount to anything more than an unthinking suspicion of the medium, some other reason must be found by those who wish to reject computer art. In other words, *how the medium is actually used* and *what the computer actually does* must become the focus of attention.

6.5 Duplicability, Open-endedness, and Skill

Several of Collingwood's criteria for art are prima facie problematic with respect to computer art. In this section and the next, however, we see that most of these criteria can be satisfied, in principle or (often) in practice, by this novel genre. Only one is strictly incompatible with C-art, or rather, with an important *subclass* of C-art.

The first such criterion is his mentalism. We see in section 6.3 that a work of art, for Collingwood, is not a physical thing. If that is so, then the images and sounds presented as C-art by C-artists are not really art at all. However, no C-artist is going to lose sleep on that account. By that criterion, even the *Mona Lisa* or Michelangelo's *David* is not a work of art.

The work of art, Collingwood insisted, is the mental construct in the artist's (and viewer's) mind that expresses the experience concerned. Or rather, it is the relevant mental construction in the artist's *and multiple viewers'* minds. There are thus countless near-equivalent works of art associated with Leonardo's or Michelangelo's masterpiece—and with every other physical artifact commonly regarded as a work of art.

I say near equivalent rather than fully equivalent because each one is freshly constructed by the individual human mind concerned. Despite Collingwood's extreme particularism—"'I want to get this clear,' not something else, however like it this other thing may be"—it is surely unrealistic to suppose that the relevant experiences are exactly alike in every respect.

It would seem to follow that the mere *duplicability* of a computer artwork—or for that matter, of a traditional print (see section 6.6)—should not count against its status as a work of art. On the one hand, there are always many near-equivalent (mental) works of art. And on the other hand, a (physical) print—again, for Collingwood—has no such status anyway. So a certain print being unique can give it rarity value as an object within the art market but does not enhance its value *as art*.

By contrast, for those people who assume that some works of art are physical things, duplication often does undermine the work's claim to be taken as art. This does not apply to Walter Benjamin, who rejected uniqueness as elitist: he welcomed technologies of art reproduction, such as still photography and film, as democratically progressive (Benjamin 1968). A print, lithograph, or etching, no matter how much its skill is admired, is usually less revered than a painting. Even if only one example of it actually exists (perhaps because only one was printed or because all the others have been lost), the mere potential for duplication can compromise its perceived status as art.

With respect to computer art (especially CG-art), this certainly happens. That is, critics often downgrade it precisely because they feel that, as computer output, it can be duplicated or nearly matched indefinitely. That is one of the skeptical reactions that greeted David Cope's Emmy program, which composed highly plausible music modeled on the styles of human composers from Mozart to Joplin (Cope 2001, 2006). And it is one of the reasons Cope decided to destroy the musical database that he had taken twenty-five years to build, thus making Emmy's oeuvre complete—as those of deceased human composers are (Cope 2006, 364; Boden 2007a).

In short, duplicability (among other things) was preventing people—such as the concert-avoiding "reviewer" mentioned earlier—from treating Emmy's music as *music* and from taking Cope's C-art seriously as *art*. Were one to accept Collingwood's mentalism, however, that reaction would be ill based.

What of Collingwood's insistence that true art is open-ended? If this means that it is unpredictable, that the end point cannot be foreseen, then CG-art (and even most CA-art) is included. To be sure, one can usually (although not quite always; see later discussion) predict, in general terms, what type of CG-result will ensue. But unpredictability in detail is par for the computer course.

In fact, utter unpredictability is not a feature of human art either. In other words, one must question Collingwood's curious claim that "no artist, so far as he is an artist proper, can set out to write a comedy, a tragedy, an elegy, or the like. So far as he is an artist proper, he is just as likely to write any one of these as any other" (1938, 116). This has some plausibility when applied to a poet laureate, committed by his office—not by his royalist sentiments—to write an elegy for a dead king or a prothalamion for a prince's wedding. It has some plausibility, too, in cases in which an artist is specially commissioned to produce a work of art that otherwise she or he would not have undertaken. In general, however, the claim is highly dubious. A poet enthused by a daughter's pending marriage could surely "set out to write a [prothalamion]" in celebration and could identify or express his own particularized emotion in the process.

It follows that the mere fact that no computer program is "as likely to [generate any one result] as any other" does not mean that it is not unpredictable in more relevant ways.

The best-known case of CG-art, Harold Cohen's AARON program, can generate indefinitely many unique drawings and colored prints or electronic displays (Cohen 1995, 2002; Cohen, Lugo, and Moura 2007). The works produced by the most recent version of the program "teeter on the edge between abstraction and representation," allowing color to function as "the primary organizing principle, whilst maintaining a link to the external world" (Cohen and Jacobson 2008). Earlier works were more obviously representational, and AARON's competence in mimesis improved considerably as the program was developed over the years. So did its competence as a colorist. Indeed, Cohen (personal communication) has said, referring to a fairly recent version, "I am a first-rate colorist. AARON is a world-class colorist."

Quite apart from their interest to people who are knowledgeable about CG-art and their novelty value (as examples of *computer* art) to those who are not, AARON's drawings are both realistic enough and attractive enough to be exhibited around the world—in the Tate Gallery, for example. Collingwood would not be persuaded by that, of course. For him, as we have seen, success in representation (mimesis) is artistically irrelevant. Likewise, visual attractiveness and entertainment value do not add up to art.

More to the point, in this context, is that AARON's pictures are individually unforeseen and unpredictable—even by Cohen himself. In that sense, the program is open-ended.

Certainly, the images generated by any given version of Cohen's program (which he developed over forty years) are all drawn in the same style and depict the same general theme—for example, people with jungle foliage or acrobats with medicine balls or multicolored leaflike abstract designs. However, human artists too, even great artists, spend almost all their time in exploring a certain style. They vary the subject matter more than AARON does (although Claude Monet was temporarily obsessed by cathedrals or

water lilies, and William Turner had a thing about sunrises—so much so that he lived in several houses on England's eastern coast). But their general approach and also their personal signature (Boden 2010) vary only a little.

Besides such *exploratory* creativity, which leaves the style better understood but essentially unchanged, human artists sometimes (although rarely) engage in *transformational* creativity (Boden 2004, chaps. 3, 8, 12). This alters one or more aspects of the style, one or more dimensions of the relevant conceptual space, so that new structures or ideas can now be produced that were impossible before. The passage from impossibility to actuality surely counts as open-ended. And Collingwood, as we have seen, was as favorably impressed as anybody by the "new poetry" and the "new way of writing prose" found in the transformational work of "Mr. Joyce, Mr. Eliot, Miss Sitwell, or Miss Stein."

Insofar as CG-art (as opposed to CG-artists) can produce stylistic transformations, it does so by means of evolutionary programming, or Evo-art. This was defined in chapter 2 as CG-art that is *evolved by processes of random variation and selective reproduction that affect the art-generating program itself.*

Whether Evo-art can produce *truly* fundamental changes is discussed in chapter 10. Here, let us just note that it sometimes appears to do so. This is especially likely if some of the changes in the program's own rules are structurally radical—such as concatenating two whole image-generating miniprograms or hierarchically nesting one inside another and perhaps another (Sims 1991). Although the types of rule change are predetermined by the programmer, the individual changes that actually happen are random—much as biological mutations are. There is no question, then, of the resulting Evo-art being foreseen by the human artist.

Admittedly, the types of mutation allowed are sometimes deliberately limited, so as not to depart too far from the original style. For example, a series of point mutations, in which one numeral in a programmed instruction is substituted by another, generate changes that look like adventurous stylistic exploration rather than radical transformation (see Todd and Latham 1992). But even so, the human artists concerned avow that they could not possibly have imagined (still less predicted) the results. In short, Evo-art is even more open-ended than other types of CG-art.

Interactive computer art (CI-art), *in which the form/content of some CG-artwork is significantly affected by the behavior of the audience* (see chapter 2), is open-ended too. That is not just because of the complexity of the programs but also because of the unpredictable behavior of the human beings involved in the interaction. Insofar as the latter reason applies, the open-endedness of CI-art cannot be attributed *to the computer.* As in other (nonevolutionary) cases of C-art, the programmer will be able to predict the general types of art that can result. But the individual cases may be even less foreseeable

than they are when they are generated by a computer program running alone, such as AARON.

Most CG-art is open-ended in another sense too, which is that there is no end point foreseen at the beginning of the art-making process. In AARON, for instance, there is no goal state aimed at *by the program itself* when it starts on a drawing. On the contrary, AARON's decisions are taken on the fly, sometimes at random and sometimes depending on what other decisions have been made previously.

Open-endedness, in this sense, is not only a criterion of *art* for Collingwood but a crucial factor in his distinction between art and craft. On his view, craft skills are aimed at some preconceived end. C-art programming does not always fit that constraint. Were he alive today, Collingwood would have to admit that the programming involved in computer art is a highly skilled activity. However, and despite much C-art programming being open-ended, he would probably call it craft, not, as Edmonds does in chapter 10, art. My own view is that programming is not a craft, because crafts exploit universal human dispositions to interpret certain stimuli in ecologically relevant ways (Boden 2000).

Moreover, he would probably point out that this skill is utterly foreign to most human beings. Even people who use computers every day may be wholly ignorant of programming, relying instead on custom-made packages whose interfaces hide all the programming details. So in contrast to his remarks about poets making poets of us all, there *is* a "distinction of kind" between computer artist and audience.

More accurately, there is a distinction between *CG-artists* and their audience. By contrast, *CA-artists*, who rely, for example, on graphics packages such as Photoshop or Brushes, are typically just as ignorant of programming as anyone else. There are exceptions; section 6.4 describes a CA-art system written by AI professionals. For instance, the hugely successful painter David Hockney praised a faster version of Photoshop as "a fantastic medium" (Hockney 2009) and in 2012 held an acclaimed one-man exhibition comprising mostly CA work at London's Royal Academy of Art. But he draws on the computer screen with a light pen or with his fingers on a touchscreen: no programming is involved.

Even those few CG-artists who get someone else to write their programs for them develop a sense of what is achievable by programming that is not available to the man on the Clapham omnibus. Whereas painting, sculpture, music, and literature all depend on skills that exploit universal psychological properties employed by us every day, programming relies on a highly specialist variety of formal reasoning. This activity is potentially open to everybody, but it remains largely undeveloped in many societies and social

groups. Collingwood would probably say that computer art will never be able to touch its audience directly as a result.

As well as granting the skillfulness of computer artists, he would presumably concede that some C-art is decorative, amusing, entertaining, and perhaps even, as demanded by his earlier theory of aesthetics, beautiful. And he might also allow (discussed in section 6.6) that C-art can sometimes seem to express emotions and so can be used in emotionally manipulative ways. He would insist, however, that *art proper* it is not. But why? And would his strictures apply equally to all forms of computer art?

6.6 Particularism and the Expression of Emotion

Let us consider CA-art first. Human artists, such as Hockney, can use Photoshop as an electronic palette or drawing aid or rely on their own digital photographs or or public domain images on the Internet as a source of items for a collage. There is no reason the results could not express certain kinds of emotion. They might communicate or elicit joy, fear, or sadness just as well as many paintings do. And they might therefore be useful for manipulating people's emotions in entertainment, advertising, and propaganda. They might even be used to encourage the unexamined "corruption of consciousness" that is involved in popularist politics, such as fascism. It is an interesting historical irony that Max Bense, the first philosopher to write on the aesthetics of computer art and the instigator of the seminal *Cybernetic Serendipity* exhibition (Reichardt 2008), favored this art *precisely because* the Nazis—whom he had publicly opposed in prewar Germany—had abused the populist power of emotion in art.

Indeed, one CA-system was developed specifically to depict emotions—namely, anger, disgust, fear, happiness, sadness, and surprise (Colton, Valstar, and Pantic 2008; Colton 2012). This is The Painting Fool, which won the award for the best demonstration at the British Computer Society's AI conference in 2008. As remarked in chapter 2, the distinction between CA-art and CG-art is not always clear-cut—and the Fool is a CA-system with a generous dose of CG-processes in it. Indeed, its authors see it rather as CG-art, describing it as a "creative collaborator in [the] art project," as opposed to a system that "merely enhances the efficiency/creativity of [human] users." They even hope that it "will eventually be accepted as a creative artist in its own right" (Colton, Valstar, and Pantic 2008, 304).

The Fool generates "emotional" portraits by first interpreting the facial expressions of a human being (in person or from a brief video or photograph) in terms of the emotions just listed. This feat requires a complex AI-vision program in itself. Then, having

identified the point at which, and the specific facial features by which, the predominant emotion is most strongly expressed, it adjusts the digitized image in numerous ways so as to exaggerate the emotion concerned.

These adjustments are carried out by software designed for rendering visual images in a painterly (nonphotorealistic) way. They include expressive distortions generated by the Fool's underlying model of twenty-three facial muscles. They also include painting style. For instance, the Fool may choose to depict rage by harsh brushstrokes (in 2-D, not 3-D) of "angry" reds, greens, and black or sadness by gentle strokes with muted colors. And the portrait will simulate some familiar artistic medium—such as acrylic, oils, pastels, water colors, charcoal, or chalk. The brushstrokes characteristic of these different media are defined in terms of seventeen parameters, representing (for instance) brush size, tapering, transparency, friction, stroke length, and varying colors and shades. And the (nonhuman) straight lines generated by the program's segmentation of the original image are converted into slightly wobbly lines or curves.

The program's status as CA-art or CG-art is ambiguous because it can be used in different ways. The overall style of rendering may be selected automatically from a list of around 150 predefined sets of rendering parameters (50 for pencil drawings alone), each containing numerous detailed constraints. If left to its own devices, the program may choose a style at random, but it can also opt for an emotionally appropriate medium: pastels for depicting melancholy, vivid colors in "slapdash acrylic" for happiness, or low-saturation grayish colors (indicating rottenness) for disgust. Used in that way, as it was at the AI conference, the Fool can be seen as an exercise in fully automated CG-art. Alternatively, the rendering may be chosen by the user, who (if sufficiently expert) may even specify the style in some detail on the fly. In those cases, The Painting Fool is better seen as a tool for CA-art.

Whether the Fool would have won an award for portraiture, as opposed to AI, is highly doubtful. It is certainly an interesting AI achievement. But its simulated paintings are visually crude in many ways (examples are shown at http://www.thepaintingfool .com). The more it adjusts the initial image, the less likely that the person concerned will be recognizable as the subject of the portrait. And the degree to which the six emotions can be reliably recognized varies (anger and sadness being especially difficult). In short, the mimetic subtleties commanded by the competent human painter are not available to the program.

The authors are well aware of that and plan to improve the Fool in various ways (Colton, Valstar, and Pantic 2008, 311). The main point is that this work shows that painterly programs dealing with emotional images, whether facial expressions or collages

of emotive images of other kinds (including images with sociopolitical relevance), are possible.

For Collingwood, of course, a program's ability to express or elicit emotions in general would not be enough to make it art. But even his particularist aesthetic could, at least in principle, be satisfied by CA-art. This would require that the human CA-artist be able to exploit and supplement the (rich) computer resources with such skill and sensitivity of judgment that the result expressed a *particular* emotional experience, as may be done by the masterful use of paintbrush or chisel. Hockney's enthusiastic remarks about Photoshop imply that he thinks this is possible. In this process of conscious construction, the CA-artist would gradually become aware of just what experience it is that is in question, as happens—according to Collingwood—in the noncomputerized case.

Collingwood might object, here, that the emotional expressiveness of the computerized medium is much weaker than that of paint on canvas, for example. He was insistent that art produced by "a man at work before his easel" depended crucially on "the artist's psycho-physical activity of painting; ... his felt gestures as he manipulates his brush, the seen shapes of paint patches that these gestures leave on his canvas" (1938, 307). Put that way, using a light pen on a computer screen, as Hockney does, is perhaps excluded. Painting, he said, "can never be a visual art: A man paints with his hands, not with his eyes. The Impressionist doctrine that what one paints is light was a pedantry which failed to destroy the painters it enslaved only because they remained painters in spite of the doctrine: men of their hands, men who did their work with fingers and wrist and arm, and even (as they walked about the studio) with their legs and toes" (1938, 144–145). Indeed, he saw art in general as based in "an original language of total bodily gesture" (1938, 246).

With no paint in evidence and no muscular activity involved in the production, could a computer-produced image match even "pedantic" Impressionist paintings for expressiveness?

Some CG-art does involve the automated application of liquid paint to physical surfaces. One version of the AARON program, for instance, mixes its own paints and then applies them, with varying quasimuscular pressures, by using half a dozen painting pads of different sizes. It must be admitted, however, that the results do not have the wide range of physical textures seen in human-painted pictures. They are thus much less expressive.

In principle, the CA-artist might be able to do better than this without using actual paint. He or she could turn to 3DP-art (see the taxonomy of chapter 2). That is, he or she could apply the recent techniques of 3-D printing—developed for rapid prototyping

in commercial design but now being used by artists too (Sequin 2005)—so as to mimic differing types of brushstrokes on the images printed out by the computer. Although the reflectance properties of paint would not be matched, the 3-D contours of the painted surface would. Each printed layer can be only 0.01 millimeter thick. Those 3-D textures, in turn, could form part of the expressive powers of the medium. A delicately executed Pointillist painting, after all, is less apt for expressing anger, joy, or grief than one painted with the speed and energy, and the generous use of oils, of a Van Gogh. Similar expressive possibilities would presumably inhere in the computer-produced textures concerned. That is especially true for art audiences already culturally familiar with the effects of wielding paintbrushes in different ways and under the influence of different emotions.

That technological strategy (faking brushstrokes of certain kinds where none really exist) might be criticized as betraying a lack of authenticity and so disbarring the result from being a work of art. The concepts of art and authenticity are closely linked (Boden 2007a). In response to such criticism, the human CA-artist could simply drop the faking strategy and rely only on Photoshop or on some other CA-application (such as the Fool) that produces flat images. And to rebut any aesthetic complaints about the flatness—that is, the *lack* of 3-D texture—of the results, he or she could cite the ColorField painters (e.g., Kenneth Noland), who followed Clement Greenberg's insistence that the paint should be *as flat as possible*. Or the artist could say "This is not a painting, but a print. And who is to say that prints cannot be works of art?" even adding "especially one-off, unique prints, like this one." This assumes that the computer artist is not a follower of Benjamin.

Even if Collingwood were persuaded that what is called C-art is both expressive (of general classes of emotion) and open-ended and even if his mentalist ontology of works of art were set aside (there being no *conscious* construction in the computer), he still would not accept most C-art as art. The reason would lie in the other key aspect of his theory of art—namely, his particularism.

Why would he reject only "most" C-art? Well, we have seen that *CA*-art could, conceivably, be particularist. One may doubt whether computer resources will ever exist that are rich enough and computer-using skills strong enough to make this happen in practice. But because CA-art is executed under the close and continuous direction of the individual human artist, there is room—in principle—for a particular emotional experience to be formed, sharpened, and expressed by working within this medium, much as Collingwood described.

But the case is very different for any type of generative art, or G-art. This is defined in chapter 2 as *art in which the artwork is generated, at least in part, by some process that is*

not under the artist's direct control. As we see there, this category includes *noncomputerized* examples as different as Mozart's dice music, Hubert Duprat's caddis-built jewelry, and Gustav Metzger's autodestructive bags of rotting rubbish.

The computerized types of G-art, or CG-art, are those in which *the artwork results from some computer program being left to run by itself, with minimal or zero interference from a human being.* Despite the admitted vagueness of the term "minimal," this clearly excludes the careful adjustments and sensitive judgments that would be needed to produce something expressing a highly *particular* emotional experience.

Even in Evo-art, in which the natural selection is typically done by the human artist, the randomness of the rule changes effected by the genetic algorithms would constantly threaten to undermine whatever level of particularist appropriateness had previously been reached. A successfully particularist expression of emotion could occur only as an extraordinary coincidence, and the Evo-program would have to be instantly aborted to prevent its being destroyed.

One could, in principle, cheat. One might first evolve a successfully particularist work of CA-art and then freeze the system so that it could produce the same result *automatically.* That would fit the letter of the definition of CG-art. But it would not fit its spirit. It would be like waving a magic wand over Leonardo's brain while he was working on the *Mona Lisa* so that he then went on to paint it in exactly the same way, over and over again. The real work of particularist emotional expression would have been done only on the first occasion.

More importantly, the particularist intent of the artist as envisaged by Collingwood goes against the grain of CG-art as such. This activity exploits, even exhilarates in, the huge generative potential of the digital computer. That is what "celebrating the medium" means in this context (see section 6.4). A large part of the point of CG-art is to explore, and to exhibit, a certain *range* of possibilities. Each CG-artwork is unique, yes. But they are unified—both perceptibly and historically—by the program that generated them. The audience is expected to notice that unity and to appreciate it. Whether most audiences actually can notice or appreciate it is discussed in chapter 4.

In the terms used by Davies (2004, chaps. 2–3), GA-works do not "speak for themselves." Like all art, to be appreciated they must be viewed in a particular art-historical context. Specifically, one in which they have been produced by a computer, not a human hand, and in which indefinitely many other distinct-but-similar works could have been generated too.

In cases in which the CG-artist was aiming to arouse emotions in the audience's minds, that potential generative unity would be as important as ever. That is, each individually unique emotion-eliciting artwork would be interpreted as an exemplar lying

within the CG-range, not as a stand-alone, nicely constructed expression of a highly particular emotion in the human artist's mind.

A CG-system could generate a range of works eliciting varying experiences lying within one broad type of emotion (fear, for instance). And there already are some CG-programs that can express or elicit instances of a number of different emotions (fear, joy, anger...). Some music-composing programs do this, up to a point (e.g., Riecken 1992). And as we have seen with respect to The Painting Fool, visual C-artists occasionally do so too.

However, recognizing a computer-generated portrait as representing Joe Blow experiencing a moment of fear or joy is not at all the same thing as communicating—or eliciting—a highly specific emotional experience in Collingwood's (particularist) sense. And that is not the aim of the exercise: insofar as a work by The Painting Fool is considered CG-art, its whole point is that *any* human face, and *very many* different emotions, can be represented by it. Pure CA-art is different: Photoshop can be applied to any visual image, but the execution is achieved predominantly by the decisions of the human user. For a CG-artist to write a program capable of generating an artwork eliciting just one, highly individuated, emotion would be a contradiction in terms. Particularism simply is not what is wanted here.

In brief: G-art in general and CG-art in particular may be able to express, communicate, and elicit *types* of emotion. But it could never construct or express particular emotions, as envisaged by Collingwood. *If* true art demands particularism, then CG-art is not really art.

6.7 So What?

Collingwood opened his book by saying that he intended to offer a definition of "art," admitting at once that this term is commonly used equivocally (1938, 1). In other words, his definition would not be a report of common usage but rather what Charles Stevenson (1938) would soon call a persuasive definition. A persuasive definition seeks to direct our attitudes, whether favorable or unfavorable, onto some aspects of the everyday concept concerned while ignoring or underplaying others.

Persuasive definitions are especially likely to be offered with respect to concepts that cannot be defined by a set of necessary and sufficient conditions or by a disjunctive list (so that meeting one or more criteria suffices for something to fall under the concept concerned). That certainly applies to our everyday concept of *art*. Far from being a neatly definable idea, it is more a matter of overlapping family resemblances (Wittgenstein 1953, 31–33).

What is more, and worse, the concept has what Friedrich Waismann (1951) called open texture, whereby unpredictable extensions are always in principle possible. That is evident in the conceptual changes that have happened in cultural history. For instance, Danto's definition of art could not have been proffered before the early mid-twentieth century because the art world of dealers, auctions, private galleries, and collectors buying to invest did not then exist. To be sure, Leonardo and Michelangelo depended on wealthy patrons and clients; and the young Picasso was not innocent of the commercial markets of his day. But the art world as we know it now developed only later (Becker 1986).

If all that is correct, some readers may feel that any attempt to define "art" is futile. Collingwood was wasting his time, and we are wasting ours in considering his definition. That is overly dismissive. Even if a cut-and-dried definition is unattainable, a consideration of some of the candidates on offer can help us think clearly about art in general and focus on what is special (and what is not) about computer art.

Collingwood's account, like all persuasive definitions, respected certain aspects of the everyday notion while downplaying others. I suggest, in this chapter, that his emphasis on open-endedness was overdone: an artist *can* aim to write a tragedy or a celebratory poem for a wedding. Nevertheless, some degree of open-ended unpredictability is normally thought of as characteristic of art. That is so even though ongoing interaction with the medium can gradually specify a goal of the activity (Harrison 1978).

Some of his other startling claims, too, had close connections with familiar intuitions. Consider his mentalist ontology of "works of art," for example. Counterintuitive though it may seem, this was intended to emphasize the psychological work done by both artist and audience.

He was not alone in stressing this. For instance, we see in chapter 2 that Marcel Duchamp (whom Collingwood would not have regarded as a proper artist) declared, "The creative act is not performed by the artist alone; the spectator [in deciphering and interpreting it] adds his contribution to the creative act" (1957, 139). In other words, the appreciation of art is almost as creative an activity as its origination and involves many of the same mental processes. It follows that a psychological theory of creativity should ascribe largely similar mechanisms to both artist and audience. For Collingwood, these concerned the conscious conceptualization, by means of language, of preconscious emotions (1938, bk. 2). Alternatively, one may focus on the mental mechanisms underlying creativity (Boden 2004).

In emphasizing the open-endedness of art, Collingwood did not merely mean transformational creativity, which typically causes "impossibilist" surprise (the new structure having been impossible prior to the stylistic change). He also meant the unpredictability

that is involved even in the exploration of a familiar style. In addition, and crucially, he meant the unpredictability involved in trying to express a preconscious, largely inchoate, thought or emotion clearly enough to identify it—indeed, to form it—as *that* thought or emotion.

A further aspect of art that he wanted his readers to favor was its basis in emotion. Put in that way, this too is a commonly accepted criterion, and one that, at first sight, seems to preclude computers from being used as an artistic medium—but see section 6.4. We have probably all heard people refusing to accept Escher's work as art on the grounds that it is too cerebral, too mathematical—in a word, too unemotional.

But Collingwood's way of putting it was highly idiosyncratic. That is, this aspect of his persuasive definition—namely, his particularist account of the link between art and emotion—was unusual. Whereas most commentators were content to focus on the expression, communication, and elicitation of general classes of emotion, he was not. For him, art is concerned only with highly specific (and successfully specified) emotions: "Nothing will serve as a substitute. [The artist] does not want a thing of a certain kind, he wants a certain thing" (1938, 17). Moreover, that "certain thing" is an emotion experienced in its full specificity by the artist himself.

Collingwood's particularism is the aspect of his definition that is least easy to reconcile with computer art. It excludes most CG-art in principle, as we have seen, and practically all cases of CA-art too. However, it also excludes a host of examples that would normally be regarded as art—indeed, as great art. Never mind Escher and Duchamp, both of whom are regarded with deep reservations by many people. Just think of Shakespeare.

Although Shakespeare's sonnets can be seen as subtle expressions of highly specific emotions in the poet's mind, his plays cannot. There may be some passages within them in which the poet is expressing particular emotions that he has felt, but in general that is not so.

Consider, for instance, "Uneasy lies the head that wears a crown"—the cry of anguish from Henry IV, tossing restlessly in his perfumed chamber on his sleepless kingly couch. Head of his household Shakespeare may have been, but he never experienced the awesome responsibilities of kingship. Probably, he empathized with the emotions of all his fictional characters, not just Henry. But that is not the same as highly particularized imaginative construction, still less authentic autobiographical experience. Moreover, we have already remarked Collingwood's insistence that aiming to write a certain kind of text ("a comedy, a tragedy, an elegy, or the like") is not an artistic activity. Shakespeare's plays, then, count not as art but as a skillfully crafted combination of entertainment and historical or political propaganda.

In sum, computer art (more strictly CG-art) can satisfy most of Collingwood's criteria, but it falls down on his particularism. However, if it is excluded as art proper for this reason, then it is in very good company. Whether a persuasive definition of art that has no room for Shakespeare's dramas is persuasive enough to be accepted is for the reader to decide. The verdict, I suggest, should go against Collingwood.

References

Becker, H. S. 1986. *Doing Things Together: Selected Papers*. Evanston, IL: Northwestern University Press.

Bell, A. C. H. 1914. *Art*. London: Chatto and Windus.

Benjamin, W. 1936/1968. "The Work of Art in the Age of Mechanical Reproduction." Publ. in German in 1936, trans. 1968. Reprinted in *Continental Aesthetics: A Reader*, edited by R. Kearney and D. Rasmussen, 166–181. Oxford: Blackwell.

Boden, M. A. 2000. "Crafts, Perception, and the Possibilities of the Body." *British Journal of Aesthetics* 40:289–301. Reprinted in M. A. Boden, *Creativity and Art: Three Roads to Surprise*, 50–69. Oxford: Oxford University Press, 2010.

Boden, M. A. 2004. *The Creative Mind: Myths and Mechanisms*. 2nd ed. London: Routledge.

Boden, M. A. 2006. *Mind as Machine: A History of Cognitive Science*. 2 vols. Oxford: Clarendon Press.

Boden, M. A. 2007a. "Authenticity and Computer Art." In "Computational Models of Creativity in the Arts," edited by J. Jefferies and P. Brown. Special issue, *Digital Creativity* 18 (1): 3–10. A longer version is in M. A. Boden, *Creativity and Art: Three Roads to Surprise*, 193–209. Oxford: Oxford University Press, 2010.

Boden, M. A. 2007b. "Creativity and Conceptual Art." In *The Philosophy of Conceptual Art*, edited by P. Goldie and E. Schellekens, 216–237. Oxford: Oxford University Press. Reprinted in M. A. Boden, *Creativity and Art: Three Roads to Surprise*, 70–91. Oxford: Oxford University Press, 2010.

Boden, M. A. 2010. "Personal Signatures in Art." In *Creativity and Art: Three Roads to Surprise*, 92–124. Oxford: Oxford University Press.

Carroll, N. 1993. "Essence, Expression, and History: Arthur Danto's Philosophy of Art." In *Danto and His Critics*, edited by M. Rollins, 79–106. Oxford: Blackwell.

Cohen, H. 1995. "The Further Exploits of AARON Painter." In "Constructions of the Mind: Artificial Intelligence and the Humanities," edited by S. Franchi and G. Guzeldere. Special issue, *Stanford Humanities Review* 4 (2): 141–160.

Cohen, H. 2002. "A Million Millennial Medicis." In *Explorations in Art and Technology*, edited by L. Candy and E. Edmonds, 91–104. New York: Springer.

Cohen H., and B. Jacobson. 2008. *Harold Cohen: Colour Rules (9 July–15 August 2008)*. London: Bernard Jacobson Gallery, Cork Street. Exhibition catalog.

Cohen, H., M.-E. Lugo, and L. Moura. 2007. *AARON's World: 20 de Junho–28 de Julho 2007*. Lisbon: Antonio Prates, Arte Contemporanea. Exhibition catalog.

Collingwood, R. G. 1925. *Outlines of a Philosophy of Art*. Oxford: Oxford University Press.

Collingwood, R. G. 1938. *The Principles of Art*. Oxford: Oxford University Press. (References are to the paperback edition of 1958.)

Colton, S. 2012. "The Painting Fool: Stories from Building an Automated Painter." In *Computation and Creativity*, edited by J. McCormack and M. d'Inverno, 3–38. Berlin: Springer.

Colton, S., M. Valstar, and M. Pantic. 2008. "Emotionally Aware Automated Portrait Painting." *Proceedings of the 3rd International Conference on Digital Interactive Media in Entertainment and Arts (DIMEA)*, edited by Sofia Tsekeridou, 304–311. New York: Association for Computing Machinery.

Cope, D. 2001. *Virtual Music: Computer Synthesis of Musical Style*. Cambridge, MA: MIT Press.

Cope, D. 2006. *Computer Models of Musical Creativity*. Cambridge, MA: MIT Press.

Danto, A. 1964. "The Artworld." *Journal of Philosophy* 61:571–584.

Danto, A. 1981. *The Transfiguration of the Commonplace*. Cambridge, MA: Harvard University Press.

Davies, D. 2004. *Art as Performance*. Oxford: Blackwell.

Duchamp, M. 1957. "The Creative Act." In *The Essential Writings of Marcel Duchamp*, edited by M. Sanouillet and E. Peterson, 138–140. London: Thames and Hudson, 1975.

Guyer, P. 2003. "History of Modern Aesthetics." In *The Oxford Handbook of Aesthetics*, edited by J. Levinson, 25–60. Oxford: Oxford University Press.

Harrison, A. 1978. *Making and Thinking: A Study of Intelligent Activities*. Hassocks, UK: Harvester Press.

Hockney, D. 2009. "Drawing in a Printing Machine," at http://www.lalouver.com/exhibition .cfm?tExhibition_id=520. See also Cristina Ruiz, "David Hockney Swaps Oils for Pixels," Times Online, March 22, 2009, at http://www.lalouver.com/html/gallery-history-images/other-resources /hockney_sunday_times.pdf.

Kemp, G. 2009. "Collingwood's Aesthetics." In *Stanford Encyclopedia of Philosophy*, edited by E. N. Zalta. Stanford University. Article published March 4, 2009. http://plato.stanford.edu/archives /spr2009/entries/collingwood-aesthetics/.

Lewitt, S. 1967. "Paragraphs on Conceptual Art." *Artforum* 5 (10): 79–83. Reprinted in *Theories and Documents of Contemporary Art: A Sourcebook of Artists' Writings*, edited by K. Stiles and P. Selz, 822–826. Berkeley: University of California Press, 1996.

Lippard, L. R. 1973. *Six Years: The Dematerialization of the Art Object, 1966–1972*. New York: Praeger.

Lippard, L. R., and J. Chandler. 1968. "The Dematerialization of Art." *Art International* 12 (2): 31–36.

O'Hear, A. 1995. "Art and Technology: An Old Tension." In *Philosophy and Technology*, edited by R. Fellows, 143–158. Cambridge: Cambridge University Press.

Reichardt, J. 2008. "In the Beginning...," In *White Heat Cold Logic: British Computer Art 1960–1980*, edited by P. Brown, C. Gere, N. Lambert, and C. Mason, 71–81. Cambridge, MA: MIT Press.

Ridley, A. 1998. *R. G. Collingwood: A Philosophy of Art*. London: Orion Books.

Ridley, A. 2003. "Expression in Art." In *The Oxford Handbook of Aesthetics*, edited by J. Levinson, 211–227. Oxford: Oxford University Press.

Riecken, D. 1992. "Wolfgang: A System Using Emoting Potentials to Manage Musical Design." In *Understanding Music with AI: Perspectives on Musical Cognition*, edited by M. Balaban, K. Ebcioglu, and O. Laske, 206–236. Cambridge, MA: AAAI/MIT Press.

Sequin, C. H. 2005. "Rapid Prototyping: A 3D Visualization Tool Tasks on Sculpture and Mathematical Forms." *Communications of the ACM* 48 (6): 66–73.

Sims, K. 1991. "Artificial Evolution for Computer Graphics." *Computer Graphics* 25 (4): 319–328.

Stevenson, C. L. 1938. "Persuasive Definitions." *Mind* 47 (187): 331–350.

Todd, S. C., and W. Latham, W. 1992. *Evolutionary Art and Computers*. London: Academic Press.

Tolstoy, L. 1899. *What Is Art?* Translated by A. Maude. London: W. Scott.

Waismann, F. 1951. "Verifiability." In *Logic and Language (First Series)*, edited by A. G. N. Flew, 117–144. Oxford: Blackwell.

Wittgenstein, L. 1953. *Philosophical Investigations*. Translated by G. E. M. Anscombe. Oxford: Blackwell.

7 The Gothic and Computer Art

Margaret A. Boden

7.1 Introduction

At first sight—and maybe on further examination, too—computer art (C-art) and the Gothic are worlds apart. Twenty-first-century technology and medieval cathedrals: what can these things possibly have in common? Even if they could be shown to share some features, surely the differences between them are immeasurably greater?

And anyway, who cares? Why does it matter? Computer art is worlds apart from stone axes, too—but why would anyone bother to say so?

Well, they would not. No one has centered an entire account of art on Neolithic axes. The Gothic, however, is different. One hugely influential aesthetic theory takes it as the pinnacle of art. Moreover, this theory has entered so deeply into our culture that certain aspects of it are widely regarded as simple common sense. Accordingly, people who have principled or prejudiced reservations about the enterprise of C-art often base their criticism on the many differences between these two genres.

Comparing them carefully, then, may help us understand the widespread suspicion of computer art that is found in the art world (see chapter 8). It may enable us to see some (largely unsuspected) continuities between them. It may even help us understand, at least for some cases, why a computer artist has chosen to endow his or her artworks with *this* feature or *that* one.

7.2 Treading in Ruskin's Footsteps

When people speak of Gothic art today, they are sometimes referring only to architecture: buildings rich with pointed arches under steeply gabled roofs and perhaps with grotesque gargoyles. Often, however, they mean dark near-horror stories in literature or film—like Mary Shelley's *Frankenstein* and Emily Bronte's *Wuthering Heights* or Roman Polanski's *Rosemary's Baby*. Or they may be thinking of music with a wildly depressing

emotional tone. They may even have in mind deliberately ghoulish fashions in dress, jewelry, and cosmetics.

But what do wild passion and black lipstick have in common with gables and pointed arches? Today's arrestingly somber Gothic clothing is utterly unlike the colored jerkins, elegant wimples, and flowing gowns of medieval times. So why are all these very different things given the same label? The answer lies in the concept of Gothic art defined by John Ruskin (1819–1900) a century and a half ago.

Ruskin's 1853 essay "On the Nature of Gothic Architecture" first appeared as a chapter tucked away inside the second volume of his hugely detailed treatise *The Stones of Venice*. But it did not stay tucked away for long. It was reprinted as a separate item—with a laudatory introduction by William Morris—only a year later and has remained in print ever since. It has long outlasted the fact-filled introductory chapters, which were reissued many times as guides "for the use of travellers while staying in Venice and Verona" (Ruskin 1854). And it has influenced aesthetics very widely. Its message was potentially relevant not merely to architecture or Venice but to art *in general*.

Ruskin was not the first to recommend Gothic styles in architecture. Claiming that the destruction of civilized Rome by the barbarian Goths had led Renaissance thinkers to use "Gothic" as "a term of unmitigated contempt" (1854, 4), he allowed that Gothic styles had recently been "vindicated" by the antiquaries and architects of his own century. One of those architects was Augustus Pugin, who had initiated the nineteenth-century revival of medieval styles in architecture and in internal decoration too (Clark 1962). The wallpapers, furniture, and door carvings in the Houses of Parliament today were mostly designed by Pugin. And Pugin himself had been preceded by Johann von Goethe (1980), whose essay on Strasbourg Cathedral had favored Gothic style over neoclassicism.

Nor was Ruskin's influence needed for the rise of the Gothic approach in literature. Horace Walpole had written *The Castle of Otranto* almost a century earlier, and Emily and Charlotte Bronte had respectively published *Wuthering Heights* and *Jane Eyre* several years before *The Stones of Venice* went to press (Hogle 2002). Moreover, Romanticism (and Goethe) had long celebrated the sublime wildness of "Nature" and the creative freedom of the human spirit—both key themes in Ruskin's writing.

In those senses, then, he was going with the tide: following the taste of the time, not forming it. But he did offer something genuinely new: an explicit defense of Gothic as the very *paradigm* of art, supported by a savage denunciation of the effects of the Industrial Revolution—alias the machine—on art makers.

Ruskin was not just categorizing; he was prescribing. He saw the Gothic as the best type of art, the pinnacle of human achievement. All other forms were inferior. This was not a matter of superficial beauty: visual glories, he admitted, had been offered by

Assyrian, Egyptian, Romanesque, and Renaissance art too. Rather, it had to do with the human and cultural values expressed (often unselfconsciously) in artworks by the people who made them.

Ruskin's concept of art makers was also unusual. It included unknown stonemasons and carvers as well as the famous artists named in the history books and romanticized as geniuses in garrets. In other words, his aesthetics respected craftworks as well as fine art. Plato, too, had classified artists and craftsmen together, as makers of objects requiring techne, or skill (*Gorgias* 503e). But the rise of fine art (and professional artists) as a social institution since the Renaissance had driven a cultural wedge between the two. Ruskin's approach implied that, to the contrary, there is no fundamental distinction between them.

There is, in fact, a distinction here but not one that can be used to assign every artifact to one class or the other (Boden 2000). Craftworks draw on evolved perceptual affordances, whereas fine art involves creative processes that exploit rich cultural, not evolutionary, resources. But these differing psychological mechanisms can occur in the mind simultaneously and so generate many mixed or borderline cases.

Tellingly subtitled "And Herein of the True Functions of the *Workman* in Art" (my italics), this key essay was an impassioned argument that the only art truly worthy of respect is informed by the idiosyncrasies of the individual artist or worker who freely, and pleasurably, created it with his own hands. In other words, the primary focus was not on visual styles (pointed arches and the like) or even on the religious beliefs visually depicted in them (angels, mangers, Madonnas, and so on) but on the moral-psychological climates within which art objects arise and that make them possible. Only Gothic art, grounded in Christian beliefs and values, Ruskin argued, respected the creativity of every human individual instead of degrading humble workers into machines.

A few years later, his allegiance to dogmatic Christianity, and especially to the evangelical Protestantism in which he had been raised, was shattered (Landow 1971, chap. 4, sect. ii). And his sensitivity to art was partly responsible. He had doubted the literal truth of the Bible ever since he was fourteen and the existence of an afterlife as a young adult. But one Sunday in 1858 he became, as he put it, "a conclusively un-converted man." He attributed this to two contrasting experiences during a visit to Turin. The first was his being "overwhelmed" by Paul Veronese's painting *Solomon and the Queen of Sheba*, which celebrated sensuous—and sensual—beauties decried by Protestantism; the second, just a few hours later, was the joyless sermon preached in the gloomy fundamentalist chapel nearby, promising eternal damnation to all who failed to share the beliefs of the twenty souls gathered there. But his Christian commitment to the dignity of every human individual remained. If anything, it grew even stronger.

It was this aspect of his thought that spread Ruskin's views way beyond aesthetics, narrowly defined. His chapter influenced not only art criticism but politics too. Others before him had denounced industrialization, of course—William Blake, for one. But Ruskin focused especially on its demeaning sociocultural effects for manual laborers, insisting that society's elite—including all true lovers of art—should approach them and their works of art or craft not only with human sympathy but also with profound respect.

One important artist and social thinker who was inspired by these thoughts was William Morris. He and Ruskin were the key founders of the Arts and Crafts movement, still visible today in the flourishing tradition of craftwork in Great Britain (and its downmarket offshoots in village craft fairs and National Trust shops). They were crucial, too, within several protosocialist political groupings that eventually led to the rise of the Labour Party.

In addition, they encouraged the formation of anti-industrial communes focused on traditional self-sufficiency. Now, such communities are largely justified in terms of scientifically based ecological or environmental concerns. But their original impetus was a deep-rooted suspicion, even rejection, of "the machine." Ruskin and Morris were not the first to provide inspiration here: Charles Fourier and Robert Owen (both born in the early 1770s), for instance, predated them. But they provided additional, and powerful, ammunition for the cause.

Over and over again, in his chapter on the Gothic (and elsewhere), Ruskin bemoaned mechanization's growing influence on many aspects of culture. Even more than its potential for misery-making social upheaval of various kinds (rural despoliation, mass relocation to city slums, and uncongenial work patterns such as night shifts), he rued the tendency for industrialization to degrade the workman into the image of the machine. Indeed, he projected this notion backward in time when criticizing much preindustrial art: his prime complaint about classical and neoclassical architecture, as we see in section 7.4, was that it had forced the artisans (workmen) of previous centuries to behave almost as though they were machines, not free and fallible human beings.

Clearly, then, no one could be less sympathetic to the ethos of computer art than Ruskin. "So what?" you may ask. "Why should we care about the views of this long-dead Victorian worthy?"

The reason is that they underlie much of the suspicion of C-art that holds sway in the art world and especially among the general public today (see chapter 3). Many of his ideas about art are now taken for granted by people who have never even heard of him.

That is not to say that his passion for the Gothic style was shared by all who came after him: a leading art historian remembers that in the 1920s it was "a kind of architecture

which everyone agreed was worthless" (Clark 1962, 2). At that time, of course, minimalist and abstract art were in the ascendant. Nor is it to say that his stress on *art making* was echoed by all. It was countered, for instance, by the aesthetics of pure form developed by Roger Fry (described by the same historian as "incomparably the greatest influence on taste since Ruskin" [Clark 1949]) and also by Marcel Duchamp's *Fountain* and all other ready-mades.

Still less is it to say that his ideas are right (and this chapter does not argue that they are). However, they are so widespread that most readers will probably have some sympathy with them.

It is worth asking, then, whether any type of C-art can be defended in light of his position. In short, does his work imply that computer art is an inescapably inferior form of art or, worse still, a deeply deceptive illusion, not really *art* at all?

7.3 The Six Principles of Gothic Art

Ruskin defined Gothic art in terms of six principles. Or rather, he identified two parallel sets (1–6 and 1′–6′) concerning *art objects* and *art making*, respectively. In other words, the six or twelve principles referred not only to the perceptible features of the finished artwork but also—and more important—to the spirit in which it was made. In particular, they were focused on how this art making reflected the humanity (including the religious and political culture) of the artist or artisan as an individual.

In order of importance, said Ruskin, the six overt characteristics of Gothic architecture were (1854, 4)

1. Savageness
2. Changefulness
3. Naturalism
4. Grotesqueness
5. Rigidity
6. Redundance

Those perceptible features, he said, characterize Gothic buildings. As applied to the builders (artisans and artists), instead of the buildings (art objects), they were psychological rather than purely aesthetic. Considered as "moral elements," they were

1′. Savageness, or Rudeness
2′. Love of Change
3′. Love of Nature

4'. Disturbed Imagination

5'. Obstinacy

6'. Generosity

Lacking any one or two of these principles, Ruskin said, an artwork could nevertheless be regarded as Gothic. But absence of the majority of them would exclude it. In fact, the criteria are not mutually independent, as Euclid's axioms are: taking the first one seriously leads to all the rest. For Ruskin, such exclusion would imply that it was an inferior artwork—although it might be a perfect instance of an inferior *type* of art.

His explanations of what he meant by his definition of Gothic took up many pages of delectably purple prose. Those pages were necessary because his parallel lists (1–6 and 1'–6') must be interpreted with caution. As we will see, some of the everyday words used in them were intended in an unusual way. "Rigidity," for example, did not mean what is normally understood as rigidity; "Generosity" did not quite mean generosity; and "Obstinacy" did not mean obstinacy.

It followed from Ruskin's six principles—or rather, it was a presupposition of all of them—that Gothic art should "both admit the aid, and appeal to the admiration, of the rudest as well as the most refined minds" (34). Given his position as a highly refined member of the Victorian elite, this attitude is perhaps surprising. But it was all of a piece with his protosocialist politics.

In applying his ideas to C-art, we must bear in mind three dimensions: what he said about the style and content of artworks, what he said about the artists and artisans who made them, and what he said about the general accessibility of art.

A caveat, before we begin: Sections 7.4–7.9 consider the extent to which C-art satisfies Ruskin's six principles. The question of whether C-art is, indeed, *art* is taken up in section 7.10—where we see that Ruskin himself would not have allowed that it is and that his followers today do not do so either.

7.4 Savageness

The "unmitigated contempt" for Gothic architecture that lasted from the Renaissance to the early nineteenth century had been largely driven, Ruskin said, by aversion to its "rude and wild" nature. One might have expected him to counter that apparently unflattering description. On the contrary, however, he insisted on it: "It is in this very character that it deserves our profoundest reverence" (1854, 4). In other words, the first—and, he said, the most important—principle of Gothic art is Savageness, or Rudeness.

The wildness of the landscape and climate of northern Europe ("mighty masses of leaden rock and heathy moor…splintering into irregular and grisly islands amidst the northern seas, beaten by storm, and chilled by ice-drift" [5]) was compared *favorably* to the "great peacefulness of light…laid like pieces of a golden pavement into the sea-blue" of Syria, Greece, Italy, and Spain. The "shaggy" wolf, bear, and Shetland pony were similarly favored over the "multitudes of swift and brilliant creatures" of Africa and the Mediterranean. And whereas southern architecture naturally employed "burning gems" and "smooth [soft-sculptured] jaspar pillars," the northern workman must "with rough strength and hurried stroke, smite an uncouth animation out of the rocks which he has torn from among the moss of the moorland." In short, Savageness involved "creations of ungainly shape and rigid limb, but full of wolfish life" (6).

These deserved from us "no reproach…but all dignity and honourableness." Gothic architecture also possessed a "higher nobility" when considered as "an index, not of climate, but of religious principle." In other words, the Savage style and material of Gothic art (principle 1) was paralleled by the Savage human spirit that made it (principle 1′). And there "Savageness" was contrasted with "servility."

Servility or its lack was visible in the manner of ornamentation employed in the artwork. The most servile school of art, he said, was that of classical Greece. Here, "the execution or power of the inferior workman is entirely subjected to the intellect of the higher." Because perfection was required, ornamentation was reduced to "mere geometrical forms—balls, ridges, and perfectly symmetrical foliage." These could be made with absolute precision "by line and rule"—so that the workman was, in effect, "a slave" (6).

Medieval cathedrals, by contrast, neither showed nor demanded such regularity and perfection. This was only partly due to the recalcitrance of the materials. It was due also, he said, to the Christian religion, which recognizes the individuality, and the fallibility, of every human soul. Each workman can do his own thing—but he will very likely do this imperfectly ("rudely"). And those imperfections, as evidence of the human freedom that led to them, are to be valued *for their own sake*. Indeed, "the principal admirableness" of the Gothic cathedrals was that they were made by "the labour of inferior minds, and out of fragments full of imperfection…, [which] raise up a stately and unaccusable whole" (7). So an aesthetics that demands perfection is an inferior aesthetics. It did not follow that maximal Savagery or Rudeness produces the best art, for *superior* minds make fewer errors: "Delicate finish is desirable from the greatest masters, and is always given by them" (11).

Christianity implies that even inferior minds are worthy of respect and capable of improvement: "[In] every man, however rude and simple, whom we employ in manual

labour, there are some powers for better things: some tardy imagination, torpid capacity of emotion, tottering steps of thought.... But they cannot be strengthened...unless we prize and honour them in their imperfection above the best and most perfect manual skill" (7).

It follows that we should take a certain attitude toward workmen, in whatsoever sphere—an attitude that was all too rare in Victorian England (and, dare I say it, also today). "What we have to do with all our labourers," he said, is "to look for the *thoughtful* part of them." Inevitably, if we do that, we will see errors. If you encourage a workman to think for himself, as opposed to always (for instance) cutting a perfectly straight line, "his execution becomes hesitating; he thinks, and ten to one he thinks wrong." But if you do allow this freedom, "you [will] have made a man of him for all that. *He was only a machine before, an animated tool....* Let him but begin to imagine, to think, to try to do anything worth doing; and the engine-turned precision is lost at once" (8; italics added).

Accordingly, his rejection of the then-popular neoclassical style—"a wearisome exhibition of well-educated imbecility" (7n)—was based not only on a critique of the visible forms involved (blandly perfect rather than "rudely" interesting; see principle 1) but also on a complaint about the diminished experience of the workmen who made them (principle 1'). These artisans had been denied the opportunity to exercise creativity in their work and to take pride in it accordingly. Neoclassicism had thus involved "the degradation of the operative into a machine" whose only pleasure in his work was to gain wealth (9).

Expressing this in political terms, Ruskin declared, "The great cry that rises from all our manufacturing cities, louder than their furnace blast, is all...for this—that we manufacture there everything except men;...to brighten, to strengthen, to refine, or to form a single living spirit never enters into our estimate of advantages" (10). And the remedy, he said, is for the moneyed classes to consider "what kinds of labour are good for men, raising them, and making them happy."

They may then adapt their habits of consumption, being prepared "[to sacrifice] such convenience, or beauty, or cheapness as is to be got only by the degradation of the workman; [and to demand] the products and results of healthy and ennobling labour." So we should "never encourage the manufacture of any article not absolutely necessary, in the production of which *Invention* has no share" (10). Moreover, because self-directed manual labor is intrinsically honorable, no one should avoid it: "The painter should grind his own colours; the architect work in the mason's yard with his men; the master-manufacturer be himself a more skilful operative than any man in his mills" (13).

Clearly, it was no accident that Ruskin was a hero to early socialists and to the Arts and Crafts movement too. But can he be a hero for C-artists as well? Can he even be seen as a sympathetic voice?

His stress on the value of imperfections in artworks sits uneasily with computer art. To be sure, imperfections and errors can occur in C-art: see the discussion of the Grotesque in section 7.7. Nevertheless, C-art aims for and often achieves a certain kind of perfection. In Ruskin's terms, then, it counts as an inferior type of art. However, so do classical and neoclassical art, as we have seen. And so do more modern forms, such as Abstract art, Surrealism, Minimalism, and Conceptual art—none of which satisfies his six principles.

Computer art faces an extra hurdle, which most (although not quite all) other examples of modern art do not have to negotiate. Namely, it is thought of as machine made rather than manmade. This flies in the face of Ruskin's assumptions about art in general and also challenges his emphasis—in principles 1 and 1'—on the hand of the human maker.

"Hand," here, is meant literally. Ruskin's respect for manual labor—which he recommended for *everyone*—did not prevent his also valuing intellectual work. C-art involves plenty of that—and "Invention," too (see chapter 10.) But he did attribute a special dignity to manual labor, and the work of C-artists does not usually involve that. Finger tapping on keyboards does not count. Robotic art, or R-art (see chapter 2), is an exception: Edward Ihnatowicz's *Senster*, for instance, drew much of its aesthetic impact from its hand-engineered Meccano-like frame (Zivanovic 2005). In general, however, the work required for C-art is intellectual rather than manual.

Ruskin made great play of the fact that manual labor (stone masonry, for instance) leaves the marks of the individual workman on it. Those marks do not pronounce merely that *some* human being made the object but that *this* (perhaps anonymous) human being made it. Anyone else would have done it somewhat differently. As he put it, "In a design which cannot be mathematically defined, one man's thoughts can never be expressed by another" (12). Here, he was thinking of the impossibility of carrying out instructions from a master artist of the Gothic (as opposed to classicism) without thereby adding one's own mark. But the point generalizes to the master artists themselves. Indeed, the stylistic differences found *within* a Gothic cathedral were due, he said, to there being successive architects over the years.

At first sight, this criterion, too, sits uneasily with computer art. Indeed, some of the early C-artists thought as much and embarked on C-art precisely to minimize—or, in Paul Brown's case, even to lose—their own personal signature. But it turned out that,

for very general psychological reasons, this was much easier said than done (Boden 2010). Even using the randomizing methods of Evo-art may not entirely destroy the personal traces of the original artist (see also chapter 5). In short, C-artists, like cathedral architects, leave marks of their individuality in their work. That is especially true of CA-art, in which the formative hand of the human artist is nearer. But it applies to CG-art as well.

As we have seen, Ruskin had political reasons for lauding manual labor and for conflating the categories of art and craft. He wanted to resist Victorian society's tendency to value only people who do intellectual work (or, of course, none at all). In his words, "We are always in these days endeavouring to separate [manual labour from intellect]; we want one man to be always thinking, and another to be always working, and we call one a gentleman, and the other an operative; whereas [each should be doing both], and both should be gentlemen, in the best sense" (12).

Here, C-art is not in a strong position. It not only rarely involves nonintellectual labor but is done primarily (only?) by highly educated people. The increasing spread of personal computers and the growth of Net-art (see chapter 2), may ameliorate this to some extent. But it will remain true that only a relatively privileged group of people will have the opportunity to do C-art. That is so whether we consider only professional C-artists or also people doing Net-art in their leisure time (as Ruskin would have put it, "by the wayside").

That fact relates to the third dimension of comparison between the Gothic and computer art: their general accessibility. Can C-artworks be understood and appreciated by the public at large? This question is explored at length in chapter 4. Here, let us just note that some aspects of the appreciation of C-art may not be possible for people with no knowledge of programming or of how the computer system involved actually works. Insofar as that is so, C-art is elitist to a degree that Ruskin would not have approved and that did not apply to his beloved cathedrals.

7.5 Changefulness

Ruskin defended Changefulness, or variety, in two ways: sociopolitical and aesthetic (14–19).

On the one hand, he saw it as an inevitable consequence of "allowing independent operation to the inferior workman," which should be done "simply as a duty *to him*" (14). For "wherever the workman is utterly enslaved, the parts of the building must of course be absolutely like each other; for the perfection of his execution can only be

reached by exercising him in doing one thing, and giving him nothing else to do" (14). We have only to look at a building of classical Greece, for instance, to see that "all the capitals are alike, and all the mouldings unvaried," which shows that "the degrading [of the Greek workman] is complete." By contrast, the freedom of the Gothic workman is evident in the "perpetual change both in design and execution" of the medieval cathedrals.

On the other hand, perpetual variety in architecture is intrinsically rewarding for those who experience it, if they are not brainwashed by academic or neoclassical architects into scorning it. The Gothic cathedrals, he argued, show exceptional stylistic variety. In part, this was because, over the decades, a new architect would take over on another's death. But it was primarily due to principle 2' on his list, the "Love of Change" that he saw as being peculiar to the Gothic spirit. This was "a strange *disquietude*, … [a] restlessness of the dreaming mind, that wanders hither and thither among the niches, and flickers feverishly around the pinnacles, and frets and fades in labyrinthine knots and shadows along wall and roof, and yet is not satisfied, nor shall be satisfied" (19).

His readers, he said, had been taught to value the predictability of the classical triglyph furrow (part of a Doric frieze) over the diversities of fretwork. But they were willing to appreciate variety in "every other branch of art." What they needed to learn was to enjoy "reading a building as we would read Milton or Dante, and getting the same kind of delight out of the stones as out of the stanzas" (15). For "great art, whether expressing itself in words, colours, or stone, does *not* say the same thing over and over again; … to repeat itself is no more a characteristic of genius in marble than it is of genius in print; and we may … require of an architect, as we do of a novelist, that he should be not only correct, but entertaining."

Thus far, C-artists might well agree. Although their love of change might be less pressing than the Gothic love of Change. After all, a CG-art program typically generates indefinitely many different, and unique, works. Indeed, this is a large part of the point of the exercise (which is why CG-art is ill suited to expressing highly *particular* emotional experiences; see chapter 4). And the official catalog of the pioneering *Cybernetic Serendipity* exhibition made a point of saying that it showed "the links between the random systems employed by artists, composers and poets, and those involved in the use of cybernetic devices" (Reichardt 1968, 5). Moreover, many C-artists since then have used randomness as a key feature of their work.

But some have not. Ernest Edmonds, for example, says, "In my mind, randomness … is inherently uninteresting. My goal was to make work that is complex enough to be

engaging, but not so complex as to seem random" (2008, 351). In other words, variety and unpredictability are to be valued, but not if they arise merely from randomness. Ordered complexity can be engaging or, as Ruskin put it, "entertaining."

Here, however, we encounter a glaring disagreement between C-artists (whether or not they use randomness) and Ruskin. For Ruskin went on to say what he declared to be self-evident: "Nothing is a great work of art, for the production of which either rules or models can be given. Exactly so far as architecture works on known rules, it is not an art, but a manufacture" (16). What he had in mind were the five orders of architecture, defined by Academicians, and Corinthian, Doric, and Ionic capitals. A good architect, he said, should no more aim to reproduce these faithfully than a good painter would copy heads and hands from Titian.

Ruskin was not, and still is not, the only one to think it self-evident that art cannot be entirely rule driven. Immanuel Kant (1952, sect. 46), for example, had insisted that no definite rule can capture artistic genius. Many people will grant that art can, to some extent, be rule based. Any artistic style is, in effect, a system of generative rules whose potential is explored by artists (Boden 2004). But because many details are not specified by the style, room is left for significant variety in the art objects.

That variety is widely taken as evidence that strict, exceptionless rules are not in play. This evidence, however, is not conclusive. As Edmonds's remark implies, rule-based complexity—if complex enough—can lead to unpredictable and aesthetically "engaging" variety. Moreover, the phenomenon of the artist's *personal signature* suggests that there are extrastylistic rules, specific to individual artists, that select one variation rather than another during the execution of the work (Boden 2010). Ruskin himself pointed out that "every successive architect, employed upon a great [cathedral], built the pieces he added in his own way, utterly regardless of the style adopted by his predecessors" (18).

He assumed, of course, that the variety arises primarily from the free spontaneity of the human artist—something that can never be understood by science or modeled in machines. I say primarily because he allowed that some of the variety in Gothic architecture results from "practical *necessities*" (18; italics added). Many people today would agree with him. For them, CA-art leaves room for the exercise of human freedom, but CG-art does not. Or rather, the CG-artist acts freely in writing the program (see chapter 10), but the subsequent generation of the art object by the program is a matter of rules, not freedom.

This is not the place for a *computational* analysis of human freedom (but see Boden 2006, 7.i.g; Dennett 1984). Suffice it to say that Ruskin's belief about the (ruleless) origin of variety in art, despite his claim to self-evidence, is *not* obviously true.

7.6 Naturalism

By Naturalism, Ruskin meant "the love of natural objects for their own sake, and the effort to represent them frankly, unconstrained by artistical laws" (19). So the highly stylized leaves and flowers of Eastern art, although admittedly beautiful, were—for him—aesthetically inferior to the more realistic foliage seen in Gothic art.

What counts as representing nature "frankly" is not clear. It does not imply slavish copying, so it leaves many stylistic options open. In Ruskin's day, it ran from carefully depicting every dewdrop on a peach (as in a sixteenth-century Dutch still life) and every petal in every flower (as in a medieval tapestry or a painting by the Pre-Raphaelite brotherhood) to giving a seemingly wild, yet realistic, impression of a sunrise (as in a canvas by William Turner). Mimesis, in other words, can be achieved in very different ways.

Jumping 150 years, to our day, do any examples of C-art represent nature frankly? Arguably, several stages of Harold Cohen's line-drawing AARON program aimed to do so—with increasing success. And AARON, of course, is an example of CG-art, not CA-art. It owes nothing to the real-time guidance of the artist's hand.

Even the relatively minimalist AARON of the early 1970s suggested 3-D solidity (weighty rocks scattered around), and occlusion was soon added. AARON's pictures of the 1980s contained human figures in realistic attitudes; for instance, an acrobat balancing tiptoe on a medicine ball would have arms extended in a physically plausible way. The acrobats' faces, however, were merely formulaic, and there was no overt depiction of the ground plane. By the late 1980s, human figures could be placed among broadly realistic jungle foliage, with the ground plane now filled appropriately. Next, a different type of human figure became possible, with self-occlusion—someone's arm lying across the person's own body, for example—and very much more detailed faces. The latest versions of AARON are less realistic, the focus now being on color, not human or floral figures; even so, these seemingly abstract images still carry a suggestion of 3-D foliage.

The acrobat line drawings are reminiscent of Pablo Picasso's Vollard Suite: minimalist cartoons rather than full-fleshed portraits. Ruskin would not have regarded them as representing nature "frankly." And he would have been even more critical of Picasso's distorted bulls and human bodies and faces. But one might want to say that AARON's human-figure drawings, and the Vollard images too, are *frank* and nearly *full* representations of nature. They are not aiming at every-petal accuracy, to be sure. But they are aiming at, and achieving, some degree of verisimilitude.

One form of C-art, namely VR-art (defined in chapter 2), does sometimes aim for every-petal accuracy. Or rather, it sometimes aims for every-petal *depiction* while

also ensuring that some aspect of the virtual world is perceptibly *unlike* the real world. An extreme example is the animated teddy bear in Steven Spielberg's (appallingly bad) film *AI*, every one of whose thousands of hairs is individually depicted and individually movable. In principle, a VR-artist enthralled by the wonders of Nature could offer us computer-generated (CA or CG) lions, butterflies, or dinosaurs represented on that level of detail. Only in principle, however; because achieving such highly detailed VR is inordinately complex and expensive, and so it is not something that a lone artist or a small art group could undertake. But the main point stands: VR-art can express "the love of natural objects for their own sake" and can exemplify "the effort to represent them frankly, unconstrained by artistical laws."

Some other cases of CG-art can be seen as celebrations of nature and even as realistic depictions of it. Several (Evo-art) examples of this attitude can be mentioned in relation to Generosity. However, these are—at best—*frank*, not *full*. Judged by principles 3 and 3', they are much inferior to Gothic art.

With respect to the dimension of accessibility, all these examples of CG-art (and comparably realistic examples of CA-art) can be appreciated by the general public. Spielberg's teddy bear, like Walt Disney's Mickey Mouse, was enjoyed by many millions. And Richard Brown's *Mimetic Starfish*—a CI-art installation wherein a huge starfish seemed to be trapped inside a transparent table, moving (in lifelike ways) in response to the voices and movements of the people around it—attracted large audiences when exhibited in London's Millennium Dome; it was even described in the *Times* (London, January 8, 2000) as "the best thing in the Dome." Whether computer art works depicting or celebrating nature can be *near fully* appreciated by the public, as a Pre-Raphaelite painting (for instance) can, is another matter. Again, the issues involved here are explored in chapter 4.

7.7 The Grotesque

The fourth aesthetic principle named by Ruskin was the Grotesque, defined as "the tendency to delight in fantastic and ludicrous, as well as in sublime [i.e., beautiful], images" (32).

Put like that, there seems to be no reason why C-art could not encompass the Grotesque. Even CG-art could satisfy this desideratum. If AARON had been programmed to depict gryphons instead of acrobats or heads composed of vegetables (after Giuseppe Arcimboldo) instead of realistic faces, the results would have been fantastic and ludicrous for sure. William Latham, arguably, has already succeeded (Todd and Latham 1992). One of his Evo-art projects generates myriad images of strangely shaped and rainbow-colored creatures, resembling nightmarish marine invertebrates even more

bizarre than gryphons. And VR-artists could "delight" in computer-generated worlds containing not only unfamiliar experiences (such as flying or activating highly unnatural causal chains) but "fantastic and ludicrous…images" as well.

As for CA-art, in which the initial images and the modifications are provided by the artist, there is even less of a problem. A graphics program such as Photoshop can be applied to any image, whether fantastical or beautiful or simply banal.

But when giving the definition of Grotesque, Ruskin added that this tendency toward the grotesque is "a universal instinct of the Gothic imagination." Why did he insist on it? Could someone not delight in gables and pointed arches without also delighting in the grimacing gargoyles and fabulous beasts around them?

His answer lay in the moral-psychological interpretation of the principle: in 4′ rather than in 4. "Disturbed Imagination" did *not* mean hallucinations or madness. On the contrary, Grotesque (i.e., "fantastic and ludicrous") imagery inevitably arises in everyday, artisanal creativity and is appreciated by creator and viewer alike because of the recognition of the humanity of the art maker. To reject it because it is not "beautiful" would be to show scant respect for the workman involved. This was not just a question of good manners, of avoiding insult to someone of an inferior social status whose "artistical efforts must be rough and ignorant, and their artistical perceptions comparatively dull" (48). The Grotesque is positively valuable as an expression of human individuality and fallibility.

In other words, fellow feeling with another human being, not academicians' principles of beauty, should ground our aesthetic response: "However much we may find in [nonprofessional art or craft] needing to be forgiven, [it is] always delightful so long as it is the work of good and ordinarily intelligent men. And its delightfulness ought mainly to consist *in those very imperfections* [italics in source] which mark it for work done in times of rest.…*It is to the strength of [the viewer's] sympathy, not to the accuracy of his criticism, that it makes appeal*" (49; italics added).

The Grotesque can also be valued because of the playful or humorous intent that often lies behind it: "Now it is not possible, with blunt perceptions and rude hands, to produce works which shall be pleasing by their beauty; but it is perfectly possible to produce such as shall be interesting by their character or amusing by their satire. For one hard-working man who possesses the finer instincts which decide on perfection of lines and harmonies of colour, twenty possess dry humour or quaint fancy…because *these are exercised in our daily intercourse with each other, and developed by the interest we take in the affairs of life*, while the others are not" (48; italics added).

Twentieth-century art offers many examples of "fantastic and ludicrous" graphics driven by "dry humour or quaint fancy." Some of these are inspired by science fiction or fantasy novels. Less exotic (less Grotesque) examples include Beryl Reid's paintings

of bars and dance halls, Donald McGill's saucy seaside postcards, and Disney's Mickey Mouse. Were he alive today, Ruskin would not laud these things (largely because they are not sufficiently naturalistic; see principles 3 and 3′). But he would probably be less snobbish about them than many self-professed art lovers are. He had little patience with elitist attitudes that refuse to treasure the Grotesque alongside the conventionally beautiful: "No man can indeed be a lover of what is best in the higher walks of art, who has not feeling and charity enough to rejoice with the rude sportiveness of hearts that have escaped out of prison, and to be thankful for the flowers which men have laid their burdens down to sow by the wayside" (49).

Admittedly, Reid, McGill, and Disney had not escaped from the "prison" of industrialized manual labor, and they did not produce their work "by the wayside" (at leisure). Mickey Mouse and Reid's dancers were professionally produced, not casually whittled at the fireside like a child's pennywhistle. So Ruskin might well criticize their art more sternly than that of uneducated amateurs when it fails to satisfy conventional criteria of Naturalism or beauty. But as ever, his basic criticism would be of the artists (for not fulfilling their human potential despite their many social advantages), not of the Grotesquerie of the artworks considered in themselves; that is, principle 4′ rather than 4.

What of computer art, in this context? Ruskin saw three aspects of human artistry reflected in the Grotesque: error, humor, and playful fantasy. The last of these can be expressed in CG-art, as the example of Latham's disturbing creepy-crawlies attests. Images much less "fantastic" than these can also be seen as the result of playfulness, albeit in pursuit of a specific artistic goal. Even relatively minimalist CG-art, such as Edmonds's ever-changing color juxtapositions, can be seen as playful although not as fantasy.

Humor is more difficult to translate into CG terms. It is more likely to be expressed in images of human beings or animals—their interactions or their facial expressions—than in images of inanimate objects or abstract patterns. Although the latter is also possible: the impulse to anthropomorphize the movements of even highly abstract images is very strong (Heider and Simmel 1944; Weir 1974). In principle, The Painting Fool (described in chapter 6) could be nudged toward generating humorous images—perhaps by basing some of the facial distortions that are made by the program on anatomical caricature rather than on exaggerated emotional expression. Indeed, caricature-drawing programs may already exist.

But here we run up against the principle 4 versus 4′ distinction again. A program that automatically enlarges a face's ears, whenever it notices that the (real) ears are somewhat larger than usual, is not being driven by "dry humour" or "interest in the affairs of life." Possibly the C-artist responsible for it was so driven. But will the audience respond to its CG-images accordingly? The more suspicious they are of C-art in general, the less likely they are to read genuine humor into the computer graphics.

There is genuine humor in many animations, of course—Mickey Mouse, for one. But Mickey was hand drawn, frame by painstaking frame. Computerized animation tools, such as programs that generate the intermediate stages between one body attitude and another, can produce humorous results. However, the initial and final images have to be carefully chosen, and the in-betweening algorithm may have to be specially adapted too. So these examples are best thought of as CA-art wherein the humor comes almost directly from the human artist.

As for error, there is one sense in which this is impossible within C-art. The program (any program) does what its instructions tell it to do. That is true even if there is a bug in it. In brief, programs cannot make errors.

But people can. And C-artists are as prone to human error as anyone else. Occasionally, the error is clear—and also (as Ruskin suggested) endearing. For instance, an early program written by John Lansdown (a cofounder of the Computer Arts Society) generated choreographic sequences for fencing duels. When these were interpreted by Shakespearian actors, accustomed to performing choreographed duels, they were surprisingly realistic—except that, every so often, one actor would stand still with his arms spread, leaving his body wide open to attack. This was extremely funny to watch, and part of the charm was that it clearly had not been intended by Lansdown. Moreover, anyone who had ever done any programming, howsoever elementary, could sympathize with him.

However, people with no experience of programming tend to think, wrongly, that bugs are caused only by gross stupidity or carelessness on the programmer's part, which limits the human sympathy elicited on observing them. Lansdown's unprotected duelers will then seem idiotic rather than charming.

Even more to the point, it is often more difficult than in the dueling case for the C-art audience to recognize the C-artist's errors. As discussed in chapter 4, appreciation of C-art involves some understanding of the computational processes that underlie the perceptible artwork. As Ruskin knew, most of us can recognize the mark of a clumsy chisel and can sympathize because we have been guilty of such clumsiness ourselves— whether in practiced wood carving or in childish potato cuts. But comparatively few people have done computer programming. Many CA-artists have not done it either; as Cohen has put it, "People today are consumers of computers, not producers" (personal communication). Even if they have, the C-artist's original intention may not be so clear as in the dueling example, so noticing that there has been an error—never mind identifying its source—is tricky. It follows that Grotesque effects may occur in a work of C-art but not be recognized (or, of course, appreciated) as such by the audience.

Whether they are recognized or not, unintentional errors will occur in C-art. Intentional "errors" may occur too. Indeed, they may occur precisely to satisfy the Disturbed

Imagination of the human audience. So one early C-art feature was a process for converting clear, clinical CG-lines into believably hand-drawn—that is, imperfect—lines (Vince 2008, 372).

An even earlier (midcentury) suggestion was a CAD/CAM program for designing carpets, envisaged by the German computer pioneer Konrad Zuse (Zuse 1993, 130). He recommended that the program allow for deliberate flaws in the weaving to make the carpets appear handmade and thus (on Ruskin's aesthetics) more valuable. These deliberate imperfections, however, were not really errors. They were fake errors, comparable to the holes made in fake antiques by woodworm guns. The Grotesque was being imitated, not instantiated. Ruskin would not have approved.

7.8 Rigidity

For anyone wanting to bring C-art under the protective aesthetic umbrella of the Gothic, the fifth principle, Rigidity, looks—at first—like a godsend. After all, if error and fallibility sit uneasily with CG-art, rigidity (i.e., lack of flexibility) seems all too apt a description.

That need not be so for CA-art or for those cases of CI-art in which changes in the human participant's behavior can prompt very surprising variations in the result. And maybe it is not so for Evo-art (see chapter 5). But for noninteractive, nonevolutionary CG-art, which explores a given style without ever transforming it into another, inflexibility is the name of the game. Variability and surprise there may be, in the sense that many different artworks can be generated by one and the same program. But they are all rigidly confined to the chosen style.

However, Ruskin himself admitted that "rigidity," in its normal meaning, did not accurately express his fifth principle and neither did any other. What he meant by Rigidity was "not merely stable, but *active* rigidity; the peculiar energy which gives tension to movement, and stiffness to resistance, which makes the fiercest lightning forked rather than curved, and the stoutest oak-branch angular rather than bending, and is as much seen in the quivering of the lance as in the glittering of the icicle" (32).

Primarily, he was thinking of *architecture*—of the transmission of force in buildings and how this may be made visible in the structure or ornamentation concerned. So he contrasted the "passive" stones of Greek architecture, which stand "by their own weight and mass," with the "elastic tension and communication of force from part to part" that is found in the vaults and traceries of Gothic cathedrals. Similarly, he contrasted the "surface" and "flowing" ornamentation of ancient Greece and Egypt with the medieval ornament that "stands out in prickly independence, and frosty fortitude, jutting into crockets and freezing into pinnacles; here starting up into a monster, there

thorny, bossy, and bristly…but, even when most graceful, never for an instant languid" (32).

It is not clear how one would apply that principle to traditional arts other than architecture, never mind C-art. Even C-art focused on 3-D design may lie outside its scope if it does not deal with physical forces (Latham's weightless 3-D graphics, for example). When C-art involves architectural design, this principle could conceivably come into play—given explicit reference to stress and support as in some CAD programs. But many architectural programs, such as one that generates plans and elevations for Palladian villas (Hersey and Freedman 1992), ignore physics. Ruskin would have criticized the Palladian program for that reason and also because he rejected neoclassicist style.

R-art could conceivably show Rigidity if the artistic emphasis was on the robot's physical construction and its quasikinesthetic properties. A newly designed *Senster*, for instance, might bear ornamentation that somehow reflected its physical dynamics. Perhaps a robot that was "thorny, bossy, and bristly…but, even when most graceful, never for an instant languid" might fit the bill. And maybe some future version of the Australian artist Stelarc's human-robot hybrids will do this too (Smith 2005). But these imaginary comparisons are too far-fetched to be readily plausible.

So much for Ruskin's principle 5. As for 5′ (Obstinacy), the cast of mind that Andrea Palladio presumably lacked, this word too was understood by Ruskin in an unusual way.

Obstinacy, for him, involved "the habit of hard and rapid working; the industry of the tribes of the North, quickened by the coldness of the climate, and giving an expression of sharp energy to all they do…; the habit of finding enjoyment in signs of cold…; and [of rejoicing] in the leafless as well as the shady forest." This cast of mind, he said, not only favors "the softness of leafage nourished in all tenderness" but also "finds pleasure in dwelling upon the crabbed, perverse, and morose animation of plants that have known little kindness from earth or heaven, but, season after season, have had their best efforts palsied by frost, their brightest buds buried under snow, and their goodliest limbs lopped by tempest" (32–33).

This curious paean to cold and tempest echoes the homage to Savageness expressed in principle 1. But Ruskin had more to say about Obstinacy. It involves, he concluded, overall, "strength of will, independence of character, resoluteness of purpose, impatience of undue control, and [a] general tendency to set individual reason against authority [as opposed to] the languid submission, in [warmer climes], of thought to tradition" (33).

All this had a strongly religious aspect: it was no accident, he thought, that "the Protestant spirit of self-dependence and inquiry" was developed in northern Europe. Moreover, he said, this spirit of "philosophical investigation, of accurate thought…[and] of stern self-reliance" was traceable in the distinctive features of Gothic architecture: in

"the veined foliage, and thorny fretwork, and shadowy niche, and buttressed pier, and fearless height of subtle pinnacle and crested tower" (34).

Whether or not independence of thinking is especially visible in these aspects of Gothic architecture (I am not persuaded), this cast of mind is only marginally germane to C-art.

All CG-artists need "accurate thought," to be sure, and many join in "philosophical investigation" regarding *art* and, in the case of Evo-artists, *life* (see Boden 1999). Furthermore, any new form of art challenges "authority," and its practitioners often need "stern self-reliance" to persevere with an approach that is nearly universally scorned (Gardner 1993). Chapter 3 records some of the difficulties that C-artists have had to face in presenting their work to the authority of the art world. Someone wholly lacking in Obstinacy, then, is not well suited to be a C-artist. And C-artists could, of course, use their art to challenge received views—on religion or anything else. But beyond that, principle 5′ is irrelevant.

7.9 Redundance and Generosity

The last and least important (because often absent from Gothic architecture) of Ruskin's aesthetic principles were Redundance in the artwork and Generosity in the art maker. In a word, this boiled down to *ornamentation*. Had he lived to see the emergence of minimalist art in the early twentieth century, he would have bemoaned its failure to satisfy this sixth principle.

Redundance, for Ruskin, is "the uncalculating bestowal of the wealth of [the workman's] labour" (34). Even though the aesthetic effect of much superb Gothic architecture depends primarily on "loveliness of simple design and grace of uninvolved proportion," our appreciation of the most characteristic examples depends also— sometimes almost wholly—on "accumulation of ornament" (34). So lacy traceries and fretwork in wood and stone and a profusion of statues and gargoyles are not mere optional extras: they are crucial to the aesthetic effect. The reason, said Ruskin, is that everyone, including the "rudest" minds, can warm to these things. By contrast, it takes a certain educational level to appreciate the uncluttered lines of classicism.

In the artist and artisan, Generosity (6′) is a habit of thought that humbly provides a rich display of ornamentation. (One might cite Ruskin's own joyously flowery prose.) "Humbly," because it does not assume that every line of its art work is perfect. As Ruskin put it, "No architecture is so haughty as that which is simple" (34). The workman's "inferior rank," he added, is often shown "as much in the richness as the roughness of his work." Besides "winning the regard of the inattentive," this richness has the good effect of hiding many of the work's imperfections.

But that seems more like prudence than generosity: why should the *best* architects and stonemasons need to multiply ornamentation? Ruskin's answer was to turn from principle 6 to 6′ and to gloss Generosity as "a magnificent enthusiasm, which feels as if it could never do enough to reach the fullness of its ideal; an unselfishness of sacrifice, which would rather cast fruitless labour before the altar than stand idle in the market; and, finally, a profound sympathy with the fullness and wealth of the material universe, rising out of [the Naturalism of principle 3]" (34).

His reference to "the altar" reminds us that the paradigms of Gothic art are the medieval cathedrals. In principle, computer artists could be deeply religious, and use their work to reflect their belief. And C-artists could certainly display both "magnificent enthusiasm" and "sympathy with the fullness and wealth of the material universe." So when Evo-artists celebrate the wonders of biological nature in their art (as opposed to merely borrowing its mechanism for other artistic purposes), they are showing Generosity in Ruskin's sense. Examples include Jon McCormack in his artworks *Eden* and *Future Garden* and Karl Sims in his *Panspermia* and *Aquazone DeLuxe*.

Much C-art, however, is decidedly un-Generous in spirit, and non-Redundant in form. Computer art that delights in visual mathematics, whether simple lines or fractal complexities, is more closely allied to the Bauhaus than to Westminster or Chartres. Indeed, some early C-artists were initially drawn to the genre because they were already committed to modernism, whose heroes—from Walter Gropius to Piet Mondrian—eschewed Generosity too. Examples include Edmonds and Paul Brown.

In sum, Generosity can be found in C-art, but it is not a universal characteristic. Indeed, the mathematical rigor that is built into C-art's medium, the computer, provides strong temptations against it.

7.10 Coda

This chapter opens with the thought that computer art and the Gothic are worlds apart, that artworks produced with modern technology can have little or nothing in common with medieval cathedrals. We have seen that they do not have nothing in common. However, we have also seen that computer art, in practice or sometimes in principle, rarely satisfies more than one or two of Ruskin's principles. To the extent that C-art fails to measure up to his criteria of the Gothic, Ruskin would judge it to be inferior.

Or rather, *if he were willing to regard it as art at all*, he would judge it to be inferior. We must now ask whether he would be prepared to see it as art in the first place.

Ruskin's remarks about the workman in his chapter in *The Stones of Venice* implied that all art, whether superior or inferior, is made by human beings. And elsewhere he said, "[The artist] is pre-eminently a person who sees with his eyes, hears with his

ears, and labours with his body, as God constructed them; and who, *in using instruments, limits himself to those which convey or communicate his human power, while he rejects all that increase it*" (1875, chap. 2, sect. iv; italics added). He was not thinking about computers, of course. But he was thinking about electricity (and steam power). He continued, "Titian would refuse to quicken his touch by electricity; and Michael Angelo to substitute a steam-hammer for his mallet. Such men not only do not desire, they *imperatively and scornfully refuse, either the force, or the information, which are beyond the scope of the flesh and the senses of humanity*" (Ruskin 1875, chap. 2, sect. iv; italics added).

That passage alone shows that he would not have been a cheerleader for computer art *as art*. In rejecting the computer as a suitable instrument for artists, he would even have denied the possibility of CA-art, never mind CG-art. He would have regarded both these activities as species of manufacture, not art.

The computer's renowned—and, by C-artists, *celebrated*—ability to "increase human power" significantly would make it unacceptable to Ruskin. Admittedly, his claim that the artist "labours with his body" seems to refer to physical actions, such as wielding a paintbrush or a mallet. But his insistence that we refuse any information that is beyond the scope of the senses appears to outlaw increased mental powers as well. In short, being made by the direct force of the human hand was a defining characteristic of art for Ruskin. And this criterion was heavily underlined by the Arts and Crafts movement that he cofounded with Morris.

Had he lived to see C-art, he might have admitted that some of it is beautiful. But as we have seen in considering his six "moral elements" (principles 1′–6′), the style or content of an artwork is not, primarily, what makes it significant as art. What gives it artistic quality, rather, is its ability to communicate the freedom, values, and experiences of the artist or artisan who made it and, in so doing, to excite our fellow feeling with that other human being.

For Ruskin, the humanity of the artist was crucial. Even a degraded humanity—as in an artist debased by machinelike stylistic rules or perhaps by a morally evil culture (think of Nazi propagandist art, for instance)—was enough to qualify a work as genuine, albeit inferior, art.

That was not a new idea, but Ruskin's writings gave it a greater force. And many writers after him have made similar claims, although they may have put it in terms, for instance, of emotion rather than cultural values: see the discussion of Robin Collingwood in chapter 6. (An intriguing historical tidbit is that Collingwood's father was Ruskin's secretary and all three are buried alongside one another in Coniston churchyard.) Moreover, some philosophers of aesthetics have specifically cited Ruskin in claiming that art is *by definition* made by, and for, human beings, and expresses or communicates human experience of some kind. Anthony O'Hear, for instance, quotes this

passage from Ruskin's *Seven Lamps of Architecture*: "[An artwork's] true delightfulness depends on our discovering in it *the record of thought and interest, and trials, and heart-breakings—of recoveries and joyfulness of success*; all this can be traced by a practised eye: but, granting it even obscure, it is presumed or understood; *and in that is the worth of the thing*" (O'Hear 2008, 127–128; italics added).

O'Hear's essay is of interest here for another reason too. He addresses the question of whether, on his (and Ruskin's) view, so-called computer art is genuine art. He concludes, because of the lack of direct and continuous guidance from a human hand, that it is not. It is called art only as an "honorific title." In brief, it is parasitic on real art, in which we do encounter some other human being (O'Hear 2008, 133, 136).

Because O'Hear does not discuss any specific examples of C-art work, it is not clear whether he would accept certain instances of CA-art as real art. Quoting Ruskin again, he says that the art making of a great painter "is *at every instant* governed by a direct and new intention" (O'Hear 2008, 130; italics added). Interpreting that literally would exclude much CA-art (and all CG-art, of course) or any wherein the artist's guidance is not continuous ("at every instant") but sporadic. The only CA-art that could satisfy this criterion is that wherein the artist's *monitoring* is continuous and can lead at any instant to intervention on his or her part. But even that concession ignores that not every aspect of the developing work can be affected by the human artist's intervention.

A further difficulty arises with respect to whether such interventions are "direct" or express "a direct intention." Does someone who uses sugar tongs to pick up a lump of sugar pick it up *directly*? And does someone who uses a computer instruction (whether newly written on the fly in LC-art or already available in the CA-program) to change some aspect of an image do so *directly*? Ruskin, presumably, would answer no. We have already seen that he would reject the use of the computer as an artist's instrument.

In sum, Ruskin would not have described C-art as an inferior type, to be set alongside Greek or neoclassical and Egyptian art, and judged, like them, in comparison with the Gothic. Applying the six principles to computer art, as done sections 7.4–7.9, would be misguided or irrelevant. For him, C-art is not inferior art because it is not *art* at all.

Many people today agree with that. But this *philosophical* view is often mixed with *empirical* beliefs about just what C-art can or cannot be like. Our discussion of the six principles shows that many of these beliefs are false, or only partly true, or true only of certain types of C-art, or sometimes true in practice but false in principle.

Finally, rejection of C-art is also often supported by *social-political* misgivings about what Ruskin called the machine. Here, his critique is less easily countered.

Industrial society has degraded human experience in many ways, despite providing material advantages and liberating us from much physical and mental labor. And over the last half century, computers, initially developed for the military-industrial complex

(Boden 2006, 11.i.a–c), have played a large role in this. Given computers' many insidiously dehumanizing applications (some of which are far from obvious), C-artists do not have to be working for the military to be accused of having *les mains sales* (11.i.d).

But that, as they say, would take us into another ballpark.

References

Boden, M. A. 1999. "Is Metabolism Necessary?" *British Journal for the Philosophy of Science* 50:231–248. Reprinted in M. A. Boden, *Creativity and Art: Three Roads to Surprise*, 235–254. Oxford: Oxford University Press, 2010.

Boden, M. A. 2000. "Crafts, Perception, and the Possibilities of the Body." *British Journal of Aesthetics* 40:289–301. Reprinted in M. A. Boden, *Creativity and Art: Three Roads to Surprise*, 50–69. Oxford: Oxford University Press, 2010.

Boden, M. A. 2004. *The Creative Mind: Myths and Mechanisms*. 2nd ed. London: Routledge.

Boden, M. A. 2006. *Mind as Machine: A History of Cognitive Science*. 2 vols. Oxford: Clarendon Press.

Boden, M. A. 2010. "Personal Signatures in Art." In *Creativity and Art: Three Roads to Surprise*, 92–124. Oxford: Oxford University Press.

Clark, K. 1949. "Roger Fry." In *The Dictionary of National Biography 1931–1940*, edited by L. G. Wickham Legg, 298–301. Oxford: Oxford University Press.

Clark, K. 1962. *The Gothic Revival: An Essay in the History of Taste*. 3rd ed. London: John Murray.

Dennett, D. C. 1984. *Elbow Room: The Varieties of Free Will Worth Wanting*. Cambridge, MA: MIT Press.

Edmonds, E. A. 2008. "Constructive Computation." In *White Heat Cold Logic: British Computer Art 1960–1980*, edited by P. Brown, C. Gere, N. Lambert, and C. Mason, 345–359. Cambridge, MA: MIT Press.

Gardner, H. 1993. *Creating Minds: An Anatomy of Creativity Seen through the Lives of Freud, Einstein, Picasso, Stravinsky, Eliot, Graham, and Gandhi*. New York: Basic Books.

Goethe, W. von. 1980. "On German Architecture." In *Goethe on Art*. Edited by J. Gage, 103–112. London: Scolar Press.

Heider, F., and M. L. Simmel. 1944. "An Experimental Study of Apparent Behavior." *American Journal of Psychology* 57:243–259.

Hersey, G., and R. Freedman. 1992. *Possible Palladian Villas (Plus a Few Instructively Impossible Ones)*. Cambridge, MA: MIT Press.

Hogle, J., ed. 2002. *The Cambridge Companion to Gothic Fiction*. Cambridge: Cambridge University Press.

Kant, I. 1952. *Critique of Judgment*. Translated by J. C. Meredith. Oxford: Clarendon Press.

Landow, G. P. 1971. *The Aesthetic and Critical Theories of John Ruskin*. Princeton, NJ: Princeton University Press.

O'Hear, A. 2008. "Art and Technology: An Old Tension." In *The Landscape of Humanity: Art, Culture, and Society*, 126–142. Exeter: Imprint Academic.

Reichardt, J., ed. 1968. "Cybernetic Serendipity: The Computer and the Arts." Special issue, *Studio International*. London: Studio International.

Ruskin, J. 1853/1854. "On the Nature." In *The Stones of Venice*, chap. 6. Vol. 2 of *The Sea-Stories*. London: Smith Elder. (Published separately, with an introduction by William Morris, in 1854. Page-references are to this edition.)

Ruskin, J. 1875. *Deucalion*. In *The Complete Works of John Ruskin*, edited by E. T. Cook and A. Wedderburn, 26:95–360. London: George Allen.

Smith, M., ed. 2005. *Stelarc: The Monograph*. Cambridge, MA: MIT Press.

Todd, S. C., and W. Latham. 1992. *Evolutionary Art and Computers*. London: Academic Press.

Vince, J. 2008. "PICASO at Middlesex Poly." In *White Heat Cold Logic: British Computer Art 1960–1980*, edited by P. Brown, C. Gere, N. Lambert, and C. Mason, 361–375. Cambridge, MA: MIT Press.

Weir, S. 1974. "Action Perception." *Proceedings of the AISB Summer Conference July 1974*, 247–256. University of Sussex/Society for the Study of Artificial Intelligence and Simulation of Behaviour.

Zivanovic, A. 2005. "The Development of a Cybernetic Sculptor: Edward Ihnatowicz and the Senster." In *Creativity and Cognition 2005: Proceedings of the Fifth Conference on Creativity and Cognition*, edited by L. Candy, 102–108. New York: ACM Press.

Zuse, K. 1993. *The Computer, My Life*. Translated by P. McKenna and J. A. Ross. New York: Springer-Verlag.

III

8 Computer Art and the Art World

Ernest Edmonds

"If you have to plug it in, it isn't art."

When the artistic director of Biennale of Sydney 2008, Carolyn Christov-Bakargiev, spoke at a public meeting that year, she said, "If you have to plug it in it isn't art."[1] So to some people, Dan Flavin's work using fluorescent light tubes, let alone computer-based art, is not art at all. It was strange that this view was expressed in Sydney because, in fact, Australia has been one of the leading countries to recognize computer-based art as legitimate.

While the major public galleries in Australia may have been no more receptive to art that has to be plugged in than public galleries in any other country, the main funding body, the Australia Council for the Arts, has a progressive history. I spoke with **Andrew Donovan**, director of Emerging and Experimental Arts at the Australia Council, who explained the development of the council's interest:

> We're fortunate at the Australia Council in that we do have, and we have had, sections devoted to supporting these new and emergent practices. ... The Australia Council probably first started responding to computer-based art in the 1980s, and they formed the Art and Technology Committee, which I think was formed in the late eighties, and in fact the Australian Network for Art and Technology grew out of that committee.
>
> The Art and Technology Committee then merged into the Hybrid Arts Committee. ... So the Hybrid Arts Committee kind of was born and was formed in the early nineties. ... Keating released the Creative Nation arts policy of 1994, ... [and] the New Media Arts Board, which was formed in 1998 ... ran the course of its life until 2004, so that's six years, which probably wasn't very long, but there was also a view forming in the council around about 2004 that

This chapter is based on a set of interviews with curators, dealers, and administrators working with computer-based art. Much of the chapter consists of direct quotes from these interviewees, whose names and titles are listed at the end of the chapter.

1. Reported by Deborah Turnbull, who attended "The Art of the Curator: Times, Spaces, Biennales," Goethe-Institut Australien, Sydney, Australia, May 2, 2008.

electronic art and media art practice was becoming so ubiquitous across the art forms that it wasn't felt that it was necessary to have a separate board.... Then the Inter Arts Office was formed.

And now in 2013, the Inter Arts Office has sort of merged into the emerging experimental arts section, and I think that will give us a lot more freedom to respond to media art practice that is really pushing the boundaries and is really challenging our understanding of what art can be. Importantly, the experimental art section will have the same status as those other art forms and will have the same voice at the various policy tables.

We only have to consider social media to see that the general public, particularly young people, are very comfortable indeed with the computer-based media that artists have been working with for fifty years or more. In 2013 Sydney held its annual Vivid Festival,[2] where interactive experience, interactive art, was shown along all the central harbor shoreline in a significantly bigger program than had been presented before. It was a sensation. The transport authorities were caught out by the crowds. People could not board full ferries, overflowed the streets, and created an atmosphere that rivaled New Year's Eve, which is quite an occasion in Sydney. Computer-based interactive art was interesting to the public, without any question. As Andrew said,

> There is an enormous appetite among the general populace to have arts experiences that are...outside of the conventional spaces for art.... We all understand that the work presented through Vivid could be far more interesting...but understandably, they're very much focused on building audiences and getting their numbers up so they can go back to government and say, yes, we're a success.

It so happened that the Nineteenth International Symposium on Electronic Art was held in Sydney at the same time as Vivid and the chairman of the Australia Council opened one of its exhibitions. Andrew reported the chairman's very positive statements about the new art forms, as exemplified by Vivid: "The comments the chairman made last night...very much [indicate] that the conventional art form practices need to make way for the new practices as well."

Andrew says, about the next stages,

> It was a really interesting discussion at the National Experimental Art Forum about whether the approach of the experimental arts area should be to create solely experimental arts focus events and organizations or whether you try and infiltrate the mainstream. [In the context of the mainstream, there] is probably the need for us to fund some curatorial fellowships within some of these institutions...to help them understand this practice and understand what they need to do.

2. "Vivid Sydney 2013 Lights up Harbour City with Biggest Program Yet," Vivid Festival media release, March 21, 2013, accessed July 31, 2018, https://www.destinationnsw.com.au/wp-content /uploads/2013/10/Vivid-Sydney-lights-up-habour-city.pdf.

Internationally, perhaps the best place to look in terms of the established view of art is the Venice Biennale. I was able to talk with **Francesca Franco**, who has made an extensive study of computer-based arts as they have appeared at the Biennale. She explained,

> The first time that proper computer art was exhibited at the Venice Biennale was in 1970. And there was a big experimental show…that included computer artworks by Frieda Martin, CTG, Herbert Franke but also optical art from the sixties.…So that was a section of computer art…[that] was probably one reaction from the Venice Biennale Institution to the student protests of 1968. So the Venice Biennale as a conservative institution until then wanted to show an openness to a younger audience. So they decided to find a new approach to art and curation…and it also changed in terms of its structure, its internal structure. So from 1970, for instance, there were no categories involved in the prizes. Again, this can be seen as a result of the 1968 protests.

Even so, computer-based art had not become integrated into the Biennale and could not be said to have achieved acceptance. In fact, Francesca says, "I talk about anomaly" when speaking of that period.

> [However,] after that, from 1986 really,…computer art and technology started to be accepted.…The whole Biennale theme was art and science in 1986…that's when Roy Ascott curated and exhibited works like *Planetary Network* and other big projects that tipped the whole area.…That is when, probably, computer art became accepted and shown more as a standard feature at the Biennale.…And that's also thanks to curatorial projects everywhere at that time, including the Patric Prince show in Dallas and the SIGGRAPH Art exhibition in 1986.[3] That was a way to historicize computer art. So that made it kind of safe for a conservative institution like the Venice Biennale.

Despite the relatively early interest in computer-based art in this key forum, we might still judge that interest to be somewhat peripheral to the core issue of the medium: software and computation. As Francesca said,

> From the nineties [onwards] the Biennale became addicted to video art. So they started showing a lot of video art, and [making] award[s for] video art.…So that was a preference. And you can still see that trend now. There was also a "virus project" in 2001 that was awarded.[4] That would be probably one of the few software art projects that I know. And that was in 2001, the

3. "Patric Prince is an American art historian and collector of Computer Art, who followed and documented its rise from the earliest days. She was responsible for organising some of the key computer art exhibitions, including the SIGGRAPH retrospective in 1986, as well as lecturing and writing on the subject extensively." "The V&A's Computer Art Collections," Victoria and Albert Museum, accessed July 7, 2018, http://www.vam.ac.uk/content/articles/t/v-and-a-computer-art -collections/.
4. Artists Eva and Franco Mattes exhibited a computer virus as an artwork. For a description, see "Eva and Franco Mattes," Biennale.py, accessed August 10, 2014, http://0100101110101101.org /biennale-py/.

0101.org project.... It was basically a virus exhibited at the Biennale as an artwork. And it was sold in CDs at [AU]\$1,500, together with T-shirts and gadgets. I forgot which pavilion that is. I think it is the Slovenian pavilion. So it didn't look very much like a forwarding boundaries project—I mean, with that commercial aspect.

So far, it seems that computer-based art is still not normal in the core of the Venice Biennale. Francesca continued,

I know already that there will be [in] 2014 a project involved with software art. But I know already that is outside the official areas. So that will be in a small gallery near the Museum of Modern Art.... It happens that there are external curators... they call it a collateral event.

A few well-established institutions have fully embraced computer-based art, and London's Victoria and Albert Museum (V&A) is a notable example. I talked there with **Douglas Dodds**, senior curator of the Word and Image Department, and **Melanie Lenz**, Patric Prince Curator of Digital Art.

Doug said,

[I] started when the V&A's library merged with the Prints and Drawings Department, and at that point I transferred from the library.... What became apparent to me was that we hadn't really been documenting the history of this new medium as much as perhaps we could have done.... I realized that we didn't have very much that was computer generated.... We had a very small number of prints that had been acquired in the late 1960s in conjunction with *Cybernetic Serendipity* show.... There was very interesting internal debate, for example, about the acquisition of some of those early works and who would take responsibility for them within the museum; where they fitted in the museum collection.... There were a couple of Manfred Mohrs, I think, already in the collection quite early on, collected sometime in the midseventies. But they were the only things that really would count.

A very important step was when Doug managed to acquire the Patric Prince collection and, subsequently, the archives of the UK Computer Arts Society:

The first one was the artworks, which were actually given to us via an organization called the American Friends of the V&A [and] then ultimately became our property. But in parallel with that, [Patric Prince] also gave her entire archive, her library and her ephemera and all the rest of her material to the museum directly.... Pretty much in parallel with that, we were also negotiating the transfer of the archives of the Computer Arts Society to the V&A.... George Mallen and colleagues at Systems Simulation had held on to it, stored it in their offices for many years, realizing the significance of it, and without them it wouldn't have survived.

These collections form the basis of what would become a significant part of the V&A's work with computer-based art and design. One might have thought that a national art gallery would have taken this on, but, Doug argued,

We were probably a natural home for it in the sense that, if you look at the history of computer art and its reception by curators and by art historians, it had a very bad reputation; it had a

very bad press. Many of those people were very reluctant to be seen anywhere near it. For us, that whole debate about Is it art? didn't matter so much as it would matter in a different institutional context.... We're interested in the design world. We're interested in graphics. So it doesn't matter whether it's computer graphics or whether it's art—it's still of interest to us. So that debate doesn't particularly apply.... The Word and Image Department of V&A covers exactly that range of material anyway.

So the very fact that computer-based art did not have to be labeled as art within the V&A was a significant advantage. Just as the Venice Biennale still keeps computer-based art largely at arm's length, so the British art establishment has left it to the V&A, our primary museum of art *and* design, rather than just art, to lead the way. Tate Modern is the obvious location in London to see the most modern art. Interestingly, at the time of this writing, its prominently displayed and well-promoted *Timeline*, made by Sara Fanelli, does not mention computer-based art at all. It has "Video and Film" listed and even "Düsseldorf School Photography" but nothing that covers all that the computer has brought to modern art. Slightly off center, the more trendy Tanks at Tate Modern shows performance and film, and so on, and computers certainly can find their way in there even if, normally, they do not appear in the main galleries.[5] "Modern" as the Tate might be, perhaps the processes that underpin computer-based art are still difficult to grasp in the context of such an institution. As Melanie said about the V&A, however,

> One of the things that informs the collection is this interest in process, and I think that is the crossover, because we're interested in the finished product but also the methodology.... If you just look back to the relationship between the history of the museum being the first place to collect photography, fine arts, etc., it's not such a massive step to understand that we would collect other new forms.

Collecting computer-based art, then, is bound to introduce new issues, just as photography did. As Doug explained,

> [It] is a new process, it's a new medium.... It took us a while to raise our hands and say "Oh, by the way, we're also collecting the software that these things relate to."... The process, then, I think is particularly interesting, because if you're interested in process, then you've got to take an interest in software for a certain class of art.

Software has a number of issues relating to it that would have been new to a museum. For example, it requires either particular hardware or a particular operating system to run. The hardware and the operating systems evolve and even change quite radically

5. In 1983, when we had just the Tate Gallery (now Tate Britain), a major exhibition of Harold Cohen's computer-generated work was indeed mounted, but that seems to have been another anomaly, as Francesca put it in relation to Venice.

over time. So using, or running, the software can become very difficult. The survival of software-based art is, therefore, a potential problem. Doug points out that such issues are hardly new, however:

> For instance, consider David Em's artwork.... We realized that our print of it was a different color to his print of it, and our print was produced using a different photographic technology, and the color wasn't so stable on it. At the time it was thought to be the best available process, but it obviously wasn't. So thirty years later, looking back at it, you realize that, actually, even the photographic print hasn't survived as well as we thought that it would at the time. So it's not just an issue with digital media.

With digital media, the museum sometimes just buys computer code:

> Casey Reas is an example of that. When we acquired a work of his, we made sure that we got the artist to state what the requirements would be for it. In that sense he was an example of an artist who was very helpful, because he said, of the hardware, it doesn't matter—the work is in the software. The particular hardware used is expendable and can be replaced by equivalent units, so long as you try and maintain the aesthetic values of the original. So if the monitor that it's on dies, it doesn't matter. In fact, he didn't even supply the monitor—it's our monitor.... We had one classic example of that actually quite early on. Quite soon after we acquired the Casey Reas, we had a request come in to borrow it for an exhibition in the US. And of course, because it's just the code—the object really is just a code—there's a representation of it, which is this box, but the object is just a code. In fact, we never actually sent them the code because of course the artist retained his own copy of it. So he supplied it to them. But because we're the only location for that particular version of that work, it was effectively a V&A object. So the label said that it was shown "Courtesy of the Victoria & Albert Museum London," but we never physically had provide anything physical, just the code.

Melanie added that the standard documentation procedures, as used for objects, worked perfectly well even for the very abstract software held by the museum: "So the code will be given a museum number, and it'll be documented in the same way as any other object would. So when...the Casey Reas was lent, it was lent in the same way, even if it wasn't physically taken."

The example of the V&A shows that public institutions can, and in some cases do, embrace computer-based art. In the commercial art world, however, it is even harder. **Robert Devcic** runs GV Art London and, at the time of the conversation, its associated gallery. GV Art is a hub for collaborations between artists and scientists for exhibitions and discussions. His concerns are broader than computing and art, but that broader view has many of the same properties. Robert's intentions are clear:

> For me, if there isn't some sort of meaningful dialogue between the art objects and the art and some kind of science, then I tend to lose interest pretty quickly.... I'm trying to develop how

to engage the general public when they walk into the gallery, and I wonder, do I put wall labels up, and do I have to provide information?...Fifty-six percent of the people who buy our art happen to be scientists or work within the sciences, so that's really unusual....We do a lot of debates and exhibition-related events.

Sometimes it can be really rewarding.

I had a nine-year-old come into the current exhibition, and he spent a lot of time asking his father really good questions and me some good questions and responding really well, and that would have made the whole show worth it.

The work of GV Art has not been easy.

When we first started I had people in the art world...saying "Well, what are you doing, polluting art and science?"...But in...the last eighteen months there's been a huge rise in popularity in what we would loosely call science-inspired art....There's a lot of people doing it.

The gallery's plans have to take something of a long-term view and, as Robert sees it, there is a need to rethink the way that the gallery system works.

I don't do auction houses and all the rest of it, so what I'd like to eventually develop is kind of a new model for a contemporary art gallery. And I'm not quite sure what that model is, but it would combine the community in lots of ways that a conventional commercial gallery wouldn't necessarily feel comfortable in today....So we're very limited, and basically everything that we generate in sales goes back into the gallery.

As we have seen in several contexts, GV Art is finding it easier to make progress outside the center of the art scene. Robert says, "[Galleries] like the Tate don't quite get it yet....The Science Museum, they've recently started talking, using language like aesthetics, and that's really cheered me up."

But Robert finds there is much work to do; for example, he says,

grooming journalists not to feel intimidated by the fact that the art has some science in it, so getting them to be comfortable with it and getting to know it and then eventually—I mean there's one writer who came to every show for two years and suddenly she did a fantastic piece in a major international publication, but it took her two years to feel confident enough to be able to do that....And scientists equally might feel intimidated, because they've not talked about art and will not feel comfortable about art....I think that there will come a time fairly soon where your traditional art collector won't be kind of suspicious or wary, and they'll be wanting to invest in emerging young art-and-science artists.

This role of working to change the climate and help develop new ways of engaging with art, embracing science and technology, seems to be a stronger feature of certain commercial galleries than of many of the public art institutions. Another, newer gallery in London that is also changing the climate is Carroll/Fletcher, where I spoke with

cofounder **Steve Fletcher** (now Director of The Artists' Development Agency, London). He was quite clear about the particular role that a commercial gallery should take:

> As a commercial gallery we are simply one element within the complex of institutions that are involved in art. So you might have a commercial gallery like us, a public space like the Tate or the Chisenhale Gallery, or an artist-run space. There's room for all these different spaces that fulfill different roles. … It's our job to sell the work.

The arts that use digital technologies are varied and need quite varied methods of presentation as well as financial models to support them. As Steve put it,

> Some of it is supported by public sector funds or private sector patrons, because it's a performance or it's an installation that exists for a certain period in time. … The danger is when you try to force the wrong economic model onto a piece of work, because that undermines its integrity and the integrity of the artist.

So it is important to understand that the commercial art world does not represent everything that is important, and perhaps, this is particularly the case for the moment in relation to the computer-based arts. Steve again: "There is really fabulous work being done in areas that are currently sitting outside the mainstream commercial world, and there is an opportunity for us, as a new gallery, to develop an identity based on the support of certain sorts of work that we believe in."

This opportunity is not easy to take and must be given time, however, as Steve explained:

> We started off and said it was going to take three to five years to understand whether it was going to be a success. That wasn't three to five years necessarily to make it a success; it was three to five years to understand whether you could make it a success. You have to think ten to fifteen years is the ultimate payoff period … but then if you look at the museum departments, when they were set up they would have painting and sculpture and photography. … Now, obviously, over the last five to ten years that's begun to change, where you have performance departments.

From a gallery point of view, whether it is commercial or public, the design of the space is quite significant in relation to the computer-based arts. Mostly we do have to plug things in and often connect one box to another with wires. There are aesthetic, safety, and security issues that are somewhat different from a gallery that shows only paintings. Carroll/Fletcher was fortunate, as Steve said, "to be able to design the space," constructing it with appropriate false walls and cable ducts, and so on, making the display of computer-based works possible in an elegant, as well as a safe, way. Steve went on to explain how it was also possible to think quite hard about facilitating an appropriate viewer experience through exhibition design:

> We spent a lot of time thinking about it in terms of the way it was laid out such that the works themselves, in the individual spaces, can be seen to best effect. … Exhibition making is very

important, and we see any exhibition as a journey. And therefore when thinking about the space in terms of the different rooms and how you journey round the rooms…some sort of metanarrative emerges.

Beyond the exhibition, as before, Steve is largely concerned with developing interest or, perhaps one might say, developing the market:

It's about developing relationships…public or private sector collector or as a curator.…Then we have to develop a track record that shows that we're going to be around for a while. [But there are] multiple types of collector.…It's not just about owning a work; it's about being part of something.…Not because they're going to get an object but because they're going to get an experience, they're going to get some prestige, some enjoyment.

In terms of the behavior of collectors, Steve made a clear distinction between those looking for investment and those in what he termed the luxury goods sector:

I think people are worried about stock markets, they're worried about property. It seems to us that the blue chip sector,…the market for Picasso or for Gainsborough or today Bacon and Freud, for example, is different. That sector's buoyant.…It's a good place to put money.…The luxury goods sector of the market, the area that we're interested in and talking about, doesn't fall into that category.…It's not a store of value.…We're not in a bubble type thing where you can think "Well, this is the next hot thing."…In our sector they like to collect things.…They can actually put together an important collection for a relatively small amount of money.…I talked to some serious, important collectors of video art who have built up over the last fifteen to twenty years fantastic collections. But they've never spent more than, let's say, $10,000 or $15,000 on a work.…They're not necessarily massively wealthy, able to collect Bacon.

The individual and unique nature of an artwork is not always a major concern, as Steve explained:

A painter is perfectly capable of turning out multiple copies of the same painting, but they choose not to.…Look, for example, at Munch's work and the number of *Screams* that are out there.…Producing an object isn't the only thing that people will invest in.…People collect cigarette cards and video art, for example.…When you're buying some cigarette cards you probably want to put them in the original album, etc. Now, you can get the original album out and look at them, but they're not something that you put on a wall. I think if you think about the whole notion of collecting, it has many facets.

A serious issue in relation to computer-based art is maintenance and the lifespan of any particular work. On this subject, Steve said,

The issues of preservation have been there for a long time. You just have to look at the light conditions one needs to keep watercolors in, or the necessity of cleaning oils, etc.. Look at what's happening with film collections.…My colleague Jonathan owns a work by Rafael Lozano-Hemmer called *Pulse Room*, which uses incandescent light bulbs.…That technology

is declared to be obsolete, so what do you do? That is a lot more challenging. ... Energy-saving light bulbs don't quite hack it.

More specifically, he said,

an artist's concept can have a certain manifestation—for example, in the underlying source code—...that drives the artwork, and then there's the...manifestation of it—what it looks like. I think you need to preserve each element, the concept and the manifestation....I quite like the idea of it being a testimony to a dead civilization. ... Some artists that we work with...when you buy one of their works, it comes in a beautifully produced box, and in the boxes you'll get a flash drive with the work on [it]; you might also get a Betamax copy, a Blu-ray disc, or a DVD. Often you'll get...one that's watermarked. You get these different manifestations...with something that's as lasting as you could possibly get, so that while these formats may go out of use, hopefully this thing, ...the flash drive with the source code on, remains. I took an early work on consignment...and I went to the collector to pick it up, and I get literally a plastic bag with a bunch of things in it.

There's only so long that Thompson and Craighead, for example, can tie themselves in for sourcing a new one for you. "For X period of time, every six months" or "every three months"—whatever it may be—"we will check that those cameras are working, and if they're not working, we'll contract to find another one." ...But you can then do the film version. ...It's almost easiest with software and generative work, because there's an algorithm, there's a code, etc., which underpins it. Manfred's work is really interesting in this respect. For Manfred, what matters is the output. He doesn't need to preserve the source code for any of his drawings, paintings, or sculptures, because you've got it. Then if you look at his time-based work, that's obviously slightly different, but there's a core that is the same.

Fundamental to Steve Fletcher's position in any case is that the commercial gallery is only part of the picture: "I think that, to my mind, ...what you're doing as a commercial gallery—it's working with the artist, not just to sell the work."

A slightly different perspective is that of **Keith Watson**, who coordinates London's Kinetica Art Fair and works as curator at Canary Wharf's Level 39, an art display in a high-tech business environment. Although his main concern is showing work in various contexts, he does sell. As he puts it, he sells into the "normal art market, but it's not necessarily to people who are looking at collecting it. They're buying it because they like it. They don't really distinguish digital arts and painting or photography in any way."

So this confirms Steve Fletcher's points from another perspective. The Kinetica Art Fair, in particular, is, Keith said,

a great bed for discussion and networking and everyone meeting each other. People who take part in the show are just blown away with the amount of contacts they get with the public and with each other. ...They wouldn't have known each other before the fair but have gone on to do other projects together, which is just fantastic, which is one of the best things to come

out of it.... However, even though Kinetica Art Fair is encompassing in terms of the profile of people that we attract, and we fit all the bills for funding, they still don't get it. It's quite amazing how the official bodies just bluntly refuse to fund such a popular thing.

This is another example of computer-based art not being fully accepted in the traditional art world. Level 39 is rather different, however, as Keith explained.

I've been there five years, and I haven't really had the opportunities to show much of the digital side of my practice. But in the last six months I have been able to, and it's really opened their eyes to what is possible.... I am showing work to people that don't really have much interest in art.... They're general public; they may like something if they see it. If they don't, they're not really bothered.... They're not buying things to collect or anything like that.... They're very excited by what they see, and they're really open to new ideas and new work.... They are much more used to working on computers all the time; they have their mobile devices, they're playing with their Connects or Wiis at home or whatever, and they see things on TV as well.... I think people subconsciously are seeing... TV or they're watching big blockbuster movies, and they're seeing all these interactive things going on, and that is actually informing them in terms of what they might like. When they're seeing art that has that kind of discipline, they're much more receptive to it.

Keith's remarks suggest that there is much less of a problem with the general public in relation to computer-based art than there is with the art world.

I talked with **Wolf Lieser**, who worked with Keith in a London gallery for a while but went on to set up DAM Gallery, a successful, or sustainable, digital arts gallery in Berlin. He runs various associated activities and has also reached out to other German cities. He is one of the most important international dealers in computer-based art. Wolf is more optimistic than some. He said,

Recently interest has really grown and people have started to understand, now, that this is really something new in the art world.... It's so exciting and why I think that is the future in art for sure.... I would say [that] in the last two or three years there's much more interest coming back from institutions, from collectors, and so on, who are suddenly realizing there could be something going on, which they hadn't really put enough attention on before.

Starting out, however, presented many problems. Wolf looked at art galleries that had succeeded in other areas. For example,

Leo Castelli's... was a very good example for me.... I visited his gallery beginning of the nineties.... What really made him so influential... was being a good businessman as well as being convinced about this new kind of pop art, which was not that big when he started to take it over. He was convinced and loved it and stood behind it and supported it for a long time and basically built it up.

You have to persist and communicate it long enough to impinge. It takes a while; at the beginning people just don't take you serious. And the museums or curators, they just don't talk

to you. When you survive, let's say, five, six, seven years, then they start thinking about it because they think, well, they know you don't have the big money behind you so there must be some foundation.

In terms of what Wolf sells today, he said,

More than 50 percent of all my sales in the gallery is software art.…I'm selling a file. I'm selling just a digital file, a digital process, which they receive on a stick or whoever, what kind of art ware. But these collectors or these institutions already accept the idea of owning a software piece and that's it.

The issue of multiple copies, editions, of digital artworks is also interesting. Like Steve Fletcher, Wolf also deals in editions, but he is less convinced about the significance of them today:

Some…are selling them as single pieces like Casey Reas does. Others are selling them as an edition.…Conceptually I think the idea of an edition is old-fashioned. It doesn't apply to this field anymore.…It makes no sense to produce twenty pieces, which are exactly the same. It's not logical from the whole concept of programming art.…Casey doesn't do it. Casey only sells his piece once, and sometimes when he sees there is some interest, then he has two or three variations.

In fact, the whole nature of the art object is shifting.

It is a very strange idea to get a file which could be deleted by pressing the wrong button…owning it as an artwork.…So I'm trying to draw the attention away from this idea of this materialistic aspect. And of course I'm not alone.…If you analyze the market in new tendencies, it's already obvious that this aspect is going to influence the art in the twenty-first century in a drastic way. So this is very easy to see,…from a purely financial point of view, you should buy it.…Ten years ago, it would have been a big risk.

Wolf sees the big institutions as making moves in the direction of accepting computer-based art.

Pompidou [Centre], for example, has created a new position about two years ago. And the curator…approached me and he visited me in the gallery in Berlin.…That was only very recently. They have bought from Vera Molna, but she actually produces paintings as well. So they had bought some plotted drawings because these were the background drawings, and later on they realized they are probably going to be much more valuable in the end than the paintings.

If the collections[6] hadn't been donated to the V&A, maybe the V&A would still not bother much about digital art. But luckily enough they were, and Douglas Dodds[7] could put more attention on digital art and expand it, and it is really growing.

6. Wolf is referring to the Computer Arts Society archive and the Patric Prince collection.
7. This is the V&A's Douglas Dodds interviewed here.

> I just prepared an exhibition in Taiwan, in one of the three biggest museums in Asia. ... They have one department, which is called Digi Art, and they do only digital media.

Naturally, the big public institutions are particularly concerned about the long-term maintenance of the works in their collections. Wolf said, "They have to think about what's going to happen in twenty, thirty, fifty years. So they have to have different kind of restorers, people who are familiar with programming, being able to handle these kind of pieces and preserve them for the next generations."

In terms of the DAM Gallery, Wolf said, "As long as the artist agrees with it, we upgrade the software to newer contexts or platforms as long as they are alive. That is normally free. ... They know that they will not run into problems in a short amount of time."

We see from these many different points of view that computer-based art is still not fully part of the standard art scene. But is that such a surprise? Radical innovation normally takes quite a while to embed itself into its proper social context. It is not as if such art is just a new style or a variation on an accepted form. Computer-based art, and software art in particular, is radically different from what preceded it, even though we can trace its origins to art practice that was current before the invention of the computer. Wolf Leiser said his vision of the future is that "it will be great."

> I'm totally sure that digital technology will be the most influential medium. When you look at the twentieth century we had photography, which totally changed our aesthetics in painting as well as in other media. ... But the digital medium has already done that. People don't even recognize it ... [but] the good times have just started to happen for this medium and for people working in that field. And, as I said, the institutions are starting to buy it. ... Of course, there can always be bigger shows, always other things. There's still a lot of expansion possible, but I think that will be exciting times for all these people who have survived it that long.

Interviewed

Robert Devcic, GV Art London

Douglas Dodds and Melanie Lenz, Victoria and Albert Museum, London

Andrew Donovan, Australia Council, Sydney

Steve Fletcher, The Artists' Development Agency, London

Francesca Franco, De Montfort University, Leicester, UK

Wolf Leiser, DAM Gallery, Berlin

Keith Watson, Kinetica Art Fair and Level 39 at Canary Wharf, London

The chapter was also informed by a discussion with Deborah Turnbull of New Media Curation, Sydney.

9 Formal Ways of Making Art: Code as an Answer to a Dream

Ernest Edmonds

Writing computer code is quite an exacting task. It makes one think very hard about what exactly one wants to do and typically leads one to take a fairly structured approach to whatever that is. This applies just as much to making art with code as it does to making anything else with code: aircraft control systems, holiday-booking websites, or whatever else. It is not surprising, therefore, that many of the origins of software-based art can be found in art that already used a language of formal structures, geometry, mathematical series, and so on. Computer code offered an answer to the dreams of some of the artists who were using mathematics, procedures, and formal structures even before computer programs existed.

9.1 Systems in Art

If we go back to well before the invention of the modern computer, we can find words from Cézanne that seem to point forward to a more formal view of art making: "The technique of any art consists of a language and a logic" (Doran 2001, 17).

An artist's language consists of many elements: colors, lines, shapes; the logic is the set of rules developed by the artist for selecting those elements and putting them together. Of course, Cézanne was not referring to the formal rules of mathematics and certainly not to the logic of a computer program. Nevertheless, one can see both in his work and in this statement the seed of much that has followed.

Another significant grounding point was in K. S. Malevich's essay of 1919, "On New Systems in Art" (Malevich 1988, 83–118). In it, he introduces the notion of making art with the help of "a law for the constructional inter-relationships of forms," by which

This chapter is an extended version of the introduction to the catalog of the GV Art exhibition *Automatic Art: Human and Machine Processes That Make Art*, curated by Ernest Edmonds, July 3 to September 10, 2014.

he meant the language, or system of form, rather than representations of the visual world. Furthermore, he maintains, "nowhere in the world of painting, does anything grow without a system" and "in constructing painterly forms it is essential to have a system for their construction, a law for the constructional relationship of forms."

As in Cézanne's case, we need to be careful not to project too much of the modern approach to the use of systems in art onto Malevich. But his remarks are clearly pointing in the same direction as Cézanne's and, as we will see, in a direction that leads to at least one stream of art today.

In relation to Malevich, Maria Gough explains how, by discarding realism, the important question arose of "what would be the logic or principle by which the non-objective painter would organise" the elements of the painting (Gough 2005, 22). The situation was one in which Malevich discarded realism, or painterly illusionism, for a realism based on the painting itself as an object. He explained that the "new painterly realism is a painterly one precisely because it has no realism of mountains, sky, water" (Malevich 1968, 133). Gough goes on to argue that "if the first task of early-twentieth century abstraction was to get rid of the referent in a painting...its second task is the determination of new logics or principles by which this 'painterly content' might be *organised*" (Gough 2005, 22).

A founding step in the Constructivist[1] tradition, the discussions of the General Working Group of Objective Analysis in 1921 in Moscow (Lodder 1983), is also a key relevant moment in this argument. The group drew a distinction between composition and construction in making their art. Briefly, composition was seen to be about arranging forms according to relationship rules, and construction was about making a work according to a plan for its production.

The discussions of the group were complex, and they did not all take the same position. It is probably best understood through Maria Gough's careful analysis of the composition and construction drawing pairs that the group made (Gough 2005). She shows that the group had at least five interpretations of construction, so clearly the artists were still wrestling with the problem of which "logic or principle" should be used. There is no reason to think that there should be only one, but for the argument of this chapter the most relevant idea was the introduction of the notion of making a visual artwork according to a plan rather than by the application of rules of composition. In 1921, of course, the plans were executed by the artists themselves. But later, artists began to express these plans in the form of computer programs. Then, as we see later in the chapter, the construction of the artwork was done by a computer.

1. I use the term "Constructivist" here in the broadest sense.

9.2 Mathematics and Procedures

In some respects we could argue that there was nothing new in using organizing principles in painting. The portrait painter is constrained by the sitter and the principle of making a likeness. The painter of townscapes has long used the principles of perspective. However, the so-called abstract artists had to find new, more or less internal principles to use. Max Bill (see figure 9.1), for example, famously took the problem on by advocating the use of mathematics. In 1949 he argued that "it is possible to evolve

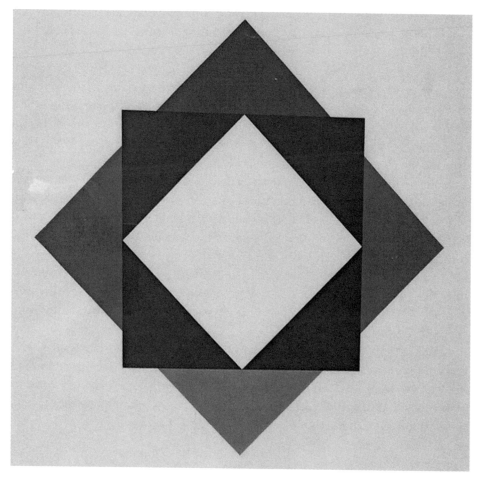

Figure 9.1
Max Bill. *Ardiv III*. 1972, screen print. See color insert. (Reproduced by permission of Ernest Edmonds.)

a new form of art in which the artist's work could be founded to quite a substantial degree on a mathematical line of approach" (Bill 1978, 110).

Bill saw this as the next step to take and, with Richard Paul Lohse, he was influential on many artists in Europe. Lohse said, of his own work, "To obtain new operative bases it was necessary to systematize the media so that they could form logical sequences and would permit a multiplicity of operations. The result: variability and extensibility" (Lohse 1992, 22).

One area of influence can be seen in the *New Tendencies* series and the artists associated with that development. Extensive documentation and commentary has been provided by Margit Rosen (Rosen 2011). *New Tendencies* began in 1961 with the participation of artists who used the "notion of making a visual artwork according to a plan." As Rosen points out, the work was often programmed, although the program was executed by the artist. The really interesting development was the call for the 1968 event *New Tendencies 4*, to be held in Zagreb, for works that used a computer and in which the programs were executed by computer rather than by hand. The exhibition presented and discussed computer-based art and took place at more or less the same time that *Cybernetic Serendipity* was showing in London (Reichardt 1968). However, despite the conceptual coherence of the inclusion of computer programming as a medium within *New Tendencies*, those people showing such work in 1968 did not include many artists who had previously been involved in the *New Tendencies* events.

This became a significant public debate, and the contributions to that debate by Alberto Biasi and Frieder Nake are included in Rosen's book.[2] It seems that *New Tendencies 4* was contributed to by people who were primarily scientists, whereas on previous occasions the contributors were artists. Nake wondered if the main task in the future should not be to bring these two groups together. *New Tendencies 5*, held in 1973, in many ways did this, although from a current perspective it seems that the togetherness was being side by side rather than integrated.[3]

Compared with the developments on the Continent, a rather more integrated development took place in Britain. This is an integration, or a set of close connections, that has not been recognized very much in the literature. Partly under the direct influence of Max Bill and Richard Paul Lohse, systematic methods and mathematics became important to artists in the UK.

2. Alberto Biasi, "Situation 1967," in Rosen (2011), 268–269; and Frieder Nake, "Reply to Alberto Biasi," in Rosen (2011), 270–271.
3. See the chapter "1973: Tendencies 5," in Rosen (2011), 473–528.

Alastair Grieve's 2005 book, *Constructed Abstract Art in England*, describes important developments in British abstract art from 1950 to 1970, including the work of Mary Martin, Kenneth Martin, and Anthony Hill. In 1954, they were included in the important publication *Nine Abstract Artists* (Alloway 1954) and in the associated exhibition, often seen as a turning point in British abstract art. They influenced, and sometimes taught, a group of British artists who became known as the Systems group. The Arts Council of Great Britain exhibition *Systems* toured in 1972–1973 and included artists such as Malcolm Hughes, Colin Jones, Michael Kidner, Peter Lowe, Jean Spencer, and Jeffrey Steele. Apart from the direct influence of mathematics in its own right, as advocated by Bill, the significance of mathematics in nature as described in D'Arcy Thompson's groundbreaking 1917 book *On Growth and Form* was very important to many of these British artists as discussed, for example, by Grieve (2005, 226–228). In particular, in 1951 London's Institute of Contemporary Arts mounted an exhibition, *Growth and Form*, which led to a multidisciplinary book[4] that explored structure and form in many aspects of the world, including in art (Whyte 1951).

In his introduction to the catalog for the *Systems* exhibition, Stephen Bann provides a full historical context for these artists' work and makes one point that is particularly relevant to this chapter. He asks what had attracted these artists to the tradition of Constructivism and answers that the appeal "without any doubt, is the attraction of systematic procedures based on an order which is not necessarily apparent in the final work" (Bann 1972, 9).

9.3 Computer Programming

Perhaps computer programming was waiting in the wings. In 1967, Jeffrey Steele (see figure 9.2) had speculated about "the extension of the scope of an idea within the terms of its original proposition by the use of computers, which could thereby both assist and clarify the creative process itself."[5]

Then, in 1969, he made a proposal for an experimental workshop in the newly established Portsmouth Polytechnic, which in the end was not implemented. However, Stroud Cornock had just established the Media Handling Area at Leicester Polytechnic, and together he and I presented a paper at Brunel University's "Computer Graphics 1970" conference in which we discussed the future impact that the computer would

4. The book was conceived as a catalog but grew into a full book and termed a "symposium."
5. Personal communication, 2014.

Figure 9.2
Jeffrey Steele. *SYNTAGMA SG III 104*. 1992, oil on linen, 61×61 cm. See color insert. (Reproduced by permission of the artist.)

have on art practice and the creative process.[6] In 1973, Malcolm Hughes established the Experimental Department at the Slade School of Fine Art, where he installed a computer for the use of his postgraduate students. In such ways, the connections between the Systems group and computer artists in Britain began to grow.

At this time, the Hughes operation at the Slade had strong connections with Leicester Polytechnic (now De Montfort University), where I started. By 1968, I was writing computer programs as part of my art, beginning with the single mainframe computer

6. We revised the paper and later published it (Cornock and Edmonds 1973).

Figure 9.3
Ernest Edmonds. *Nineteen*. 1968–1969, multimedia, 183×145×17 cm. See color insert. (Reproduced by permission of the artist. Image courtesy of Jules Lister.)

that Leicester Polytechnic owned at that time. I arranged the elements of a twenty-part relief, *Nineteen*, by writing a program to search for solutions that matched the rules that I wanted to follow (see figure 9.3). I realized that the systems that I, and others, used in our art could be described in computer programming languages. Once programming became used in art, the form of art now known as generative appeared (Brown 2003). Generative art is one of the notable new art forms that arose in the twentieth century.

As discussed in chapter 2, in generative art (CG-art) the artist specifies a set of rules by writing a computer program. A computer then uses the program to construct the artwork. Often it is in real time, and the audience watches the generative process (LC-art, in the taxonomy of chapter 2). Unlike a film, of course, a time-based generative work can go on forever without looping. Furthermore, the computer can respond to events

Figure 9.4
Dominic Boreham. *STOS 55*. 1979, plotter drawing, ink on paper, 50×50 cm. (Reproduced by permission of Ernest Edmonds and the artist.)

in the world, such as people walking up to it, and so the generative artwork can become interactive (CI-art). Such interaction is fully in the spirit of Systems art.

Artists who studied with Malcolm Hughes at the Slade and used the computer include Paul Brown, Stephen Bell, Stephen Scrivener, and Dominic Boreham (see figure 9.4). The last two of these went on to study and work with me at Leicester Polytechnic, where Systems artists Colin Jones and Susan Tebby also taught. I moved to Loughborough University, and Stephen Bell came to study with me there. Malcolm Hughes was an external supervisor at Leicester, and Michael Kidner was an external examiner. Both Michael Kidner and Peter Lowe were artists in residence, working with computer experts, at Loughborough University. So the connections between the Systems artists and those using computers were clear.

Such direct personal connections, as well as the shared ideas about the use of procedures and structures, grew stronger over time, and there are many more connections than this short chapter has room to mention. The development of computer art in

Britain, and in particular at the Slade and Leicester Polytechnic, has been documented in a book by Catherine Mason (2008) and another edited by Paul Brown, Catherine Mason, Charlie Gere, and Nicholas Lambert (Brown et al. 2009).

It is important to point out that art made by computer programming is not to be equated with digital art in general (see chapter 2). The latter includes all kinds of ways of making artworks that involve computers, the Internet, or digital data and may not involve the artist in writing programs at all. When a program is the medium, the artist is encapsulating rules and procedures in a formal description and arranging for a computer to act out the consequences. This makes programming an obvious extension to the methods used in the art of the Systems group (Bann 1972). In this sense, the constructive tradition might be said to continue to break new ground through artists writing computer programs.

In fact, none of the Systems group artists, and none of the UK abstract artists who preceded them, wrote computer programs. But their art was a strong influence on those who did, as I come to in a moment.

Another facet of this inspiring stream of activity was that in the early 1970s Harold Cohen, already a highly respected artist, started his lifelong quest of writing and developing his computer program AARON that automatically produced drawings and paintings, most recently in partnership with the artist himself, as Cohen puts it. By this he means that having seen a painting by AARON, the artist responds by making changes, applying modified colors, for example, that are stimulated by that painting. So the partnership results in a work jointly composed by Cohen and AARON.

Cohen was a frequent visitor to the Slade and also visited both Leicester Polytechnic and Loughborough University. Some members of the Systems group met regularly with other sympathetic artists, such as John Carter, Nathan Cohen, and Trevor Clarke, in the context of Exhibiting Space (Exhibiting Space 1986)—although, as I recall, the presence of computer-based art there was limited to my participation. Thus the Systems and the computer artists overlap and have many connections. As I have indicated, writing computer programs is an extension of the Systems approach and one that provides new opportunities afforded by the technology itself.

The artists in the Systems group and the computer-based artists who followed them were working in different media and with different agendas. But their approaches overlap significantly, and they have influenced one another—sometimes in ways that are rarely documented in contemporary art histories, another "neglected avant-garde" (Grieve 2005).

From a personal perspective, I was interested in the constructivist tradition and related art from my student days. For example, as a student, I worked on an analysis of

a Mondrian painting and found mathematical regularities in it, regularities that were almost certainly not in Mondrian's mind, I admit. A key step in completing *Nineteen* was the use of a computer program. I used a structured approach in completing the work, but it led me to understand that the notion of computation and the use of formal structures and procedures could be valuable in making the work.

When I came across the Systems group, very shortly afterward, I was immediately in tune with the work. My difference with them was simply that I came at the ideas more or less as a result of finding the value of computer programming, whereas some of them were seeing the potential of programming as a way forward from Systems art. In any case, I have practiced ever since using systems and structures to underlie the making of my artworks. Sometimes I embed those systems in code, and sometimes I apply them manually, but the principles are the same whichever route is taken.

Whichever way we look at it, however, the search for principled ways of making art has been important. It came with the moves toward and into abstraction that have now been with us for over a hundred years. Perhaps artists were destined to embrace computer programming as an important new and pertinent form of expression, as an answer to many artist's dreams.

References

Alloway, L. 1954. *Nine Abstract Artists: Their Work and Theory*. London: Alec Tiranti.

Bann, S. 1972. Introduction to *Systems*. London: Arts Council of Great Britain. Exhibition catalog.

Bill, M. 1978. "The Mathematical Approach to Contemporary Art." In *Max Bill*, edited and translated by Eduard Hüttinger, 105–116. Zurich: ABC Editions.

Brown, P., ed. 2003. "Generative Computation and the Arts." Special issue, *Digital Creativity* 14 (1).

Brown, P., C. Mason, C. Gere, and N. Lambert, eds. 2009. *White Heat Cold Logic: British Computer Art 1960–1980*. Cambridge, MA: MIT Press.

Cornock, S., and E. A. Edmonds. 1973. "The Creative Process Where the Artist Is Amplified or Superseded by the Computer." *Leonardo* 16:11–16.

Doran, M., ed. 2001. *Conversations with Cézanne*. Berkeley: University of California Press.

Edmonds, E. A. 2007. "The Art of Programming or Programs as Art." In *Proceedings of the 6th New Trends in Software Methodologies, Tools and Techniques*, edited by H. Fujita and D. Pisanelli, 119–125. Amsterdam: IOS Press.

Exhibiting Space. 1986. *1985 Autumn Programme: CONSPECTUS*. London: Exhibiting Space. Exhibition catalog.

Gough, M. 2005. *The Artist as Producer: Russian Constructivism in Revolution*. Berkeley: University of California Press.

Grieve, A. 2005. *Constructed Abstract Art in England: A Neglected Avant-garde*. New Haven, CT: Yale University Press.

Lodder, C. 1983. *Russian Constructivism*. New Haven, CT: Yale University Press.

Lohse, R. P. 1992. "Lines of Development, 1943–1988." In *Richard Paul Lohse*, edited by Bernard Holeczek, Bryan James, Johanna Lohse, Lida von Mengden, and Ludmila Vachtova, 22. Budapest: International Colour and Light Foundation.

Malevich, K. S. 1968. *Essays on Art 1915–1933*. Vol. 1, edited by Troels Andersen. London: Rapp and Whiting.

Malevich, K. S. 1988. "From Cubism and Futurism to Supremitism: The New Painterly Realism." In *Russian Art of the Avant-garde: Theory and Criticism*, translated and edited by John E. Bolt, 116–135. London: Thames and Hudson.

Mason, C. 2008. *A Computer in the Art Room: The Origins of British Computer Arts, 1950–80*. Norfolk, UK: JJG Publishing.

Reichardt, J., ed. 1968. *Cybernetic Serendipity*. London: Studio International.

Rosen, M., ed. 2011. *A Little-Known Story about a Movement, a Magazine, and the Computer's Arrival in Art: New Tendencies and Bit International, 1961–1973*. Cambridge, MA: MIT Press/ZKM.

Thompson, D. W. 1917. *On Growth and Form*. Cambridge: Cambridge University Press.

Whyte, L. L., ed. 1951. *Aspects of Form: A Symposium on Form in Nature and Art*. London: Lund Humphries.

10 Programming as Art

Ernest Edmonds

10.1 Art and Programming

The computer enhances the artist's ability to shape the underlying structures of art-works and art systems. This is because the computer enables us to define the structure and organization of data in a new way. We are able to define the dynamics of that data: how it changes and develops in time and as a result of interactions with the world. As a result, artists can define the underlying structures that they are concerned with and let the computer system put them into practice. The computer enables the artist to work at the level of structure and organization, leaving the realization to automatic processes.

Computer systems are used in art practice in many different ways, as discussed in chapter 2. Sometimes the computer and its software provide a tool for the artist to work with. At other times it is best seen as a medium in which the artwork is formed. A tool is used to make a task easier, whereas a medium is the substance in which an artwork is made.

In the case of the tool, it might extend capability or it might simply make the artist's task less difficult. On the other hand, in the case of a new medium, the computer may be used to create new art forms. When the computer is seen as a new medium, the artist often needs to use the full capability of the machine by writing programs. Although a computer-based tool might come in the form of a packaged application that requires no programming to be done, our concern in this discussion is with computer systems used as a medium and with programming undertaken as a central part of art making.

Through the advent of computer programming, new concepts and constructs have become available in ways that enable new forms in art. One significant concept is generative art, discussed in chapter 2 and, for example, in the collection edited by Paul Brown (Brown 2003). Here, artists specify their intentions and a computer program builds the artwork from that specification. Many new possibilities arise from this development and challenges also present themselves. One such challenge is to find appropriate methods

and notations in which to represent the specification of the artwork. These specifications amount to programs, subject to the condition that they completely describe the generative processes involved.

The computer scientist Donald Knuth famously promoted programming as an art. In fact, he titled his much-read technical compendium *The Art of Computer Programming* (Knuth 1973–1998). Knuth was concerned with a thorough, precise, and clean approach to writing computer programs of quality. He considered this an art. Whether the word "art" is thought to be appropriate or not, programming is certainly a skill and has much in common with craft, as I discuss in the next section.

Knuth's concern goes beyond considering just how the code looks, in terms of a neat layout and so on. Knuth's concern includes also how attractive it is in its organization, efficiency, and structure. Programming is mostly done by software engineers, who are deeply concerned with the technical and functional aspects of their work. However, the design process that they use has strong aesthetic values. If the resulting code control structure looks like spaghetti, for example, it is not highly rated even if it performs its functions perfectly. In many ways the aesthetics of software design are derived from the aesthetics of formal mathematics, in which brevity, elegance, and clarity are much admired.

Today, the majority of software is probably interactive. Hence, integral with the design of the algorithms is the design of the interactions that the user will have with the system. This does not change the core nature of the art of programming, but it does extend the range of the issues of concern. Our desire for elegance (for example) in the algorithms and their expression in the code is extended to an additional desire for elegance in the interaction design and *its* expression in the code.

As with programming, concerns for the aesthetics of interaction design go beyond user interface presentation. The issues are to do with the abstract representation of interaction processes and the realization of those representations in software architectures and code. This area has been widely discussed in the field of human-computer interaction. A review of much of the foundation work is contained in the book *The Separable User Interface* (Edmonds 1992).

Interaction design is, of course, important for many artists working in this field but we consider the broader issue of programming in general, interactive or otherwise. Generative artists write programs of primarily one kind or another. Although they certainly practice the art of programming, they may be seen, more significantly, to be turning computer programs into art.

All is not simple or clear in the world of generative art, however. As Florian Cramer puts it, "While software, i.e. algorithmic programming code, is inevitably at work in all

art that is digitally produced and reproduced, it has a long history of being overlooked as a conceptual and aesthetic factor" (Cramer 2001, 8).

Cramer's point is that we tend to look at art produced with digital means as if the digital programming is a minor technical part of it. In fact, programming is at the center of such work. Digital art cannot exist without programming, and the concepts that underlie programming, such as the use of variable values, differentiate such art from other forms.

The Internet and, in particular, the rapid growth in the central importance of the World Wide Web, social communication software, YouTube, and so on, to many people has an impact on art as well as on other aspects of life. The implications were discussed, even before much of this technology existed, by Roy Ascott, for example (Ascott 1966). Artworks that encourage audience participation over the Internet are common today. These involve both the modification and the contribution of material to the structures that artists have provided. To date, the collective aspect has not normally involved programming—that has been retained in the artists' territory. However, the concepts of open source software, in which everyone is free to modify or add to the code, have attracted artists and point toward a new art form, involving collective programming, that may soon emerge.

10.2 Craft and Programming

We normally consider craft to be an activity that is very much involved with the use of our bodies and, in particular, the hand (Boden 2010). In this respect, programming can hardly count as a craft; however, many characteristics are common to programming and craft. As Boden remarks, "Craftsmen focus on the execution and perfection of their skills" (Boden 2010), which is certainly what programmers do. In fact, Richard Sennett goes so far as to say, "Craftsmanship cuts a far wider swath than skilled manual labour; it serves the computer programmer, the doctor and the artist" (Sennett 2008). However, he goes on to make the more widely accepted point that craftsmanship "focuses on the intimate connection between hand and head" but then says that "the Linux system is a public craft," by which he meant that, as open software, it is free for everyone to work on, changing, extending and improving it. It is crafted by the public, one might say, although Linux's public is a very select group of experts, of course.

In any case, it is quite clear that programming requires significant skill and considerable attention to detail. All of Sennett's dimensions of skill, commitment, and judgment play a significant role. The Arts and Crafts movement may not be one that happily embraces machinery and certainly is not a movement that one would link to

modern computing (see chapter 7). Nevertheless, the use of computer programming in art practice is closely connected to the broader notion of craft.

Although the use of computer-based tools, such as painting systems or photograph-manipulation applications, might be seen by some as an easy way of making art, the medium that includes a central role for programming is certainly not. Learning how to program in the first place is a serious undertaking, for which people often follow formal courses. Once learned, the skill of programming requires considerable attention to detail and often depends on experience to succeed.

Most obviously, programming requires that one undertake a significant degree of abstraction from the physical world. This alone makes it quite hard for some people. Second, the detail of the descriptions that must be provided is considerable and beyond anything that we are used to providing when we give instructions to human helpers.

Beyond these issues, however, it is also necessary to take many possible eventualities into account. These include everything from unavoidable problems, such as the need to recover after a power failure, to unexpected circumstances, such as unplanned changes in the lighting when analyzing images. It is also quite normal for hardware and systems software (that software that comes with a computer to enable it to work) to have faults in them. Programmers are used to looking for such faults and finding work-arounds that avoid them.

Computer programming within art making introduces a new *skill* and certainly matches the earlier skills with which we are familiar, such as carving, drawing in perspective, or impasto painting. The *art*, of course, relies on the skill but is something else beyond it. This is as true of computer-based artworks as it is of oil painting. We see in the use of programming within art practice, however, what might be considered to be a revival of the central role of craft, or at least skill, in art, a revival because the importance of skill was explicitly denied by the Conceptual artists of the 1970s.

In sum, computer programming is quite hard, has many features of craft in it, and when used in art making, is often of central importance to the nature of the work produced.

10.3 Art Theory and the Implications of Software

How programming has affected art and art theory is important to understand. This new medium has encouraged experiments and investigations both in practice and in theory. Jack Burnham was an extremely important early theorist in the area of software as art. "He conceived of 'software' as parallel to the aesthetic principles, concepts, or programs that underlie the formal embodiment of the actual art objects, which in turn parallel 'hardware'" (Shanken 2002).

In making an artwork through writing a computer program, the artist might be seen to be describing, in the program, the core concepts or principles of the work. The program contains a complete description of the arrangements—timing and dynamics, for example—that are to be used. Of course, certain aspects will be excluded, such as the size of the screen or the color of any physical structure (a frame, for instance) that forms part of the work. The parts of the work that are essentially digital are specified within the computer program. Even if pseudorandom numbers or interactions with the world are used, *how they are used* has to be fully stated within the program.

Edward Shanken (2002) explains a key implication for art practice of the use of programming: "Here meaning and value are not embodied in objects, institutions, or individuals so much as they are abstracted in the production, manipulation and distribution of signs and information."

Burnham saw very significant implications for art in the developments of information technology. In particular, he saw art as being redefined by making systems, rather than objects, the central concern.

> Information processing technology influences our notions about creativity, perception and the limits of art. …It is probably not the province of computers and other telecommunications devices to produce works of art as we know it, but they will, in fact, be instrumental in redefining the entire area of esthetic awareness. (Burnham 1970a, 11)

Specifically, he asserted that the "central thesis of my book…is that we are moving from an art centered upon objects to one focused upon systems" (Burnham 1969).

In this sense, a system is a collection of interacting entities that can be completely abstract. A computer program is a description of a set of abstract entities, signs, variables, or numbers and their relationships: a definition of a system. Systems of this kind are not new for artists. Perspective is a very familiar example of a system used in art. However, the computer program is of a new level of complexity and so has made us much more focused on the systems aspect of art. Burnham recognized that it was not altogether new. In an interview, he drew a specific parallel between the concerns of the programmer and those of the artist in which he mentions the computing concept of recursion, wherein something refers to itself: "All this business about recursion…and I thought to myself, you know, this is the way artists think" (Dammbeck 2001).

So we might say that the computer has led to a greater concern for the systems aspect in art making, and the center of this concern is in the task of programming. To return to the computer science viewpoint discussed earlier, John von Neumann (1956) said, concerning mathematical theorems, "One also expects 'elegance' in its 'architectural' and structural makeup. These criteria are clearly those of any creative art."

10.4 Conceptual Art and Software

In visual art—for example, painting—the artist works directly with the materials that form the final work. In traditional Western music, on the other hand, the composer will normally work with a score, which is an abstract representation of her or his intentions. The adequacy of such representations largely depends on the composer's ability to mentally map the notation to sound. Such mappings are difficult and sometimes very complex but, nevertheless, are direct and one to one. They are specified in a presentation notation, the process being an implicit linear progress in time. The one-to-one nature of the notation used makes it relatively easy to move between abstract and concrete representations of the music. However, this exact mapping between representations does not apply to generative art.

As explained in chapter 9, perhaps the most obvious starting point for generative art was in the discussions of the General Working Group of Objective Analysis in 1921 in Moscow (Lodder 1983). This was the beginning of the art movement generally known as Constructivism. The group drew a distinction between composition and construction in making their art. Briefly, composition was seen to be about arranging forms according to relationship rules, and construction was about making a work according to a plan for its production. The discussions of the group were complex, and its members did not all take the same position. It is probably best understood through Maria Gough's careful analysis of the composition-construction drawing pairs that the group made (Gough 2005). For our concerns, however, the key point was the introduction of the notion of making a visual art work according to a plan rather than by the application of rules of composition. In 1921, of course, the plans were executed by the artists themselves, but in generative art they are executed by computers.

The art theorist Nelson Goodman drew an important distinction between what he called notional and non-notional works of art. He argues that any sequence of letters in a novel for example, that corresponds with the original text is a genuine instance of the work. One might say that the essence of the novel is not the book object at all. It is in the notional object that we access through the book (Goodman 1978). He drew a distinction between execution and implementation, such as the writing of a novel and its implementation as a book (Goodman 1982). The parallel with programming a work of art and realizing it physically is easy to draw. From this point of view, we can see that art that involves significant programming is more *conceptual* than, for example, traditional painting.

Conceptual art is, of course, a significant movement within twentieth-century art (Alberro and Stimson 1999). Sol LeWitt made clear contributions to the practical

realization of such art that made full use of the execution-implementation distinction without using software. "In conceptual art the idea of concepts is the most important aspect of the work.... The idea becomes a machine that makes the art" (LeWitt 1967).

The idea, the system, the concept, or the computer program can be thought of as *invisible*, which must be seen to be important, Burnham argues, using Hans Haacke as an example: "In a systems context, invisibility, or even invisible parts, share equal importance with things seen" (Burnham 1968).

For example, Haacke's piece *Photo-electric Viewer Programmed Coordinate System* reacted to its environment, and in the artist's view, the invisible behavioral system was as important as the physical object (Haacke 1968).

Of one artist, Burnham said, "I suggested...that his pages of computer data...were more intriguing than the resulting sculpture" (Burnham 1970b). This was not intended as a criticism of the sculptural object but as an assertion of the importance of the system that it rested on.

The boundaries of art are changed by the advent of software. In practice, the software itself becomes a key component of the art (if not its core) and the art object becomes the implementation of the work in Goodman's meaning. In this sense, art becomes more conceptual than before. Burnham even predicted that

> the traditional notion of consecrated art objects and settings will gradually give way to the conclusion that art is conceptual focus, and that the boundary conditions of form as process and system transcend the more literal notions of geometrically defined form. (Burnham 1970b)

The art in software is increasingly recognized (Fishwick 2006). Software, the computer program, in art has been underrated, however. The computer artist's challenge is software, not because it is difficult, but because it is the conceptual representation of the new art.

How an idea, concept, or instruction is represented has a significant bearing on both the ease with which we can understand it and its precise meaning. Some things are easier to say in French than in English: "See you later" might be close to "Au revoir" but does not have quite the same meaning. The nature of the representations in which programs can be expressed is important.

Computer programs are descriptions of instructions to be followed by the machine. Through the development of methods for providing such descriptions, very many programming languages have been devised, and quite a few different approaches to the issue have arisen. These approaches amount to different ways of representing sets of instructions. There is no universal best representation. Rather, different representations are convenient for different purposes.

Pioneering artists, such as Harold Cohen or Manfred Mohr, have used various pro-gramming languages as their work has developed, but the choice has rarely been arbi-trary. In recent computer-based artwork, such as live coding, in which digital musicians write and modify programs during a performance, an appropriate representation is vital (Brown 2006) as discussed in chapter 12. A survey of the full range of approaches used is beyond the chapter's scope, but in the next section, I present a brief review of approaches I have used as an indication of the variety of methods that can be employed.

10.5 Representations: A Personal History

Given that software is important for art, then the precise nature of software needs to be understood. In this section, the representation needs of generative art are considered, and I review a few examples from my personal experience. Three main approaches are covered: procedural, logical, and graphical. No one of these entirely fulfills the needs but each has a significant role to play. My own approach to generative art making pro-vides the basis for all the work discussed.

10.5.1 Generative Composition

In generative art, such as my video constructs (Edmonds 2005), the composition is notated as a set of rules, constraints, or logical structures, and a computer program auto-matically generates the artwork using them. There is an important distinction between the structures that define the work's progress in time and the mappings (Doornbusch 2002) from those structures to specific images and sounds. Whereas the former are not necessarily perceivable in the art object, the mappings directly result in the artwork as seen or heard. The terms "process notation" and "presentation notation" distinguish between the two distinct representations that correspond to defining the progress in time and the mappings, respectively.

In generative artworks, the representations that artists create specify the rules that must be used in the process of realizing the work. These rules may be of many forms, such as instructions to follow, constraints (things to avoid), or contingencies (rules about what to do should some specific event occur). But in all cases they cannot be mapped by a simple one-to-one relationship onto the concrete artwork. Instead, they must be used together with some well-defined process, normally a computer program, to make the work. For example, the specification of a piece of music might be as a set of rules that govern the evolution of a given life game (Gardner 1970). It is specified in a process notation. This can give us the structure of the work, but then a one-to-one mapping

must also be defined so as to select which sounds and sound features relate to the aspects of the structures.

For this reason, two forms of representation are required for generative works, both a presentation and a process notation. One notation relates abstract entities, which could be letters or numbers, to colors, shapes, sounds, or other physical attributes of an artwork. The other notation specifies the rules by which the generation process should proceed. This second type of notation could, for example, be an algorithm that leads to a drawing or a process that produces an infinite piece of music. Whereas the implications of the first can be inspected and reviewed by placing the notation next to the physical elements, a list of numbered colors, for example, the second has a more distant relationship to the final work. In generative art the artist may truly not know how the work will look or sound in detail until the generative process is performed.

10.5.2 Procedural Representations

In 1968 and in the early 1970s, I used the procedural programming language FORTRAN (Katzan 1978) to implement problem-solving algorithms used in art practice. From this experience, it became apparent by 1980 that the steps in the operation of a program, known as its trace, could be used to define a sequence of events. The process of the program running could be the center of interest rather than the result that the program came up with. Thus, a computer program could be used to define a generative process for a time-based work. A significant issue was to find appropriate ways in which to specify work of this kind.

At around this time the Atari 400 and 800 computers appeared on the market.[1] They had, for their time, significant computer graphics capability built into their firmware. This could be accessed from the languages that were available for the machine. The key programming language available was BASIC. In some respects, of course, this was not unlike FORTRAN. However, there were also significant differences.

One difference was that BASIC was an interpreted language rather than a compiled one.[2] Interpreted representations seemed then, as they have since proved, to be extremely

1. See "Atari 400," Obsolete Technology (website), updated May 7, 2016, http://oldcomputers.net /atari400.html.
2. An interpreted language is used by the computer in the form in which it is written and acted on (interpreted) line by line as the program runs. When a program is written in a compiled language, on the other hand, the whole program is translated into the computer's internal code before it is run. The distinction is, in practice, rather more blurred than this, but this describes the principles behind the difference.

important in supporting creative system development. Just as the composer often sits at the piano and switches frequently between writing a score and listening to the equivalent sounds, so this flexibility of an interpreted language allows the artist to switch at will between composition and execution. All the representations that I used after BASIC have this property.

Another difference that applied to the Atari version was the integration of computer graphics functions. These were very significant for the production of generative visual work because it was possible to specify an algorithm that produced or modified graphical objects on the screen, as it was executed, instruction by instruction. Almost certainly, the main intention of the developers of this version of BASIC was to enable programmers to construct static images and graphical user interfaces. However, because the changes to the images were made after each graphical instruction was executed, it was a system in which a time-based generative work could be specified in terms of the execution of a program.

In the Atari BASIC representation, the presentation notation was direct and intuitive. The process notation, however, was that of a procedural programming language[3] and hence was weak in expressing the rules that define the generative artwork. In any case, the Atari was limiting, and I found it necessary to move to other machines. I settled on the significant new machine of the time, the Apple Macintosh.

10.5.3 Logic Programming

The next step was to recognize that logic programming[4] could be used as a method for handling structures in time and as a more appropriate process notation. It can be used to make generative work in which the rules specified in logic control the form and order of a sequence of images. The sequence can potentially go on forever without loops, depending on the rules. So, for example, an endless series of changing images can result.

In practice, this approach depended on using the logic programming language Prolog (Shapiro and Sterling 1994), which was widely available, including on the Macintosh computer. In Prolog, one writes statements, in something rather like logic, that express the rules that the system must obey. For instance, the rules (expressed in English) may say "If the number X exists, then so does the number $X + 1$" or "If the line X exists, then the parallel line Y must exist 1 centimeter away from it." Once a set of such rules

3. A procedural programming language is one in which the actions that the computer is required to perform are specified step by step.

4. Logic programming language provides a set of sentences in a variant of formal logic that expresses facts and rules, without any explicit information about the steps to be taken.

has been composed, Prolog can be given the task of trying to find out if something or another is true under those rules. It does this by adding a rule that says that the target fact is false and then looking at the consequences (making deductions using the rules) to see if it can find a contradiction. If it does, then the assumption that the fact is false must be wrong, and so we then conclude that the fact must be true.[5] The point here is that, as Prolog works this out, we can follow the program at work or the *trace* of the steps. In the way that I used Prolog, I defined the rules, posed a question to the system, and used this trace as the process that the artwork follows.

Another concept in Prolog is the side effect. This is an action, such as drawing a line on a screen, that can be linked to the operation of a rule. So our previous parallel-lines rule can be linked to a side effect: "If a line X exists, draw a line Y parallel to it 1 centimeter away." In this way, I used side effects to define the presentation, or appearance, of the works.

Naturally, a fundamental aspect of this process is coming up with rule sets that characterize both interesting images and interesting transitions between images over time. In my case, I have taken geometric rules that I have used in my art over the years (when working without computers) and coded them into computer programming languages, such as Prolog. These rules deal with issues such as adjacency and also color relationships.

10.5.4 Graphical Representations

A further development has been the integration of audio and visual elements in the generative pieces. At first, the Prolog-based notation was used together with more or less conventional scores for the music. My work with the sound artist Mark Fell has integrated the audiovisual production into a single generative process (Edmonds and Fell 2004). This work has raised new issues in the choice of notation, because of the added complexity, and a new approach has been developed based on the Max/MSP notation.[6] The simple presentation notations used previously no longer seemed adequate. This was because of the need to specify both audio and visual elements and, in addition, to specify the sound processing that was to be used so as to effect the specification in real time.

5. This may sound a little like a twisted argument, but it is soundly based on the idea that a set of true statements cannot imply a contradiction. It also requires the belief that each fact is either true or false. Although this seems simple enough, it is not always accepted in practice—but we leave that for another debate.

6. See "Max Connects Objects...," Cycling '74, accessed August 13, 2014, http://cycling74.com /products/max/.

The Max/MSP system is a graphical object-based notation using familiar sound art constructs, such as patching, in its language. It is natural in this notation to provide sound, shape, and color palettes while composing the code to determine exactly how those elements are employed on the screen and through the sound system. In this way, the presentation notation itself is divided into two parts: the palettes and the realization methods.

Max/MSP, on the other hand, does not include any logic programming constructs. However, it has not proved difficult to add appropriate elements to the system so that the equivalent to the earlier logic programming process notation can be incorporated into the Max/MSP environment.

One of the most attractive aspects of language systems like Max/MSP is that a program can be changed as it is running, so that programmers can obtain immediate feedback as they try out different ideas. Of course, in classic approaches to programming this facility is frowned on, on the basis that everything should be determined before a program is written. However, in creative uses of software there is often an intimate intertwining of designing the program and seeing the implications of a design decision. This is a point that we see more of in chapter 14, when interviews with ten artists who write code are presented.

10.6 Conclusion

It is very instructive that computer scientists consider programming an art. They see aesthetic issues as significant ones for their work. It is not altogether surprising from that point of view that programs can be seen as art. The important point, however, is that software art is a radical and relatively new step forward for art. Notwithstanding much said here, software art does not remove the importance of art objects any more than an understanding of the executed object that is a novel reduces the importance of a book. Rather, software art adds a conceptual dimension to art that changes the focus from a largely object-oriented one to a broader and perhaps deeper systems-oriented one.

Art is all the richer for embracing software, but in so doing, the challenge to artists is to be at least as deeply involved in software as in any other aspect of their practice. There are many ways of writing code, and each way has different implications for the creative process. Programming is as much a new skill, or new set of skills, for the artist to choose and master as it is in many other walks of life.

References

Alberro, A., and B. Stimson. 1999. *Conceptual Art: A Critical Anthology*. Cambridge, MA: MIT Press.

Ascott, R. 1966. "Behaviourist Art and the Cybernetic Vision." *Cybernetica* 9:247–264.

Boden, M. A. 2010. "Crafts, Perception and the Possibilities of the Body." In *Creativity and Art: Three Roads to Surprise*, 50–69. Oxford: Oxford University Press.

Brown, A. 2006. "Code Jamming." *M/C Journal* 9 (6). http://journal.media-culture.org.au/0612/03 -brown.php.

Brown, P., ed. 2003. "Generative Computation and the Arts." Special issue, *Digital Creativity* 14 (1).

Burnham, J. 1968. "Systems Esthetics." *Artforum* 7 (1): 30–35.

Burnham, J. 1969. "Letter: Art's End." *New York Review of Books*, November 20. http://www .nybooks.com/articles/1969/11/20/arts-end-2/.

Burnham, J. 1970a. "Notes on Art and Information Processing." In *Software Information Technology: Its New Meaning for Art*, edited by J. B. Burnham, 10–14. New York: Jewish Museum.

Burnham, J. 1970b. *On the Future of Art*. New York: Viking.

Cramer, F. 2001. "Software Art and Writing." *American Book Reviews* 22 (6): 8.

Dammbeck, L. 2001. "Excerpts from an Interview with Jack Burnham." October 17. http://heavy sideindustries.com/wp-content/uploads/2010/10/Jack-Burnham-interview-by-Lutz-Dammbeck -2001.pdf.

Doornbusch, P. 2002. "Composers' Views on Mappings in Algorithmic Composition." *Organised Sound* 7 (2): 145–156.

Edmonds, E. A., ed. 1992. *The Separable User Interface*. London: Academic Press.

Edmonds, E. A. 2005. *On New Constructs in Art*. Forest Row, UK: Artists Bookworks.

Edmonds, E. A., and M. Fell. 2004. "Broadway One." In *Electronic Art and Animation Catalogue, SIGGRAPH2004*, edited by Sue Gollifer, 30. New York: ACM Press.

Fishwick, P. A., ed. 2006. *Aesthetic Computing*. Cambridge, MA: MIT Press.

Gardner, M. 1970. "The Fantastic Combinations of John Conway's New Solitaire Game of 'Life.'" *Scientific American* 223 (4): 120–123.

Goodman, N. 1978. *Ways of Worldmaking*. Indianapolis, IN: Hackett.

Goodman, N. 1982. "Implementation of the Arts." *Journal of Aesthetics and Arts Criticism* 40:281–283.

Gough, M. 2005. *The Artist as Producer: Russian Constructivism in Revolution*. Berkeley: University of California Press.

Haacke, H. 1968. *Hans Haacke*. New York: Howard Wise Gallery. Exhibition catalog.

Katzan, H. 1978. *Fortran 77*. New York: Van Nostrand Reinhold.

Knuth, D. E. 1973–1998. *The Art of Computer Programming*. Reading, MA: Addison Wesley.

LeWitt, S. 1967. "Paragraphs on Conceptual Art." *Artforum* 5 (10): 79–84.

Lodder, C. 1983. *Russian Constructivism*. New Haven, CT: Yale University Press.

Neumann, J. von. 1956. "The Mathematician." In *The World of Mathematics*, edited by J. R. Newmann, 2053–2063. New York: Simon and Schuster.

Sennett, R. 2008. *The Craftsman*. London: Allen Lane.

Shanken, E. A. 2002. "Art in the Information Age: Technology and Conceptual Art." *Leonardo* 35 (4): 433–438.

Shapiro, E., and L. Sterling. 1994. *The Art of Prolog: Advanced Programming Techniques*. 2nd ed. Cambridge, MA: MIT Press.

11 Diversities of Interaction

Ernest Edmonds

11.1 Introduction

Art becomes interactive when audience participation is an integral part of the artwork. Audience behavior can cause the artwork itself to change. In making interactive art, the artist goes beyond considerations of how the work will look or sound to an observer. The way that it interacts with the audience is also a crucial part of its essence.

The core of such art is in its behavior more than in any other aspect. The creative practice of the artist is, therefore, quite different from that of a painter. A painting is static and so, insofar as a painter considers audience reaction, the perception of color relationships, scale, or figurative references is most important. In the case of interactive art, however, it is the audience's behavioral response to the artwork's activity that matters most. Audience engagement cannot be seen just in terms of how long they look at the work. It needs to be judged in terms of what they do, how they develop interactions with the piece, and whether they experience pain or pleasure.

Interactive art is distinguished by its dynamic responses to external stimuli, such as people moving and speaking. For artists, this means that observing people interacting with their works provides a way of understanding exactly how the work performs—that is, how it responds to the gestures, sounds, and other features of audience behavior in the immediate environment. Observing the responses of an interactive work can reveal unexpected effects that may or may not be predictable from the artist's point of view. Understanding how people feel about their experience with interactive artworks is an altogether different matter. It is impossible to directly observe the inner feelings of the audience, but for some artists, this is critical to the artwork. In that case, being able to explore the interaction space involves some form of evaluation with audience cooperation.

This chapter draws on E. A. Edmonds, "Interactive Art," in *Interacting: Art, Research and the Creative Practitioner*, ed. L. Candy and E. A. Edmonds (Oxford: Libri Press, 2011), 18–32.

However, whatever the level of interest that artists take in the audience's interaction with the work, they will typically see the physical artwork and the participating audience together as a unified system. It is impossible to understand an interactive artwork by considering just the art object unrelated to its audience and the audience actions. Hence, the artist's focus will be on a combined artificial (artwork) and human (audience) art system.

The aesthetics of interactive art include the nature of the behavior of this total system. The aesthetic experiences of the audience include experiences of action and response, as well as experiences of perception as in the case of a static work of art. The aesthetic decisions made by the artist include decisions about the fine details of the behavior of the artwork as much as its appearance. The growth in interactive art as a form has, therefore, extended the range of aesthetic considerations being employed. This extension of artistic form and extension of the scope of aesthetic decision making, as discussed by Boden (2010), are the backdrop to this chapter.

11.2 Interaction and the Art System

An interactive artwork can be described in terms of its behavior, the mechanism by which it operates, and the means of its construction. It can be helpful to see the interactive artwork in systems terms. A system is a collection of elements, or objects, that relate one to another: a change in one implies changes in others according to the relevant relationships. A static system is one in which nothing changes. An artwork such as a painting is essentially a static system, "essentially" because the nature of light that falls on a painting, the color of the wall on which it is hung, and so forth, certainly change how it looks. Physically, however, the painting does not change. By art "system," I mean an artwork that consists of a system that changes within itself and in which that change is apparent to an observer. The physical art system itself can also be seen as an element of a larger system that includes the audience; this was referred to as "the matrix" by Stroud Cornock and me (Cornock and Edmonds 1973, 12).

Art systems are systems of interrelated and interacting parts that change either by virtue of their internal mechanisms or because they are responding to the environment around them. The distinction between an art system that has an internal rationale that alone determines how it responds or behaves and one that is affected or stimulated by external factors, such as the degree of light or the presence of a moving human being, is an important one and distinguishes the two primary kinds of art systems.

The first is known as a closed system because it is not subject to any external influence. It is like a clockwork mechanism that moves and changes within itself according to its

own logic. The second is known as an open system because at least some of the elements can be changed by external forces, be they the wind or human intervention or something else. We can further distinguish between open systems that are influenced by the general environment, such as wind or temperature, and those that are (or are also) influenced by the audience. Kinetic works that respond to wind or temperature change are at one end of a spectrum and interactive installations at the other. Gina Czarnecki's *Silvers Alter* interactive art system, for example, makes sense only with human participation:

> The installation takes the form of a large scale back-projection on which human forms "live." These figures are changed by the audience's presence and movement within the space. Interactivity is very physical. It encourages a social, physical and verbal interaction between people before the interaction with technology. (Czarnecki 2005)

By "interactive art system" I mean the category in which human actions, or measurements from human bodies such as heart rate, affect the behavior of the system. In this chapter, the term "art system" refers to this interactive case.

Computer components are frequently used in the construction of interactive art systems because of the speed and flexibility with which they can control responsive devices. Computer technology is fundamentally general purpose and at the same time readily adaptable for whatever form of interaction is required. Today, almost any interactive system, from a washing machine to a car to an art system, is controlled by computers and realized through software.

The use of the computer as a control device that handles interactions according to complex and possibly changing rules has transformed participative art. By programming the computer with the rules that define the artwork's behavior, the artist is able to build significant dynamic interactive art systems that would otherwise have been impossible to construct and very difficult to conceive in the first place. The computer programs that act as controllers of interactive art can be quite complex, however. This means that considerable effort can be required to understand them, and it is often difficult to be sure about the behaviors that can arise in all the expected and unexpected circumstances. Thus, the artist often experiments as a work is made, to be clear about what its behavior is. The alternative perspective is to treat the work as one full of surprise, even for the artist.

11.3 Early Interactive Art

It is possible to debate at great length about the origins of interactive art but, for the purpose of this chapter, I start with Marcel Duchamp. In 1913, excited perhaps by the new technology in bicycle wheel hubs, he took a wheel, fixed it on a stool, and

placed it upside down in his studio. Today it is seen as a significant work of art, but Duchamp said,

> Please note that I didn't want to make a work of art out of it. The word "readymade" did not appear until 1915, when I went to the United States. It was an interesting word, but when I put a bicycle wheel on a stool, the fork down, there was no idea of a "readymade" or anything else. It was just a distraction. (Cabanne 1971, 47)

Part of the distraction was in spinning it, so, art or not, it was interactive in the simplest sense. When, later on, he made *Rotary Glass Plates*, this work was intended to be an artwork. It was also interactive in an extremely simple sense: the viewer had to turn it on and hope not to be injured it seems! According to Duchamp, the first version "nearly killed Man Ray" when he started it and the glass shattered (Naumann and Obalk 2000, 91–95).

Much later in the century, in 1952, John Cage composed *4.33*, his famous silent piano piece. Although not exactly interactive, this work was, like the Duchamp pieces, incomplete without the actions and attention of the audience; *4.33* encouraged the audience to listen to the ambient sounds around them.

Then, in 1953, Yaacov Akam started making what he called *Transformable Reliefs*: artworks that could be rearranged by the audience. He also made other pieces that were play objects of a sort; they had to be stroked or touched in some other way for the audience to experience them as intended. His interest, according to Günter Metken, was "to release the creativity of the art public, to encourage people to enter into the spirit of his work and change it according to their tastes" (Metken 1977). This interest, put this way, probably captures the intention of many artists who explored interaction in the early days. Akam went on, beyond the transformable works, to try many other ways to have the audience participate in the creative act.

The kind of work that Duchamp, Cage, Akam, and others were making became known as open works once Umberto Eco's 1962 essay on the subject became known (Eco 1989). Largely based on an analysis of modern music (but not mentioning Cage), this paper articulated a growing concern for "an open situation, in movement. A work in progress." Eco stressed that an open work is not one to which the audience can do what they like.

> The *possibilities* which the work's openness makes available always work within a given *field of relations*. As in the Einsteinian universe, in the "work in movement" we may well deny that there is a single prescribed point of view. But this does not mean complete chaos in its internal relations. What it does imply is an organizing rule which governs these relations. (Eco 1989, 19)

Eco distinguished between a performer and a member of the audience, "an interpreter," but argues that, in the context of an open work, they are in much the same situation. Looking at, listening to, or interacting with an artwork is in essence a performance in his terms. This point is relevant to the work of Andrew Johnston (Johnston, Candy, and Edmonds 2009). The audience for his virtual instruments consists of performing musicians but his consideration of their interaction with his systems is close to other work that considers members of the public as audience. Involving the audience actively in the art work had many advocates, such as GRAV,[1] and was part of the development of Happenings,[2] in which participation was also prevalent. M. Kirby described rather basic examples of participation in Allan Kaprow's *Eat*: "Directly in front of the entrance, apples hung on rough strings from the ceiling. If the visitor wished, he could remove one of the apples and eat it or, if he was not very hungry, merely take a bite from it and leave it dangling" (Kirby 1965a).

Participation in the artwork, by becoming part of the art system and interacting with whatever the artist provided, was becoming a familiar experience, whether it was typing at a keyboard or eating an apple.

Jack Burnham, an influential writer concerned with a systems theory perspective on art, saw the importance of understanding artworks in their environment and that all things that process art data "are components of the work of art" (Burnham 1969). By that definition, the audience is part of the artwork.

Stephen Willats has also worked from a systems' point of view and on audience participation in art since the 1960s. He explains that the function of his work is

> to transform people's perceptions of a deterministic culture of objects and monuments, into the possibilities inherent in the community between people, the richness of its complexity and self-organisation … the artwork having a dynamic, interactive social function. (Willats 2011)

In 1965, Willats published the first issue of *Control Magazine*; it has included many contributions on socially situated, participative art and on interactive art systems. In the first issue[3] he states that the artist provides a starting point for the observer[4] as shown in box 11.1 (Willats 1965):

1. GRAV (Groupe de Recherche d'Art Visuel), in their manifesto promote, for example, the "active participation of the spectator" (GRAV 1967).
2. Happenings was a form of theater, performed in the street; it is sometimes confused with Fluxus (see Kirby 1965b).
3. Roy Ascott was one of the contributors to *Control Magazine*'s first issue.
4. Today we would be more likely to use the term "participant" rather than "observer."

Box 11.1

The observer is given restrictions inside these restrictions are variables, with which he determines his own relationship.

This captures a significant aspect of many artists' attitude to their work at that time. The artist set up a system, with restrictions, that the participant could operate in a way that led to their own completion or resolution. For some, like Willats, ignoring those restrictions was also welcomed, so that the possibilities become "limitless," in Willats's term.

A significant pioneer in interactive art was Nicolas Schöffer, who developed the concept of cybernetic sculpture through a series of innovative works (Schöffer 1963). In 1956 he presented *CYSP 1*, a dynamic sculpture that interacted with a dancer and the environment using photoelectric cells and a microphone as sensors.[5] Another early innovator was Robert Rauschenberg, who in 1959 made the combine painting *Broadcast*, which had three radios built into it that members of the audience were free to tune as they wished.[6] It was not his only excursion into interaction. John Cage recounts,

> (I cannot remember the name of the device made of glass which has inside it a delicately balanced mechanism which revolves in response to infrared rays.) Rauschenberg made a painting combining in it two of these devices. The painting was excited when anybody came near it. Belonging to friends in the country, it was destroyed by a cat. (Cage 1961, 106)

Possibly the cat's reaction was an early example of behavior in relation to interactive art that did not conform to the artist's expectation, although it might have pleased Cage.

As electronics developed, the opportunities for making interactive art increased. Edward Ihnatowicz, for example, showed his work *SAM* in the *Cybernetic Serendipity* exhibition (Reichardt 1968). *SAM* looked rather like a flower mounted on a short backbone. It

5. *CYSP 1* (Cybernetic Spatiodynamic 1) is an environmentally perceptive robotic sculpture (see Samantha Cesarini, "The Certainty of Uncertainty," http://www.museomagazine.com/938538 /THE-CERTAINTY-OF-UNCERTAINTY).

6. This was the first interactive art work that I encountered. I saw it in the 1964 Rauschenberg exhibition at the Whitechapel Gallery, London.

Figure 11.1
Edward Ihnatowitz. *Senster*. (Photograph Edward Ihnatowitz.)

used hydraulics to move its parts in response to sound detected by four microphones in the flowerlike head. *SAM* was more sophisticated in the way it interacted than most of the earlier work, in that it not only responded to sound but also restricted its response to sound of an acceptable volume—not too quiet and not too loud. *Cybernetic Serendipity*,[7] at the Institute of Contemporary Arts, London, in 1968, was one of the defining exhibitions of early cybernetic and computer-based art. Another significant early interactive work in the exhibition was Gordon Pask's *The Colloquy of Mobiles* (Pask 1968). This was a work based on Pask's cybernetic principles in which a set of five mobiles interacted with one another, communicating through light in aiming to reach a stable state of satisfaction. Although it was primarily based on interactions between the mobiles, the public was able to use lights and mirrors to influence the behavior of the work, and so it was a very early example of interactive art.

After he showed *SAM*, Edward Ihnatowicz went on to build the *Senster* (figure 11.1), which was a very early, possibly the first, interactive sculpture driven by computer. It was a very large lobsterlike-arm construction that detected sound and movement in response to which it moved, rather in the same way that *SAM* did but with a much more sophisticated appearance. In fact it was highly reminiscent of a giraffe, turning its head and bending its neck to "investigate" the human observer. In fact, as with *SAM*, it

7. Nicolas Schöffer was another exhibitor.

seems that the algorithms[8] used to drive the behavior were relatively simple. It was the complexity of change in the environment and certain rules within the algorithm (such as ignoring very loud noises) that led to this sophisticated appearance. In Ihnatowicz's work, it is clear that how the sculpture looked was of relatively little importance. What mattered was how it behaved and, in particular, how it responded to the audience.

At the same time that Ihnatowicz was developing the *Senster*, Stroud Cornock and I were using a computer to develop another interactive artwork, called *Datapack*. Interestingly, but perhaps not surprisingly, we used a machine very like the one employed by Ihnatowicz. We used a Honeywell DDP-516,[9] and he used a Philips machine that was very similar and, possibly, a version of the same computer.

By 1966, Roy Ascott had developed a view in which participation and interaction between the audience and the artwork was central:

> In California in the 1970s, introduced to the computer conferencing system of Jacques Vallée, *Informedia*, I saw at once its potential as a medium for art and in 1979 abandoned painting entirely in order to devote myself wholly and exclusively to exploring telematics as a medium for art. (Ascott 1998)

Ascott has become one of the most active figures in the community, as a teacher, speaker, writer, and conference organizer, as well as a practicing artist. Notwithstanding that he "abandoned painting entirely" in the 1970s, he has continued to produce objects from time to time, as can be seen in his 2011 London exhibition.[10] But all have addressed the issues of participation and the implications for art of the ideas of computing and communications.

The development of interactive art was a geographically wide phenomenon with significant activity, for example, in Australia. The Sydney collective Optronic Kinetics was committed to responsive artworks, and they made such a work (unnamed) around 1969. Davis Smith, of Optronic Kinetics, said, "It consisted of a dark room in which was placed a cathode ray screen controlled by a radio frequency device sensitive to movement. As one moved about the room a wave pattern changed form on the screen and a sound of varying pitch was emitted from a device called a Theremin" (Jones 2011, 164).

8. An algorithm is a set of instructions performed in a defined sequence to achieve a goal.
9. See http://www.old-computers.com/museum/computer.asp?c=551 (accessed 17.4.2011).
10. *Roy Ascott: The Syncretic Sense* at Space, May–June 2011, http://www.spacestudios.org.uk/whats -on/exhibitions/roy-ascott-the-syncretic-sense.

11.4 The Growth of Interactive Art

From the early days of experimental interactive art, it became apparent that the computer could have an important role in facilitating, or managing, interaction. This role is quite different from that of the computer as a means of producing graphic art images. By "managing" is meant that the computer controls the way an artwork performs in relation to its environment, including its human audience. Because the role of the computer was envisaged as critical to the experience, some speculated that such work could transform the artist from a maker of artworks to a catalyst for creativity. The role of the audience was seen as the important new element in the artwork.

Once the personal computer and the individual workstation appeared, the pace of change in interactive art accelerated significantly. Earlier minicomputers had been interactive and people had developed ideas about human-computer interaction before personal computers appeared, but the new availability of computer power brought access to interactivity out of specialist laboratories. Although artists did not necessarily restrict themselves to using personal computers, the availability of such machines certainly caused a significant growth in interest and activity.

The history of these developments in interactive art still has to be told in full, but a number of authors have included partial histories in books that address the broader subject of digital, or information, art. Stephen Wilson (2002) devoted significant parts of his major book *Information Arts* to reviews of developments in art using artificial life, robotics, gesture, touch, and so on and covered an interesting selection of such art in a later publication (Wilson 2010). Another example is Wolf Lieser's (2009) book *Digital Art*, which includes a section devoted to selected artworks, "Interactive Objects and Art in Public Spaces." There is no space to repeat or extend such histories in this volume, but a few examples (discussed later) present a background picture of the field and illustrate the context in which authors have conducted their work.

Karl Sims is an artist, with expert technical skills, who developed a strong line of work around the notion of evolution in artificial lifelike systems. These were implemented in his case, as for many others, by the use of cellular automata. A cellular automaton is a matrix of simple on-off elements (cells) that have an effect on their near neighbors at each step in a step-by-step process (each step being a generation). All kinds of rules may be invented to determine the effect. For example, a cell might turn on at the next step if it has two neighbors that are on. Artists, such as Sims, produce graphical representations of such evolving processes as time-based artworks, sometimes using random variation in the rules and a selection algorithm that decides with which, among the alternatives, next generation to go.

Sims has made works that turn them into interactive artworks by replacing the selection algorithm by human choice, a process that he called "perceptual selection" (Sims 1992). Sims's work *Galápagos*, from 1997, exemplifies this approach. The work consists of twelve screens on stands driven by a network of twelve Silicon Graphics workstations. Pads on the floor are used for participant actions. They are used in two ways. When there is a set of displays on the screens a participant can stand on a pad in front of the one she or he likes best and so make the perceptual selection. Other pads activate the development of the next generation of the system. As Sims put it,

> Twelve computers simulate the growth and behaviors of a population of abstract animated forms and display them on twelve screens arranged in an arc. The viewers participate in this exhibit by selecting which organisms they find most aesthetically interesting and standing on step sensors in front of those displays. The selected organisms survive, mate, mutate and reproduce.... Although the aesthetics of the participants determine the results, the participants do not design in the traditional sense. They are rather using selective breeding to explore the hyperspace [of] possible organisms. (Sims 1998, 68)

The interaction is simple, but the computational complexity that it drives is quite high. It is an example of interaction in which relatively simple acts, when taken together and over time, can lead to a wide range of outcomes and to complexities that may seem quite surprising in relation to those simple acts taken individually.

Christa Sommerer and Laurent Mignonneau have a substantial history of collaborating on interactive art works based on artificial life (Sommerer and Mignonneau 2009). Indeed, as early as 1992 they made a work, *Interactive Plant Growing*, that used *real* plants as the interface that participants touched or approached. The voltage difference between the plant and the human participant was interpreted as an electrical signal that was used to determine the behavior of computer-generated images of plants.

A classic example of their work is *Life Spacies* (figure 11.2), which was created in 1997. Physically, the work consists of a laptop computer on a stand in front a large projection screen. Virtual creatures appear, grow, and move on the screen, thanks to the artists' use of artificial life concepts. Participants are invited to type text into the laptop, and as they do, the text is used by the computer to generate new virtual creatures that enter the space. For example, the letter *T* is considered in its numeric, internal, ASCII value, which is 84. That number is then used as a seed to generate a random number,[11] which is in turn used to select a modification for the creature from a list of options. Participants can also type text that becomes food for the creatures to feed on.

11. The random number is technically a pseudorandom number.

Figure 11.2
Christa Sommerer and Laurent Mignonneau. *Life Spacies*. 1997, screenshot, collection of NTT-ICC, Tokyo, Japan. See color insert. (Reproduced by permission of the artists.)

> The creature's lifetime is not predetermined, rather it is influenced by how much it eats. ... A creature will starve when it does not eat enough text characters and ultimately die and sink to the ground. ...
>
> Written text ... is used as genetic code, and our text-to-form editor translates the written texts into three-dimensional autonomous creatures whose bodies, behaviors, interactions and survival are solely based on their genetic code and the users' interactions. (Sommerer and Mignonneau 2009, 107–108)

Many artists have explored artificial life. Mitchell Whitelaw (2004) talked with many of them and published a theoretical study of the field. In "Twenty Years of Artificial Life Art," Simon Penny provides a brief survey of those developments (Penny 2011). He cautions us to remember the vast changes in technology when we look at early examples of this kind of art (and implicitly other kinds). As he says, however, "There is still much grist

Figure 11.3
Sidney Fels and Kenji Mase. *Iamascope*. 2000, in the Millennium Dome Play Zone, London. See color insert. (Photograph courtesy of Linda Candy.)

for the mill in the application of these ideas in emerging cultural forms." In other words, despite the rapid growth in research and art in this area and the changes in technology that have gone with it, artificial life still has significant potential to inspire new work.

An interactive artwork that uses a direct relationship between the input and aspects of the output is *Iamascope* (figure 11.3). As the designers of this system describe it,

> The Iamascope is an interactive kaleidoscope, which uses computer video and graphics technology. In the Iamascope, the performer becomes the object inside the kaleidoscope and sees the kaleidoscopic image on a large screen (170″) in real time. The Iamascope is an example of using computer technology to develop art forms. As such, the Iamascope does not enhance functionality of some device or in other words, "do any thing," rather, its intent is to provide a rich, aesthetic visual experience for the performer using it and for people watching the performance. (Fels and Mase 1999, 277)

The idea is that one member of the audience acts as performer. An image-processing system detects certain movements that the person makes (typically, arm waving) and

uses that to generate both kaleidoscopic-type image transformations of the movements and music. It is also intended to be interesting to other members of the audience who just watch the action—and in the case of *Iamascope*, it certainly is!

Some artists have placed more emphasis on the object and the physical, one might say sculptural, qualities of their interactive art works than the interaction process. Jeffrey Shaw, for example, has made many such artworks in which the interaction process is quite simple but the sculptural qualities are quite powerful. A well-known early example of his is *The Legible City*, 1988–1991. In this work a

> bicycle with a small monitor on the handlebars is mounted in front of a big projection screen. When the observer pedals, a projection is activated and he can move through three different simulated representations of cities (Manhattan, Amsterdam and Karlsruhe). The architectural landscape of streets is formed by letters and texts.…Jeffrey Shaw presents a poetic image of the architecture of different cities, and leaves the discovery of the virtual information structure to the observer on the bicycle.…The illusion is successful because riding, looking and reading compel the observer to dive into the picture. The rider loses himself in total immersion. (Schwarz 1997, 149)

Immersion is one of the qualities of the interactive experience that many artists have pursued, and *audience experience* is a concern in most of the other contributions.

More recent work naturally builds on the art I have mentioned, but it is also influenced by the many more recent technological developments. A few examples of the technologies that have been employed include robotics, global positioning systems, the web, virtual reality, and many interaction techniques, such as gesture recognition, image processing, and active objects, in which the object can change and is controlled in some way by computers. The range of artwork produced is too extensive to cover here, but the Wilson and Lieser books are examples of descriptions of these recent developments (Wilson 2002; Lieser 2009). The basic principles of interaction and participation, however, stand above the exploitation of interactive technologies, and the current focus is on understanding and exploring the area in terms of participant experience, which is discussed in chapter 9.

11.5 Interactions and Correspondences

It is not difficult to see a relationship between time-based visual art and music. My interest in time came from music in the first place. Adding a concern for music is a step back to the starting point. In some respects, the combination of the two is normal in twenty-first-century Western culture. When we watch a film we accept music as a natural part of the work. More generally, the sound track is recognized as a crucial element

in the quality of the film in its total sense. However, at times the music is thought of as an accompaniment to the visual element, whereas it might alternatively be thought of as having equal weight and importance.

In popular music as it evolved in the 1960s and 1970s, the opposite situation has often occurred, in which a visual element was added either in parallel to the music or derived electronically from it but, in either case, again, as an accompaniment. Later, the pop video developed as a new form that extended the music and was often as elaborate and significant as the music that it was intended to promote. Such videos extend, but primarily illustrate, the music that is their source. Perhaps the most interesting integration, however, is when the music and the visual element are equal so that, for example, one can see a visual display as one instrument in a piece in which other instruments, such as violins, happen to produce sound. The composition of such work can begin either with the music or the visual or swap between them. Alternatively, it might begin from some more abstract description or notation that can be mapped into either sound or image, as discussed in chapter 12.

11.6 From Interaction to Influence

In general systems theory the behavior of a system or the interrelationship of one system to another can be seen to be more complex than some of this chapter's examples (Bertalanffy 1968). An interaction involves an exchange but need not necessarily lead to a significant change in behavior. Interaction cannot be simply understood as if, for example, "what happens to a system in an interaction is determined by the perturbing agent and not by its structural dynamics" (Maturana and Varela 1987, 196). An interactive system is an open system that exchanges information or matter, in both directions, with its environment. One key concern is the relationship between any input and later output. In the simplest such system, any given input is followed, after a certain interval, by a predictable output. One depresses a switch and the light comes on. If we add the notion of an internal state, then a slightly more complex version can be described. The output associated with a given input may be a function of both the associated input and the current internal state or, as it is often described, the system's mode.

As a simple example of an interactive system with an internal state, consider a remote control device that can operate both a TV and a digital set-top box. It may have two buttons (TV and BOX, say) that, when pressed, produce no observable reaction. Instead, they change the mode so that any subsequent button press is directed to the indicated device. Hence, each of the two modes leads to the device displaying a different set of responses to the same set of user actions. For example, the power button may turn the TV or the box on, depending on the current mode.

Even in this very simple case it is interesting to consider some of the interaction structures in place. The TV and BOX input buttons are not associated with action-response behaviors. Instead, they change the internal state and, hence, the action-response behaviors of later button depressions.

Of course, there is no reason an input might not both generate a direct response and change the internal state. Thus, we can consider various kinds of input to an interactive system. We can identify ones that do the following:

- Generate a given response after a given time
- Change the internal state (and so influence later behavior)
- Both respond to and change the internal state

In addition to responding in these ways, a system can take actions (generate outputs) purely as a result of internal mechanisms. For example, an automatic controller might turn the room lights on and off at certain intervals. Hence we can also consider output that are the following:

- Responses to inputs (relative to the current state)
- Generated autonomously (relative to the current state)

Clearly, these outputs can be different parameters of the same output event, such as the pitch and amplitude of a note. A similar point can be made in relation to inputs, of course.

So the question arises of what we really mean by "interaction." In some respects, with delayed response (as a result of mode change) and even delayed influence on autonomous output (in the same way), "interaction" does not seem an appropriate word to use. Perhaps the words "influence," "stimulus," and "interchange" are more evocative of the meaning discussed here. Perhaps the influence of one system on another could be said to come about as a result of stimulus, interchange, or even cooperation and conversation if we add a layer of meaning to the situation. We may talk about the audience's "influence" on an art system whose behavior development is affected by the interactions that it has experienced.

As an example, my *Shaping Form* (and *Space*) (figure 11.4) series consists of unique abstract interactive artworks that are each generating colors and forms in time from a set of unique rules. They also take data from a camera and continuously calculate the amount of activity seen in front of the work. The computer software then steadily modifies the rules. The artwork and its development over time are influenced by the people who look at it: the audience helps shape the work. *Shaping Form* is a representation of computed life, moving and changing of its own accord but maturing and developing as a result of the movement of audiences. Each work interacts gently with

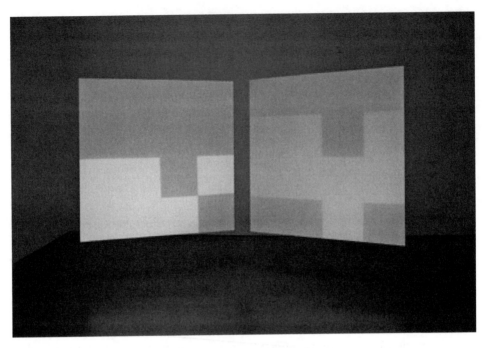

Figure 11.4
Ernest Edmonds. *Shaping Space*. 2012, interactive installation. See color insert. (Reproduced by permission of the artist. Photograph Site Gallery, Sheffield, UK.)

its environment. The *Shaping Space* installation is in a darkened room where there are two changing images in space creating a field of color. The screens show a living matrix of colors that sometimes change very slowly and at other times burst into life. The colors use a small, but changing, palette of hues. Images are generated using rules that determine the colors, the patterns, and the timing. These are generative works that are changed by the influence of the environment around them. People can readily detect the immediate responses of the work to movement, but the changes over time are apparent only when there is more prolonged, although not necessarily continuous, contact with it. The shaping of the form is a never-ending process of computed development.

Thinking in these terms, we can consider the artwork and the audience as interacting systems that influence one another. We can consider the development of computational art systems that are open to influence and that develop over time as a consequence. Equally, we can think of the influence that such systems will have on their audiences. We therefore need to think about this kind of computational generative art in open systems terms from the very core of their design.

References

Ascott, R. 1966. "Behaviourist Art and the Cybernetic Vision." *Cybernetica* 9:247–264.

Ascott, R. 1998. "The Technoetic Dimension of Art." In *Art@Science*, edited by C. Sommerer and L. Mignonneau, 279–290. New York: Springer.

Bertalanffy, Ludwig von. 1968. *General Systems Theory: Foundations, Development, Applications*. New York: George Braziller.

Boden, M. A. 2010. "Aesthetics and Interactive Art." In *Creativity and Art: Three Roads to Surprise*, 210–243. Oxford: Oxford University Press.

Burnham, J. 1969. "Real Time Systems." *Artforum* 7 (September): 49–55.

Cabanne, P. 1971. *Dialogues with Marcel Duchamp*. London: Thames and Hudson.

Cage, J. 1961. *Silence*. Cambridge, MA: MIT Press.

Cornock, S., and E. A. Edmonds. 1973. "The Creative Process Where the Artist Is Amplified or Superseded by the Computer." *Leonardo* 16:11–16.

Czarnecki, G. 2005. Silvers Alter. https://www.ginaczarnecki.com/silvers-alter (accessed July 31, 2018).

Eco, U. 1989. *The Open Work*. Cambridge, MA: Harvard University Press. First published in 1962 as *Opera Aperta*.

Fels, S., and K. Mase. 1999. "Iamascope: A Graphical Musical Instrument.'" *Computers and Graphics* 23 (2): 277–286.

GRAV. 1967. "Manifeste du Groupe de Recherche d'Art Visuel (GRAV)." *Opus International* 1:42–43.

Johnston, A. J., L. Candy, and E. A. Edmonds. 2009. "Designing for Conversational Interaction." In *Proceedings of New Interfaces for Musical Expression (NIME)*, edited by Roger B. Dannenberg and Kristi D. Ries, 207–212. Pittsburgh: Carnegie Mellon University.

Jones, S. 2011. *Synthetics: Aspects of Art and Technology in Australia, 1956–1975*. Cambridge, MA: MIT Press.

Kirby, M. 1965a. "Alan Kaprow's Eat." *Tulane Drama Review* 10 (2): 44–49.

Kirby, M. 1965b. *Happenings*. New York: E. P. Dutton.

Lieser, W. 2009. *Digital Art*. Königswinter, Germany: Tandem Verlag.

Maturana, H. R., and F. J. Varela. 1987. *The Tree of Knowledge: The Biological Roots of Human Understanding*. Boston: Shambhala.

Metken, G. 1977. *Yaacov Agam*. London: Thames and Hudson.

Naumann, F. M., and H. Obalk. 2000. *Affectt Marcel: The Selected Correspondence of Marcel Duchamp*. London: Thames and Hudson.

Pask, G. 1968. "The Colloquy of Mobiles." In *Cybernetic Serendipity*, edited by J. Reichardt, 34–35. London: Studio International.

Peacock, K. 1988. "Instruments to Perform Color-Music: Two Centuries of Technological Instrumentation." *Leonardo* 21 (4): 397–406.

Penny, S. 2011. "Twenty Years of Artificial Life Art." *Digital Creativity* 21 (3): 197–204.

Reichardt, J., ed. 1968. *Cybernetic Serendipity*. London: Studio International.

Schöffer, N. 1963. "Three Stages of Dynamic Sculpture." In *Nicolas Schöffer: Space, Light, Time*, 132–142. Neuchatel, Switzerland: Griffon.

Schwarz, H.-P. 1997. *Media Art History*. Munich: Prestel-Verlag/ZKM.

Sims, K. 1992. "Interactive Evolution of Dynamical Systems." *Towards a Practice of Autonomous Systems: Proceedings of the First European Conference on Artificial Life*, 171–178. Cambridge, MA: MIT Press.

Sims, K. 1998. "Artist's Statement." In *ICC Concept Book*. 2nd ed. Tokyo: NTT.

Sommerer, C., and L. Mignonneau. 2009. *Interactive Art Research*. New York: Springer-Wien.

Whitelaw, M. 2004. *Metacreation: Art and Artificial Life*. Cambridge, MA: MIT Press.

Willats, S. 1965. "Man Lives in a Constantly." *Control Magazine* 1:9.

Willats, S. 2011. http://stephenwillats.com/context/ (accessed April 17, 2011).

Wilson, S. 2002. *Information Arts: Intersections of Art, Science and Technology*. Cambridge, MA: MIT Press.

Wilson, S. 2010. *Art + Science Now*. New York: Thames and Hudson.

12 Correspondences: Uniting Image and Sound

Ernest Edmonds

12.1 Introduction

Chapter 9 discussed the significance of code, computer programs, in much current art. The emphasis was on the interest that many artists have in structure and ordered systems underpinning the construction of their artworks and the revolutionary opportunity that the writing of computer code offered in this respect. Indeed, the development of interest in formal structures was also the basis of the historical developments, pre- and postcomputer, discussed in chapter 10.

Beyond structure and order, the very nature of the abstract symbol manipulation that is at the heart of code has another significant implication. To relate the symbols to reality, mappings are required. The mappings may relate a detected sound or movement, for example, to a particular symbol. Equally, they may relate symbols to particular colors or tones, and so on. Thus, two of the key elements that define a computer-based artwork will often be the code and the relevant set of mappings.

In time-based and performance works the code and the mappings may change over time. In *live coding* the code itself is changed during the performance. Equally, the performers can change the mappings as the piece develops.

There has been an interest in artworks that combine image and sound in various ways from well before the invention of the computer, as we see later. The computer-based notion of code and mappings, however, introduces a new possibility for the realization of such art. The code itself is essentially media independent. Only when the mappings are applied does any particular physical medium come into play. Most particularly, the

Part of this chapter draws on E. A. Edmonds and S. Pauletto, "Audiovisual Discourse in Digital Art," *SIGGRAPH 2004 Electronic Art and Animation Catalogue* (New York: ACM Press, 2004), 116–119. Exhibition catalog.

same code can be mapped onto both image and sound, for example. In fact, specific aspects of the code, particular symbols, might be mapped to sound and others might be mapped to image elements, such as color. This possibility has enabled the developments discussed in this chapter.

In art and entertainment it is no longer possible to consider the purely visual representative of the norm. The integration of music or other sound elements has become common. This chapter reviews these issues in the specific context of audiovisual art and its recent manifestation in digital works, although a historical, precomputer, review is also presented so as to put this recent work in its long-term context.

12.2 Historical Context

Many people used to think a clear distinction between the visual arts and music composition exists: a painter is not a composer, a sculptor is not a musician, brushes and chisels are not violins or pianos, and colors are not sounds. We can also find an immense amount of literature for both music and visual art history that follow, and therefore stress, this distinction.

On the basis of a clear distinction between the art of the eye and the art of the ear, one cannot classify the increasing amount of art works and instruments that stimulate, couple, and interconnect sounds and colors. Questions then start to arise. When in history did the need for combining sounds and colors come about? What are the predecessors of cinema, television, and computer? It seems plausible to be able to outline a history, parallel to that of music and visual art, that traces the evolution of image-sound systems, or audiovisual systems, and the corresponding art works. It is a difficult task to place the main phases of this history, mainly because to do so requires the identification in visual art history and music history of the connecting points, the history of the in-between. Divisions blur, and the historical classification of works as purely musical or purely visual is questioned. How important, for the whole perception of an acoustical musical work, is it to watch the musicians playing in concert? Is the experience of hearing musical patterns and rhythms an integral part of the perception of patterns of colors and shapes in space? How much does the eye influence the ear and vice versa?

Since antiquity, thinkers and philosophers have searched for unifying principles that could explain our multisensory experience of the world. Such an all-embracing harmony principle was often believed to be based on numbers. The search for a scientific relationship between color and sound can be considered as a part of this wider search for harmony. Pythagoras discovered the relationship between musical sounds, the length of strings, and the division in octaves (van Campen 1999); Aristotle produced

a color theory in which he related the consonant quality of tone intervals to colors (Jewansky 1999). In the sixteenth and seventeenth centuries artists like Arcimboldo (Gage 1993) and thinkers such as André Félibien, historiographer and architect (Jewansky 1999), produced scale systems and theories about the relationship between colors and sounds.

With Newton's *Opticks* (1704), the physical relationship between color and sound, as we know it today, was revealed. From that moment, it was understood that both colors and sounds could be described in terms of wavelengths, bandwidths, and frequencies. In the eighteenth and nineteenth centuries, instrument makers started to build machines or instruments that could stimulate simultaneously both the aural and the visual senses. They are the first examples of machines with which it was possible to create an abstract audiovisual composition in real time. The relationship between the colors and the notes was predetermined by the builder of the instrument and based on mathematical or perceptual systems. These instruments were often called color organs, and summaries of their history can be found in papers by Kenneth Peacock (1991a, 1991b). Color organs were built by Louis Bertrand-Castel (clavecin oculaire), D. D. Jameson, Bainbridge Bishop, A. Wallace Rimington, Frederick Castner (pyrophone) and Thomas Wilfred (clavilux).

The term "colour organ" was first used in a patent application by Rimington in 1893 (Peacock 1988). These instruments often looked like typical musical instruments but when played they controlled colored gas lamps or colored paper strips illuminated by candles, for example. The production of these instruments stimulated discussions regarding the possible analogy between color and sound. Similarities and differences were noticed and discussed. Examples of subjects of these discussions are the different concept of consonance in sound and in color (consonance in sound is due to physical properties of sound, but it is culturally based for colors); dissonance in music is often thought to be more unpleasant than dissonance in color; two colors create a new unit, but two tones do not create a new tone; and a series of colors cannot be memorized as easily as a series of tones that build up a melody (Jewansky 1999).

12.3 An Audiovisual Discourse

The majority of people make associations between colors and sounds, but these associations have historical and cultural reasons, not physical ones. Thus, there has been a considerable interest in finding or creating systems of correspondences and instruments that could allow the manipulation of those correspondences, one that treats the audio and visual realms almost as a whole. At the end of the nineteenth century, in many ways visual arts were acquiring characteristics typical of music. These were

mainly the use of colors in an abstract way (sounds have normally been abstract) and the introduction of the sense of movement and therefore time.

This can be seen in the development of abstract art; in Futurism, in which the representation of movement and speed was central; Calder's mobiles; and Fluxus, in which the integration of paint, music, poetry, and performance was fundamental. At the same time aspects typical of the visual arts acquired increasing importance in music. In the twentieth century the simultaneous manipulation of sound and color saw a great expansion due to the technological applications of two consecutive discoveries: electricity and the conversion of analogue electric signals into digital information. These two factors allowed the inventions of new technologies. Recording visual moving images and sound was a revolution that influenced music and art making forever. Siegfried Zielinski, in the 1999 book *Audiovisions*, writes, "My conceptual starting point is: over the last 150 years, in the history of the industrially advanced countries, a specialized, tending to become ever more standardized, institutionalized area of expression and activity has become established. I call it the audiovisual discourse. It encompasses the entire range of praxes in which, with the aid of technical systems and artifacts, the illusion of the perception of movements—as a rule, accompanied by sound—is planned, produced, commented on, and appreciated" (Zielinski 1999, 18).

In the middle of the twentieth century, score writing became a visual outcome in itself, as was well shown in the exhibition *Eye Music* promoted in 1986 by the British Arts Council (Drew and Harrison 1986), and the movement of sound in space, possible with the new playback technology, became an important parameter of music production as pitch and rhythm always were. The use of recorded or synthesized sound samples in music pushed composers to investigate two important elements of sound that are closely linked to the visual realm: one is timbre, or tone color, and the second is the effect on music perception of the absence from the audience's view of the sources of the sounds. This second factor showed how much the visual aspect of a performance (for example, watching an orchestra playing in concert) is part of the musical experience itself. That is a possible reason much of today's digital music is performed in public together with a digital visual show.

When we watch a film we accept film music as a natural part of the work. More generally, the sound track is recognized as a crucial element in the quality of the film in its total sense. At times the music is thought of as an accompaniment to the visual element, at others it might alternatively be thought of as having equal weight and importance. Much the most interesting integration, however, is when the music and the visual element are equal so that, for example, one can see a visual display as one instrument in a piece in which other instruments, such as violins, happen to produce

sound. The composition of such work can begin either with the music or the visual or swap between them. Alternatively, it might begin from some more abstract description or notation that can be mapped onto either sound or image.

Many have been inspired by the idea of integrating sound and vision. by Baudelaire's poem "Correspondences," in which he speaks of "long-held echoes, blended somewhere else into deep and shadowy unison ... the sounds, the scents, the colors correspond" (Baudelaire 1982). There is considerable interest in this integration today, and as I have argued, the advent of the computer has enhanced the possibilities in this area enormously. There are two key reasons for this. One is its ability to control the real-time production of sound and image with considerable flexibility and speed. The second reason for the importance of the computer is that it is basically a symbol-manipulation machine, and so it is able to take a symbolic form (such as a score, which is a symbolic representation of music) and automatically work with it by, for example, transforming it according to a rule. We can operate with structures that mediate between sound and vision so that a unified work can be produced that integrates both. Thus, a single unified abstract structure is mapped onto sound and image to produce the integrated synesthetic work.

12.4 Live Coding

A quite different kind of correspondence is one that exists between the music, for example, and the code. As mentioned in chapter 10 there is a significant movement that performs *live coding* (Brown 2006). The performers write and modify code to generate the music during the performance itself. The distinguishing feature of this kind of work is that the code is shown to the audience, usually by displaying it in prominent projections. So from the audience's point of view, the performance is audio and visual.

Live coders take the view that, because the code has a key role in their art, it is part of the art. Of course, one may argue with this position, but it clearly has merit, particularly in the live situation when the code is being changed to generate different results. So here we have a special case of the audiovisual experience. For the most part we do not find live coders paying as much attention to the visual experience relating to seeing the code as they do to the audio experience of hearing the music. So the visual part is more cerebral than the sound. It is an important line of work in that it brings the code to the foreground in a way that no other current artistic practice does. Its future may be in developing that aspect of the work into a true aesthetic experience equal to the music that the live coders make.

12.5 Correspondences: A Personal Exploration

In my own work, the idea is to operate with abstract structures that unify sound and vision. As well as fully composed pieces, it is possible to introduce improvisation or other performance attributes. For example, the sounds made by a musician can be analyzed in real time so that an extra note or a change in rhythm can be fed into the image-generation system and influence its development. In this way, an improvised duet between a sound instrument and an image instrument becomes possible.

My time-based work uses generative procedures that relate closely to those often used in music today (Edmonds 2003). In a series of collaborations through the 1990s and beyond I have worked with composers to make audiovisual abstract performance pieces. The underlying concepts for all these works is that a single structural form, represented in the code, generates both audio and visual representations. These audio and visual representations are not necessarily equivalent—that is to say, they need not have a one-to-one mapping, but they are part of the same underlying generative structure. Typically, a generative system is implemented in Max/MSP that produces a sequence of vectors according to a particular set of rules. The programs incorporate two sets of parallel mappings from these vectors to image and sound data. The implicit correspondences between audio and visual information are not intended to correspond to any particular physical or psychological theory. Rather, they constitute the specific aesthetic of the given work. In both domains the style is very minimal, and the works can be seen in part as developments from the Systems art tradition (Bann 1972). For example, the visual element might consist of a changing display of between one and eight stripes of closely related colors. In one case there are just two stripes, and the saturation gradually increases during the piece. The hues are selected by the generative system, and the brightness of each stripe is under the direct control of a different per-former. The audio parameters are treated in a parallel manner.

I worked with Jean-Pierre Husquinet and a group of Belgian musicians on pieces in which the live music was combined with a video construct. The first such performance was in Liège in 1990, and others followed over the next few years. In these works each musician was allocated one component of the image to follow as a score, and a set of rules provided for a direct reading of the image into music. In 2000 I worked with another composer, Maddy Aldis, on a work that was performed that year at the open-ing of my exhibition at Loughborough University. In this piece, *Correspondence 1*, a sequence of patterns, in the abstract, was first defined. Correspondences were deter-mined between those patterns and, on the one hand, projected images and, on the other, a score for violin. In 2003 I began working with Mark Fell on purely electronic

works. As with *Correspondence 1*, a pattern sequence was mapped onto both visual and audio realizations but, in these later works, both the audio and the visual streams were generated completely from code. The formal structures used are medium independent and are used together with sets of mappings onto the visual and the audio domains. The audiovisual works with Mark Fell developed into a number of forms. These were performances, a film,[1] and installation works that went on changing over long periods and were shown in gallery settings.[2]

The work *Kyoto to Sheffield*, for example, is displayed on a wall-mounted plasma screen, with sound relayed over a small pair of audio monitors or headphones. It is a generative piece written using Max/MSP/Jitter software.

The software consists of several discrete processes. These are grouped into three sections: (1) pattern generation, (2) image display, and (3) a representation of the mappings used between the symbols manipulated in section 1 and the physical sound and image events.

DC_Release is another generative audiovisual performance work composed with Mark Fell. It is performed from two Apple laptops running Max/MSP and related software. The work is part of a series that began in 2003. The core concept is that of an integrated audiovisual experience. The work is driven from an internal generative structure from which audio and visual mappings are used to realize the physical manifestation of the piece. The colors and sounds are drawn from carefully selected palettes that define the general nature of the piece. The generative processes, which control selection, sequencing, and timing, are modified in real time by the performers. The time base and the shifting relationships between performer and generative (automatic) control define the central shape of the piece. *DC_Release* begins with slow, simple performer-controlled changes and progresses to exhibit increasing generative control and a cumulative quality. The first performance was in the Corcoran Gallery in Washington, D.C., April 2007, as part of the ColorField Remix festival. Subsequently, it was performed in Sydney, Australia, and in the UK in London, Sheffield, York, and Leeds.

The use of digital computers creates changes in the established work practices, opening new possibilities to explore. For example, the digital nonlinear editing now possible marks the transition from a horizontal to a vertical method of working in video and cinema. Now, with computers, every operation is become a kind of expanded data-processing operation. Computers are the most extendible and all-comprehensive machines that we

1. *Port Hacking* was in the film section of the Sonar 2004 Festival in Barcelona.
2. These were shown, for example, at the SIGGRAPH 2004 art exhibition, Los Angeles, and the GRAPHITE 2004 art show, Singapore.

produce at this moment in history. Using computers, any type of audiovisual composition can be created: descriptive or abstract, interactive or noninteractive, with direct mathematical correspondences between sound and visual parameters or with an intuitive, metaphorical relationship between sounds and images, and so on.

Computers are the instruments with which the simultaneous manipulation of sound and images can be done at a very deep level, creating cross- or intermedia art systems. All the information, whether visual, auditory, or textual, is represented in the same digital code. Filmmaker Malcolm Le Grice observed, "It is perhaps in the continued development of the recurrent, more radically abstract theme of 'chromatic music' that the digital media could make their most significant contribution" (Le Grice 2001).

12.6 Conclusion

A history of the evolution of the relationship between the aural and the visual realms is one of scientific discoveries, evolution of technology, perception studies, and artistic results. The developments of technology in the twentieth century, and in particular the development of digital technology, have made finally explicit what has been called the audiovisual discourse. The panorama of artistic works that can be placed inside this discourse is not at all uniform in terms of form, content, or technology used. The writing of code, however, has been a key element in providing a unifying approach.

References

Bann, S. 1972. Introduction to *Systems*, 5–14. London: Arts Council of Great Britain. Exhibition catalog.

Baudelaire, C. 1982. "Correspondences." In *Les Fleurs du Mal*, translated by Richard Howard, 15. Boston: David Godine.

Brown, A. 2006. "Code Jamming." *M/C Journal* 9 (6). http://journal.media-culture.org.au/0612/03 -brown.php.

Drew, J., and M. Harrison. 1986. "Eye Music: The Graphic Art of New Musical Notation." Exhibition booklet.

Edmonds, E. A. 2003. "Logics for Constructing Generative Art Systems." *Digital Creativity* 14 (1).

Edmonds, E. A., and S. Pauletto. 2004. "Audiovisual Discourse in Digital Art." In *SIGGRAPH '04 ACM SIGGRAPH 2004 Art Gallery*, edited by Sue Golifer, 116–119. New York: ACM Press.

Gage, J. 1993. *Colour and Culture: Practice and Meaning from Antiquity to Abstraction*. London: Thames and Hudson.

Jewanski, J. 1999. "What Is the Colour of the Tone?" *Leonardo* 32 (3): 227–228.

Le Grice, M. 2001. *Experimental Cinema in the Digital Age.* Wiltshire, UK: Cromwell Press.

Peacock, K. 1988. "Instruments to Perform Colour-Music: Two Centuries of Technological Instrumentation." *Leonardo* 21 (4): 397–406.

Peacock, K. 1991a. "Famous Early Colour Organs." *Experimental Musical Instruments* 7 (2): 1–20.

Peacock, K. 1991b. "Famous Twentieth-Century Colour Instruments." *Experimental Musical Instruments* 7 (3): 1–20.

van Campen, C. 1999. "Artistic and Psychological Experiments with Synesthesia." *Leonardo* 32 (1): 9–14.

Zielinski, S. 1999. *Audiovisions.* Amsterdam: Amsterdam University Press.

13 Diversities of Engagement

Ernest Edmonds

13.1 Introduction

The use of computer systems is seeing a growth of dynamic and interactive *ambient* art in which the artwork is an integral part of an ordinary environment, such as a meeting space, bar, or square. Computer-based interactive art has encouraged a concern for a better understanding of audience *engagement*.

At the simplest level, this is a measure of how long someone looks at an artwork. In the museum world such simple measures are used to judge how attractive an exhibit is or, perhaps more accurately, how attracted to an exhibit members of the public are. The concept of engagement can be elaborated. For example, at least three kinds of engagement can be identified: *attraction* (the work drawing attention to itself), *sustainability* (the length of time that someone finds it engaging), and *repeatability* (the extent to which someone wants to experience the work again and again).

We can relate the first two categories to Alessandro Bollo and Luca Dal Pozzolo's terms (2005). In a busy public place, be it gallery or bar, it is particularly important to overcome other distractions and ensure that the work has enough attraction power. If attention is sustained, the work has sufficient holding power to create a hot spot, as Bollo and Dal Pozzolo would put it. Another form of engagement is one that extends over long periods, in which the visitor returns for repeated experiences, as in seeing a favorite play many times. These are factors that enable the hot spot to remain hot on repeated visits to the exhibition. Facilitating this meets with the highest approval in the museum and gallery world.

Thus, artists who make digital works that take engagement into account become involved, in quite explicit ways, in strategies for drawing the audience in and retaining their interest. This process can be one that includes an element of audience education, in the sense that the artwork can be designed so as to attract the public and interact with them in ways that develop interest and engagement. The predictability of such

designs is not always strong and normally requires evaluation in context. Thus, evaluation methods have become incorporated into some artists' practice as a result. Examples of this can be seen in the curated program of interactive art exhibits and their evaluation in the public exhibition area *Beta_Space*, discussed later in this chapter.

The artworks that are made for the new audiences that these artists aim for can be *ambient*, or existing in the environment without any specific signals indicating that they should be seen as *art*. Of course, the context itself can be a strong indicator in this sense. So we might distinguish between such art in a gallery and art in the street, for example. Engagement and ambient art are concepts that are important in the digital art world, but they have good continuity with the nondigital world.

An increasingly common concern is in coming to an understanding of the experience itself in the context of facilitating audience experience, whether by provoking it or gaining knowledge about it. Experience can take many forms, from pleasure to fear, from captivation to creation of danger, of difficulty, of joy. Any of them can be part of an art system. When creating interactive art, the artist will often be considering issues of audience experience in terms of one or more of these forms. Whether or not artists talk about aesthetics explicitly, they make aesthetic decisions, and in the case of interactive art, some of those decisions relate to the quality of the interactive experience. There are aesthetic qualities in interaction just as there are such qualities in color, shape, movement, or sound. Examples of the properties that, for example, Boden (2010) identifies as pertaining to aesthetics of interaction are predictability and control, attributability (to what extent is the audience able to detect that they are causing change, for example), and the speed of feedback (response time, in computer terms).

The quality of the interactive experience is an issue for the aesthetics of interaction, and the decisions made by artists are often framed by the kind of experience that the work is concerned with. That influences the aesthetic decisions made during the construction of such a work.

13.2 Interaction Engagement and Experience

The physical way that the audience interacts with a work is a major part of any interactive art system. Three main approaches are used. In the first, members of the audience physically manipulate the work. In the second, members of the audience are provided with special devices of some kind, such as the headsets in Char Davies's works using virtual reality (McRobert 2007) or George Khut's *Cardiomorphologies* (Khut and Muller 2005). The third approach is ambient, in which audience movements, or states are detected by noninvasive devices such as cameras, floor pads, or infrared beams.

These approaches are

- direct
- facilitated
- ambient

In making such works, questions need to be asked about participant or audience engagement. Do people become engaged with the artwork? Is that engagement sustained? What are the factors that influence the nature of the engagement? Does engagement relate to pleasure, frustration, challenge, or anger, for example? Of course, artists can use themselves to represent the audience and rely on their own reactions to guide their work. Much art is made like that, although asking the opinion of expert peers, at least, is also normal. However, understanding audience engagement with interactive works is quite a challenge and needs more extensive investigation than merely introspection.

Many forms of engagement may or may not be desired in relation to an artwork—for example, attractors, or attributes of an artwork that encourage the public to pay attention and so become engaged. The immediate question arises of how long such engagement might last, and we find that the attributes that encourage sustained engagement are not the same as those that attract in the first place. Another form of engagement is one that extends over long periods, in which one goes back for repeated experiences such as seeing a favorite play or movie many times throughout one's life. We often find that this long-term form of engagement is not associated with a strong initial attraction. Engagement can grow with experience. These issues are ones that the interactive artist needs to be clear about, and the choices have significant influence on the nature of the interaction employed.

13.3 Engagement and Experience

What are the relationships between interactive art, audience engagement, and experience design, and what might each offer the other? We can break this primary question down into engagement, evaluation, and familiarity.

13.3.1 Engagement

What factors influence engagement with interaction? Which modalities are most significant? If we combine sound and image, for example, is engagement increased? Can we predict engagement? What kind of engagement is interesting and valuable? Is engagement with art relevant to engagement with, for example, an information system?

The central point is to see if we can discover how to predict engagement with interaction in these various respects. First, however, we need to know if there *is* any engagement in any particular situation. Certain clues can be obtained by simple observation. If after a quick look someone walks away and goes to do something else, we might assume that they were not very engaged. On the other hand, if they keep coming back to a work and actively interact with it over time, we might assume that they were engaged. These simple measures are helpful. But to understand the factors better, we need to use methods that elicit the information from participants by either having them verbalize their experiences or by asking them in interviews.

When an interactive work is engaging, why is it so? It is probably not simply because it sounds or looks nice. It is likely to be based on the experience of the interactive relationship itself. So what are the characteristics of interactive relationships that engage us?

In evaluating interactive art and trying to find if it is engaging, we clearly need to make comparisons and try to isolate the influential factors. Laboratory-style controlled experiments are hard or impossible to conduct in this area, because of the complexity of the problem. There are many variables, and we do not have direct access to the human experiences that are a central concern. We need to find some way of drawing comparisons between different design features and participant experiences, some way of drawing comparisons between how different design features lead to different participant experiences. So we need to conduct research that does so and, even if it cannot be as reliable as we might wish, find ways of forming confident opinions. For example, we might use collective expert opinion as a source that can lead us to results that we trust.

13.3.2 Evaluation

How do we get at the experience of our users and audiences? Can we ask them to articulate their feelings during the experience? Must we rely on recall? Are there any objective measures?

Following on from our first question, there is a need to identify and develop methods for conducting evaluation. In the world of human-computer interaction (HCI), closely related questions are seen to be important, and both practitioners and researchers are trying to find answers, such as in a CHI conference workshop (Väänänen-Vainio-Mattila, Roto, and Hassenzahl 2008) and in publications (e.g., Candy 2014).

13.3.3 Familiarity

If we are familiar with something, is our engagement likely to be lower? If the experience is subtle, might our engagement actually increase with familiarity?

The crucial point is that both the levels and the quality of engagement will change as time goes on. For almost every question that we ask, we can expect to find that the answer evolves, or even changes dramatically, over time. Changes may occur while a participant is interacting, between sessions, or over months or years of familiarity. Initial delight and excitement in a simple, well-designed interaction piece may well turn to boredom after ten or thirty or a hundred repeat visits.

As participants engage repeatedly with a given work over time they might come to yearn for it to do something different. Of course, some artworks do change their behavior over time, but then a change in behavior implies at least the possibility of a change in the level of engagement. Zafer Bilda's work (briefly discussed later in this chapter) makes a contribution to the answer to this question, in the sense of showing how, in any particular case, we might tackle it (Bilda, Edmonds, and Candy 2008; Bilda 2011).

13.3.4 Art in the Object and in the Experience

Is interactive art about artworks? Perhaps it is concerned only with audience experience and not with objects at all? Might HCI design be less related to graphic or industrial design than we thought, less concerned with the object and more with the experience?

In one respect this is a philosophical rather than an empirical question. It asks where the essence of an interactive artwork is to be found. We might compare it to a question about a poem. Is the poem embodied in this particular text on this particular piece of paper? We might argue that the poem is some abstract thing that finds embodiment on the page. That is not good enough in the case of the interactive artwork, however. Somehow the participant's behavior and experience is central to the essence of the work. So this is a hard question. Rather than try to answer it, we might simply note that we need to consider what we can discover about participant experience with at least as much vigor as we consider aspects of the object—interactive artwork, information system, or whatever it might be.

13.3.5 Lessons from HCI

What can interactive art learn from research in human-computer interaction? Can interactive artists make better art through engaging with HCI? On the other hand, does HCI make their art boring, less intuitive and authentic? Which artists benefit: professional gallery artists or artist-researchers creating prototypes?

A key current HCI issue is the problem of supporting people to be more creative. The implied research required is about understanding creative processes. This includes the contexts in which they flourish and the constraints that help or hinder successful

results. Hidden behind this research is a requirement to evaluate creative processes and, hence, a need to determine the success or failure of their outcomes.

Taken as a whole, we can see that this is a particularly difficult research challenge. So how can art help? Well, it is common in science to look at what are known as boundary conditions or boundary cases. We can often learn more by studying the more extreme conditions than we can by studying just the normal everyday ones. For example, vision research, or how we see and understand the world around us, is quite a difficult topic. One way it has been advanced is by looking at when the process goes wrong by, for example, studying visual illusions, in which we can find clues about how the process works, or by looking at how failures actually stimulate creativity (Fischer 1994).

13.4 Understanding Experience in Interactive Art

With the preceding section in mind, some specific contributions are now reviewed, each of which adds to our ability to deal with the issues discussed.

13.4.1 The *Beta_Space* Model

Beta_Space is a joint venture between the Powerhouse Museum and Creativity and Cognition Studios at the University of Technology, both in Sydney, Australia, that began in 2004. It was (it is currently suspended) an exhibition space that showed new interactive art in a public area of the museum and was curated by Creativity and Cognition Studios. The specific model used was that artworks technically complete but not yet shown to the public could be exhibited, and audience reactions to the work could be gathered in formal ways. This evaluation process helped artists refine their works and helped researchers understand audience engagement better (Candy and Edmonds 2011).

The starting point for the *Beta_Space* developments might be placed in 1996, when a particular set of artist-in-residence studies were undertaken (Edmonds 1996). In these studies, four established artists worked with technologists to explore the application of digital technologies to their work, and particular attention was placed on the processes involved. In short, this exploration led to funded research projects in which Linda Candy and I investigated collaborations between artists and digital technologists.

These took place in the UK between 1998 and 2003 and involved some twenty projects in two phases (Candy and Edmonds 2002). The artist-in-residence projects conducted from 1998 on were also influenced by the UK Department of Trade and Industry's Technology Foresight Program, in which I was a member of the Creative Media subgroup. In particular, I was chair of the Access and Creativity Task Group from 1997 to 1999,

which was partly influenced by the Mission to Japan, in which experimental situations were observed (Edmonds et al. 1998). In its conclusions, the task group recommended that collaborative art and technology research initiatives should be strongly encouraged (Edmonds 1999). As a result, I set up a research grouping, which formed the context for the artist-in-residence series of projects.

13.4.2 Costello's Pleasure Framework

In the context of making interactive art, Brigid Costello has argued that the nature of play can best be understood using a taxonomy that she has termed a "pleasure framework" (Costello 2007, 2011; Costello and Edmonds 2010). In *Just a Bit of Spin* (figure 13.1), for example, participants enter into a gamelike situation and play with excerpts from Australian political speeches.

In doing this work Costello has synthesized a collection of research results that relate pleasure to thirteen categories, each of which has quite different characteristics. In the following, Costello describes each of her categories, giving each one a name:

> *Creation* is the pleasure participants get from having the power to create something while interacting with a work. It is also the pleasure participants get from being able to express themselves creatively.
>
> *Exploration* is the pleasure participants get from exploring a situation. Exploration is often linked with the next pleasure, discovery, but not always. Sometimes it is fun to just explore.

Figure 13.1
Brigid Costello. *Just a Bit of Spin*. 2007, two views of someone interacting with the work. See color insert. (Reproduced by permission of the artist.)

Discovery is the pleasure participants get from making a discovery or working something out.

Difficulty is the pleasure participants get from having to develop a skill or to exercise skill in order to do something. Difficulty might also occur at an intellectual level in works that require a certain amount of skill to understand them or an aspect of their content.

Competition is the pleasure participants get from trying to achieve a defined goal. This could be a goal that is defined by them or it might be one that is defined by the work. Completing the goal could involve working with or against another human participant, a perceived entity within the work, or the system of the work itself.

Danger is the pleasure of participants feeling scared, in danger, or as if they are taking a risk. This feeling might be as mild as a sense of unease or might involve a strong feeling of fear.

Captivation is the pleasure of participants feeling mesmerized or spellbound by something or of feeling like another entity has control over them.

Sensation is the pleasure participants get from the feeling of any physical action the work evokes, e.g. touch, body movements, hearing, vocalizing etc.

Sympathy is the pleasure of sharing emotional or physical feelings with something.

Simulation is the pleasure of perceiving a copy or representation of something from real life.

Fantasy is the pleasure of perceiving a fantastical creation of the imagination.

Camaraderie is the pleasure of developing a sense of friendship, fellowship or intimacy with someone.

Subversion is the pleasure of breaking rules or of seeing others break them. It is also the pleasure of subverting or twisting the meaning of something or of seeing someone else do so. (Costello 2007)

Even a very brief look at the categories that Costello has identified shows that playful interaction comes in many forms, and so the characteristics of a playful artworks may be quite different from one another when they evoke or encourage different kinds of playful engagement. Whether we look at this from the point of view of an artist making a playful work or of an interaction designer incorporating play into an interactive system, we can see that questions need to be addressed in more detail than indicated in the previous section. From Costello's work we also begin to see some of the answers.

It turns out that the time spent with a system and its familiarity change the nature of the experience, whether we are concerned with playfulness or not. This is the focus of the second framework to be discussed.

13.4.3 Bilda's Engagement Framework

Zafer Bilda has developed a model of the engagement process through studies of audience interactions with a range of artworks (Bilda, Edmonds, and Candy 2008; Bilda 2011). He found that the engagement mode shifts from unintended actions through to deliberate ones that can lead further to a sense of control. In some works, it continues into modes that engage more exploration and uncertainty. He has identified four interaction phases: adaptation, learning, anticipation, and deeper understanding (figure 13.2).

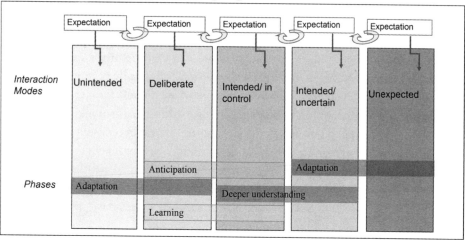

Figure 13.2

Zafer Bilda's creative engagement model. See color insert. (Reproduced by permission of Zafer Bilda.)

Adaptation: Participants adapt to the changes in the environment, learning how to behave and how to set expectations. They work with and through uncertainty. This phase often develops from unintended-action mode through to deliberate-action mode.

Learning: Participants begin to develop an internal or mental model of what the system does. This also means that they develop (and change) expectations, emotions, and behaviors, as well as accessing internal memories and beliefs. In this phase, the participant interprets exchanges with the system and explores and experiments with relationships between initiation and feedback from the system. They develop expectations about how to initiate certain feedback and accumulate interpretations of the exchanges. This phase can occur from deliberate-action mode to intended or in-control mode.

Anticipation: In this phase, participants know what the system will do in relation to initiation. In other words, they can predict the interaction. Their intention is more grounded compared with the previously described phases. This phase can occur from deliberate action mode to intended or in-control mode.

Deeper understanding: Participants reach a more complete understanding of the artwork and what their relationship is to the artwork. In this phase participants judge and evaluate at a higher, conceptual level. Thus, they may discover a new aspect of

an artwork or an exchange not noticed before. This phase can occur from intended or in-control mode to intended or uncertain mode.

Costello's forms of engagement and Bilda's stages of engagement may or may not be relevant to a particular artwork, but they provide examples of the choices that the interactive artist might make. However, whatever the nature of the experience, and presuming that the attractors have gained attention, it typically becomes desirable to begin engaging the audience in a way that can sustain interest for a significant time. This aspect of engagement might be found in the learning phase of Bilda's model.

Facilitating the kind of engagement that leads to interest in repeated experiences of the work might be found in the deeper understanding phase of Bilda's model. We often find that this long-term form of engagement is not associated with a strong initial attraction. Engagement can evolve with experience. These issues, once recognized, are important to the interactive artist, and such conscious choices have significant influence on the nature of the interaction employed.

From the artist's point of view, interactivity has added both a new dimension and a new set of issues to art making. It has become difficult to understand an interactive artwork, even one that we have created ourselves, without reference to the participant's responses. So we can expect a growth in the informed attention to the human participant's perception and cognition of the art system and its context. This in no way implies that artworks will increasingly be made to please or to match consumer demand. On the contrary, it implies that the artist will be more able to challenge perception and cognition, to disturb, alarm, or confuse participants should they want to, as well as to relax, indulge, or mesmerize them if that is their choice. The application of evaluation methods in interactive art is likely to lead to a stronger emphasis on perception and cognition in interactive situations.

References

Bilda, Z. 2011. "Designing for Audience Engagement." In *Interacting: Art, Research and the Creative Practitioner*, edited by L. Candy and E. A. Edmonds, 163–181. Oxfordshire: Libri Publishing.

Bilda, Z., E. Edmonds, and L. Candy. 2008. "Designing for Creative Engagement." *Design Studies* 29 (6): 525–540.

Boden, M. A. 2010. "The Aesthetics of Interactive Art." In *Creativity and Art: Three Roads to Surprise*, 210–234. Oxford: Oxford University Press.

Bollo, A., and L. Dal Pozzolo. 2005. "Analysis of Visitor Behaviour Inside the Museum: An Empirical Study." *Proceedings of the 8th International Conference on Arts and Cultural Management,*

Montreal, July. http://neumann.hec.ca/aimac2005/PDF_Text/BolloA_DalPozzoloL.pdf (accessed August 1, 2018).

Candy, L. 2014. "Evaluation and Experience in Art." In *Interactive Experience in the Digital Age: Evaluating New Art Practice*, edited by L. Candy and S. Ferguson, 25–48. London: Springer.

Candy, L., and E. A. Edmonds. 2002. *Explorations in Art and Technology*. New York: Springer.

Candy, L., and E. A. Edmonds, eds. 2011. *Interacting: Art, Research and the Creative Practitioner*. Oxfordshire: Libri Publishing.

Costello, B. M. 2007. "A Pleasure Framework." *Leonardo* 40 (4): 370–371.

Costello, B. M. 2011. "Many Voices, One Project." In *Interacting: Art, Research and the Creative Practitioner*, edited by L. Candy and E. A. Edmonds, 182–194. Oxfordshire: Libri Publishing.

Costello, B. M., and E. A. Edmonds. 2010. "A Tool for Characterizing the Experience of Play." In *Proceedings of the Sixth Australasian Conference on Interactive Entertainment*. New York: ACM Press.

Edmonds, E. A. 1996. *The Artist and the Proceedings of Creativity and Cognition 1996*, edited by L. Candy and E. A. Edmonds, 269. Loughborough, UK: Loughborough University Press.

Edmonds, E. A. 1999. *Final Report: Access and Creativity Task Group*. London: Creative Media Sub-Group of ITEC/OST-DTI.

Edmonds, E. A., S. Deutsch, B. Ferran, and J. Pettigrew. 1998. *Mission Report: The Interaction of Art and Technology in Japan*. London: Department of Trade and Industry.

Fischer, G. 1994. "Turning Breakdowns into Opportunities for Creativity." *Knowledge Based Systems* 7 (4): 221–232.

Johnston, A. 2014. "Keeping Research in Tune with Practice." In *Interactive Experience in the Digital Age: Evaluating New Art Practice*, edited by L. Candy and S. Ferguson, 49–62. London: Springer.

Khut, G., and E. Muller. 2005. "Evolving Creative Practice: A Reflection on Working with Audience Experience in Cardiomorphologies." In *Vital Signs: Creative Practice & New Media Now*, edited by P. Anastasiuo, R. Smithies, K. Trist, and L. Jones. Melbourne, Australia: RMIT Publishing. https://www.artlink.com.au/articles/2751/vital-signs-creative-practice-and-new-media-now/ (accessed August 1, 2018).

McRobert, L. 2007. *Char Davies's Immersive Virtual Art and the Essence of Spaciality*. Toronto: University of Toronto Press.

Väänänen-Vainio-Mattila, K., V. Roto, and M. Hassenzahl. 2008. "Now Let's Do It in Practice: User Experience Evaluation Methods in Product Development." In *Conference Proceedings and Extended Abstracts: CHI 2008*, 3961–3964. New York: ACM Press. DVD.

IV

14 Conversations with Computer Artists

Ernest Edmonds

This chapter presents a set of conversations with artists who use computer-based systems in various ways, primarily via writing of computer programs. Following short introductions, the conversations are presented in full for readers to develop their own understandings from the point of view of the artists' voices.

14.1 Art and Computer Programming

I had conversations with eleven artists who use computer code in their art, in art forms that range from drawing to performance. The conversations were informal, and I asked basically the same questions of each of them, as is apparent. But the conversations went in unexpected directions, each developing in response to the artist's inclination—as well as my own, of course. I have also talked with many other artists in preparing this chapter and, in the past, on the subject of this book. All these exchanges have influenced the earlier chapters but there are many views, and not everyone agrees even about some of the most significant issues. This chapter, then, both gives artists' perspectives and raises questions that we hope will stimulate thought that can find a firm grounding in the earlier parts of this book and perhaps reach beyond them.

Minor edits have been made to the conversation transcripts for clarity, but essentially they are printed as a direct transcription of the conversations that took place. In this way the reader is able to sense the feelings and mood of each artist as well as know the facts and opinions.

One of the pioneers that I talked with was Harold Cohen. It is particularly interesting to see how he came to use computers in his art. Back in 1967, just before he started to program computers, he went to EXPO67, in Canada, and reported on it in *Studio International*. Contemplating the exhibits and, in particular, the use of the latest technologies, he mused about what we might see in the next EXPO and remarked

that "when the new machines, the even more complex computers, get going next time round, would I want to be in front of them or behind them?" (Cohen 1968).

It was not very long before his decision became clear. In 1968 he went to the United States and first programmed computers. In a 1983 conversation that I had with Cohen (Cohen 1983), he recalled that time in interesting ways. "I started programming by accident. I never intended to do it, it's just that I found it rather curious. ... I had no notion that I would use it for anything at all."

He soon found computer programming interesting in the context of his art. Harold Cohen was already an internationally well-regarded artist by this time. One of the reasons he is important in the context of this book is that he brought a successful artist's sensibility to computer-based art and used code to push the boundaries of his well-developed practice. It is worth quoting his explanation to me, from 1983, at some length:

> My work had changed through the 60's in a very particular way. there are a number of problems central to painting mostly having to do with the nature of representation in a conventional sense, but the central mystery of painting always had to do with the fact that one can make marks and some people believe that they stand for something and, as the 60's proceeded, I found myself becoming increasingly frustrated in trying to handle that—it was as if all the painting that I was doing simply constituted a larger and larger dictionary of the way things can stand for other things without ever allowing me to generally, as it were, feel the theory of representation and, in that state of mind, of being frustrated by the act of painting itself.
>
> My painting actually moved further and further away from that until the time I went to the States in '68 I was really doing some formalist things, almost like colour-field paining. I was becoming more and more frustrated. They were very beautiful and everyone said they were wonderful and I was selling them, but I kept wishing that someone else had done them. I thought they were nice but I didn't know what they had to do with me.
>
> When I first decided that programming could do something in relation to art making in a rather simple-minded way, I said let's see if I can formalise what I am doing in painting. The first paintings, in fact, were formalist in the same way that my painting, at that time, was formalist. It was an attempt to rationalise the distribution of colours onto a flat surface. In a very simple minded way, what is a painting? Well, it's a set of coloured shapes. Then, as I got further and further into it my memory started breaking up and I started to realise that had never been my definition of painting. In fact, the marks stand for something other than themselves. The fact is simply physically, being marks on the surface is not really what I was involved in. I realised that interesting games were games of meaning or games of form and that was the point that I was lucky enough to get myself invited back to Stanford. From the time I went to Stanford I was involved much less in the art aspect than in simply trying to discover what people do when they make representations of things. That's really the thrust of the work.

So we see that Cohen was not just exploring computing, he was exploring approaches to art making, on which he said in the same conversation, "You can't really approach

art making by looking at the appearance of art. You have to approach it by finding out how art got to have those appearances." As we see in the chapter, this last remark could be taken as a guiding principle behind most of the work discussed.

Of all the pioneers represented here, Aaron Marcus was the first to make art using computer programs. Already, Michael Noll had been making line drawings on a Stromberg Carlson SC-4020 microfilm plotter (Noll 1994). He did this at Bell Laboratories, where Marcus managed to find a post with Noll, who was not himself an artist but who had a strong interest. From 1962 Noll was drawn into making art within the very open and equipment-rich world of Bell Labs. He worked with others and, in 1965, Noll and Béla Julez showed their drawings, generated from code, in the Howard Wise art gallery in New York (Patterson 2015). This was the second exhibition of computer-based art, the first being earlier in the same year in Stuttgart.

Frieder Nake, who I have also talked with many times, had written the computer code that enabled a graph plotter in Stuttgart to be controlled by a computer (code known as a device driver). The graph plotter, called at the time a drawing machine, was a Zuse Graphomat Z64. It was a large flatbed machine with four changeable pens, designed to work with a Zuse computer. The Stuttgart group wanted to use the greater power of their Standard Electric computer, however, and hence Nake's task of writing a device driver. So now they had the capability of writing code to make drawings. Interested in art and naturally curious Nake used the plotter to explore art making with algorithms. His work included making drawings for his 1964 Christmas cards, which was a very early public outing for computer art drawings.

Nake found programming conducive to his attitude to art: "I had already, before encountered the computer, … thought of art as being built up of parts, elements, objects, discrete entities, and not so much of movement, expression" (Nake 2014). From this point of view, the *New York Times* review of the Howard Wise 1965 show was much less negative than intended when it predicted that "the artist would eventually be reduced to the producer of mathematical formulas" (Patterson 2015, 28). As the interviews that follow suggest, some artists have found mathematical formulas and computer code as much a way of releasing their creativity as constraining it.

As another artist who wrote code from the early days put it, "Software is an exploratory device: it allows one to speculate on the generative potential of a field of concurrent options. Most of the options are unknown to the programmer; they have not revealed themselves, but they exist in a largely subconscious personal search space waiting to be discovered." Furthermore, "The functionality embedded in the program exposes itself to the programmer and the system talks back" (Beyls 2015, 231).

Even simpler formal devices than computer code are often important in the art-making progress. Take, for example, the grid, which we see in Paul Klee's work, Sol LeWitt's work, and in many other cases. A decade before Brian Eno became a beta tester of the generative-music software Koan, one of the ways that he was laying the ground was by employing a grid: "Things like 'Warsaw' and 'Subterraneans' started very mathematically, which is to say I just thought, okay, I'm going to put a grid down—I'd divide a piece of blank recording tape up like a tape measure and say, okay, something's going to happen on event number three" (Williams 2009, 248). Sometimes a grid is used but never seen. A painter friend of mine, Alun Leach-Jones has told me about his use of intuition and instinctive judgment in front of the canvas for years. He has always expressed doubts about the use of formal methods and computer programs. In 2015, however, in his studio he picked up a piece of charcoal, drew a grid with it, and said, "That's how I start a painting." He then explained that charcoal was perfect because he could remove any trace of it. Looking at the resulting painting you would never know that it started with a grid.

Aaron Marcus furthered his computer programming experience by chance when he obtained an internship at Bell Labs in 1967 (Marcus 1976). Art trained but not at that time a figure in the art world, he used the computer to push his art forward as Cohen was soon to do. To him it was not a barrier to his art but a partner. Whereas Nake has based much of his work on the exploitation of random numbers, Marcus came to see mistakes and failures in his code writing as random stimuli to his creative processes—"they made you think." In contrast, Manfred Mohr is made to think by the very act of writing code and by the required precision. He does use random numbers but only to "make the machine go." He is very clear that there is nothing random about the core of his work.

Among the younger artists, although they do not talk explicitly very much about randomness or error, some clearly see the unexpected as an important element of using code. Mark Fell talks about the value of "messing about." Julie Freeman talks about discovery, stepping back, and "losing control" as positive features of her approach to coding. As mentioned in chapter 10 different programming languages and environments encourage different working styles, and we have seen a shift in the process of programming from the 1960s to today. In some contexts programming is done in the well-established orderly manner, clear specifications preceding the writing of code, whereas in other, more recent ones, the specification evolves during the coding process. The former approach tends to be associated with precision and *clear thinking about what is to be coded*; the latter with the *coding itself leading to the clear thinking*. Both approaches

can be used to stimulate an artist's creativity, but as the conversations demonstrate, different artists use quite different processes.

One obvious difference among the artists is a function of their age. For example, Cohen, Mohr, and Roman Verostko can identify the changes that discovering the computer made to their art. Many of the younger artists grew up with computers and even with writing code. For them, because the computer was already a part of their lives, when they came to make art it seemed natural to use it. Alex May, Andrew Brown, and Mark Fell, for example, are in this category, and it is interesting to notice that they tend to see writing code in making art as both a natural and a unified process. They do not even think in terms of exploiting computers in art. The computer and programming are simply normal elements of doing many things and so quite natural to use in art.

Perhaps Alex McClean provides the clearest example of someone in this younger category. In a sense, he sees his programming *as* the music. He cannot think about it as a means to an end. Code is simply the most suitable way that he knows for thinking about music.

Rather than elaborate further, I let the artists speak for themselves and encourage the reader to listen to the artist's voice.

14.2 The Art World and Computing

I return to the concerns of chapter 8 the art world, in relation to the artists in this chapter. Beyond having the reported conversations, I discussed this subject with several of the artists represented. Not surprisingly, their views were not quite the same as the curators and dealers and, also not surprisingly, they tended to be even less encouraging.

None of the artists made work for the market, and even selling work is seen only as a necessity for living at best. So in one sense the commercial art world does not figure as all that important. As Harold Cohen put it, "I've never thought of making money as a worthwhile goal. It's never been the issue. I'm very happy if I make enough money to keep my operation going."

Recognition, at least by peers, does of course have a place and reviews fall partly within that area. However, reviews are often not produced. Cohen again: "Art critics as a race will never do anything to show that they don't know something. And you know I almost never come across a critic who would risk showing that he didn't understand what I was doing. So getting reviews anywhere has been problematic."

Mohr was quite active in the art world prior to finding the computer, but the shift in his work was accompanied by a rather negative shift in his relationship to that

world: "[In] the midsixties, I lived in Paris and I had, you would say, success. I had gallery shows, I sold things, and people wrote about me. So that seemed to be a good start for a young twenty-five-year-old. When I started with a computer, everything changed. All the doors closed, the galleries threw me out, the newspapers wouldn't write anymore about what I was doing, because the word 'computer' was absolutely no-no!"

Things have changed since the 1960s, of course, particularly with the formation of a few galleries that actually specialize in this area. But in general, artists are finding that they are only at the beginning of the acceptance process. As Paul Brown put it, "The commercial sector is now saying 'Well, maybe we better get on board. Maybe this is something that's interesting.'" There is hope, but the earlier attitudes are still often encountered, as Julie Freeman noted, "I find there's a little bit of dismissiveness about people working with technology. And I don't think they see that it's difficult or complex, or that it's a craft or a skill. ... If you get a really good painting, they can appreciate the skill in it. If you present something that has got really complicated algorithms and coding in it, ... they don't understand what's gone into it. ... The reason that there are so many digital art systems and media art festivals and stuff like that for us to show our work in, is because the traditional art market doesn't show it. So we've had to create our own."

So the artists in this area often find themselves operating, performing, or exhibiting in contexts that are on the edge or outside the art world. Kate Sicchio said, "I find myself much more comfortable in media arts or technical computational arts. Because they seem to understand the place where I'm coming from."

In music, things are a little different from the visual arts. This is largely because of the importance the Internet for music distribution. Mark Fell said, "If you search for me on the Internet, you'll go to loads of file-sharing websites, where you can get my music for nothing, and actually, now, I've even started pointing people to them. If they say 'Where can I get your record?' I just say, go there. Because I've given up trying to make money out of selling records."

Many of these comments on the art world may well echo artists' remarks from earlier times concerning developments in art practice and media. However, taken together with the views from curators and dealers reported in chapter 3, it seems clear that the acceptance of computers, as an integral part of the mainstream visual art world, still has quite a way to go more than fifty years into its evolution. On the other hand, if we look at what artists are actually doing and what the public is engaged with, computers are everywhere.

14.3 Conversation with Aaron Marcus, April 30, 2014

Aaron Marcus grew up in Omaha, Nebraska, in the 1950s. He was always interested in both science and visual communication. Before college, he learned drawing, painting, photography, and calligraphy. He obtained his BA in physics at Princeton University in 1965 and his BFA and MFA in graphic design at Yale University's School of Art and Architecture in 1968. At Yale, while a graphic-design graduate student, he also began the study of computer graphics, which was extremely unusual for the time. He learned FORTRAN programming on his own time at the Yale Computer Center in 1966. In 1967, Marcus spent a summer as a graduate student intern researching design with computers and making computer-based graphic art at AT&T's Bell Laboratories in Murray Hill, New Jersey. He may be the first graphic designer in the world ever to work full-time with computers. During 1968 to 1977, at Princeton University's School of Architecture and Urban Planning and in its Visual Arts Program, he taught color, computer art, computer graphics, concrete and visual poetry, environmental graphics, exhibit design, graphic design, history of design and visual communication, information design, information visualization, layout, publication design, systematic design, semiotics, typography, and visual design. In 1971–1973, while a faculty member at Princeton University, he programmed virtual reality art and design spaces, the first professional designer to have done so. After teaching in Jerusalem and researching visual communication in Honolulu, he moved to Berkeley and, after teaching at the University of California, Berkeley, and researching user-interface design at Lawrence Berkeley Laboratory, in 1982, he founded Aaron Marcus and Associates (AM+A), a user-interface design and consulting company, which was one of the first such independent, computer-based design firms in the world.

Ernest: I'm most interested in the work you did in the early days of computer technology. Could you say something about where programming and computing came into your art and design, what were you doing before you discovered the computer, and how did your use of the computer begin?

Aaron: My university education originally was in science, so I studied physics, mathematics, and philosophy at Princeton University. At that time I didn't use computers at all. They were too new; in fact, I used to earn money plotting data charts for scientists, the very computer graphics that computers first produced. When I decided "to achieve escape velocity" and moved from physics to art and design, I landed at Yale University's School of Art and Architecture, specifically in the Department of Graphic Design. There, the faculty introduced me to color theory, typography, visual design,

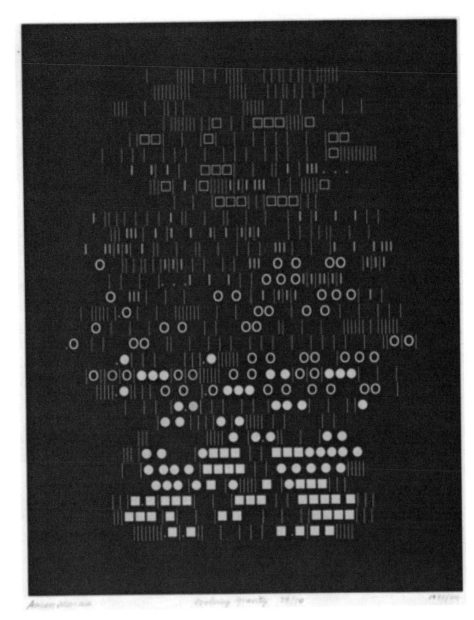

Figure 14.1
Aaron Marcus. *Evolving Gravity.* 1972–1974. See color insert. (Reproduced by permission of the artist.)

composition, publication design, etc., topics in which I'd always been interested, but in which I never had any formal training. It was a magnificent experience to work sixteen to eighteen hours a day in this new world.

I didn't use computers in my first year, 1965 through '66. For some reason, I can't quite remember why, I had a feeling that I, as someone from the sciences, now in an art school or design school, should know about or have something to do with these new computers. I took advantage of being a student to take a course in the fundamental logic of computers. I loved the idea that I could understand the basic operations of a central processing unit and a mathematic/logic unit, from which all computing derives. That study gave me a thrill, I suppose appealing to the systematic, scientific, and logical in me.

In the following year I continued my studies of graphic design and visual communication. I've always drawn since early childhood, and I've always been involved with calligraphy, photography, poetry, and later, visual poetry. In the spring of 1967, I learned about job interviews for positions with AT&T Bell Labs that were taking place on the Yale campus. I thought, well, why not? I went and met with two interviewers, Michael Noll and Peter Denes, who were then involved with acoustics research at Bell Labs.

Peter was a brilliant man, Hungarian, odd, and intense. Michael, also, was odd and intense. They seemed, in retrospect, like the two secret agents in the movie *Men in Black*, two people in dark suits, white shirts, and thin ties. As I came in a small room for the interview, I said, "I have no idea why you would want to hire me. I was studying physics for four years, quantum electromagnetic theory and so on, and now I'm cutting out pieces of colored paper in an art school, studying graphic design, and wondering if I'm just in psychotherapy somewhere in an asylum. Can you do anything with that? Do you want me for any reason?" thinking, no they didn't. They turned, looked at each other, smiled, then turned back to me, and one of them said, "Well, actually, we're looking for someone exactly like you!" I was astonished. That moment began my future career, first as a summer intern at AT&T Bell Labs, which exposed me to state-of-the-art computer graphics equipment.

I spent the summer playing with computers, learning how to program their machines, producing art as well as thinking about design uses. I thought I should experiment with producing artwork, and I was influenced by one researcher there, who was visualizing quadratic equations formulae. I adopted some of his approach and produced my own complex dot patterns exhibiting the mathematical properties of quadratic equations spread out graphically. They were quite beautiful, intriguing, mathematical visual objects. I was satisfied. I also realized I could interject randomness in such images so that they were not perfectly ordered, because then they would seem to me to be a little

boring and merely a mathematical depiction. And so I did further experiments, and sometimes when I miscoded, the mistakes, the failures, were often surprisingly intriguing images, and I said, oh, actually, I like that better than what I was trying to do. I will declare that image my work, and thanks to the computer, which interrupted my intentions, I produced something that is a bit of a jarring discord and a surprise for me and for the viewer.

Ernest: Did that affect quite what you did next? Did you sometimes...?

Aaron: Try to achieve mistakes?

Ernest: Well, not exactly, but I wonder if your making a mistake made you think, well, actually I could have done it a bit differently.

Aaron: There would be occasions when I would think, oh, that went far awry from what I wanted, but, actually, I like the results better. Now let's see, how can I achieve that kind of result in a more systematic and controllable way, and also [how can I] develop other kinds of images by learning from that error. I would say also as a computer artist that I was interested in typographic forms in artworks, coming in part from my studies of graphic design and my interest in signs and symbols, in fact, phonogram symbols. I would try to incorporate these symbols into my artwork.

So in 1967, I did that first experimental work, and I later exhibited some of those works. I continued at Bell Labs in 1969 through '71 to be a consultant. I would also continue, sort of on the sly, to create visual artworks that were not part of my official assignment, which was to program an interactive page-layout system for the Picturephone, a sort of desktop publishing system about ten years ahead of commercial products, a case study of which I published in the *Journal of Visible Language* in 1971. Back at Princeton in '71 to '73 I continued to explore computer art and computer design using an LDS-1 [Line-Drawing System-1] computer graphics system in the Biology Department. I experimented with 3-D interactive environments, inspired by engineering research examples of flight simulation, e.g., take off from and landing on an aircraft carrier.

As a result, I created the first virtual reality displays designed by an artist or professional designer. They were quite simple: stick-figure human beings in a three-dimensional space. The computer graphics system could display two thousand vectors in a real-time display, and I could enable a viewer or a visitor to my space to traverse a large empty landscape, find a symbolic highway, move along that highway, view Burma-Shave-like slogan-signs along the highway that gave philosophical thoughts, find a dynamic, spiraling sculpture of signs in space, and encounter a random actor-dancer who was moving around in the space. I was inspired by and adapted something with which Michael Noll had experimented: computer-generated dancers.

I exhibited those *Cybernetic Landscapes, 1971–73* and many other artworks around the world, and I published them in many journals, books, and magazines, especially *Soft Where, Inc.*, volume one and two, monographs documenting my own work in computer art, visible language experimentation, and conceptual art. During a sabbatical from teaching at Princeton, I went back to Yale in 1972, where I had the opportunity to program artworks using a Linotype phototypesetting machine controlled by a PDP-10 computer. That system at Yale was among the first programmable phototypesetting machines connected to medium-sized computers. Most recently, these works of *Cybernetic Landscapes* and other of my computer artworks were purchased by the San Francisco Museum of Modern art in 2016 and displayed in an exhibit called *From Typeface to Interface*.

Ernest: Sounds good.

Aaron: During my years making computer art in the 1970s, the mistakes were interesting, and I tried to develop them further. I have a series of serigraphs and lithographs that were created from those 1972 black-and-white originals. In 1974, several of them were later translated into color images for a bank's annual report, because the bank representatives wanted some artwork that was futuristic. Also in 1974, I transformed black-and-white images through the Pratt Graphic Center in New York City, which commissioned me to do two serigraph editions, *Noise Barrier* and *Evolving Gravity*. I still have and sell signed copies of these editions. Now, I've mentioned about four different computing platforms that I have used, and four different contexts in which I had access to computer technology, all of which I certainly could not have afforded personally.

Ernest: Were they four different physical realizations as well? Did your work start with a plotter, for example, or was it screens?

Aaron: I did create some ink-plotter-generated art, but not much. I recorded my images at AT&T Bell Labs originally on computer-generated microfilm. I also printed out many artworks on line printers and on phototypesetters. The phototypesetter, by the way, was paper-tape driven, with eight-bit holes, and the output was on phototypesetting paper in black on white. The two serigraph editions that I mentioned were in color achieved through standard, conventional color manipulation of the photo originals.

Until recently, I still had all of my computer art and also some of the programming decks of input cards, stored in my garage. However, during 2016 and 2017, I have donated almost all of my computer art and design works to the San Francisco Museum of Modern Art, the Victoria and Albert collection in London, the Computer History Museum in Mountain View, California, the Letterform Archive in San Francisco, and the RIT Vignelli Archive at RIT [Rochester Institute of Technology] in Rochester, New York.

Ernest: So when exhibited these would have looked, how?

Aaron: Originally, the LDS-1 images of 1971–73 could only be viewed stereoscopically in real time using whirling disks of filters held in front of one's face. To record them, I photographed the screens and exhibited a photodocumentation of a trip through the space as white-line-on-black-background photos. Many of the works have appeared in museums and computer graphics exhibits as black-and-white, high-resolution, high-contrast photoprints. For most of my work, I never had an opportunity to generate multicolor original media. As I mentioned, the San Francisco Museum of Modern Art exhibited last year one of my *Cybernetic Landscapes, 1971–73*, which is now in their collection, together with a print out of the program that generated the artwork.

Ernest: In all of that work, could I ask you, when were you writing the programs in order to create the works, and before you were using computers, you were just using scissors, pencils, or whatever medium was at hand to make artwork?

Aaron: Yes, before computers, I used traditional materials to make art (and designs). Even after starting to use computers, I continued to make other artworks with Helvetica-font Letraset, i.e., press-on letters, and graph paper, and other traditional media but not using computer graphics.

Ernest: Okay, so in the beginning you were mixing it, as I still do actually. The question is, did you feel that doing some of the work by writing programs changed your attitude to making art, or did it just make some things easier to do?

Aaron: Well, having access to programs certainly changed some of the kinds of art that I could produce. For example, I would never have had the patience to draw out little circles or dots of images to create visual patterns, I would have produced something quite different without the mechanical regularity of the mathematical imagery that I was producing.

Ernest: So, did you?

Aaron: Hold that question for a moment. So the amount of effort required, which was reduced, was very important for being able to do this kind of art. Being able to produce, even with precision, certain forms and shapes was valuable. In fact, I wanted to find ways to create things that looked like they were natural manifestations or artifacts. I was using the computer to try to simulate them—for example, trying to simulate strange hieroglyphics or hieratic writings from some unknown civilization—and I would arrange things so that the computer would generate some random forms that, in assembly—that is, in group appearance—would look as though they were created by hand maybe by some strange people writing some strange language that we didn't

know. I could have done it by hand, but I doubt if I would have had the patience to do it.

Ernest: Did you think of different things to do because of the programming that you perhaps wouldn't have come up with as a concept?

Aaron: Well, it's an interesting point. You say "programming"; you could ask that, but it's also the computer graphics display mechanisms. They were also instrumental in making me realize, oh, I could do certain things that I might not otherwise have thought to do, because of the computer graphics hardware platform.

Ernest: So treat my question as that broader question.

Aaron: Well, so first we'll go back to software. Software dealing with algorithms and repetitive do-loops meant I could think about creating little things and repeating them, and it might tempt me to think, what other little things could I create and repeat and play with in a way that might have occurred to me. But as I just mentioned, think about the sheer effort of producing these marks, even to make one of them. I might say, Oh, well, I don't want ever to do that again; it took me ten hours or fifty hours to do it. I thought, Oh, it's good that I have this device to let me envision and try things quickly and then decide, No, that's not good, or, Oh, there's something I can pick up and take further. Seeing works in progress was certainly a pleasure and would give me insights into effects, into processes, into forms that I might not otherwise have had time or the ability to explore.

Ernest: And you made the interesting point that the display mechanisms themselves were important.

Aaron: Yes. They offered unique phenomena, like, for instance, with the phototypesetter, the machine is taking an image of type fonts, and then with lenses, mirrors, adjustments, [it's] focusing them line after line in a particular place on the phototypesetting paper for typesetting. When I understood and looked carefully at the mechanism, I realized, well, this is all very good, I like that, and I did some things with those symbols, but I also want something that's more calligraphic. How can I do this? And I realized, well, the phototypesetter is using a glass plate with the images of all those carefully designed letterforms that someone had spent a lot of money and time in creating. I realized that I could take blank sheets of glass, cover them with black ink or candle-flame carbon and scratch away random symbols and line elements, then put that glass plate into the phototypesetting machine. The phototypesetter would have no awareness of what it was phototypesetting, and out came computer-generated "chicken scratches," which delighted me.

I thought they had quite a lot of character, and I tried to judge best what would work out, and that led to one of my works, called *Noise Barrier*, which otherwise might have been a text that someone had typed and printed out. I forget even what text was driving the phototypesetting machine, but out came line after line of chicken scratches that made a wonderful texture. Also, I had messed up the program, and the output image came out with a completely black stripe, providing the right visual contrast to these lighter, more "hairy" line elements, so there was a gap and then some more chicken scratches, which altogether created a composition or rhythm, of an interruption of something and then continuation. In the end, it was, to my judgment, acceptable and what I wanted to show. So playing with the device revealed capabilities of which I took advantage. It had limitations that I would play with and distort, as people in decades past might have taken magnets to an oscilloscope screen to produce strange images. Mine was maybe more drastic and permanent in terms of what one could do.

Ernest: Well, you could almost argue that you were inventing a new medium.

Aaron: Well, I wouldn't say an entirely new medium, but I was certainly, as an artist, playfully, willfully, and dramatically distorting the intended purpose of this device.

Ernest: Yes.

Aaron: Like Bob and Ray, two US comedians from the 1960s, who once convinced two independent television stations in New York to broadcast them from one television studio. They urged all viewers at home watching their weekly show to set up two television sets, close to each other, and to tune in to the two different TV channels. Bob was on one, Ray was on another, and they played ping-pong with each other, with space in between the two television sets. Viewers at home saw something they had never seen before, as the ping-pong ball seemed to travel through the space in their rooms between the two sets.

Ernest: Wow, yes.

Aaron: Or another media artist, Ernie Kovacs, a playful US television comedian who was an artist in the 1950s and '60s, a visionary who broadcasted a skit for his show in which an entire room was shown that was tilted dramatically. Viewers were amazed that he poured milk on live television and the milk went at an angle and didn't hit the cup.[1] So playing with the laws of expectation, playing with the rules and boundaries, well, artists do that a lot.

Ernest: All the time, most of us.

1. "Ernie Kovacs—Kovacs in Color, the Tilted Table Sketch," *Kovacs Corner*, video, 1:44 December 27, 2009, https://www.youtube.com/watch?v=PefS8tY_gnI.

Aaron: And that's what I was doing when I substituted chicken scratches for typefaces. So I wouldn't say it was a new medium, but I was certainly distorting and finding new possibilities for a given medium.

Ernest: Good. I want to come back to an earlier point and to see if there's anything more to say about it, which is that you talked early on about making mistakes and that leading to something that was actually of value and that maybe you even carried forward. Could you think of any other kind of examples?

Aaron: Well, I would say that I've always been interested in sign and symbol systems. And that's what motivated me to try to create semiautomatic, semi-computer-generated writing systems, as though I wanted to come into contact with the writing of a civilization that no one had ever known about or seen. How could I do this? And I would say that some of the compositions that I created were based in the computer's helping me to do that, because I couldn't generate as much fast, innovative, crazy, yet systematic imagery as I could with the help of a computer. And so that kind of influenced me over a period of a couple of years to try to create images that had that quality or that feeling.

It's like creating computer-generated Paul Klee symbol paintings that are strange, mysterious, subconscious, or evocative of symbolic imagery, so that you can say, oh, that came out of the play in his mind, and we can see the influence of X, Y, or Z or maybe some contemplation with Miro's work or of someone else, but in this case, it was computer-generated, somewhat autonomously created notation or sign-language artifacts that represented the look of some strange, distant, or unknown civilization.

Ernest: I'm very, very interested in this point, and I'll explain my interest, and then I can ask you about it. My interest is this: to my knowledge, in the past, that when Michael Noll first showed in New York in '65, that was kind of roughly speaking in parallel with the Germans showing in Stuttgart.

Aaron: Yes.

Ernest: And the people in Stuttgart were very influenced by semiotics, which, of course, came from America really, first, might I say?

Aaron: Yes, I mean, American semiotics came from America, French semiologie came from France…

Ernest: Yes, but I think they were mostly influenced by the American, I think.

Aaron: It's interesting that you bring up semiotics and semiologie, because I was very much intrigued by and influenced by these disciplines. Umberto Eco, the great semiotician came to Princeton in 1975 or '76, when I first met him, that was late in the game, but I had already been interested, in '72 or so, in pasigraphy, universal writing

systems. I even had one of my students at Princeton, Peter Laundy, investigate the entire Yale library collection of books on the subject to create a bibliography of pasigraphic systems.

Ernest: Now that you say it, by the way, it's obvious that semiotics is central to your work in general.

Aaron: Yes, did I forget to mention that? [*laughs*]

Ernest: No reason, but it's obvious to me, now that I think about it, obviously, yes, but I was just thinking in the context of this digital art where I had always been thinking that the Germans were very influenced by semiotics but the Americans were not, but you contradict my expectations.

Aaron: I was definitely interested in semiotics, and the questions would be, Where did this come from and When did it start?

Ernest: Yes, that's a good question.

Aaron: Well, when I came to Princeton in 1968, right out of graduate school, to teach, I was first introduced to the semiologie of Roland Barthes. When did I first encounter Charles Sanders Pierce? I don't know. Probably at the same time. Buchler's book about the writings of Pierce, chapter seven, was one which I assigned to all of my students beginning in 1969, I think, and I used this reference and Pierce's definitions of sign frequently in my writings. I would have to go and check my own bibliography to remember when I started to do semiotic analysis of concrete poetry, for example. I think it was 1974.[2] I also did a semiotic analysis of our team's project from the East-West Center in Honolulu to visualize global energy interdependence in 1979.[3] Now I should say, also, that I've been involved with the concrete poetry movement for years.

Ernest: Well, I was going to come to that, yes.

Aaron: I exhibited in those collections, part of my Soft Where, Inc., Vol. 1 and 2, which are monographs about my computer graphics, concrete poetry, and conceptual art. The works are all involved with sign systems. For me, one of my most enjoyable works in conceptual art was *An X on America*, in which I instigated, with AT&T's help, four public telephones ringing in four cities of the United States. I was at one location, and random people answered the phone on the street, unable to resist the ringing phone.

2. Aaron Marcus, "An Introduction to the Visual Syntax of Concrete Poetry," *Visible Language* 8 (4) (1974): 333–360.

3. Aaron Marcus, "Visual Rhetoric in a Pictographic-Ideographic Narrative," in *Semiotics Unfolding, Proceedings of the Second Congress of the International Association for Semiotic Studies*, vol. 3, pt. 6, ed. Tasso Borbé (Berlin: Mouton Publishers, 1983), 1501–1508.

I talked with them and said, "I'm doing an artwork, a conceptual artwork; would you want to talk with me for a few minutes?" They replied, "Sure, who are you?" And so we conducted a conference call, which was somewhat unusual in those days, especially among random pay phones. While the phone call was in operation in New York; Washington, D.C.; Omaha, Nebraska; Los Angeles; and San Francisco, an "X" three thousand miles wide was conceptually drawn across America.

Ernest: Beautiful.

Aaron: I wanted to make a trace in space, signing my name at a very large scale, the scale of the entire USA. Where could I find a piece of paper large enough or enough ink? I could only accomplish my objective through computer-based telecommunication systems, with which I could manage only an X for my signature. I was also not in favor of the president of the US at the time, Richard Nixon, and of corporate influence on the nation, corporations like Exxon. In the work I was also "crossing out" a Nixon America. The alternative readings of *An X on America* were "a Nixon America" and "an Exxon America" and "a nix on America."

Ernest: That's a brilliant example. I'm very sympathetic to all of this because in the sixties I was writing concrete poetry.

Aaron: Ah!

Ernest: So some of my work was conceptual at that time too.

Aaron: Weren't we all at that time?

Ernest: Yes, exactly.

Aaron: So I was in contact with and met on a visit to Indiana University in about 1971 Marie Ellen Solt, the nun at Indiana University who promoted concrete poetry in her book, as well as Thomas Sebeok, an esteemed polymath and semiotician. I published [in] many small journals, exhibited my work, and corresponded in the 1970s with Richard Kostelanetz, E. F. Higgins, and Emmet Williams, I believe.

Ernest: So this is all very interesting.

Aaron: It was all interrelated and all fluttering about, like bees around a flower of theory, and what I considered [that] I did in my practical work was applied visual semiotics.

Ernest: So this is great. I'd like to ask you how the process of, I presume you could say, terminating the making of computer-based art happened.

Aaron: Why did I stop?

Ernest: Why did you stop? Was it technology?

Aaron: No, not at all. I can't remember the last time I programmed. I was at Lawrence Berkeley Laboratory as a staff scientist during 1980–81. They didn't know what to call

me, so staff scientist seemed to fit. I worked on user-interface [UI] design, UI standards and guidelines, writing some of the first user-interface guidelines ever written, for the Department of Energy's SEEDIS project, the Socio-economic Environmental Demographic Information System, which was being constructed by Lawrence Berkeley Lab computer scientists. About that time I must have pretty much stopped, I'm trying to remember, I think I did do some things in '82 or '83, but by '83, I had started my business, became divorced, and left academia. It was all rather overwhelming, and it was all I could do to figure out how to survive as a businessperson.

Ernest: So it was really nothing to do with art or computer-based art at all; it was life.

Aaron: Yes, it was life impinging on me, with a limited time to sleep and be awake and take care of children and so on, and so I had to support my family, and I was trying to create this business of a kind that pretty much had never existed before, which was a computer-based design firm, and all that had come to absorb my intellectual and physical life.

Ernest: Well, I think most people here would say that what followed was a very successful and important venture.

Aaron: Yes, but even though I devoted so much time to research and design in human-computer interaction, you know, I still love to draw. I do draw. I have very little time to do it, but every time I do, it gives me intense pleasure to be able to do so. In fact in the past few years, I have started to draw a series of cartoons based on weekly portions of the Torah, in the style of R. Crumb, and incorporating drawings of my grandchildren into the episodes. I also continue to take photographs (perhaps 115,000 in Apple's Photos currently, not counting others elsewhere in my computer), but I don't manipulate the photos or do collages as I did before, and I don't use computer-based systems to create computer art—not from lack of interest but lack of time. Nevertheless, I am happy that I could accomplish what I did in computer art, and I am pleased that SF MoMA has purchased many of my works, that several museums and archives have collected my work, and that plans are under way to publish and exhibit my work further.

Ernest: Okay, thank you. I think that's perfect, and very, very interesting.

14.4 Conversation with Harold Cohen, July 15, 2009; Margaret Boden Also Present

"Harold Cohen's work as a painter has been exhibited widely both in galleries and in major museums. During the 1960s he represented Great Britain in the Venice Biennale, Documenta 3, the Paris Biennale, the Carnegie International, and many other important international shows. After moving to San Diego, Cohen became interested

Figure 14.2
Harold Cohen. *Coming Home #2*. 2007, permanent pigment ink on panel, 57.5×169.5 cm. See color insert. (Reproduced by permission of the artist.)

in computer programming and particularly in artificial intelligence. Much of his work since that time has been concerned with building a machine-based simulation of the cognitive processes underlying the human act of drawing. The resulting ongoing program, AARON, has by now been seen producing original 'freehand' drawings in museums and science centers in the United States, Europe, and Japan, including the Los Angeles County Museum, Documenta-6, the San Francisco Museum of Modern Art, the Stedelijk Museum in Amsterdam, the Brooklyn Museum, the Tate Gallery in London, and the IBM Gallery in New York. He has a permanent exhibit in the Computer Museum in Boston, and he represented the United States in the Japan World Fair in Tsukuba in 1985."[4] Harold Cohen died in his studio in 2016.

Ernest: Actually, you may have forgotten, but we had a recorded discussion like this maybe twenty-five years ago… [*laughter*]

Harold: Must have forgotten.

Ernest: Yes, you will have forgotten, but I recently found a copy of it, and so that was quite interesting. I wouldn't hold you to whatever it was you said in those days, but I do remember you actually drew, so it was quite interesting in a way that, to talk about what you were doing, you found it helpful to draw things. So you explained yourself partly through drawing not just through language. However, the first question is, has the computer or software opened up new avenues for you as an artist? In your case maybe it's obvious, but what I meant by that was has it led to you doing things as an artist that are quite different?

4. From http://www.artnet.com/artists/harold-cohen/biography (accessed August 1, 2018).

Harold: Well, yes, I think so. I think perhaps I should try and remember why I got involved in computing in the first place. And I think, at the lowest level, it was because, after twenty years of painting, I thought I didn't know anything more about image making than I had when I started. And I thought, rightly or wrongly, at that time I thought I saw in computing a way of learning something much more objectively about images and how one goes about making them.

Ernest: I was interested, and excited, when I saw your Tate show in 1983. The pictures were from your program AARON, but I saw Harold Cohen's works on the wall.

Harold: It's interesting that you say that. I mean, you know, a lot of people said, oh Harold, we'd know your hand anywhere.

Ernest: Yes.

Harold: What hand are we talking about? In fact there was an even more pointed case of that when I was doing the show in San Francisco. What I thought would be the whole show was backdropped by a gigantic painting on the wall, maybe 130 feet long. I was told by the director that one day, when myself and my team had gone out to lunch, some New York art critic came in (actually, to look at something else), saw the half-finished mural on the wall, and said to the director, "Who did that? I mean it reminds me of what Harold Cohen was doing, but I haven't seen his work in a long time." Now I don't find that quite as mysterious as perhaps I should, but I mean, the notions that informed art making when I started doing it were exactly the same notions that I'd had then.

Ernest: The need to be able to look, for example?

Harold: Yes, yes.

Ernest: And if you know how to look, then you can see Harold Cohen's hand.

Harold: Well, actually, I didn't see it at time. I was, I mean, my reaction, the take was, oh well, very clever; we'd know your hand anywhere. There's a bloody great sign outside saying Harold Cohen, you know. But I didn't actually see the implication.

Ernest: Let's move on a little bit. Programming—does programming matter to you? Does the software itself matter to you, or is it just like something you have to do?

Harold: I think it must matter to me, because I spend quite a lot of time on stuff that may superficially appear to be irrelevant to the end product. I do spend a lot of time rewriting code.

Ernest: It is a critical part of the art. It's not just a means to an end. And yet you don't necessarily show your code to anyone.

Harold: Well, they couldn't understand it if you did.

Ernest: No, no. Whereas with the live coding music people, they actually show the code on the screen. Although I don't know that it helps very much.

Margaret: But why do you bother to clean it up? Is it because the formal part of you, the formalist part of you, wants it to be as elegant as possible, and that's why you do it? Or is it…because once you have tidied it up, you can understand it and think about it more easily? So if you want to change it and push it forward, it's easier to do that if it's an elegant piece of code in the first place?

Harold: That's certainly part of it, no doubt. You know, the program is big enough now that there are parts of the program I haven't actually looked at in five years. And if I have to go back and alter it, I frequently have to read it like I've never seen it before.

Margaret: Yes.

Harold: And you're quite right. I mean, if you've written it cleanly and elegantly, it's much easier to understand. So there certainly is a practical aspect of that. There's also, I recognize, an aesthetic aspect to it. I just don't like to look at sloppy code.

Ernest: You said to me in London that you'd produced this new program with much smaller number of lines of code. Was that conciseness a quality that mattered? Is the art in part in the code?

Harold: Give me an example.

Ernest: For example, in poetry, where is the poem? You know, I can have the poem in this book, printed in this typeface on this particular piece of paper, or in this book printed on a different piece of paper, or a different typeface, but it's still the same poem. And the poem exists even behind that. So there's a question, in our case, about whether the software has some merit or meaning, if you like?

Harold: Well, I'm not sure. It seems to be a similar situation, but I don't in fact think it is. You could make the same argument about whether music exists in the abstract.

Ernest: Exactly.

Harold: The difference is that anyone can read the text of a poem; any musician can read the score. But almost nobody could read the code and come out with the slightest idea of what would happen when you ran it. Including me. You know, I have to run it to find out what it's going to do.

Ernest: Yes. And do you find that important in your work, that actually the discovery of new things arises from running the program?

Harold: Of course. Yes. I mean, that's why we were talking about it.

Ernest: Yes, that's right. So I think it's important to be specific about it. That, you know, it's kind of experimental. You could say that art practice is a kind of experimental process. What you do is make stuff and then you look at it.

Harold: Right. But at that point you have to worry about misunderstanding in the other direction. A lot of people think experimenting is just a question of throwing things together and see what happens. You know, as a scientist you never do an experiment unless you have expectations.

Ernest: Right.

Harold: I think of it more in terms of a dialogue than in terms of an experiment.

Ernest: Dialogue is a great word, yes.

Harold: I'm talking to the program, and the program says Oh you mean this?

Ernest: Yes. So I have another question, which kind of leads on to that, which is, do you find that the kind of work you do distances you from the object in a way? That you're working in the software, and the object is somewhere more distant?

Harold: It is not the same relationship to the object as you had when you spent three months or six months working on a single canvas. Nothing comes for free, and that's part of the price I pay.

Ernest: One of the things that interests me in your work is that some people find the time-based element quite exciting. I don't know whether it's still around, but you used to have that program that basically was painting the image...

Harold: The painting machine.

Ernest: I'm aware of quite a few people finding the actual time-base process of it exciting aesthetically, not just the object that it generated. And I wondered how you feel about that?

Harold: Well, I'm not sure that I feel anything very special about it. You know, the most obvious example right now is the installation: slowing it down is really rather coarse. I was quite concerned, actually, that the one here would be so damned slow that everybody'd die of boredom before they saw it. I was very surprised at how fast it is. It's actually running too fast to run a test.

Ernest: Oh, okay.

Harold: But in a way that's no more the case than back in the 60's, when I was getting commissions to do tapestry design. I paid quite careful attention to the nature of tapestry. And I think any artist would say, well, you know, if I'm working in this medium, I have to pay attention to what the medium is like. What, you know, what you can or cannot hope to get away with. And I don't think it's any different from that.

Ernest: No. So you do see software as a medium?

Harold: Oh, yes, certainly. Yes.

Ernest: Good. Yes. And in a way, maybe what you've done all the time, well for a long time anyway, is explore the implications of that medium?

Harold: Well, in the context of what else I'm doing. If you're painting, you pay a good deal of attention. I think one should pay a good deal of attention, of course. But as I said, that's true in any medium.

Margaret: In respect of a time issue again, with the painting machine. Did you make an attempt at all to make the time course of the placement of the paints of the different colors and the different paint pads, and so forth, similar to what you would have done if you had been doing it yourself by hand or not at all?

Harold: No, I had absolutely no control.

Margaret: That's what I thought.

Harold: It was as much as I could do to keep my head above water with that damned thing.

Ernest: Yes, but you made judgments about how quickly the dye got dry, and stuff like that.

Harold: That's a good point. I mean, the problem of the application of the dye actually resulted in my inventing a filling algorithm designed to stop the stuff drying in one place while it was busy painting somewhere else. So I had to do a work-around on that particular problem. So the medium very much affected the way the whole process was designed. But certainly, with issues like timing, it was a long way beyond my control.

Ernest: But in that work you presumably chose a certain palette of colors. Now [that] you're printing, you have much more flexibility about the palette. Do you use that flexibility?

Harold: Yes. It's also not exactly true that I chose the palette. I took what was available.

Ernest: Yes.

Harold: I'd actually used those same dyes for coloring drawings, you know, computer drawings which you then fill in with color. And some of the colors are very beautiful, actually. But when you come to look at them, in order to try and, you know, get some reasonable coverage of the complete spectrum, it's very uneven. There's a lot going on there, and then there's a big gap. You know, so I finished up with, if I remember correctly, with seventeen colors.

Ernest: Which is quite a lot.

Harold: But when you came to use them, there were probably three or four blues, almost no bright reds. So it was a fairly limited palette. And there was also the problem of the screen. If I had tried mixing those things, I would have just used pure colors. You know, you can have blue there and yellow there, instead of which I tried to simulate a fuller range, and it was very, very difficult. I spent a lot of time doing that.

Ernest: But now it's a more complex problem, really. In printing you can choose the color black, for example, and so in a way it's harder.

Harold: You know, it's not entirely true, actually. When I'm printing, in fact, now I always do a lot of proofing before I make a work. And I'm not talking about proofing before making a run of a particular edition. I'm talking about before I make a single print.

Ernest: Right.

Harold: Because printing is always a compromise. You want to differentiate between two very different dark colors here, but you're going to find that you just lost that color differentiation over there. So you know, you try to pick a path that gives you optimum results.

Ernest: Yes.

Harold: It's not true that you can print anything that you can specify.

Ernest: No, no. Aren't you trying to do the impossible, really?

Harold: Yes, predicting what's going to happen from a mixture is extraordinarily tricky.

Ernest: I asked you the other day about spraying. Just tell me about that again. This is a technical question. You were saying that you use a spraying technique over your prints.

Harold: Well, in the first place I wanted to be able to use the images in an orthodox traditional context. And you know, there are some motivations behind that. I've always felt that the computer art game has never been accepted in the art world. But in fact, it's never tried very hard. And I wanted to take on the art world in its own terms. So the decision to exhibit things in galleries, which I walked away from for many years, involved having objects that could be shown in galleries. And that meant that they'd have to be physical things that had the same characteristics as paintings. I felt they had to be permanently mounted on a rigid surface, and the surface had to be protected. I didn't want to have to put Plexiglas over them.

Ernest: Right.

Harold: So now we have this big frame that's supposed to move backwards and forwards, and the gun was supposed to move up, a bit like an X-Y plotter. The varnish

being as dense as will go through the gun, which of course then leaves a very glossy surface, which I don't want. Then that gets what, in the trade, they call a sacrifice coat, a spirit-based varnish, which comes in a matt form. So you spray a coat over the varnish and suddenly all the varnish disappears, but you still have the depth of color. Which is the crucial issue.

Ernest: Yes. It's interesting, isn't it, that the amount of effort is so great. It's true in art practice in general, very often, that the core of the work is in some code, for example, but there's a massive amount of work in actually generating the object.

Harold: Think about stretching canvas.

Ernest: Yes, exactly. That's my usual example. Yes, stretching canvases and stuff is a big part of life. Nothing much to do with creativity, but it kind of enables it.

Harold: I'm not sure that it's nothing much to do with creativity.

Ernest: Okay, tell me.

Harold: When I was teaching at Saint Martin's School of Art I'd walk around the studio [of a wonderful painter, who is dead now,] and there were these dreary looking objects. He was an absolute magician with materials, but his teaching must have been appalling because the student [I saw there] didn't know anything. She was painting on a piece of absorbent cardboard, and then wondered why she couldn't get any sort of vibrant color.

Ernest: So who were you teaching with? I just wondered who you mixed with in those days.

Harold: Well, who I went round to the pastry shop for coffee with?

Ernest: Well, I suppose that's right, yes. It matters.

Harold: It does. But I really don't remember who I was with. Like, I remember at Ealing I was with a bunch of people including Ron Kitaj, for example; he was teaching there. But once again, our contact was mostly going out to lunch together.

Ernest: Sure. But that's an interesting thing. We were talking earlier about collaboration and so on. And I didn't quite agree with you in this sense, that although art practice is very much an individual thing…

Harold: I think an essential element in art practice is an ongoing dialogue about the nature of art.

Ernest: Yes.

Harold: And you conduct that dialogue partly through your work, partly through conversation, partly through reading.

Ernest: Yes.

Harold: No, I have absolutely no doubt about the social implications there.

Ernest: I met someone at your recent London opening who didn't realize that the works had anything to do with computers.

Harold: Most people don't, you see. Most people don't.

Ernest: Maybe it doesn't matter, in a sense.

Harold: Yes.

Ernest: That's *your* business, that's how you generate it.

Margaret: Skill, and it's a huge skill. Part of your skill is having succeeded in the task of putting your aesthetic sensibilities onto the page via computer, which is an amazing thing to have done. And you've done it amazingly well. Is that not something that you are rightly proud of as an artist?

Harold: Yes, I'm proud of it.

Margaret: And so, in that sense, wouldn't you prefer that somebody knew that that was the way that it was done, rather than it was done with a paintbrush?

Harold: No, I'd rather people knew about it, but not because it would stimulate my ego. I'd rather people knew about it because I think the significance of my work goes further than the appearance of the individual piece.

Margaret: Well, exactly. Yes, that's what I'm trying to say, that's right.

Ernest: Yes, exactly. Yes.

Harold: You know, I'm trying to say something about the future.

Margaret: So when Ernest said, you know, some of them didn't realize it was done by computer and you said well that doesn't matter, I mean, it sort of does matter, surely, to you?

Harold: No, I don't think I said it doesn't matter.

Ernest: No, you didn't quite say it. Well, you said something like that, but, yes, it does matter anyway, I think. It's odd. In a way, your works as objects are important, but also the process that you've used to make them.

Harold: And I got some pleasure out of being able to say, no, I've got a machine at home that did all that. But you know, given that we're entering on very clearly an age in which robots will play an increasingly large part in our existence, computers already play an astonishing part.

Ernest: Yes, when you drive a car, or look at your watch…

Harold: Everywhere, everywhere. I mean, every science today is 50 percent computer science.

Ernest: Yes.

Harold: All of the breakthroughs we've seen in genetics, in space programs, in medicine; they all rest upon computing. And given that we seem to be on the edge of an age of robotics, I think the fact that I've got a program that can do something that we normally assume, not merely that human beings were needed to do, but actually, rather talented human beings were required to do it, is really interesting.

Ernest: Well, that's what's so special.

Harold: Yes. So, no, I'd much rather people understood that they were done by computer. I think what I meant before if I said it doesn't matter, I think I meant that it doesn't matter to them.

Ernest: Yes. So how do you feel about the code? I would have thought many computer scientists would have wanted to see it.

Harold: Well, in fact, one of the program officers at the National Science Foundation had $100,000 to give to somebody to do some work just documenting the program.

Ernest: Right.

Harold: She couldn't find anybody to do it.

Ernest: Wow.

Harold: And I said, well, I could do it. Can I have the $100,000...? [*laughter*]. No, you can't have it. No, I mean, I'm not actually quite telling the truth. There was one correspondence from somebody in the open software game who made a perfectly legitimate point that, you know, when I die, Aaron stops developing. But if I made it open source then there would be programmers all over the world who could carry it forward. To which my reply was, No, my real ambition is to leave the program in a state where it can carry itself forward.

Ernest: Exactly.

Harold: But I mean I think it's a fantasy anyway. If I were to give my program to even a skilled programmer, it would probably take him about a year before he could figure out what's going on. A casual remark was to the effect that I would be the first artist in history to have a posthumous exhibition of new work. Which was made ironically, because I knew damn well that nobody would want an endless collection of my work. If it hasn't got my signature on the back it's valueless anyway.

Ernest: You've homed in on LISP as the language that works best for you? You find it most expressive?

Harold: Yes, yes. I was stuck on the problem of coloring for a long, long time. And all my friends in the AI world will tell you, well, you should really use it.

Ernest: Yes.

Harold: I hadn't, because at that point LISP was extremely expensive. I don't mean in money. But it took twice as much memory as any other language. It was much slower than any other language, and I was using it for doing sort of real-time exhibitions. So I was still working in C. Finally, I don't remember exactly why, it broke down. I suppose I simply recognized that I certainly wasn't going forward in C.

Margaret: Did you not use LISP in the early days, when all the AI people then were using it? Because C didn't exist, did it?

Harold: My very first few programs were written in FORTRAN, actually.

Ernest: I've still got one of your drawings from the Tate Gallery.

Harold: They would have been done in C. I started off with FORTRAN, and then I persuaded the university to buy me a computer. And I got one of the original vanilla-flavored Novas, and that had 8K of memory.

Ernest: Really big, yes.

Harold: And only paper tape. It would in fact run BASIC, but that was all. So I think I did two exhibitions with this machine running programs written in BASIC. And then I went up to Stanford. I think at Stanford I was writing in Algol, actually. I'm pretty sure I was running in Algol briefly when I came back, and I stayed with C in fact until I finally changed to LISP.

Ernest: Well, C does everything. But it's a lot of effort writing in C compared to LISP, I think.

Harold: In one sense, any language can do anything. But in another sense, it's very difficult to express abstract concepts in C.

Ernest: Yes, it's only theoretically true that any language will do anything. Anyway, so there we go. We have done. I've got through my questions, Harold.

Harold: Should I eat my peach now?

Ernest: Yes, why don't you eat your peach. So thank you. Actually, I forgot it was an interview I was just having a nice conversation with you. Thanks again.

14.5 Conversation with Manfred Mohr, October 30, 2011

"Manfred Mohr is a pioneer of digital art. After he discovered Max Bense's information aesthetics in the early 1960s, Mohr's artistic thinking radically changed. Within a few years, his art transformed from abstract expressionism to computer-generated algorithmic geometry. Encouraged by the computer music composer Pierre Barbaud, whom he

met in 1967, Mohr programmed his first computer drawings in 1969. Mohr has had many one-person shows and retrospectives in museums and galleries. His work is represented in many international collections, including

- Centre Pompidou, Paris
- Joseph Albers Museum, Bottrop
- Victoria and Albert Museum, London
- Stedelijk Museum, Amsterdam
- Kunsthalle Bremen, Bremen
- Daimler Contemporary, Berlin

Among the awards he has received are the ACM SIGGRAPH Distinguished Artist Award for Lifetime Achievement in Digital Art, 2013; d.velop Digital Art Award (ddaa), Berlin, 2006; Artist Fellowship, New York Foundation of the Arts, New York, 1997; Golden Nica from Ars Electronica, Linz, 1990; and Camille Graesser-Preis, Zürich, 1990."[5]

Ernest: Going right back to when you began with a computer, was it software itself that opened up new avenues for you or was it some other things that led you in that direction?

Manfred: No, it wasn't software that inspired me. I come from abstract expressionism; that means emotional expression. In the early 1960s I came upon the German philosopher Max Bense whose philosophy profoundly influenced me. I went through a radical change in attitude of my artistic understanding. I became interested in controlling things with my mind rather than with my feelings. My conclusion was to create a systematic, a rational art where I know what I want to do before I start doing it. But that was long before I had the idea of using a computer to make art. It took me another five years to get to the next step. Only in 1967 in Paris when I met the composer Pierre Barbaud, who already wrote music with a computer since the late 1950s, I realized that that is exactly what I have to do: learn how to program. So I did, and the rest is history.

Ernest: So in a way it came as an answer to what you needed?

Manfred: Yes, I was looking and looking, and suddenly I understood that's the logical thing to do.

Ernest: So you had to learn to program.

Manfred: Yes.

5. Taken from http://www.emohr.com/ww1_out.html (accessed August 1, 2018).

Figure 14.3
Manfred Mohr. *P155c*. 1974, plotter drawing. 60×60 cm. (Reproduced by permission of the artist. Photograph Winfried Reinhardt, Pforzheim, Germany.)

Ernest: Both then and up to now, have you found that programming itself mattered a lot? Was it or is it central to the art?

Manfred: Yes. If you write a program, you have to order your thoughts, you have to really crystallize exactly what you want to do. You suddenly see everything in a different light, and in a sense, my whole world turned upside down. If I look nowadays at other people's artworks with the knowledge I have acquired, I look at everything through a logical eye—my mind-set has changed. It is the process of programming that changed my mind, not the program itself.

There's also another aspect to programming, that one should program very elegantly and beautifully, but the general law in programming is that you make it work, and then you make it better.

Ernest: And do you do that? Do you care about the elegance?

Manfred: No, not really. But if I look at old programs I wrote forty years ago, I say "My God how could I have programmed so awkwardly?"

Ernest: So whether you cared about it or not, you have in fact probably got more elegant in your programming.

Manfred: Well, a little bit. I like it, and that's fine. But I'm not looking for the best way. If it works for me and does what I want it to do, that's fine.

Ernest: Have you shifted in the programming languages that you've used?

Manfred: I shift around constantly. All my old programs were written and still are written in FORTRAN, so I'm not throwing them out. I always keep them, and use them, in whatever I have to do. So FORTRAN is still a language I'm using. But I use other languages for certain things and certain machines.

Ernest: Because FORTRAN is quite interesting, because it's in a class of language where you really have to have composed a whole program before you see what it does.

Manfred: Yes, exactly. But in the end all the programming languages do the same things. Some are more elegant, like we have just said; some are easier to use.

Ernest: But some of the languages that young people use today, you can run the program and change the program while it's running, which you can't do in FORTRAN: extreme programming. But to change the program while it's running wouldn't match what you described as the important thing, because it doesn't actually help you clarify your thinking. It's more like hacking, and you're obviously not a hacker.

Manfred: No, I'm not into this direction. It also goes a little bit into the direction of interfering, what you would call interaction. I'm not into this. I decide what I want to do, and then the program has to do that.

Ernest: I guess the central part of your work is dealing with geometric entities in different dimensions and so on. So I see two aspects, and I may be quite wrong. One is constructing the structures, the geometric structures, and the other is the ways of viewing those structures.

Manfred: When I started in 1969, I wrote a different algorithm everyday. It was very easy for me to invent new things, but at one point I felt, that can't be it, it's too easy. Since I come from the abstract world of music, I always think of music when I write programs. I thought, why couldn't I invent an instrument, like a musical instrument, for graphics, so I can play graphics? And that's when I got to the idea of the cube, because the cube is an absolute structure in itself. I mean, you see when there is something wrong. So that became my instrument. And now, with this instrument, I invent my questions, my algorithms. So now I'm playing on a cube; I can cut the cube and fracture the symmetry, which was a very important aspect of my thinking.

After a certain point I began contemplating a higher complexity, and I asked myself what would happen if I move into the fourth or even higher dimensional structures, a hypercube. It's not the fourth dimension as a mystical element but the mathematical structure, the complexity that fascinated me. A fourth-dimensional cube is in reality eight cubes logically connected to each other, making my vocabulary multifold larger.

So every few years, my questions became more and more challenging, looking for more and more complex structures. I was never interested in the spatial aspect nor the complete structure itself. I was only interested in showing aspects of a hypercube. Like our alphabet, which has twenty-six letters, we do not show all of them at once as the complete structure but choose certain letters, a subset, to form a word. Similar to this, I use subsets from the hypercube as a system. Already with the cube, I wasn't interested in the fact that you can see any three lines with certain angles three dimensionally. I'm interested in a flat sign, the semiotics aspect of it. I'm interested in a flat sign where the ambiguity of this sign is the idea. It's the ambiguity that makes it an interesting sign, where front and back is unimportant. So I have a visual sign, and that's my operating element. I sometimes explain my work to people: when one opens a bottle of champagne there's always this wire cover on top and it sort of looks like a cube. I take it off and stamp on it with my foot and now it is a flat object, I say, "That's what I'm doing." I want to find new constellations through my algorithms.

Ernest: When I was a student and I did mathematics, one of my main courses was n-dimensional geometry. So that aspect of your work, it's interested me from that point of view too.

Manfred: With respect to complexity, yes, I'm working with *n*-dimensional geometry.

Ernest: But then you produce what I call a projection.

Manfred: Yes, after all calculations are done, I flatten it out by projecting it into two dimensions. The thing is, to be honest, as an artist I am interested in finding visual solutions which I did not know or even could imagine. I'm not too interested in the mathematical part. My use of mathematics is like the four wheels on a car: if you want to move, you need the four wheels. The signs I create have to be strong and independent in themselves as an entity. They should not provoke in you the question What is it, where does it come from? You know, you go in front of any painting; you don't ask Did you do it with your left hand or with the right hand? The work has to talk for itself, and the past, how it came to be, is something you can explain, but it's not important for the visuals. If I look at you, I don't ask who were your father and your mother. You are the entity, I deal with you, and not with your father and your mother. In our field, computers in art, people think they can ask those questions, and sometimes it's good if they want to know more. But it's not the first importance.

Ernest: There's maybe another aspect of that, so I could ask this question. In the systematic area, people often produce series of works. So I could imagine that you might make one structure and then you might flatten it in different ways, slightly different projections of it.

Manfred: Well, I did series of works from the beginning. Each dimension has a defined number of 2-D projections. For example, I can look at you, in three dimensions, from the front, from the side, and from the top. I can have three 2-D views of you. The piece on the wall is based on a six-dimensional hypercube, which has fifteen views. So what you see is the same segmented line, which I call a diagonal path, seen in its fifteen different projections. One has to admit it's like a wonderful poetic language. And it's just one diagonal path seen in different aspects.

Ernest: And when you produce this latest work,[6] I mean, it's an example of exactly the same thing. But what's happening, I think, is the view, or the flattening, is changing.

Manfred: What's happening is the visual surprise of what kind of forms the algorithm can create. In my screen-based moving images you can see here on this wall, the calculation slowly rotates these sets of lines, rendering never-ending solutions.

Ernest: Because, once you've set it going it can change forever.

6. From the parallelResonance series. See http://www.emohr.com/ww4_out.html (accessed August 1, 2018).

Manfred: Yes, it changes and never comes back to the start, because in the algorithm there is a random injection into the rotation routine, so it can never find its way again. Also, each time it starts with a different random number based on the time and date, thus it never repeats. A real mathematician would say it's impossible: even in a thousand or ten thousand years, it might repeat itself. I'm not saying no, but I may say it will not come back in my lifetime.

Ernest: Yes of course, it may not, but that's not your concern, obviously. So an interesting thing there is that you could make several works which are essentially the same in the inside.

Manfred: Yes, but that's the whole point: that you write a programming logic and then you can have, maybe not endless, but many, many different possibilities.

Ernest: So this set of works might be very, very similar in many respects.

Manfred: Yes, in fact when I was first programming in Paris in 1969, I had a friend from New York who came to visit and saw me struggling to write my programs. I could not conveniently visualize the results because I had to draw them by hand. He said, "Give me your program. I'll run it back home in Long Island" on a large CDC (Control Data Corporation) computer. And then he calculated a set of light-beam-plotted drawings for me. He had a microfilm plotter and he plotted them directly on photo paper, without negatives; these were all originals. He sent them to me, and I laid them out on the floor. I could not believe my eyes. My dream of writing an algorithm of my ideas—and look at all these possibilities from the same logic—it was overwhelming.

Ernest: So it's also that the programming brought a kind of discovery process.

Manfred: Yes, completely. That's why I said at the beginning that it changed my mindset in how I look at things. Because, you know, it's true that you can look at something and say "Oh I want 15 percent more of these lines." It's a whole new attitude. No painter can say "Oh, I would like to see my painting with 10 percent less black lines"; he doesn't know what to do. But I can do that, and look at the results.

Ernest: Another question I have is what kind of impact has writing programs had on your thinking?

Manfred: I can't go back; knowledge is irreversible. Emotions are fantastic, but you can't define them. Having an idea, if you want, is also an accident, an emotional accident. You think of something, you develop that idea, and in the end that idea is not emotional anymore, it becomes a clear and rational idea. I'm always thinking when I look at other people's work, Did he or she really understand what they are showing?

Ernest: So they weren't really making rational decisions a lot of the time?

Manfred: A musician like Steve Reich is really thoughtful, absolutely. But some others, I don't think they are as clever.

Ernest: Yes, that's very interesting. But there's a sense in which there is some arbitrariness in choosing this cube rather than that one. At some level there's a judgment.

Manfred: Well, there are definitely moments in a program where decisions have to be made, but these decisions sometimes are not very important. If you're talking of ten degrees or fifteen degrees, it doesn't really matter. For example, my work is, since the very beginning, always systematic. I do series of linear transformations. I do series showing combinatorial possibilities and other developments where no randomness is involved in the logic, but even here sometimes questions arise: "Should it go this way or that way?" You have to make a decision. These types of decision are called parameters. They are not aesthetic decisions or value judgments; they keep the program running.

People sometimes think my work is all about randomness, because it sometimes has that flair, but it's not. If you take John Cage, for example, he works exclusively with randomness. That's something completely different. His work demonstrates the power of randomness, whereas I'm not demonstrating randomness. My use of it has a completely different purpose.

Ernest: It was the essence of a lot of John Cage's work. What you're saying is, everything that's important is rationally decided upon in your work.

Manfred: Yes.

Ernest: This leads me to another question. Most of the important work is actually done in the software, but there are also, of course, the objects.

Manfred: Since the beginning, it has always been the question that people ask. Is the software the artwork? For me, I'm coming from the arts. The program is a very essential part, but this is not the art. For me, it's the content of the art, but the art itself is visual. And that's why I'm a visual person. A lot of people can see this when they look at my artwork, that I'm making visual research and not programming research. One also could argue that the code of a program and the visual result are just two different states of the same thing, like ice and water.

Ernest: So using software and doing all that abstract stuff has not distanced you from the object; your art is still centrally in the object?

Manfred: Yes, exactly. It's because there are many people who think if they visualize mathematical formulas, that's art. It might be accidentally a fantastic picture, but you cannot just visualize math and expect it to become an artistic thing, it's just luck if it works out. You have to come from the visual side; you have to develop some visual

ideas. For mathematicians my visual results are largely unexpected, because I do not prove anything mathematically.

Ernest: Another aspect of the object is that you have in more recent years been making these time-based objects where we see the process of the software running. Can you comment on that?

Manfred: The software is still the content part, but it's the visual object which moves. I'm a minimal maximalist in a sense. My work became so minimal that one day, showing my work to someone, I could not explain why these five lines were complex. He just laughed in my face and said, "So what?" So I was up against the wall, and I did not know how to continue, how to show that I'm not just making five random lines, it's something that comes from a really complex system, a rotating hypercube. So I started using colors, random colors, but using them only as distinctions to visually reveal some of the complexity.

Ernest: Colors, almost like codes, to distinguish this from that.

Manfred: Yes, when I let them rotate systematically, even though you can't understand the structure, you feel that there is something very strong holding everything together and moving within a system. And then I thought, Maybe that's the idea: I have to show it moving because the movement has always been in my work, since the beginning, but I never bothered to show it, because I didn't want to make movies. I wanted to show it, let's say, frame by frame, to draw it so that the observer can go at his own speed, forwards and backwards: "I like this sign, oh, then it becomes this." That's what bothers me in the movies, that you sit there and you have one second to look at something and then it's gone. Thus, I never liked this aspect. I wanted to be free to go forward and backward and choose my own time of observing. This was at the beginning. But then when the system got so complex, like it is now, the best way to show it is with the movement, I do not have a choice anymore. Sometimes in life you contradict yourself, I have to admit.

Ernest: Do you still make static works as well?

Manfred: I still make static plotter drawings, but the structure is so complex that one can't really understand what's going on. At one point I made an installation with two screen-based works next to each other. One with continuously moving images, so you can observe the movement, the structure, but you can never catch it. And then on the other screen, the program projected every ten seconds a frozen image from the moving image. Therefore the viewer is able to observe the stable image and explore the sign if he or she wishes.

Ernest: Summarizing, we see the moving image on the screens, this is the object, the art, and it's not the software.

Manfred: It's always the object. In music, for example, the software is what the composer writes down, in a sense. So one can look at the software and observe it or can look at the music score, one can read it and hear it. But in the end it's the sound itself which becomes the music.

Ernest: So in music, for example, would you say that if someone uses software or they, for example, write a fugue and use the fugue structure or something, these are really ways of making work, ways of making music?

Manfred: Yes, in a way, but music theory is full of laws, especially in classical music: you can't do this, you can't do that, you can do that but then you can't do this. So it's like programming. And in twelve-tone music it's even more complex: you can't have this before you can do that. So everything becomes implied. For me, music is very important in my visual thinking. I consider my work as visual music. Anton Webern was for me a composer who gave the pause in music a distinct value; he composes elements and lets them connect in the silence, in space. Likewise, Henry Moore places a stone here or a stone there, and the space in between becomes part of the sculpture. That impressed me always very much, that doing something or not doing something can be equally important.

Ernest: They go together.

Manfred: Oh, absolutely. All my early paintings, I mean the emotional paintings, were black surface with white ink. You can really hear them, you know, if you look at them.

Ernest: But your work grew to be closer to Webern in spirit, in a sense, as you became more systematic.

Manfred: Not really. I come from there, and I still like Anton Webern, but my work cannot be compared to Webern. There was obviously some influences, but in all modesty, my work "sounds" different.

Ernest: That's wonderful; thank you.

14.6 Conversation with Paul Brown, July 16, 2009; Margaret Boden Also Present Part of the Time

Paul Brown is an artist and writer who has specialized in art, science, and technology since the late 1960s and in computational and generative art since the mid-1970s. His early work included creating large-scale lighting events for musicians and performance groups (such as Meredith Monk, Musica Elettronica Viva, and Pink Floyd), and he has an international exhibition record dating to the late 1960s that includes the creation

Figure 14.4
Paul Brown. *Builder/Eater.* 1977 (re-created 2014), real-time computational generative artwork, size variable. See color insert. (Reproduced by permission of the artist.)

of both permanent and temporary public artworks. He has participated in shows at major international venues like the Tate, Victoria and Albert, and ICA in the UK; the Adelaide Festival; ARCO in Spain; the Substation in Singapore; and the Venice Biennale. His work is represented in public, corporate, and private collections in Australia, Asia, Europe, Russia, and the United States. From 1992 to 1999 he edited fineArt forum, one of the Internet's longest established art zines, and from 1997 to 1999 he was chair of the Management Board of the Australian Network for Art Technology. In 2005 he was elected chair of the Computer Arts Society (CAS) and served in this position again from 2008 to 2010. In 1996 he won the prestigious Fremantle Print Award. During 2000/2001 he was a New Media Arts Fellow of the Australia Council, and he spent 2000 as artist in residence at the Centre for Computational Neuroscience and Robotics at the University of Sussex in Brighton, England. From 2002 to 2005 he was a visiting fellow in the School of History of Art, Film and Visual Media, at Birkbeck College, University

of London, where he worked on the CACHe (Computer Arts, Contexts, Histories, etc.) project. Since 2005 he has been an honorary visiting professor and artist in residence at the Centre for Computational Neuroscience and Robotics, Department of Informatics, at the University of Sussex.

Ernest: How do you think the computer has actually influenced your view of your art practice? Has it changed it?

Paul: The answer to that has to be yes. I've been using computers for so long that it seems like the whole of my life has involved digital systems. But I remember that there was a point in the early seventies when I was learning to program, and what I did was automate the kind of systematic artworks that I'd been doing previously. So the computer enabled me to work a lot faster and produce many more examples. This was very tedious, finicky, system-oriented work, and so I was using the computer as an automation and productivity tool. Then, my work began to depend on programming more, and I became more competent. This was when I was at the Slade [School of Fine Art] with Chris Briscoe. A really wonderful environment, and it was there that I realized that the computer had a lot more value as a creative assistant and that it offered new and unique opportunities to the arts.

Ernest: That leads immediately to my second question, which is, how much does programming matter to you?

Paul: It's absolutely essential. Well, no, not perhaps essential, but I'm very concerned about the number of people who simply use computers from a point of view of preexisting packages, like the many people that use Photoshop. I've seen a lot of work that I like come out of that process, but it seems to me that if I had to define a term like "computer art" or "computer-assisted art," or whatever you might want, that kind of work wouldn't fit inside that term. It's really stuff that could've been done with traditional media if you really wanted to, although it might take a million years to do it.

Ernest: Yes, exactly.

Paul: I have to really know what a computer is and how it works. This is where I get into lots of problems teaching students, because basically a computer is so simple it's ridiculous—it's just a machine that opens and closes switches. What makes it appear so magical is that there are an inconceivable number of switches, and it's opening and closing them at inconceivably fast speeds. I think that the only way to get a handle on that knowledge and understand the technology is through programming.

Ernest: So, for you, software is central and programming is essential to the art? Which is like me, actually.

Paul: I use Photoshop all the time. I use Illustrator. I use these packages, and they are very useful. But I can't use them for the core of my work. I've looked at the code-generation apps, and I've looked at Max/MSP and stuff like that but, at the end of the day it just feels a lot more natural and right for me to just go down to a level of actually writing code. I'm currently using Java.

Ernest: So you really want to be close to the machine.

Paul: I became very closely involved with digital systems and learned how to design and built digital circuits and home-brewed computer systems. After getting to know a few other artists using computers, but before I became proficient with their use, I can remember consciously thinking, "And this was all to do with the systems aesthetic, or the aesthetic governing that kind of sixties art production." Let the artwork speak for itself. So the flat-field color painters didn't frame their work, they painted the sides of the stretcher, to emphasize that this is an object on the wall and not a window into the universe. It's not trying to reveal anything apart from its own internal working methods. I can remember having this very conscious thought that by sitting at a terminal and typing in FORTRAN, which is the only language I knew at that time, I could distance myself from the work and enable the work to develop its own character and autonomy, these things we've been talking about today. I think in the late sixties, 1969, whenever it was, that decision was perfectly valid. In retrospect, it was hugely naïve to think that I was abstracting myself from the work. What I've actually done is create a whole body of work that is instantly identifiable as mine. I recognized this in the 1990s, and I was quite happy with that realization, and I'm still continuing that sort of work, but that was also the beginning of the DRAWBOT Project, of trying to think of a way to destroy signature—or not destroy, but attenuate signature. Asking myself what kind of methodologies might be available that would achieve that.

Ernest: Both are two different things aren't they, to destroy and to attenuate?

Paul: Yes. I guess I was still very interested in the whole idea that Nicolas Schöffer defined when he spoke about his cybernetic sculpture *CYSP 1*. He said, "Spatiodynamic sculpture, for the first time, makes it possible to replace man with a work of abstract art, acting on its own initiative, which introduces into the show world a new being whose behavior and career are capable of ample developments." He introduces this new autonomous, nonhuman entity—which again was hopelessly naïve but in 1956 was perfectly valid.

Then, about '97 or '98, I read an article in *New Scientist* about what Phil Husbands and his colleagues were doing at Sussex University. I think it was about Adrian Thompson's work in evolutionary hardware and electronics. I contacted Phil, and that was quite a

remarkable thing as well, because I can remember my email to Phil. I began, "You won't know who I am...." But he did! Largely through the work of the late Edward Ihnatowicz, an artist who is now recognized as a pioneer of cognitive interactionism, Phil was aware of this crazy bunch of artists at the Slade School way back in the seventies, long before Langton formalized the discipline of artificial life, who had come to this understanding through systems art. What we were actually identifying with were the foundation blocks of computation and art. But, equally, you could say we were also building a foundation for artificial life.

Ernest: Yes.

Paul: And it was wonderful that Phil actually recognized that. He's married to a sculptor and was a musician before he went back to university, so he's very open to the arts and could have that perception, which was great. So that put me in touch with the mob at Sussex. I had this idea, well, if you can't design something that's autonomous—if you design the process, however much you try and abstract it, it will inevitably carry your signature through to the artwork.

Ernest: You can't avoid that really.

Paul: And you can't avoid it. So this is a really good argument against autonomous creation. However, I was interested in the possibility that you could maybe create an evolutionary process that would lead to emergent autonomous behavior. We discussed this a lot in Malcolm Hughes's group at the Slade thanks to visitors like Ed Ihnatowicz and Harold Cohen.

Ernest: Even though Malcolm didn't—well, actually, he did use computers a little bit, but not much. But he was really essential in terms of enabling so much to happen.

Paul: Yes, absolutely. It's interesting that very few of those systems people, Malcolm's colleagues who taught at the Slade, used the computer. In fact, quite often they'd ask us to do work for them. Chris Briscoe ran the Experimental and Computing Program at the Slade, and if they wanted something made, it might be some kind of sine wave, then Chris would get us to code it up. But not as artwork, we would just assist him to help the artist. It was Chris and our group that really brought systems art and computation together. I think that was an amazing convergence, because that's what you were saying about those experiments in Russia and Constructivism. All of that coming through de Stijl, up to Systems art, and then the computer comes into that picture.

Ernest: In a way, quite naturally.

Paul: Absolutely, yes. Completely natural. I always felt as if I was connected to the modernist thing. I say this to audiences with postmodernists, and they just fall over laughing. But I think that I can go back to Giotto and beyond and look at art history and

draw a graph that goes through Giotto to Cézanne, and I consider what I'm doing to be on the extension of that line.

Ernest: Exactly.

Margaret: And correct me if I'm wrong, I get the impression that Harold didn't come out in such a strong way as I feel that both of you did, from that formalist and minimalist constructivist thing. That wasn't what was turning him on, and so it wasn't that the computer was a natural thing for him, as it was for you two. It's just it's an interesting thing, and he did wonderful things with it. Which is a different thing.

Ernest: Absolutely. I think that's correct.

Paul: I think it is. What Harold has done is absolutely amazing, he's managed to externalize his creative process so AARON is now capable of producing original Harold Cohen artworks, he can go away, and as he says, once he's dead he's still going to be able to have exhibitions of new work. Now, what is interesting is that, whereas the group that Ernest and I would identify with may be pushing the envelope with the technology further, they haven't been anywhere near as successful as Harold in actually producing autonomy in the artwork. Because Harold can go this way, he can leave AARON working and it produces 100 percent, genuine Harold Cohens. I really don't think that people working in the area of autonomy have been that successful. I'm not saying they haven't been successful at all, of course.

Ernest: Have you been influenced in some way? Has the computer had an impact on your thinking?

Paul: What the computer has done is introduce me to symbolic logic, Spencer Brown's work on boundary grammars, analytical philosophy—things that I might not otherwise have encountered and which I hold very dear now. Wonderful things that truly influenced me.

Margaret: Try saying that at a postmodernist conference. [*laughs*]

Ernest: What changes have you seen in this world?

Paul: I can remember—and you probably were there at the Slade in the late seventies, maybe the early eighties—I felt, and a I think a lot of us felt, that this future revolution was coming, that the art world would fall at our feet, that there'd be a huge paradigm shift in the art world and all of this new stuff we were involved with would blossom and flourish. And [Jack] Burnham felt the same. If you look at his book *Beyond Modern Sculpture*,[7] he says, "Our future looks very systems oriented." But it never

7. Jack Burnham, *Beyond Modern Sculpture: The Effects of Science and Technology on the Sculpture of This Century* (New York: George Braziller, 1968).

happened—the art world turned to postmodernism, embedded itself in the fashion industry, and rejected the formalist and computational explorations of modernism. So instead we became outsiders, setting up our own organizations such as *Leonardo*, ISEA International; formerly Inter-Society for the Electronic Arts, Ars Electronica. All of these things were set up as artist initiatives, in spite of the mainstream art world, and they gave us a venue, not only to exhibit our work but to come together at meetings like this to discuss our work. So we had a comprehensive community, a very well networked international community that allowed us to continue and ignore the art world. I don't think any of us for that period up until the nineties had any intentions of wanting to exhibit artwork in the mainstream art world. We didn't think that we had any engagement with it at all. We belonged to a completely different community. Now, I think one thing that's happened to me, let's say in this decade, from the turn of the new century, concerns this issue. John Lansdown died at the end of the old century, I think he died very late in '89. By then I had got a New Media Fellowship from the Australian government, for two years. I spent the first year, 2000, at Sussex and I went to see John's widow, Dorothy, and asked "What's happened to all his stuff?" What we then discovered very quickly was that we weren't alone. That there were a lot of people around the world who came to realize that this very important period of our history, primarily because of the fact that it had marginalized itself, was in danger of being forgotten.

Margaret: And the people were dying off by then, too.

Paul: Exactly. John had died, you know; a lot of people died. And so the main premise of our CACHe project, the research project that was funded by the Arts and Humanities Research Board, was to preserve and document that legacy.[8] So this was my first realization, after giving the finger to the art world for thirty years, that really we had to get back on board, because the only way to sensibly preserve this stuff was to achieve some kind of mainstream recognition. We spoke to people at the Tate but then we discovered the Victoria and Albert. To be honest I used to think the V&A was a bit old fashioned, you know, into the Arts and Crafts movement and all of that. But, in fact, the CACHe project went in with them, and I think that was the best decision we could have made. It seems to me that what Catherine [Mason] does in her book[9] is point out that one of the roots of the computer arts is the foundation of the Arts and Crafts movement. We went around collecting it, analyzing it, and documenting it and exhibiting it. And so,

8. Paul Brown, Charlie Gere, Nicholas Lambert, and Catherine Mason, eds., *White Heat Cold Logic: British Computer Art 1960–1980* (Cambridge, MA: MIT Press, 2008).

9. Catherine Mason, *A Computer in the Art Room: The Origins of British Computer Arts 1950–1980* (London: Quiller Press, 2008).

I think, the CACHe project played a major role because we got Patric Prince to donate her collection to the V&A and we arranged the donation of the Computer Arts Society collection. Then they got another grant to continue the work. But I think what's happening now—Bernard Jacobson signing up Harold is one instance. I hear rumors that Michael Flowers at Flowers East is just beginning to look seriously at the area, and I think this is because they've looked to the V&A. A lot of those galleries in Bond Street have set up smaller, more experimental operations in the East End. One is Flowers East, where they've had some really good exhibitions. So the commercial sector is now saying "Well, maybe we better get on board. Maybe this is something that's interesting." Anyway, forty years later.... And I find that now quite exciting, from my point of view. The interesting thing there, is that they still haven't come to terms with the fact that this stuff is really virtual. You know, it's not an oil painting. It's not pencil on paper—it's not unique. The artist's touch and those things are what they value. Now my response to that, and this is because I'm old, is to start painting again. Putting paint on canvas, but essentially just making computer images by hand.

Ernest: Me too, actually.

Paul: And instead of printing them, I can paint them on canvas. I'm actually hand painting them on canvas. I was very impressed by Bridget Riley's show, the big show she had in London a few years ago. And, oh, I've never seen more beautiful work in my life. And it was all hand painted you know, very carefully hand painted, and lovely.

Ernest: It was a lovely show. They moved it to Sydney, so I saw it twice.

Paul: Did you read the review in the *Melbourne Age*?

Ernest: Yes.

Paul: The reviewer interviewed her and he assumed that she used assistants because she didn't want to do the tedious work herself and that she could produce more work that way. She replied that the reason she used assistants was because she didn't want to engage with the sensuality of the medium. What a wonderful reply! Over the past few years I've done a little. It's hard to find time to do it because it's very time consuming and laborious. But part of that is also realizing that if I do want to get into the commercial art world, that'll probably be more useful to me, and I now have no objection to that. But this reminds me of the head of graphic design at Middlesex who was close to retirement when I began teaching there in 1984. He said, "I've turned into somebody in my sixties who I would've hated when I was twenty-one," and I now know exactly what he meant!

Ernest: Perfect. Thanks!

14.7 Conversation with Roman Verostko, November 15, 2011

Roman Verostko pioneered coded procedures for expressionist brushwork. He is known for his richly colored algorithmic pen-and-ink drawings and has been an active exhibiting artist since 1963. Although schooled as an illustrator at the Art Institute of Pittsburgh (1947–1949) he was attracted to monasticism and entered monastic life at Saint Vincent Archabbey in 1952, where he studied philosophy (BA), theology, and was ordained a priest in 1959. He followed postgraduate studies at Pratt (MFA), Columbia and New York Universities, and S. W. Hayter's Atelier 17 in Paris. Artworks from his monastic period are, for example, *New City Paintings* and a series of concrete reliefs that include an eight-foot load-bearing wall, *BROTHER*, for the new Saint Vincent Monastery (1966). This period included his first electronically synchronized artwork, the *Psalms in Sound and Image* (1967). In 1968 he left monastic life and joined the humanities faculty of the Minneapolis College of Art and Design. In the summer of 1970, as a Bush Fellow at MIT, he set out to "humanize our experience of emerging technologies." He

Figure 14.5
Roman Verostko. *Flowers of Learning, Black Elk*. 2006, plotter drawing with pen-and-ink, 76×101 cm. One of seven units in a twenty-five-foot installation. Spalding University, Louisville, KY. See color insert. (Reproduced by permission of the artist.)

studied FORTRAN at the Control Data Institute (1970) and exhibited his first algorist work, *The Magic Hand of Chance*, in 1982. This program, written in BASIC, grew into his master drawing program HODOS, generating art with both ink pens and brushes mounted on drawing machines. His *Algorithmic Poetry* exhibition celebrated generative art as visual poetry (DAM, Berlin, 2010–11). He currently works with mergings of hand and machine. He has received many awards and distinctions: 2009 SIGGRAPH Distinguished Artist Award for Lifetime Achievement in Digital Art; Artec '95, Recommendatory Prize, Nagoya, Japan; Golden Plotter Award, Germany, 1994; Prix Ars Electronica, Honorable Mention, 1993; Bush Fellow, Center for Advanced Visual Studies, MIT, 1970; Outstanding Educators of America, 1971, 1974.[10]

Ernest: The first question really is, has the computer or software opened up new avenues for you as an artist? What do you feel about that?

Roman: I was totally seduced by computers when I learned how coded form generators worked. My first experience watching my plotter's drawing arm was awesome, hypnotizing, and magical. Computing power gave me the leverage to execute coded procedures generating form beyond anything I ever dreamed I could achieve; we have only touched the tip of the iceberg. Computing power, in the hands of artists who create and control their own algorithms has been transforming the arts and bringing radical change to our experience of life. That's my view.

Ernest: Are you making a different kind of art to what you might have done before?

Roman: I am working with some of the same art-making ideas but at a different level. My algorist work allows me to continue exploring the resolution of opposites with code at a different level. My prealgorist artwork grew from art-making ideas pioneered by first-generation concrete artists. This would include artists like Piet Mondrian and the Pevsner brothers. Their new reality was part of what I was seeking. Do you know that manifesto on the new realism spelled out around 1920 to 1921 by the brothers Naum Gabo and Antoine Pevsner?

Ernest: Yes.

Roman: That attracted me. Algorithmic procedure in the hands of an artist extends our ability to explore regions of a new realism in all the arts. For me the new realism could also be explored by working with spontaneous expression and structure in the same picture field. My prealgorist work employed abstract expressionist gesture and constructivist elements in the same painting. I wanted to create works that brought opposites into a

10. Roman Verostko at http://www.verostko.com/algorithm.html (accessed August 1, 2018).

visual resolution. This concept grew from Mondrian's concept of dynamic equilibrium. The idea was to create dynamic equilibrium between structure and spontaneity. Eventually I learned how to achieve this with code.

Ernest: That relates very much to my own perspective that we're really working in the constructivist tradition.

Roman: I see my algorist work has grown directly from my past work. And the computer, with my drawing machines, has become a kind of prosthesis for exploring art-making ideas that drove my work. With computing power, I get visual leverage that I never had before. Regardless of what path our art-making ideas follow, this leverage gives us tremendous advantages that were not available before. When I revisited my paper on epigenetic art I identified three features that I draw on in my plotter drawings.[11]

Ernest: What are they?

Roman: Well, for one thing, my plotter can draw extensively and tirelessly, so it's okay if my art idea requires forty hours of continuous drawing in a coded sequence of loops. Secondly, extensive algorithmic procedure can be achieved with tireless precision that exceeds what I can achieve by hand. And thirdly, I can achieve self-similar structures with recursive procedures that I can't achieve otherwise. There's no way I would be able to do that by hand, and I know that. Now, on the other side of the coin, I can do things by hand that I can't do with the aid of my computer.

For example, a structure like *Black Elk* in my Flowers of Learning project [2006] was generated with a very lean piece of information. Every relationship in this form structure is derived from the code for one initiating pen stroke. That is, the initiating line was achieved with about five or six controlling coordinates. The relationship of those coordinates to each other control everything that happens in this drawing— and that applies to every one of its hundreds of lines. I could never have achieved this kind of visual form if I tried to do it by hand. I might spend a year drawing it, but to have arrived at a form structure like this, by hand, is unlikely. There's a precision and self-similar relationship that permeate the work; there's a lot of things going on. That's the same with every one of the works in the Flowers of Learning project.[12]

11. See "Roman Verostko Participates in Code: The Language of Our Time," Roman Verostko: Artwork since 1947, accessed July 10, 2018, http://www.invisum.com/archive/shows-gr/linz/epigen-sho.htm.

12. *Flowers of Learning* at http://www.penplot.com/archive/spalding/spalding.html (accessed August 1, 2018).

At the structural level, as in life, two opposites converge. In my code, works are initiated and executed with random decisions operating within controlled parameters. For example, each of the controller coordinates in *Black Elk* was chosen with a throw of the dice, as it were. The decision bit achieved through control and uncontrol drives my art just as surely as the decision bit in the chaos and order of my life. Control and uncontrol operate at every level in my code. This is the spiritual core.

The procedure improvises on scale, angle, and position using the information from the initiator coordinates. The visual form achieves an in-depth self-similarity, so I get something that's Aristotelian at root. Aristotle in *Ars Poetica* emphasized the necessity of achieving variation on a theme. What I strive to do is create many variations with a single core visual idea (theme). Every variation has a core relationship with every other variation. This is what I mean by in-depth self-similarity. That's interesting.

It would be the same case with each of the brush works in the Algorithmic Poetry Series.[13]

Ernest: Tell me about that.

Roman: Well, each Algorithmic Poetry brushstroke is a robotic stroke managed with the same loop as every other stroke. These brushstrokes were influenced by abstract expressionism and my experience teaching in China in 1985. I was trying to get spontaneous expressive strokes with a piece of code guiding the brush. And that's essentially what it was. For this show. I had decided that I wanted to come back to the brushstroke and exploit it more. As in the pen strokes, the controllers are achieved with random decisions within controlling parameters. My robotic brush work demonstrates that one can code a stroke and get some of the qualities achieved with spontaneous gesture, but maybe not as much. It's the ability to improvise with brushstroke coordinate controllers that provides visual leverage.

Ernest: This is the center of it.

Roman: Yeah, that's what I think. For the brushed works in my Algorithmic Poetry Series, my code remembers the brushstrokes. Each brushstroke is restated and arranged vertically like characters for visual poetry. So if you look at one of the small black characters arranged vertically, you will see that it identifies one of the large expressive strokes. One large stroke may be a yellow one and the next one may be red. I was trying to get evocative qualities in the spontaneous brushstroke generated by code. These works have seventeen strokes intended to mime the seventeen syllables of Japanese haiku.

13. *Algorithmic Poems* at http://www.penplot.com/dam/alg-poetry10/algorithmic_poems.html (accessed August 1, 2018).

Ernest: It raises a question in my mind as to whether the possibility of making a work—I'm thinking more of a work like this one really—is conceptually or practically impossible without using computing power?

Roman: It's a tough question. You're going to have to take a hard look at Channa Horwitz, who was a superb algorist and craftsperson. She did all her work by hand. She did not want her work identified with computing technology. Reluctantly, she agreed to exhibit with J. P. Hebert, Hans Dehlinger, and myself at Santa Barbara[, California] in our first algorist exhibition.[14] We invited her to join us, as she exemplified the power of code without the aid of a computer. I'm still of the opinion, though, even after seeing her work, that algorithmic procedure, coupled with computing power, does achieve a lot of work that exceeds what you can achieve by hand. I hasten to add that Channa's work achieves qualities that exceed what we can achieve with our drawing machines and our code. You could also go down to the Alhambra, and see some algorithmic Islamic art that is truly awesome. And you wonder how they achieved all that by hand. I could say the same for the algorithmic achievements of the mannerists. Complexity and self-similarity is not limited to algorithmic art achieved with computing power. I mean, you can do some pretty fantastic things algorithmically without a computer. There's no question about that—yet every path has its limits.

Ernest: Of course. I have found that myself.

Roman: But the question you're asking is whether I could have achieved this work without computing power, and I say no. I think I would never have found this on my own. I often hear people say, "I see, it was made with a computer." I say, yeah, Mozart did piano-generated music too. You understand me?

Ernest: So some people talk about software art, and that's kind of similar.

Roman: Well, that's an interesting one. As you know, I wrote a paper titled "Epigenetic Painting: Software as Genotype."[15]

Ernest: I do know that.

Roman: Well, maybe I should revisit some of those ideas—but not at this moment. The biological analogues are there, and that's well understood today. But when you say software art, I think we do have to distinguish between someone who is going to look at the structure of the code for the art of writing code as distinct from, let's say, the form generated by the code. I look at musical scores as algorithms. I think there is an

14. *Four Algorists in the Land of Newton* at http://algorists.org/algorists/algorists-lorez.pdf (accessed August 1, 2018).
15. *Software as Genotype* at http://penplot.com/epigenet.html (accessed August 1, 2018).

art to writing code. And someone may have such a masterful algorithm for something they've come up with that, if you understood it, for the art of writing a piece of code, then that would be a form of software art. And I think that's different from what we do. I'm interested in showing the art that my code generated.

Ernest: That was another question I was going to ask you. What is your view of a relationship between the code and the art object?

Roman: The way I got to the art object, by the way, was interesting. My *Magic Hand of Chance* [1982] was presented as a visual sequence on the monitor, and it was animated. There are sequences in the *Magic Hand* that include the "Sayings of Omphalos" and my first "Cyberflowers." I have a sample sequence available on my website.[16]

Ernest: I'll look at it.

Roman: I'll give you access to the program. I did exhibit it in several venues in the early 1980s. The *Magic Hand of Chance* and other works I exhibited with computer monitors presented the same problems I had with my synchronized audiovisuals in the 1960s. Technical failures before or during a presentation frustrated both the audience and myself.

I came finally to the point where I yearned to get back to the art object as a drawing or painting. I discovered the pen plotter. I love paper, I love books, and I love manuscripts. I settled on drawing and said to myself, "We're going to use high-tech to generate it and create it, but once it's done, the work of art is independent of tech." No more tech failures at exhibitions.

Ernest: So it doesn't matter how it got to be what it is.

Roman: Yeah, so I was less interested in showing the software. However, when we published the limited edition of George Boole's *Derivation of the Laws* I did have a show of pen-plotted drawings. While creating one drawing I saved all the information my code sent to the pen plotter to make the drawing. We printed all the coordinates that resulted in a huge sheaf of paper—a stack about this high [*touches the ceiling*]. You know how the paper came with holes?

Ernest: Yes, I remember.

Roman: I attached the paper on the ceiling, and I let it hang down, and fold into a stack on the floor. And next to the stack I displayed the painting. I was trying to show the digital information that generated this art. So I was sort of anxious that people know about the code, and I still am. When you asked that question "Software or art?"

16. *Links for Magic Hand* at http://www.invisum.com/archive/shows-gr/zkm/zkm04.html (accessed August 1, 2018).

I think you could look at it two ways. You could view your software as art and the forms it generates as art. Software as genotype, like the acorn, is not the tree. But it can be viewed as an example of the art of writing software.

Ernest: The worry that I have is that I don't understand where the art is, sometimes. For example, in poetry, I read a poem on a piece of paper in a particular font, but I could read the same poem on different paper and in a different font and it's the same poem, so there's something kind of there.

Roman: Yeah, you've got a point there. That's interesting.

Ernest: I wonder how that affects your kind of work?

Roman: I wonder if maybe you might look at it like the cartoons that were made for the Renaissance paintings. The cartoons already, now, have become another kind of subject. I think the software is a subject. I'm certainly going to put a copy of my software in Bremen [Museum].

Ernest: Are you? Good.

Roman: But I'll leave it anywhere, I think. I don't have any secret. It's so old and so difficult to run. It's like spaghetti and nobody would be able to use it. They wouldn't understand it, but it is interesting.

Ernest: Is Frieder [Nake] collecting stuff like that? Because that's a very interesting enterprise.

Roman: Frieder has been creating an archive that is all digital rather than hard copy. He has helped the Bremen Museum acquire one of the world's largest collections of digital art. His archive has a lot of information on my algorithmic work that reaches back to 1970. One of his graduate students was interested in my experience at MIT. With a Bush Fellows Grant I worked with Gyorgy Kepes at MIT's Center for Advanced Visual Studies [CAVS] and prepared a report for the CAVS on "The Changing Roles of the Artist in Our Society." I had come to know Kepes during my New York years and was present for the dedication of the CAVS.

I lived in New York in the early sixties to pursue graduate studies in both studio work and art history. I was a monk and a priest in residence at Saint Michael's rectory in midtown Manhattan, where I had a studio. Influences from my New York experience are considerable. I was there at the zenith of Abstract Expressionism and experienced the unfolding of POP, OP, Happenings, Minimal and Neo-Dada. Andy Warhol and I were born the same year [1929] in the Pittsburgh-area coal and steel industry. I recall being invited to a Harper's Bazaar party in New York and there's Andy Warhol, John Chamberlain, and others and our hostess gets people to mix and talk. Artists in NY who became friends included Barney Newman, George Brecht, and Alan Kaprow. Alan

Kaprow wanted me, as a monk and Catholic priest, to celebrate a Eucharist Mass in a hot dog stand. Now they're all gone…

Ernest: I'm very interested in Kaprow because I'm very interested in the origins of interactivity. I never met him, though.

Roman: I liked him personally.

Ernest: But I'm interested in his attitude to art and participation.

Roman: Well, he was one of the key artists creating happenings, events, and performance art. He was also associated with found objects. I had a representative, Steve Joy, who handled my work when I was in religion, and for sometime afterwards. He worked for Martha Jackson, whose gallery was renowned in those years. I recall that Steve mounted the *Environments, Situations & Spaces* [1961] that featured Kaprow's famous *Yard* of used tires. So from him I learned a lot. In my New York years I went to openings and loft parties. Occasionally some attendees thought I was wearing a uniform.

Somehow, I survived, and I went on to Paris. And then I went back to the abbey at Saint Vincent where, for example, we staged a George Brecht "Vehicle Sundown Event" that had never been performed before.[17]

Ernest: This is really exciting. I'd imagined that you came out of priesthood into art but it wasn't like that at all.

Roman: I had brought a lot from New York to Saint Vincent. The project I envisioned for myself was to create a religious art center at Saint Vincent. We had the Archabbey Press that I wanted to keep active with limited editions. But unfortunately, my belief had been undergoing change, and I had to leave monastic life and create another life. My spiritual journey underwent radical change, and it was okay. When I think about those days, I recall how we wanted to reform the church, bring it into the twentieth century and work for social transformation. Towards the end of my years there I had become a follower of Teilhard de Chardin. But I think that's another kind of conversation. But I hope that helps you see where I'm coming from.

Ernest: That helps a lot.

Roman: In the 1960s, as a monk, I created electronically synchronized audiovisual programs that led me later to take an interest in computers when I moved to Minnesota. In 1969, I filmed a linear cube spiraling to infinity and back in a Univac lab in Saint Paul, Minnesota. Seeing that algorithmic sequence led me to follow a course

17. *Vehicle Sundown Event* at http://www.invisum.com/algorithmic/sundown%20event.html (accessed August 1, 2018).

in FORTRAN at the Control Data Institute in 1970. I didn't have access to a mainframe, so I didn't really achieve much with my code in the 1970s. I created synchronized audiovisuals in the seventies because I couldn't do much with my code until I had my own machine.

Ernest: So when you could have your own machine, that was the big changing point.

Roman: Absolutely, that's it. Then, I didn't know that I would ever actually get so serious about it, but I did. There was no question in my mind. I was going to make a personal expert system that would generate art. I was rather ambitious.

Ernest: So, actually, being able to program and have your own machine was crucial.

Roman: Your own computer in your own studio, so you didn't have to stand in line somewhere.

Ernest: Was it crucial?

Roman: Absolutely. There was no way you're going to tear me out of my studio to go to some place once a week or something. My studio had to be part of my daily life.

Ernest: Do you feel that changed your view of art making or just enhanced it?

Roman: At the beginning there were moments when I almost gave up because it was so frustrating. After working on a coded routine for weeks, the software would sometimes fail in the middle of a drawing. Or the plotter connection failed or my pen changer needed recalibrated, etc. It was tempting to pick up my pen and go back to drawing.

I recall spending a couple of months developing a routine that would allow me to interact with the plotter, so I could make brushstrokes. I felt very stupid, because I became the servant of the machine. The machine would say, "Insert a brush." I'd insert a brush in the drawing arm. It would make the stroke, then stop and advise me to "remove the brush." I thought, This is crazy! and I thought to myself, It's so easy for me to make that stroke. Why am I doing this? I kept going, and I said, There is some reason why I just have to do this. It isn't that I'm going to do a lot of these, it's just to make a point.

I remember once, for the college president, that I set up the plotter at the college and gave a presentation to our board of directors. We were trying to convince the board about the future of computer graphics, and one of the board members said, "Roman, why don't you just draw with your hand? Why are you so obsessed with this thing?" Well, I was dumbfounded and had no easy answer. As I recall it was an awkward moment for me. But I kept seeing this power of the algorithm. I knew I had "drawing power." That's what drew me. I knew I could remember the brushstroke. I knew I could flip-flop

it. I knew I could do all these things, and I thought to myself, "Well, I couldn't do that by hand." Don't you see?

Ernest: Yes.

Roman: I realized that I was gaining drawing power. And I said, "Stay with it, Roman, because this is the future and just stay with it." This flew in the face of my training, as I was schooled as an illustrator: I could draw. I did landscapes. I did portraits.

Ernest: That personal question was a crucial question.

Roman: Anything you mention, I probably did it. I studied at the Art Institute, Pittsburgh '47 to '49, and I was going to be an illustrator. This was my ambition. I was going to be like Rockwell, for example. You got it?[18]

Ernest: Yes.

Roman: So, when I came to this later in life, this was a big time for me. I realized the more I got involved with it that, yes, I could do it. I quit drawing by hand for the next thirty years, up until I did the *Upsidedown Mural* two years ago [2008]. And I wanted to share this with you. This is resurrected stuff I did back in the seventies. And I used software to blow things up, make adjustments, and scale drawings. I don't know if you ever got a copy of this. This *Upsidedown Book* includes some of my best automatic drawing of the 1970s.

Ernest: I didn't.

Roman: Well, I'm going to give you a copy of that, and I'll sign it for you.

Ernest: Thank you.

Roman: Getting back to algorithmic art. At some point early on, I came to realize that this would be important in the future of art practice. I was going to do it, no matter what. People laughed at me. They couldn't see that computer graphics would revolutionize typesetting, printing, layout, design, etc. Some colleagues didn't want me showing this to students. I taught humanities not studio art. But there were some students who would come down to my studio anyway, and I would sometimes take a computer to school and meet with them after class.

Ernest: So in a sense, am I right in thinking that you've taken a line of art practice forward, and what you've done is you picked up this opportunity the computer offers to push it forward?

18. *Coalfields to Art Institute* at http://www.invisum.com/history/pgh/pgh.html (accessed August 1, 2018).

Roman: Yes.

Ernest: You might have done something else if the computer hadn't been there.

Roman: Probably something in new media. Initially, I wanted to humanize emerging technologies. I wanted to find ways to join emerging technology with fine-art traditions—especially drawing and painting. I looked at my studio as a kind of electronic scriptorium that grew from my interest in manuscript illumination. Here in London, my favorite manuscript is the Lindisfarne[19] up at the British Library.

Ernest: The British Library is wonderful, isn't it?

Roman: So a lot of my work mimes manuscript illumination. I have added some gold leaf to the text as I did with the illuminated universal Turing machine. I wanted to develop drawing that represented the information revolution. It would join or merge art traditions with emerging electronic technology. I decided around 1985 that I would become a master pen-plotter artist. There was enough here for me to explore with my master program HODOS for the next twenty to thirty years. So I decided that I'm going to become the master of pen-plotter drawing with brushwork enhancement.

Ernest: You've achieved it.

Roman: I have hundreds of pens, seven pen plotters, and lots of paper. I'm at my home and that's what I do. People come into my studio and ask, "Why don't you get the gee-whizz printing thing?" No, I say, this is what I do. "Yes, but you could make this 3-D." No, but that's not what I do. You understand?

Ernest: Absolutely. I think that's wonderful, and it's completely correct. And you are a master of this, as you had plans to be.

Roman: When I did the mural Flowers of Learning for Spalding University I thought to myself that was the moment for me.

Ernest: There was another thing I was going to ask you about, the programming languages that you used.

Roman: Okay. I studied FORTRAN but I never mastered it for my art. But I've never mastered anything other than just BASIC. My *Magic Hand* was written in IBM BASICA but now everything is in GW-BASIC. My master program is not compiled. I run it directly as written.

19. *Lindisfarne Gospels* at https://www.bl.uk/collection-items/lindisfarne-gospels (accessed August 1, 2018).

Ernest: There's nothing wrong with BASIC, by the way.

Roman: Well, BASIC is a universal Turing machine too. It's interpretative, so you can test run bits of code as you go. I could even show you some things working. I'll show you a program. This is my interface.

Ernest: So you studied FORTRAN but you never used it, really?

Roman: Well, I did a little bit. And I did a little bit with punched cards.

Ernest: What happens today?

Roman: Here it is [*opens his laptop*]. This is the interface I built. I wanted to show you my interface. If you went, for example, to my file manager up here you can see how many variables I have in my program. I invented all of these variables for drawing routines—a total language. It has a variable for every kind of action I need to make a drawing or do brushstrokes. It gets quite large, but the final data for executing a routine is very lean, almost nothing, just one or two KB. The drawing routines are chained to the master program as needed, and then they are dumped from memory. But I thought you'd appreciate just getting an idea.

Ernest: Absolutely.

Roman: I don't want to waste a lot of time on this with you, but I'll just give you an idea. For example, I have a lot of options. I can write a routine tomorrow when I get home and chain to it from my interface because everything is compatible. So once I've built about ten of these routines I have hundreds of lines of code with many options available. The entire procedure can be automated or controlled, step by step. For years I intended to rewrite everything in an object-oriented language. I stayed with it, and now it's antique, and unique. I was embarrassed to show people, but I've discovered that it wakens memories of earlier days.

Ernest: Yes, there's nothing embarrassing about it at all.

Roman: I almost didn't want to show what I do because I'm not a computer scientist.

Ernest: You're an artist, come on.

Roman: I'm a humanist and a historian. At my age, if I really wanted to do one more thing, if I set my head to it, I might still do it. I have a plan for the last work I hope to do for the University of Minnesota Landscape Arboretum.

Ernest: So what's your big thing? Tell me.

Roman: I plan to make a folio of original cyberflower drawings. The drawings will be of a modest size, in the tradition of naturalists' drawings of plants and animals. These cyberflowers formatted in a folio for the Arboretum library will include algorithmic titles based on the coded controllers for each specific drawing.

These code-generated cyberflowers would belong to Kevin Kelly's proposed "hyperspace of form." I proposed a Gallery of D'Arcy Thompson for a hyperspace of form embracing all rigorously concrete (nonrepresentational) art as noted in my 1994 web page on algorithmic art.[20] So I think that these code-generated cyberflowers for the arboretum can be viewed as primitive bits of flora in an emerging hyperspace of form. And that is indeed a vast space.

Ernest: Absolutely.

Roman: So you heard it from me.

Ernest: Yes, I did. Thank you.

14.8 Conversation with Julie Freeman, April 18, 2012

Julie Freeman translates complex processes and data from natural sources into kinetic sculptures, physical objects, images, sound compositions, and animations. Her work explores relationships between science and the natural world, questioning the use of technology in how we translate nature—whether it is through a swarm of zoomorphic butterflies responding to air pollution levels; a lake of fish composing music; a pair of mobile concrete speakers that lurk in galleries spewing sonic samples; by providing an interactive platform from which to view the flap, twitch, and prick of dogs' ears; or enabling a colony of naked mole rats to generate animation. Julie's focus is the investigation of data as an art material, using it to create work that reflects the human condition through the analysis and representation of live animal data. A mix of computer scientist and artist, Julie is a connection seeker, sniffing out potential correlations between disparate concepts and systems and combining them. She often works collaboratively and experimentally with scientists.

Ernest: How has the computer affected your art making? Has it opened up new avenues in your art? Or was it there before?

Julie: I would say that the computer was there before my art was. I first built a computer when I was about twenty, in university. I got fed up with not being able to get access to

20. Added note by Roman Verostko: "Writing on the new biology of machines, Kevin Kelly identified *The Library of Form*, a frontier hyperspace of form being pioneered by Karl Sims (*Out of Control*, 1994, Chapter 14). I propose to identify the parameters for a *Gallery of D'Arcy Thompson* to embrace computable abstract art that is rigorously non-representational, i.e., nonobjective, concrete, pure abstract art. Unveiling art within the hyperspace of forms with these parameters was certainly the dream of artists like Frantisek Kupka."

Figure 14.6
Julie Freeman. *A Selfless Society*. 2016, online animation with sound. JavaScript with HTML5 canvas element, real-time data from a colony of naked mole rats, variable size. See color insert. (Reproduced by permission of the artist.)

a computer, so I just got hold of all the bits and built my own. A 386 DX or something. Put it all together. And I really enjoyed it. And I found that whatever I was doing I would end up using the computer to do it with. I found that I started using it in unusual ways, in a more creative way. But I never thought of myself as an artist for many years. It took a long time, actually. I used to call myself a technologist. I struggled with that term, because I didn't know what I was doing, apart from I was playing with computers to use them for purposes they weren't designed for.

Ernest: What was it that you dropped out from at university?

Julie: It was a BSc in Design Technologies in the Mechanical Engineering faculty. There was a lot of physics in the course plus commercial process design. But I found that it was too straight. It was too manufacturing-world oriented for me, and it wasn't letting me be creative enough. And when I was at school I wasn't allowed to do art. I had to do technical drawing, because art wasn't seen as vocational enough. So there was a bit of pressure not to do it. So I ended up finding my artistic streak through the computer in a different way.

Ernest: So actually you became consciously an artist, or concentrated on art, using the computer, and it was a platform for you to do that?

Julie: Yes. I do sketch, and I draw. And everything starts in my notepad. It never starts on the computer. It always starts as ideas. And I make up little plans and systems of things and then start working out how I can make it. But there is always an underlying need for technology in the artwork. And I think it wouldn't exist without it. On paper they're impossible systems, or impossible things that need the technology.

Ernest: Has your art mostly consisted of making things? You might say sculptural rather than painting?

Julie: Some of my work is graphically visual. But there's a real variety. Some of it's sculptural. Some of it's screen based. I've done a lot of Internet-based work. Videos and also sound art. But I think there is always a strong visual art thread.

Ernest: Separating out sound and vision doesn't make sense for most people. What about programming? Has it made a difference to you whether you could or couldn't do that?

Julie: Yes and no. It's an essential part of the making process. I think it's essential. Because I don't believe that you can work with any material as an artist if you don't know that material inside out, or if you don't want to explore it inside out. So even if you're working with paint or clay or anything, you need to fully understand what you can do with that material. So to be able to use computers, I think, is pretty essential for my own work, anyway for my own satisfaction, that I'm doing the work myself. To be able to code, or even if I'm using proprietary software, like Flash or MAX/MSP, that's already a layer, I still need to know that I understand what's going on underneath the user interface. I only know code to the level of C programming. I don't code in assembler [language] or anything. But I think there's an importance of knowing why the computer is doing what it's doing, and how it's displaying things, and why it's processing sounds in a particular way. You need to understand the set of instructions being carried out to be able to disrupt them.

Ernest: Actually, I would say that writing in MAX/MSP is programming. I know that some computer scientists don't agree. But with one hat on, I'm a computer scientist, [and] I would say it is. It's just that it's graphical programming, rather than textual.

Julie: It's visual. And in fact I find it easier to write in Java or C or something like that than I do in MAX/MSP, because I find that I get more caught up in the logic loops. It tends to be long winded when I'm doing it in MAX.

But I also really love coding. I think it's essential, but I also love it. I really like the challenge of it. And I don't know—whether if you were working as an artist trying to make something visual or sonic with technology—I don't know where you would buy something that could do that for you anyway. How would that work if you wanted to make something original?

Ernest: So that's another factor? Apart from the fact that you might enjoy it? There's a need, because there's not much chance of going to buy something that does what you want?

Julie: Yes. It doesn't exist. I mean, I think there's no point in me trying to make a piece of artwork if it exists already. So I think that my works tend to be quite complicated, in terms of using lots of different types of technology to do what they do. Even though the end result might be quite a simple aesthetic.

Ernest: So obviously your work consists of many elements, as it were?

Julie: Yes.

Ernest: One of those elements is software, I guess. Where do you see that? Do you see that as a peripheral? Central? How does software fit in?

Julie: It's in the middle. That's boring, isn't it? But the software is in the middle. The software is in the middle and the software is the thing that is driving how the hardware behaves. So if I'm making things that have got a flapping motion, the way that I've coded that determines the movement and the speed and the frequency and what it responds to. So the software is integral to all of it, it connects. And even in terms of how something looks, so if I've got a graphical element to it, like in the lake project, that's all coded. The actual look and feel of it is all vector graphics and the movement of those vectors is algorithmic. Software is fundamental.

Ernest: So it's central? It's one of the central elements, would you say?

Julie: It is probably the central element in the realization. But otherwise the concept is probably the central element. If you didn't have the concept you wouldn't even be doing the coding in the beginning.

Ernest: Could you have the concept without the software? Or without knowing about the software? Are the concepts that you use in your work somewhat dependent upon the software?

Julie: That's really hard to unpick. That's difficult. Because I know what I know, I don't know if I could come up with the idea, if my ideas would be the same, if I didn't know the possibilities of what's available. And I know that sometimes when new technologies become available, then they sort of seep into my work. Because there's something else going on. Like when I found about Muscle Wire, the shape memory alloy. And then I ended up making a piece of work that had that in it. Whether I would have made the piece of work in a different way if I didn't know about that I can't answer. ... But in fact I had the idea of that work before I knew about the hardware I was going to use. I can't unravel, because I've been so in love with technology for long before my

art practice, so I absorb new technical directions like a sponge; they excite me. I don't know if that makes sense!

Ernest: Yes. It does. I mean, it's an integral part of your thinking really. So the question is hard to answer or maybe impossible to answer.

Julie: I guess if I thought about it in terms of, Did I come up with the idea for a big bronze sculpture without knowing what the property of bronze is? That kind of thing. I don't know if I would. I would come up with something different to someone who's a bronzesmith.

Ernest: Yes. So in working with computers and working with software, do you come up with new ideas or modify your ideas about the work in that process? Or do you know what a program should do, and all it is is a matter of just implementing it?

Julie: Yes and no. It always changes through the process of coding.

Ernest: So there's a dialogue through the ideas and the coding?

Julie: Yes. But I start with an idea of what I want to happen. And then that's generally quite open ended. And I work in a really process-oriented way. So I'm very interested in how I get there—more than the end result, often. So I have a vision. I have a vision of a framework. But I rarely have a vision of the final installation or piece of work. That's never very clear, because I know that when I'm making it, depending on what program I use or what systems that I use, it will always come out differently. I think this process also pushes my boundaries. Because if I'm programming, there's some things that I will struggle to do. And either I'll push through that and I'll have learned something new, and then I can push my artwork further, which is great. And sometimes I get completely stuck and have to go, Okay, I'm going to have to compromise and try something else. And both of those things will affect the final outcome.

Ernest: Could that be true if you were using clay? You know, "This bit is too heavy. It's going to fall off"?

Julie: Yes.

Ernest: So that's not an unfamiliar problem.

Julie: Yes. But I like the challenge of having to write something to make something work; whether I'm making a sculptural piece of work or whether I'm making a sound or a particular theme. I like the challenge of that. And particularly with sound. If I get stuck, there's often things that emerge that I could never have predicted, but I really like the way they've turned out. And so I'll just stop and go, Ah, no, that's working, even though it's not how I thought it might work. So that happens through the development of the code as well.

Ernest: That's a good example. It's the sort of thing I was wondering about. So is any of your work what I would call generative? That's to say that the work does stuff and gets to a stage that you hadn't explicitly programmed in?

Julie: There's a project called *The Lake*, which is data generated, that I think looks generative but isn't. Because it's just continuously working with real-time data. But a lot of the sound pieces I've done are fairly generative. Because I work with cut-up sounds, musique concrète style, where I use a lot of mixed-up tiny sound samples and then program in a lot of random behaviors. So different behaviors trigger each other. And every time that I play it, you get a different sequence of sounds, and it comes to different points. So that's generative in that way.

Ernest: And are you interested to see what they're going to do next?

Julie: Yes. Yes. I love that.

Ernest: So whatever anyone else thinks, it's interesting to you, anyway?

Julie: Well, yes. Sometimes I'm not very audience focused. But I really enjoy—with the sound particularly—using vocal snippets; I can sit and listen for ages because sometimes it turns into something quite [like] comedy. Often it's just very surreal. And it's quite compulsive listening. If I've written something that does that, then that's a really satisfying thing to have done. But I also like, and I've thought about this a lot, is that, the way that I work is by setting up these systems. So this piece of software will talk to this, and take some data from here, will output this thing here. And I feel in control of that. And then I feel like I step back and lose control. So I don't know how it's finally going to sound or look. And I think when I was less confident as an artist—and I don't know if artists ever get wholly confident about their work—it was really important to be able to say, "Okay, I'm about to show this to a hundred people, or launch a new piece of work," and I felt like there's a little gap where I'm not responsible. I've set the work up, and I've enabled it to happen, but if you don't like it or if it looks rubbish, then that wasn't me. You know? Of course, it was me, because I've written the program and designed the entire work, but that gap where the data or the algorithm flows through is a curious window of relief.

Ernest: Well, you've started to answer my next question, actually. Which is, does the use of software distance you in any way from the object?

Julie: Yes. Sometimes. Sometimes it really does. From the end result. But I think the use of software brings you an intimacy with what you're working with. So I just created a project that's got these little flapping objects. And once it was built, and then it needed the software to control the behavior. And when I was playing with the software I found myself, not falling in love, but becoming really attached to these little objects. To the

point where even though there was twenty-eight of them, I know now that they all move slightly differently, because they've got different lengths and different mechanical constructions. And so when the code was written to do the behavioral stuff, they came to life. And I think that if I had made a static sculpture, or a sculpture that was just plugged in and then just did something that I hadn't written myself, I wouldn't feel that closeness. I wouldn't feel like I've hatched this beautiful thing. It would be very different. So it does both. It brings you closer and allows you to step away a bit and let it get on with itself.

Ernest: What languages are you typically using when you make a piece like this?

Julie: For that piece I used an Arduino, which is C code. That was all the behaviors in Arduino for that. Some of it's in Processing [computer language]. And the Processing is Java. They tend to be my weapons of choice. And then Max/MSP for the audio. I never use Java for sounds. And in the past, and I haven't for a long time, I have used Flash for animation, for vector-based animation.

Ernest: And when you look at a piece of Processing or Java or something, do you care much about how it looks as a piece of code?

Julie: If I've written it?

Ernest: If you've written it.

Julie: Yes. I do. I don't always succeed, but I really like it to be succinct. And I like it to be understandable, but very personal. So if you look at it, it definitely belongs. I don't tend to write generic stuff. The names that I use for my variables and things like that tend to link into the work that I'm making. So if you read it, it would link to it. If I'm talking about flapping, or butterflies, or fish, or whatever, that's in the code as well. It's not just "object one."

Ernest: So there's an aesthetic of the code as well as an aesthetic of the object that the audience see?

Julie: Yes. Massively. And I think it's interesting with the code. I think there's some sort of dogma around code and how people write it and what they think about how it should be written. But actually it's a really personal, creative process. I was sitting next to someone coding: we were both working on a Java thing, and we had to do the same piece of coursework. And my solution was completely different to hers. And we had really different techniques. I don't often get a chance to do that, sit next to someone to write the same thing. I was like, "Wow! That's interesting!" And I felt I could read mine. And I looked at hers and I struggled to get my head around how she'd realized hers. It's a very personal thing. And I think it's really intriguing to see how other people do it. That's why things like the code-sharing open-source world is interesting, not only from

a learning point of view but to see how other people approach things. Where they're coming from, different logics.

Ernest: But that says to me that to you the code isn't just, "It's got to make it do this." Code is a part of the work…

Julie: Yes.

Ernest: …just as you would care how you put the paint on, you care about how you write the code? That's what I hear you saying.

Julie: Yes. I would definitely agree with that. I think it's kind of precious in its own right. It really is a part of it. Yes. I was going to say unless you're doing something simple, but actually you rarely do anything simple; you are always going to be altering and adapting.

Ernest: An open-ended question: Do you think software or computers in general inform your practice in any other ways that you can think of?

Julie: I think technology, the development of technology and how it moves forward, affects my work, just because when there's something new that's available, and when things are changing…

Ernest: You keep your eyes on what's happening?

Julie: Yes. Yes. I try to. To see if something is going to filter back into what I want to do.

Ernest: One of the advantages of your research at Queen Mary [University of London] is that you will have a line to what the latest things are.

Julie: Yes. Although sometimes I think the Arduino particularly has been a massively helpful new technology that has made doing some of the work I have wanted to do much easier and quicker. When I did some early projects, where we've had to make our own bits of hardware, that's been a really long and drawn-out process. So cutting corners like that has been really useful.

Ernest: What is an example of a good corner cut that you've had?

Julie: Not having to get somebody else to make a particular tagging system, or to actually have to send off for someone to make the circuit board, put all the pieces together. It was just beyond my knowledge. But being able to do that myself now is great. If I only work with an Arduino and I can build my own circuits, that's really nice. In a way it's opened up a little black box.

Ernest: Is it extending what the programming does, in a sense?

Julie: Yes.

Ernest: It's only the scope of influence, if you can call it programming, which you could.

Julie: It kind of is.

Ernest: It's specifying, anyway.

Julie: Yes. And I think in some ways it brings you back to being able to be even more personal about what you're creating rather than using any generic off-the-shelf stuff. For me, the less generic things that I have to use, the better. Because I feel like the more handcrafted it is, the more special it is.

Ernest: So that's an aesthetic of your practice in a way, isn't it?

Julie: Yes. I think so.

Ernest: Which not every artist would agree with?

Julie: No.

Ernest: But some would.

Julie: Yes. It depends what you want from your work.

Ernest: Well Damian Hirst wouldn't agree with that.

Julie: No. I don't give a toss what Damian Hirst wouldn't agree with. His reason for being an artist is a very different reason to what I think my reason for being an artist is. And I want to explore and have a really intense, intimate, curious relationship with technology and what I can do with it, and it leads me to link with the natural world and biological systems.

Ernest: And how do you see that? Do you see it as a process of discovery or learning or anything of that sort? Do you use any such words?

Julie: I don't know if I would say it was a process of discovery. It's all driven by curiosity to see whether I could. So if I've come up with a concept that on paper might be one of these doesn't-exist, almost-impossible ideas, What if I could get fish to make music? And then I achieve that. And I get a really big sense of self-satisfaction, but also I'm creating something novel. That is really interesting to me and I hope will be interesting to other people. The challenges are in that. So it's a chase. It's more of a chase.

Ernest: And I can see that the word "discovery" doesn't fit that properly. It's not quite right.

Julie: Not really. Because "discovery" says that there is something out there that I'm looking for.

Ernest: Which is not the case?

Julie: Yes. Not necessarily.

Ernest: No. You're inventing something or bringing something into existence that didn't exist?

Julie: Yes.

Ernest: You're not finding something that is already there?

Julie: No. And I've been learning that bringing something into existence that doesn't exist is really nice. I've been learning taxidermy, and one of the things that I find quite remarkable about that is when you put the animal back together afterwards it's got another life. All of a sudden it's doing something else, it fills another place in the world. And I get the same buzz from doing that that I get from completing an artwork.

Ernest: Great. Thank you very much.

14.9 Conversation with Alex May, July 16, 2012

Alex May is a British artist exploring a wide range of digital technologies, most notably video projection onto physical objects (building on the technique known as video mapping or projection mapping by using his own bespoke software), also interactive installations, generative works, full-size humanoid robots, performance, and video art. He has performed live video mapping at Tate Modern in London and for the inauguration of Serre Numérique in Valenciennes, France, and exhibited internationally including in Britain at the Eden Project (permanent collection), V&A, Royal Academy of Art, Wellcome Collection, Science Museum, Bletchley Park, Watermans, Goldsmiths, and One Canada Square in Canary Wharf; in Venezuela at the Museum of Contemporary Art in Caracas; in Ireland at the Science Gallery in Dublin; in the United States at Princeton University and the Beall Center for Art + Technology at the University of California, Irvine; and in Canada at the University of Calgary (international visiting artist 2016). He gives talks about many aspects of digital art, digital preservation, and public engagement with social robotics through art (e.g., at the University of California, Los Angeles; Chelsea College of Art; Waag Society in Amsterdam; Gray's School of Art in Aberdeen, Scotland; British Film Institute in London; and Ahmed Shawky Museum in Cairo) and runs workshops for artists using his own software (e.g., at UCLA, for Fluxmedia at Concordia University in Montreal, and International Symposium on Electronic Art in Istanbul), and gave the 2012 Christmas lecture for the Computer Arts Society. Alex has been a visiting research fellow, artist in residence, with the computer science department of University of Hertfordshire since 2011 and a digital media arts lecturer at the University of Brighton since 2012.

Ernest: Has the computer influenced your view of art practice?

Alex: It was always a very natural partner to it, because I was introduced to computers fairly early on, and actually my dad is a journalist and writes books. He was into it even before I was, so he was getting all these lovely photographic prints sent over from

Figure 14.7
Alex May. *Digital Decomposition*. 2017, interactive digital installation, variable size. See color insert.
(Reproduced by permission of the artist.)

America of the latest flight simulator graphics of the Rocky Mountains, and I was just like, "Wow, that's great."

Ernest: Did it actually influence your interest in art; was it maybe the other way round?

Alex: Probably, yes. I was very interested in the processing capabilities of computers as it relates to art. You can do things that are just so far beyond what a human being would be prepared to look at, so it's almost akin to like some of Pointillism; to achieve that effect they had to spend hours and hours doing these tiny little dots. And that's not to take away from that effort and to say, "You could easily do that with the computer," but it's that level, that you can do something that's so mind-numbingly boring to a human in a fraction of a second, it just kind of opens it up. So yes, I've never really separated the two.

Ernest: In your practice, how much does programming matter to you? Does the software itself matter?

Alex: Very much. I ran a sort of talk panel thing the other week, which was "Code as Art," about the actual code itself, whether there's an aesthetic thing. I program mostly as a very functional process, just to make the thing work and make the end result, but I like my brackets lined up in a certain way, and I hate people who put their brackets in the wrong place, so I must have an aesthetic side.

Ernest: You mentioned brackets, so that suggests a particular kind of language?

Alex: C++, but it also applies to things like LISP, so I have done lots and lots different.

Ernest: But do you mostly use C++?

Alex: Mostly. And there's a functional aesthetic, because if I see the brackets lined up, then mentally I can scan down the code, and it has a much more pleasing feel. And I feel that the code isn't right—even if the end result is right—I don't feel the code is right until it looks [right].

Ernest: There is an argument that some people have put forward in relation to literature: for example, a poem isn't what you see on the page; that's a manifestation of the poem. If you have a different typeface, you've still got the same poem, and I wonder if that has any analogy?

Alex: I've written articles and books, and I like text, I like how it looks. And obviously with the web you have the fluidity which drives traditional people who work with print absolutely mad, because they want the line widths to be exactly "that," but to me it's quite pleasing, and it's very much required to impart the information.

Ernest: So following on from that, do you find that the work you do with software distances you from the object? How is that relationship?

Alex: Obviously, I work a lot with video projection and the idea of augmenting objects, changing the perception of the physical object using nothing but light. Light is why we're all here and it affects our light divisions and whatever. It affects us more than we realize; it's just our brains are very, very good at processing all that information. So it's a very intrinsic relationship that I'm trying to modify, the experience of people, and so a wall might be an integral part of the piece that I'm doing, or it could be an object, or it could be you're projecting on people, or you're using them as input; it's totally integrated.

Ernest: So if I understand you right, the software is an integral part, and it may be an essential part, but not the only part?

Alex: Well, no, because even if I've got a screen-based form, I don't do many of those. How it's presented, or the screen itself, the quality of the screen, the technical specs on the screen, everything is integral. But going back to what you're saying about text, you can have it in different fonts, and does it affect you? And of course it does, a good font is a readable font.

Ernest: You probably realize very well that I agree with that. I'm not prepared to show my piece on some standard screen; I want control of that.

Alex: Yes, and although I find it very interesting to create a piece which is flexible enough to allow people to experience it in ways that you haven't first encountered, and especially with the interactive stuff, in ways that just allows them enough room to feel that they've had some input into it, because they're an integral part too. I do like that idea, and it's a bit of a tired thing, but if nobody is around, is the art still art? Because then you're just dealing with the physics and the physicality of it, and part of the work I do with lasers and projections and programming, none of it exists, and I'm going to spend my whole life creating nothing, but people have seen it, and I love that!

Ernest: So in your case, there's more than the software that has this issue around it, because of the kind of work you do?

Alex: Yes, very much, absolutely. When … I've got the output that I want, I stop working on the code, but nobody really gets to see the code and I'm still really working on that idea at the moment, because I don't really want to release my stuff open source, just willy-nilly, and I've done the prep work. To me it's a weird stage which doesn't have a direct analogy to something like painting. I mean, I drew up all these little tables of light and the code in itself. If it's a compiled language you can compile it to an application, and you throw the code away, essentially. Whereas something like a Python script, obviously, you required a code to be there, and it's a similar function. So the fact that there is this intermediary stage is kind of weird, and people should have a chance to see it and have a look at its aesthetic qualities.

Ernest: Because it's quite interesting, because actually if you think of painting, for example, Francis Bacon famously said he didn't do sketches and things, and then it turned out he did, but he hid them! Whereas other people have been quite open about it, so it's not a new issue in that sense. What do you think about live coding?

Alex: I'm doing a bit at the moment, because I'm very interested in taking the sometimes forgotten historical context for digital stuff, because a lot of the time people go, "I've done this digital thing, and it's really cutting edge," and it's like, "Well, no, actually some guy did it eighty years ago on film, and he did it much better than you did," and there's tons of it which is forgotten. There's that lovely book, *Film as Subversive Art*, which is documenting all the experimental film stuff, and it's amazing, and the painting from 1532 with the anamorphic skull. Yes, people have been playing about with stuff, and even all the projective geometry stuff, all the theories of perspective were not really settled until to the seventeenth century. So there are all these kind of parallels of this thing, so it's just sort of realizing that all this has gone before, and to put it into context, realizing that I'm not being really cutting edge and cool, it's like I'm part of this long path, a long piece of string, and the fact that music has in some ways been ahead of visual art.

Ernest: The piece that I showed when I was talking just now [*referring to an abstract time-based computer work*] was very much like early abstract film, actually.

Alex: Yes, very much.

Ernest: But just computer generated.

Alex: Early animation, and even interactive stuff is not new, but I like that historical placement of it.

Ernest: So in the historical thing, there was something that was mentioned during the talks today, about producing a tool, and some people will say it's a medium. How do you stand on that?

Alex: I don't know. Somebody asked me, "Is programming the new literature?" the other day, and I don't know, maybe people use it as a medium, maybe people use it as a tool.

Ernest: And do you know how you do it?

Alex: I suppose technically I use it as a tool. Again, I was trying to figure this out—is the code the medium, is the computer the studio that you're working within and the languages or the software in the system, because that's all part of it.

Ernest: Did you come to any kind of conclusion in that discussion that you organized, which I couldn't get to?

Alex: No, but it was nice, we had a nice range of input. You have the computer guys who were really trying to tie down where was the art in computing and at which point does the art happen, and that was lovely. And then the more art side of it, almost a philosophical thing. It feels like sort of trying to justify the use of computers and words, and I don't see what the problem is!

Ernest: So do you think that the way you see art is influenced by your knowledge of computers and your use of computers?

Alex: I think, fundamentally, it's far more influenced by the fact that I'm an artist; I'm terrible in art galleries, because the work that I'm doing with the time-based pieces where you really have to stand there, you really have to stand there for a couple of minutes to really get the full thing, and I realize that's obviously quite a short time, but when I go to an art gallery I'm racing around, because I look at things in relationship to my work and it's very difficult for me to look at a piece and completely look at it without my art brain or my technical brain kicking in and going, "Well, how does that relate to my thoughts?" Maybe I'm trying to make a penance, or doing my penance, and this time-based works to sort of slow myself down, to stop myself from, stop people like me doing it, because I suppose I might be the person that comes in and says, "Oh, there's nothing happening."

Ernest: You might be interested in some of the articles in that book I showed, because we've done a lot of research on this and on engagement. And we talk about the three stages of engagement: one is attraction, like, do you bother to look for more than three seconds, which is what museum and gallery people tend to worry about. And then there's sustained engagement, do you look for three minutes or maybe half an hour? And we have found people who are doing that. And then the third thing is forming relationships: do you come back tomorrow, do you bring your aunt or your granddaughter or something, and do you go and see Macbeth lots of times throughout your life, this kind of thing. And it's quite interesting, because it turns out that the works that have the different kind of engagement models have different characteristics, so you almost need to know what you've achieved, and you might build the work differently.

Alex: You wouldn't necessarily change the work. If the work would be attracting the flashy attractive thing, then that is just the work. Again, with all the slow stuff, we showed the robot in Kinetica [Art Fair], and it was a five-foot-tall real robot, with a big glowing face, and people just wandered by like nothing was there. It was amazing. But it worked really well there because people were looking for quite immediate feedback, and we'd speeded it up a little bit to counteract. I mean, we had people coming back, or people would take a photo of it and then that would be their Facebook profile.

Ernest: That's very nice.

Alex: It's lovely, because suddenly, after the Kinetica Art Gallery, we started seeing them everywhere!

Ernest: Another question: Although art is typically seen these days, and maybe in the romantic provision, as an individual activity, in fact, in our game, there's a lot of collaboration. How important is collaboration to you?

Alex: Yes, it's important. I suppose because I've reached a level of coding where if I have an idea I can code it and I've got video objectives and I can pretty much, single-handedly, just come up with a piece, execute it, and, money aside, I can execute it. Whereas I know, obviously, people collaborate, because, in some instances, they need skills from other sources. I collaborated for a long time with a sound artist and we created some very nice audiovisuals, some environment stuff, and it added this whole different dimension to the thing, and we collaborated with Anna Dumitriu and her interest is in mainly viral and bacterial. So it was lovely to be able to learn more about that and take elements of bacteria and say, "Well, okay, I can take things from that and it definitely relates in some ways to the work that I'm doing." And it's nice to be able to facilitate other people's visions, because people have these ideas for projecting all over buildings and stuff, and it's difficult, and it's costly, and sometimes you have to break it a bit gently to them: "What you're planning is going to cost the other side of £100,000, but I can do it!" So yes, it's nice to make these things up and it's enjoyable to work under somebody else's ideas sometimes.

Ernest: Thank you.

Alex: Thank you very much.

14.10 Conversation with Kate Sicchio, June 12, 2013

"Dr. Kate Sicchio is a choreographer, media artist and performer whose work explores the interface between choreography and technology. Her work includes performances, installations, web and video projects and has been shown in Philadelphia, New York City, Canada, Germany, Australia, Belgium, and the UK at venues such as Banff New Media Institute (Canada), V&A Digital Futures (London), FoAM (Brussels) and Artisan Gallery (Hong Kong). She has been written about in The Guardian, Dazed Digital, El Diarios, and Imperica Magazine. She has presented work at many conferences and symposia including International Society of Electronic Arts (ISEA), ACM Creativity and Cognition, Digital Research in Humanities and Arts, Congress On Research in Dance, and Society of Dance History Scholars. She has given invited

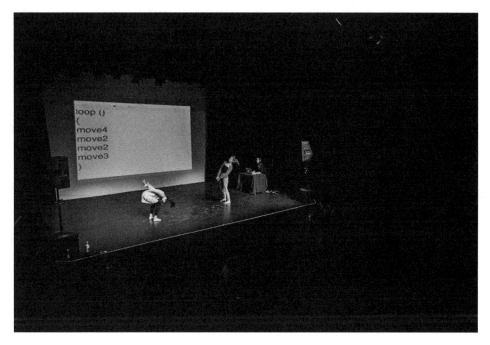

Figure 14.8
Kate Sicchio. *Hacking Choreography*. 2014, performed by Philippa Lockwood and Elissa Hind at Waterman's Art Centre, London. See color insert. (Reproduced by permission of the artist.)

talks at places such as EU Parliament (Brussels), Node Code (Frankfurt), and Resonate (Belgrade). Her research has been published by Leonardo Electronic Almanac, Computer Music Journal, Media N and Learning Performance Quarterly. Her book *Intersecting Art and Technology Practice: Techne/Technique/Technology* was recently published by Routledge. She is currently a Visiting Assistant Professor in Integrated Digital Media at New York University."[21]

Ernest: I want to start with how the computer and how computer programming came into your art practice, treating the word "art" in the most general sense.

Kate: I think growing up I always had an interest in both dance and computers. I studied dance, ballet and modern dance in particular, and then I also had a job as an intern at a web design company. We were called HTML Monkeys. We had to take these big Photoshop documents and encode them into HTML.

21. From http://codame.com/artists/kate-sicchio (accessed August 1, 2018).

So I was doing that simultaneously. I went to university for dance, and halfway through my undergraduate degree I was injured and couldn't dance for six months. I had three knee surgeries during that time. But instead of putting my studies on hold, I just went to the multimedia department and said, "I have these technical skills, what classes can I take here?"

Then when I was well enough to dance again, the head of the dance department, I think she wanted me out, because I wasn't their ideal dancer. I wasn't actually that interested; I was more interested in making dance than dancing.

So she said, sort of briefly, like, "Why don't we find a way so you can combine them both, and that will be your degree?" And I think what she meant was, "Leave the dance department and finish your degree in multimedia," but I heard, "Combine both." So that literally became the rest of my degree. I split my credits, half in multimedia and half in dance, and I made work that started to explore how to combine both studies. I made it one stream.

Ernest: So actually this all began from a student base?

Kate: Yes, really early. And I started with a lot of video practices, yeah.

Ernest: Could you give an example of an early thing that you did, perhaps as a student, that made that combination work?

Kate: One of my first things was around video. I started using the software Isadora, which is like an object-oriented programming environment, to put effects on live video. That was projected within the performance. And … I still work with variations of that now. But that was one of my first things … like, "Right, the computer actually can see things if you attach a camera to it, so how does it see dance and how do I put that back into the piece?"

Ernest: So let me understand that. Was the camera used during a performance?

Kate: Yes. It was all happening in real time.

Ernest: And also projecting images?

Kate: Yeah.

Ernest: So you had the dancer, the image analysis and the projection all …

Kate: All on stage.

Ernest: And how about the sound? Was there sound, and was it integrated?

Kate: It wasn't. And I work with sound infrequently to this day. Recently I've worked more with sound, but sound then was just an additional soundtrack over the top. And I went through a period after that of not using sound at all. So, yeah, the sound only recently has been integrated into the system.

Ernest: So how do you think computer programs, in the broadest sense of what a computer program is, how do you think computer programs influence your conception of the kind of work that you could do?

Kate: I think most recently I've been looking at just that idea of code as a score. And how programming can be used as scoring for dance. So I've recently made a fake programming language. But it is based on JavaScript. It almost is identical to JavaScript, actually. And I've been giving that to dancers to learn as a dance score.

Ernest: So that sounds very interesting. So does that mean this is a pseudocode?[22] So that the dancers can understand this?

Kate: Yes.

Ernest: And that you can take that pseudocode and actually make it real code?

Kate: Yes.

Ernest: And so the pseudocode is a way of you communicating with the dancers?

Kate: Exactly.

Ernest: So okay, that's very interesting. So you've used the code as a kind of score, so that the essence of the piece is embedded in the code?

Kate: I would say so. Because the instructions themselves for the dancers…

Ernest: Including the instructions for the dancers?

Kate: Yes. And those tend to be very open to interpretation. So there are words like "push" or—I use a lot of just "left" or "right" as well. Or "rotate" is a good one. And then so it's—yeah, the essence of the piece is in those sort of words. But then it's still interpretative.

Ernest: Do you know an English guy called John Lansdown?

Kate: No.

Ernest: Who used to do this kind of thing back in the seventies and even late sixties? I think these two aspects are very interesting. So that the whole piece you compose in code, really. That's what I hear you saying. So you're composing in code. And you're composing and choreographing in code, actually. And then part of—now I'm putting this to you to see whether I understand it, so I may get it quite wrong—so what I think I'm hearing is that that code covers more than what the computer does, because the pseudocode includes instructions to the dancers, which actually the computer program doesn't need to know.

22. Pseudocode is a simple notation that looks like computer code, but cannot actually be run on a computer. It is used to aid the design of software.

Kate: Yes.

Ernest: So in a way you're writing a total thing? In code and pseudocode. So you now have a description of the work. And then part of this can then be put into the computer to do its part, and part of it can be given to the dancers?

Kate: I haven't actually put any of it into the computer. I've just been giving it to dancers so far.

Ernest: So what you've done is you've used the metaphor, almost, of code? As a way of developing a language for a dance?

Kate: Yes. And part of why I know Alex McLean is because I started doing it live as well. Like typing the code for the dancers live.

Ernest: And they could see it?

Kate: Yes. And the audience as well. And also they have to—sometimes I change the instructions or the order, so they have to respond to that. They become a computer in a way.

Ernest: So in fact they're interpreting the code in real time?

Kate: Yes.

Ernest: Okay. That's beautiful. So the live coding notion is directly translated into this performance work?

Kate: Yes.

Ernest: And so if you work with Alex, is he working with his live coding, which is controlling the sound at the same time?

Kate: Yes.

Ernest: And how do you and Alex work together when that is happening?

Kate: Our collaborative piece that we've been doing, it tries to make a feedback cycle. It does feedback, I would say. So we both, for that piece, have visual language coding that we're using. So mine is dance instructions. They're really… "up," "down," "right," and "left," I think, and then the numbers one through six. And that gets connected in a web. And that—I have a series of gestures, and I sort of move around in the space. And that's being tracked by a camera. And then where I am in this space, and also the size of my gestures, actually changes Alex's code.

Ernest: So that your code is sent to his…

Kate: Well, how I interpret my code is sent to his code. And that creates the sound.

Ernest: And he interprets it in some way?

Kate: Or I interfere and he has to readjust! [*laughs*] And then the sound that's coming out is analyzed by another computer, and that changes my code.

Ernest: So your code isn't always written by you?

Kate: In this case, no.

Ernest: In this case. So sometimes it could be modified by another programmer?

Kate: Yes.

Ernest: That's brilliant. And do you constrain what modifications could be made? Presumably.

Kate: Yes. And we try to give it a structure as well. Just for the piece in general. So it actually grows more complex, and more and more instructions over time come on my score. To the point where, about ten minutes in, it completely overloads, and I have to just make decisions on the spot about what instructions I'm going to follow. Because there's far too many for me to ever do. We get to this point where I have to fail.

Ernest: Tell me about the camera. Now, you mentioned when you were a student using a camera, but you're using one still, sometimes? Tell me how that works.

Kate: I do really simple sort of background subtraction in order to do computer tracking. Normally I use the CCTV [closed-circuit television] camera, and I've used a couple of different software where you take a background image and then it just does the subtraction.

Ernest: What software do you use?

Kate: It varies. Sometimes I use Isadora. I've worked with the software Eyecon and Kalypso, and I've done it in the language Processing. Whatever I can get my hands on.

Ernest: And so can you take me through a scenario of what might happen? If I'm watching a piece, what would I be seeing? And what would the camera—what would the image analysis be doing?

Kate: I did a whole series where I used that to make visuals. They tended to be really abstract representations of the movement that was being captured. Usually gradients of a color that would sort of—maybe if I moved right and left across the stage it would sort of travel with me. But it would be—there'd always be some sort of remnants of it left that would slowly fade out.

Ernest: So if I see a dancer moving, or some dancers moving, I also might see on a projection an image that was a transformation of their movements in a way? And would it be in real time and sent? Or would there be delays?

Kate: Usually it's real time. I have worked with delays as well. It's an interesting idea of expanding time. But usually it's real time.

Ernest: So now there are two ways you're using code, then? One is as a score for the work, and another is to handle the image analysis and image processing?

Kate: Yes.

Ernest: Let's just talk about that image side for a moment. When you're doing that, does the—how does the writing of the code influence the work? Or does it? Does the kind of language that you're using and so on affect your thinking about what might be done?

Kate: Yes. Because I'm both creating the dance and the system for the images, I see them really all as part of the choreographic process. And sometimes the movement is more determined by what I've just designed in the software or sometimes I work opposite. I'll have this idea for movement and then I'll try to make the computer respond to that. So they're really integrated into my own process. Where I don't really divorce the two when I'm working like that.

Ernest: Ah, so you might be working with the image, let's call it image transformation, you might be working with the image-transformation code and the choreographic code at the same time to build the work?

Kate: Yes.

Ernest: And in principle the one could influence the other? Technically it's possible?

Kate: Yes. I think it does. Like in my PhD research, I looked at it as a kind of topology. It's continuously transforming the other. The only way to separate it is to stop one. Yeah.

Ernest: Well, just say something about your PhD; that might be interesting.

Kate: I looked at, particularly, these image transformations and my process of making them, and I identified sort of the score spaces that have to be choreographed. I called it the physical space; the camera space, which also included the programming; the projection space; and the compositional space. And then I said the relationship between those four spaces was topological. And then I, in my PhD I talk about the process of choreographing all those spaces together as choreo-topology.

Ernest: So you developed a conceptual model of the use of code, actually, for this kind of work? With these four spaces? And the interrelationships between them?

Kate: Yeah.

Ernest: Okay. So it sounds as if code is not an add-on to your work but is actually at the very core, is that…

Kate: Yes. I would say that.

Ernest: Would you be doing anything like you're doing if there was no such thing as code or you hadn't come across it?

Kate: I really doubt it. Like, it's always—from very early on it's been—yes, my choreographic approach has always been this—down to the code. And the computer. So I think I'd be making—well, to my own eyes—very boring dance work if I didn't have the code.

Ernest: Your work is of course very much concerned with procedures and process? Formalized process, actually?

Kate: Yes.

Ernest: So that's a step further, isn't it? Not just conceptual?

Kate: Yes. It's how the work's made.

Ernest: Maybe I should ask you what your dream is next. Where would you like to take it?

Kate: That's a good question. I think the programming language–choreography thing is the thing I'm really interested in developing further. And I can see that becoming quite a substantial piece. Because I have the piece with Alex, but then I have my other programming pieces. I have four or five of the smaller ones, and I can see it becoming a much bigger directional type event. So I guess that's my current dream. [*laughs*]

14.11 Conversation with Andrew Brown, November 30, 2011

Andrew Brown studied music, both classical and jazz, at the University of Melbourne. He was a keyboard player in touring bands through the 1980s. His interest in electronic keyboards grew into a passion that fueled his academic career in teaching and research at the University of Melbourne, Queensland University of Technology, the Australasian Cooperative Research Centre for Interaction Design, and Griffith University, where he is now a full Professor. His current practice is laptop live coding. He also works in a range of digital arts arts. Andrew's research focuses on augmenting our creative intelligence through interactions with computer systems, about which he has published widely and for which he has been the winner of numerous research grants.

Ernest: First of all, if you could think back as a musician-composer, you must at some point or another have come across a computer. I would like you to reflect on the beginnings of that. The question is, how did the computer or how did software affect your work? Did it open up new avenues from the beginning?

Andrew: My first introduction to computers in this way was at university and my music degree. Interestingly enough there was a computer in the music studio. It was at undergraduate degree time. There was an Apple II computer in the studio running some music software. The thing which intrigued me about it was the fact that you could program and customize it. That really intrigued me, because the instruments that I'd been playing up until then—traditional musical instruments, particularly the piano—I was always fascinated by how they worked, but you never had the opportunity to tweak them. I originally got into the studio on analogue synthesizers where you

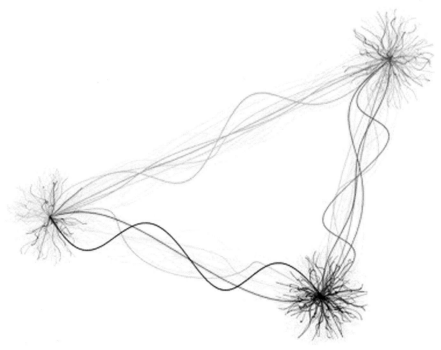

Figure 14.9
Andrew Brown. *Connections*. 2013, developed in the Impromptu environment and exhibited as part of the [d]Generate exhibition of digital generative art at the Gympie Regional Gallery. See color insert. (Reproduced by permission of the artist.)

could patch things together, so there was some level of programmability. But it was the customizability of the computer which really excited me.

Ernest: That's almost immediately into my second question, which is, does programming itself matter to you?

Andrew: Absolutely. It was interesting that I got into computers at a time where you almost needed to program. It was the early 1980s. There were some applications, of course, but it was the fact that you could program it and get it to do almost anything you wanted it to do which was fundamental.

That really has stayed with me. When we move forward to other things that I've done, programming has always been quite central. But there was another pivotal moment to me, which is when I went to work at IRCAM in the late 1990s. I'd always understood that programming was really important, but at that time it became clear to me that it was essential if you wanted to have independence as an artist.

Ernest: It was interesting that one thing that [Pierre] Boulez said to me was that he thought it was very important that people could work at home, program at home, I guess, which is part of that point.

Andrew: Yes, although in one sense the IRCAM experience for me was almost a reaction against it, because IRCAM had this model where composers would work with the technology. So Boulez would work with Andrew Gertzso. In one sense I saw that, which was the IRCAM model, and almost thought, I don't think that's right. But really the thing for me was you really had to invent your own tools if you wanted to break new ground. I think this was the other lesson.

Ernest: In terms of the software, how do you feel about it? Does the software itself matter to you or is it just a way of doing all this stuff?

Andrew: It's more than a way of doing things. I would say the musical practice is certainly primary. The coding is secondary in that sense, but it does matter, so I like to do it well. I like to develop my technique. I'm interested in reading coding books and patterns of musical coding practices. It's certainly not frivolous. I see it as technique. I think having good technique is important to be able to be very expressive.

Ernest: So it's a bit more than a tool.

Andrew: It's certainly a lot more than a tool.

Ernest: Has it influenced your thinking? Do you think about music differently?

Andrew: Yes, for sure. That's one of the interesting things about looking at programming in particular and the differences between different programming paradigms. You think differently in those ways. For example, in the last few years I've been programming in LISP, which as you know has a particular way of structuring the world. There seems to be a really nice fit between the way it is organized and the way in which my musical ideas are organized. So that seems to fit well.

Ernest: Some of the stuff I saw of yours earlier was LISP-like, I thought.

Andrew: It was Scheme, actually, to be precise. Scheme is a LISP. It's usually the way they say it.

Ernest: Do you find that the kind of work that you do distances you at all from the final object, the sound? If you're playing a piano, if you're improvising on a piano, for example, then of course it's a very direct relationship between what you do and the sound; whereas if you're writing LISP, you're further away, in a sense. Do you notice that?

Andrew: It's true that I'm further away from the sound, but I'm not further away from the music. This is an important distinction. Music in a sense is organized sound, so I'm

closer to the organization and I feel more in control of the organization, even though you are technically correct that you're one step removed from making a noise.

But in a sense my interest has often been a compositional interest, an interest in musical structures as well as in musical timbre but almost primarily in musical structures.

Ernest: So could you put that the other way round, that programming helps you be closer to the structure of the music than you could have been without it?

Andrew: Yes, and I feel as though it's more powerful as a structuring tool than ten fingers on a piano keyboard—unless maybe I was Keith Jarrett.

Ernest: Yes, of course. Every pianist's favorite pianist. It might be that Bach or Schoenberg or Webern might have been very interested in programming, for this very purpose.

Andrew: I think absolutely. Those composers you mentioned, who were very interested in musical structures, either polyphony or serialism or minimalism or any of those kinds of structural aspects would be very, very interested in programming as a way of thinking about it.

Ernest: Which interests me in another way, which is that maybe you could argue that you can give more thought, you can be more rational—maybe that's not the right word—more thoughtful about the structures of the music using programming?

Andrew: Possibly. I'm not so sure about that. There are some contradictions possibly in that. One is that through programming maybe you can be more thoughtful because you can defer decisions. But in one sense you also can hand over in generative systems responsibility for parts of those things. So in one sense you can be less thoughtful or thoughtful at some metalevel and hand over responsibility. So it's intriguing, isn't it, when you say we're further from the sound of live coding. We're doing generative structures, so we're further from the service-level pitch and rhythm decisions. So you're moving to a new level, a metalevel of organization in a sense.

Ernest: Would you say in live coding in particular that you are actually manipulating the metalevels of the structures?

Andrew: Absolutely, Yes. You're designing those structures.

Ernest: So you have generative music and then you're changing the structures during the performance?

Andrew: Correct. One of the really interesting things is that one of the craft aspects of that is to have an initial structure which affords manipulation in interesting ways. So it's not good enough just to have any initial structure. You need an initial structure which then itself can be modified in interesting ways. That's what you do when you're experimenting and practicing and so forth. It's searching for those kinds of interesting structures which are forward evolution during the performance.

Ernest: So is your thinking about that matter rather than the quality of sound?

Andrew: Yes, that's right. It's almost practicing music theory, and looking at musical structures, and using theories and models of music making, and how do I articulate them in a succinct fashion.

Ernest: How do you deal with sound itself?

Andrew: Typically, we have commercial synthesizers, virtual synthesizers, which are triggered by notes. But we also control those timbres. I've painted a fairly simplistic figure, but I'm describing to you where the kernel is, but of course all of these things relate.

Ernest: One way that I look at it, and I don't know whether this conforms to your view, is that you have structures that deal with what happens over time, and then you have mappings from those structures to the physical realities. Those mappings might be using the sound samples or whatever it is, whatever you happen to do, and they are two different sets of decisions.

Andrew: Yes. One of the things which I've developed in interaction with Andrew Sorensen—he and I have done this practice together a lot—is a set of primitives, if you like, at that very abstract level, which we've worked out how to map both structurally and directly to timbre manipulation and pitch manipulation. These are actually pretty simple things like periodic motion and gas-heat distributions; these kinds of things which we find widely applicable at all sorts of levels, from the surface level detailed through the deeper structure.

Ernest: Do you find that some of those things need to be relatively simple because of the complexity of what you're doing?

Andrew: Yes. This gets back to your earlier comment about contemplation. The thing about live performance, the live coding, is of course, there is very little time for contemplation during the performance. So it's unlike a compositional process in that sense. It's like a jazz improvisation. You have to commit on the fly, now. But I think when you rehearse you build up patterns of behavior just like a jazz improviser does.

Ernest: Maybe you have to take the advice that Charlie Parker gave Miles Davis, which was, if you remember, if you make a mistake, do it again and then do it again and then do it again.

Andrew: Totally. This is where it shares all of these things with other music practices. This is why it seems foreign in one sense, but you draw an awful lot from other instrumental performance practices.

14.12 Conversation with Mark Fell, August 7, 2012

Mark Fell is a multidisciplinary artist based in Sheffield (UK). After studying experimental film and video art at Sheffield City Polytechnic he reverted to earlier interests in computational technology, music and synthetic sound. In 1998 he began a series of critically acclaimed record releases on labels including Mille Plateaux, Line, Editions Mego and Raster Noton. Fell is widely known for exploring the relationships between popular music styles, such as electronica and club musics, and typically academic approaches to computer-based composition with a particular emphasis on algorithmic and mathematical systems. Since his early electronic music pieces, Fell's practice has expanded to include moving image works, sound and light installation, choreography, critical texts, curatorial projects and educational activities. He has worked with a number of artists including Yasunao Tone, Keith Fullerton Whitman, Okkyung Lee, Luke Fowler, Peter Gidal, John Chowning, Ernest Edmonds, Peter Rehberg, Oren Ambarchi and Carl Michael Von Hausswolff. The diversity and importance of Fell's practice is reflected in

Figure 14.10
Mark Fell. *64 Beautiful Phase Violations*. 2013, installation view at BALTIC 39. (Reproduced by permission of the artist and BALTIC Centre for Contemporary Art. Photograph by Colin Davison.)

the range and scale of international institutions that have presented his work which include Hong Kong National Film archive, The Baltic (Gateshead), Museu d'Art Contemporani de Barcelona, La Casa Encendida (Madrid), Laboral (XIxon), The Institute of Contemporary Art (London), Royal Festival Hall (London), The Serpentine (London), Raven Row (London), The Australian Centre For Moving Image, Artists Space (NYC), Issue Project Room (NYC), Corcoran (DC), Curtis R.Priem Experimental Media and Performing Arts Center (NY), Lampo/Graham Foundation for Advanced Studies in the Fine Arts (Chicago), Zentrum für Kunst und Medientechnologie (Karlsruhe), Hanger Biccoca (Milan) and others. Fell's work is in the collection of the Thyssen-Bornemisza Art Contemporary (Vienna) and has been recognized by ARS Electronica (Linz).

Ernest: The first question is, has programming opened up new or different avenues in your practice?

Mark: I guess the first time I was in the same room as a computer it was in the physics department at school. It was a ZX80, and there were all these physics nerds who were kind of sat round it and typing words into it. And I just thought, what on earth is this? So I didn't touch it or use it, but I became really fascinated with it. Then the next year I got a ZX81. I think the difference between computers now and then is that when you got a computer in 1981 you didn't have a choice about whether you were going to program it or not, you had to program it. So it's like from the beginning getting a computer wasn't about let's download this app and have a go on whatever. It was about let's start to program it to do something. So that's kind of how I started, and then I got a Commodore 64 and the first thing I did was to write software that would make sound and generate graphics. But the thing is, my cassette recorder for the Commodore 64 didn't work, so once I'd done something it was a complete loss, I'd spend about four hours typing something in and then my mum would shout "Tea's ready!" and I'd turn it off and then it'd be gone.

Ernest: Was that really frustrating? Did it matter to you at the time?

Mark: I guess what was really frustrating was when you could buy books with code in it that would take literally like six hours to type in. That was frustrating, but when you're a kid you kind of accept things, I guess. So it never really occurred to me that there might be an alternative. So I guess my ideas as an artist have always been absolutely connected to computers in that sense. Because when I was a kid I painted, and I kind of messed around with synthesizers. But although when I was at school I was quite good at drawing, my ambitions, what I liked, was clearly way better than what I could ever achieve. And the same with music, I never really studied music. So it's not as if I could play a piano or use a paintbrush, so I had to find some other device that would actually do the

thing for me, and computers just seemed like the way to go. And the way I got into it really, I think, is through doing music and messing around with analogue synthesizers. With a modular synthesizer, you could set up something that played a strange sound when you pressed a key. But I was never really interested in that. I was always interested in how can you set up a system that will generate the music itself, and you can change a dial and it'll somehow alter.

Ernest: So that means you're not using it as an instrument really, in a conventional sense?

Mark: Yes, you could say it wasn't an instrument, but you might say it was. I don't really get hung up on where that definition is. There is a difference of use, or it belongs to a different category in terms of how it functions. Just for the sake of having normal conversations, I think that distinction makes sense. It makes sense to say this is a different kind of thing to a guitar. Anyway, that led on to me using computers, and being able to develop those ideas in a digital kind of domain. The first thing I got was a piece of software, called Generator, that Native Instruments made. It was the first thing they made, and that was the first time I could really mess about with the things I couldn't try on analogue synthesizers. So I guess all this is the background?

Ernest: So when you left school did you go to art school?

Mark: I studied graphic design. The reason is because it wasn't making lots of mess with paint, but there was a room with a BBC computer, and then a room with an Apple Macintosh in there.

Ernest: So actually, the existence of computing in that course was an attractor to you, as against a painting course?

Mark: Yes. It wasn't necessarily that the computers were present when I went for the conversation, but I could tell by the things I was saying that every time I mentioned computers the guy who was interviewing me seemed to like it. So I just thought, yes, this is the way for me to go.

Ernest: So in a way, computing was there from the beginning and you'd got into some kind of programming, at least, from the beginning?

Mark: Yes. And when I started graphic design I was the only one that used the computers. I'd get the key off the technician and just stay there in this room just making stuff and just dreamt of possibilities.

Ernest: So when you were studying was most of your work done using computers?

Mark: There was a divide, because the structure of the course was essentially to take a pretend brief from a client, and make a piece of work to fit that. But there was no way of getting the work off the computer screen and into some kind of form that you could

submit. So all the stuff on the computer was really just me messing around, and not formally part of the course.

Ernest: I really want to ask you about how you see life now. Does programming, not computers, matter to you beyond the fact that you have to do it?

Mark: Yes. Well, in the first place it enables me to do what I do. If we're making music on a computer there's a few ways you can do it. For example, you can place notes on a grid, which is really boring to me. The only option for me is to program. I mean I don't necessarily call it programming because I don't really think of myself as a programmer. And I tend to use things like Max/MSP, and a lot of people say it's not a programming language.

Ernest: Well, for my purposes writing Max/MSP patches is programming.

Mark: Yes, you're setting up systems and dealing with the logic of the system. So that enables me to make better music, and the music I like to hear. Without that I wouldn't be able to make the music I make.

Ernest: So where is the software, where is the programming within your practice?

Mark: Well, I wouldn't say that the software is the work. Although I definitely feel that the systems generate the music, for example, the software has an equal status to the music in terms of how I feel about them. But then I wouldn't actually release the software. So the software is very much a way of making something, rather than a thing in itself. I am quite choosy. When I write software there's often several ways of doing the same thing, and I'll choose a way that fits ideologically with the values that I like, so they are aesthetic choices in a way.

Ernest: I would call that caring about the software. So can you give me an example?

Mark: Well, because I'm not from a formal computing background, I've just wandered into it and messed around, I've never been taught how you create algorithms, or how you structure complex things. So, for example, getting a system together to deliver a live performance. The first thing I did was create an environment, and everything that's common to all the tracks I'll put in the environment. So there were things that dealt with outputs, things that dealt with fader devices and things, and they all sat there. And then the track was a tiny thing that was inserted into that, so I could just send a number one to this output module, and it'll trigger sound number one. But actually now, I've completely changed that. So now the environment is minuscule, there's nothing there really, it's a sort of adaptable framework. And then the track, or piece of music that happens within that, deals with all the outputs itself. But there's quite a big ideological difference between these ways of developing systems.

Ernest: So the second approach takes you longer to make a piece than the first one—or does it?

Mark: It doesn't actually, because it's a lot easier and you've got much more control of what happens. It's not like you have to go into something else to change what you're doing. Instead of sending a number to trigger a certain sound, I might send a list, the note number, the duration, etc. It just means there's a lot more flexibility.

Ernest: So it sounds as if in the second case the environment is more flexible. And a way of putting that is that there are more variables in it, more things that you can control from the top level.

Mark: Basically, yes.

Ernest: So in fact the second approach is cleaner?

Mark: Yes, but I thought the first approach was cleaner when I did it.

Ernest: These kinds of aesthetics of software, how clean it is, could be one of the criteria you care about?

Mark: Yes, in fact Jeremy Bernstein, who worked for Cycling '74 [maker of Max and MSP software], saw some of my patches and I was nervous because he really knows his stuff. And he said, "Mark, these patches are so beautiful," and I was surprised but pleased. Looking at them, they are quite logical, as though everything's given a space.

Ernest: You prefer that?

Mark: Yes, just because it enables me to understand things. So it's almost like arranging furniture in a room. It's giving each thing its space, so you're able to understand it more clearly.

The other thing is, I work with Mat Steel on this project SND, and we do many live performances. Because of the amount of work it takes when you're in a collaborative thing, we've basically had three incarnations of how we work. The first one was the environment that I mentioned, but it was so complicated. And then in the second one we streamlined it a bit, and tried to deal with the problem of how two people can interact with the same system at the same time. Because at first when we played live there would be one physical device, and we'd be arguing over it, and so we developed a way of enabling two people to load different things and we used two computers. So basically my computer would be the thing that generated all the timing data, and then also there were two separate input modules, one on Mat's computer and one on my computer, but rather than try and synchronize the timing from Mat's and from my computer, which a lot of people try to do, I just thought, let's take the interface away from the bit that does the hard work and then that could be anywhere. So that was a big jump that

seemed to make total sense once we'd done it. That happened in the second incarnation of our live set, which was a result of all the problems we'd encountered with the first one. And then for the third incarnation, which we just did in Japan in…March, I think, I developed that even further. This was related to the live stuff, the environment I'd developed for my solo performances.

It's developed even further, but has become even more streamlined and really good. So we can actually now work on different parameters of the same system quite easily, or the same parameter, and that's brilliant. For example, he could be generating patterns and I could be manipulating the timing that those patterns are played back with. So it's a really new way of working. What's interesting is, you know when musicians talk about when they play a guitar they get a certain kind of headspace or they really get into it? Although that's a bit New Age for me, you can kind of see the truth in it, or the sense in it. And what's interesting is that with this thing that we've managed to make happen, there is that sense of really feeling the presence of someone else in a quite tangible way, even though it's quite abstract. Obviously, there's a lot of other people who've done that. I'm just talking about in our case.

Ernest: Yes, exactly. But this does sound to me as if the software, including the software architecture, which is the phrase I would use for what you were just talking about, is pretty integral with the work. I don't think you could say, We could make the same music in completely different ways. Well, you might, but in principle the music itself comes partly from these software structures.

Mark: Yes, we wouldn't have thought of it without that. Now we've made it, we could say let's go to a time line and re-create it. But what you can imagine is informed by the machines you use, if you know what I mean.

Ernest: Another question is, does writing software change your thinking about your work? Does it lead to new ideas? Is it a driver?

Mark: Yes. There's a really famous quote from Thomas Dolby. When I was a kid he was on some kids' program. And he said what he wants is a synthesizer where he can sit down and imagine any sound and the synthesizer will make the sound. And at first I thought wow, that's really cool. But even as a kid, I remember thinking, but hang on, then he's just trapped by what he can imagine, he's not actually messing around. Because from an early age I realized all my ideas came from messing around. Oh, when you turn this dial it does this, etc. So it's all about discovery. And if you're just sat there, just limited by what you can think of, nothing actually evolves. The biggest discoveries or advances in music, I think, are done when you can't imagine what's about to happen, and then the machine, as you're using it, just throws something out, and you think, ah, that's amazing.

Ernest: I think this has some relationship with what Arts and Crafts people talk about in terms of being in a conversation with the medium, carving wood or something, and it's actually the same kind of mental process.

Mark: Yes, I think so. It's responding to what you're dealing with. So I'm really into this idea that you don't really need a plan and you don't really need to know where you're going. You don't have to go away and formulate the idea and then make it happen using the technology.

Ernest: Is making software something you could not subcontract?

Mark: Yes, and I've even gone further than that. I don't even use the words "using technology." I don't say this piece of music was made "using Max/MSP"; I'll say this piece of music was "made with Max/MSP." Because I think even the words and the structure of the language you use to describe this is so geared up to reinforcing this belief that somehow you have the idea elsewhere, and the technology's just there for building it and making it happen.

Ernest: Yes. So you couldn't use the famous sculpture notion of making a phone call. Donald Judd makes a phone call and says, "Make me this piece of sculpture." You can't do that?

Mark: No, but Donald Judd's evolved through encounters with materials. So now I could make a phone call and say make this track and put these notes here, but I couldn't have done it before I actually did the experimentation.

Ernest: Maybe I could come at another point, which is that part of your work, certainly things you've done with me, are generative, and there are generative processes, I think, in most of your work, whether they're played with or modified in performance. In generative art, in the generative component, what you're doing is setting the parameters of the process and then the system works with it. Do you feel that distances you from the object, the sound?

Mark: Well, people accuse me of that. People tend to assume that. There's a closeness to the sound in playing the piano, although I don't play the piano, but let's say there was a distance between the artist and the generative process. Either I do nothing, or I just put up with that distance. But how do you quantify what that distance is, anyway? Who's to say the distance between me and the generative thing is X amount of units, and the distance between the pianist and his sound is another amount? Where's that come from, what is that measurement? It's not something that exists. But in terms of subjectively feeling engaged with it, then obviously I feel as engaged with it as the pianist feels.

Ernest: A composer is obviously more distant than a pianist in this sense, or could be said to be more distant, because they write their notes and someone else plays it.

Mark: Well, again I'd just say how do you measure that distance? What does it mean to talk about distance? I don't know; I'm not a composer in that sense. But I can imagine that lots of them will think, wow, I was so engaged in what I was doing, they might feel a closeness. So the opposite description could be true. But when you think of composition you think of the pianist with the notepaper and stuff. I don't know how a composer does what they do, but I'm sure they do lots of different things in order to make a piece of music. So when you ask that question it frames the answer in terms of, now imagine a person sat there at a piano with some music, but really that's not what they do. And also when I do what I do, it's not as if I'm doing one thing, I'm doing lots of different things. In the course of a day making a piece of music, it'll go from me working on a problem in minute detail and being oblivious of everything around me, you could say that's incredibly close, or it could be me going downstairs and making a cup of tea whilst not even being aware of being in the kitchen and just thinking about the problem that I'm trying to deal with upstairs. So this kind of idea of closeness, for me, I'd just like to reject it.

Ernest: One more step in this direction. It could be said that you don't actually know, in the case of music, what it's going to sound like exactly.

Mark: But that's a good thing. I mean did Jimi Hendrix imagine guitar music before picking up a guitar? Not knowing, for me, is the key to the creative bit. The famous example is DJ Pierre at the birth of acid house, messing around with a TB303 bass line and saying, "I haven't got a clue what I'm doing, but it sounds fantastic," and then from that a whole kind of genre evolves. If he'd known how to work the TB303 bass line, he wouldn't have invented acid house, he would have done some really lame kind of whatever, disco or slightly electro type thing. So for me the not knowing is the important bit and I think it's something that happens in probably a lot of practices that aren't necessarily related to computers. But then there's the other thing, the issue of control. So there's not knowing what you're doing, and then there's the issue of controlling what you're doing.

Ernest: Those are two different things, I think.

Mark: Yes, I think it's again this kind of myth that creativity happens by going away and locking yourself in a room, thinking really, really hard and having some flash of inspiration and then expressing it, or putting it into some kind of tangible form. For me creativity isn't like that. It's about messing around with stuff, and seeing what happens, and thinking, I like that, and pursuing it and then…

Ernest: So art making is more about discovery than expression?

Mark: I don't even know what "expression" means. And it feels quite arrogant that someone will come up to me and say, "Oh, what are you trying to express, or what's your

inspiration?" and the honest answer is I'm really sorry but I don't know what you're talking about. I mean, I could answer in their terms, but then I just feel really denigrated that I've done that. So I just say it's not to do with inspiration or expression and things like that. I'm not expressing anything. When you talk about expression, it's "I've had the idea over here and now I want to express it in this physical way," using something to put that into a tangible form. So for me, I've actually nicked your idea, which is that it's not to do with expression: I use the word "construction." So it's not to do with the expression of meaning, it's to do with the construction, if you're talking about meaning.

Ernest: As you know, we agree about this. Maybe people wouldn't make generative art if they didn't have this point of view.

Mark: I haven't got anything to express. If I've got something to express, I'll have a cup of tea and have a chat or something like that.

Ernest: A cup of tea isn't a bad idea! Great. Thanks.

14.13 Conversation with Alex McLean, July 2, 2014

Alex McLean is active across the digital arts, developing a creative practice centering on live coding and improvised music since the year 2000, co-founding the TOPLAP and Algorave movements, and the International Conferences on Live Coding and Live Interfaces. He applies live coding techniques in research into ancient textiles, as post-doc researcher on the European PENELOPE project, hosted by the Research Institute of the Deutsches Museum in Munich. He is based in Sheffield, where he curates the annual festival of Algorithmic and Mechanical Movement, and is trustee of the local Access Space charity working in arts, technology and education. He performs solo as "Yaxu," releasing music on Sheffield label Computer Club.

Ernest: I wanted to start with where programming and your art practice, your music, came together for you? Were you programming first, or did you come to programming after you committed yourself to music?

Alex: Definitely programming first: very enthusiastic programmer from a young age. Obsessive really. Programming is really what I've mainly done through my life, more than anything else. So I suppose programming is my way of interacting with the world. I had a career as a software developer for ten years, mainly in the music industry. I was always interested in the creative aspects of programming, and my collaborator Adrian Ward encouraged me into the world of software art. I think this path is less common in the world of live coding: usually it's musicians wanting to explore code rather than programmers wanting to explore music.

Figure 14.11
Alex McLean performing at Algorave Karlsruhe, 2015. See color insert. (Photograph by Rodrigo Velasco.)

Ernest: But you were early in the game, I guess. Was that because you were programming with and for people before you even started making music yourself?

Alex: Yes, I guess. I can't remember the exact sequence of events. I've always been interested in programming as a culture and so naturally fell into doing generative music and software art.

Ernest: Tell me about the generative music, what sort of stuff did you do?

Alex: Experimental electronic music. I worked closely with Adrian Ward, and in general he'd be more interested in the chordal and timbral aspects of sound and I'd be more interested in rhythm generation, the usual things like polyrhythms and simple cellular automata, down to just very simple modular arithmetic, but exploring rhythm through the code. We were so interested in the programming side that the programming really was the music. It's not just using programming as a means to an end, but really thinking about music in terms of abstraction and composition, the same kind of thing you think about when you're writing a program.

Ernest: Let's concentrate on this point for a moment, which is the way in which the program itself related and still relates to the music: not a means to an end but an integral part.

Alex: Yes, code is a key part of my creative process. I see programming as enabling me to reach beyond my own abilities, my own imagination. To some extent now I've come to the opinion that I don't fully understand my code, I just experience its output and have a number of ways in which I manipulate the code as a live interaction, to explore the rhythm that it's making. This isn't about having an idea, then implementing it, it's more just starting programming, hearing the results and then working with the program to sort of mold it.

Ernest: In the live coding work the performance is actually part of that exploration itself, in a sense.

Alex: Yes.

Ernest: Is that a motivating factor, actually exploring the world of programming and music with the audience? Or could you equally well be doing that in a studio and generating something and then playing it?

Alex: Either would work. I'm just not very good at working in a studio, I never really come up with particular tracks or anything like that, so when I'm performing I'm not thinking about particular themes. I might have a particular idea I want to play with but I don't have pieces of music that I perform, and so when I try and write things in the studio on my own it doesn't work. It's more like developing the software than developing particular pieces, particular recordings.

Ernest: Do you think that's because you listen to it differently with an audience present? Some kind of feedback?

Alex: Yes, I think there's just a lot of focus that you don't get on your own. It's down to motivation. Also, when people are dancing that changes it again. I am focused on the code but at the same time am sensing people reacting physically to it, dancing to the algorithms.

Ernest: So when you see people dancing to your algorithms do you respond to that?

Alex: Oh yes.

Ernest: So there's a feedback going on between what these people are doing and what you're doing.

Alex: I think it amplifies the feedback. I'm sure it's always there in an audience but when they're dancing it becomes very physical. And somehow I think coding is very physical as well, or live coding is at least, because even though I'm dealing in the abstract world of code, the actual live experience of it is very physical, because hearing becomes a very physical, perceptual aspect of the programming process.

Ernest: And does it make a lot of difference to you what language or environment you're working in, how that works? Is it a very delicate matter, or does it not matter?

Alex: Well, I only use my own music systems, so what I tend to do is create a language, and learn how to use it through doing a series of performances. I've made a language called Tidal and my first performance was in London at a preconference gig, and it didn't go very well. It was the first time I'd used it; I didn't really know what to do, which is quite a shame because some people had traveled quite far. But then through performing I'm learning too and in a sense that's part of the performance, that kind of very active exploration where you're learning how to use the software you've made.

But then after a while I start getting bored with a system, with its limits, it's like I'd explored the constraints, I'm going through the motions, it starts feeling predetermined, and that's when I feel like making a new system. In a sense, in performances I am learning to use the system, but once I've learnt it I want to make a new one.

Ernest: So you need a tension? A tension between the facility and the difficulty. You need a certain level of difficulty or else your adrenalin isn't lifted enough.

Alex: Yes. That's Csikszentmihalyi's idea of flow, isn't it, optimum experience between the boundaries of boredom and difficulty.

Ernest: But people don't often talk about that in the context of writing code in art, so that's an interesting special case, I think, where you've drawn that out in the way you're working.

Alex: Yes. With laptop performances, people often say how bored people look while they're using their interfaces, and perhaps that's true when it's a fixed user interface, but with live coding I think people look very intense, very fixed stare. For me this switched on, engaged flow means that laptop performance is less of a problem, because it's clear that there is a very strong physical engagement with the code, even though it is so abstract.

Ernest: How about the displaying of code, is that partly a good thing for that reason? What's the rationale or what's the aesthetic, do you think, behind it?

Alex: I think it's a difficult one. I've performed both with and without projecting code. I've been in the situation where I've been stood at the back of a performance or with people dancing in front and not projecting the code, and that was a really nice situation because people were reacting just to the music and to each other, and we were at the back just watching it all, it was quite nice. That was fine. I've also been in a situation where people are staring, watching the code, and it's hard to know what they're thinking, there's no real reaction to it, maybe they're getting bored, maybe they're interested. So I don't know.

But I think there is something about seeing the code appear before you and develop in complexity along with the music it represents, that you can hear. There's also something about exposing code to people who haven't seen code before, yet use software all

the time and have software that has a lot of control over their lives. Seeing someone engage with code in a very creative way, I think means that they see a different way of interacting with technology, and I think that might switch them onto the music.

So I suppose the answer is that I'm not sure; I don't know if it distracts from musical engagement or whether it opens it up, and really it needs an ethnographic study or something like this to maybe get to the bottom of it. Also, it's quite a young way of performing and there's very little in the way of reviews or any kind of critical engagement, so it's an open question really. I suppose the reason I do it is because the alternative is not showing anything, and it seems better to show something than show nothing.

Ernest: Do you feel potentially it would be interesting to look at the degree to which people are likely to better understand something about the code or not?

Alex: Yes.

Ernest: It can just look completely mysterious to some people.

Alex: Maybe the challenge is to develop new languages which are more easily understood. For music I think that means just making more declarative languages that are more about the structure of music, perhaps even something that has a kind of prosody, like a natural language. Then the audience may be able to engage with it more.

Ernest: It might be that it doesn't matter whether they understand the details, but it's getting the general drift in a sense, and if it's declarative, they're perhaps more likely to get the drift of it.

Alex: Yes. They should be able to see a change, and hear a change, and connect them. I think that's true of any instrumental performance as well, if you're a nonguitarist you won't understand the technical things that are going on, but you'll still be able to make a connection.

Ernest: So you could compare it to watching a band or an orchestra play while you're listening, and you can see something about what's going on even though you may not understand all the details.

Alex: Yes.

Ernest: You said you started with generative music, but of course the live coding is generative; it's just that you're changing the generative processes during the time, isn't it?

Alex: Yes. Which I think changes a bit.

Ernest: It's just another layer?

Alex: Yes.

Ernest: I had another question about that. Do you feel a distance between yourself and the music, the sound, because what you're working on is the generative process rather than the sound?

Alex: Yes, I think so. I play the guitar a little bit although I'm not an instrumentalist, but when I go and see a band I realize there's something very different going on that's very direct, very instantaneous, very embodied Live coding does feel distant in comparison. But that distance from the notes means you get closer to the composition. If you're describing musical relationships with code then you're very close to those structures even though you're quite far away from the sound. So it's choosing a layer of abstraction really. By getting close to these constructs you're necessarily further away from the physicality of making each sound.

Ernest: But it does mean perhaps that you don't necessarily know what it's actually going to sound like in detail. The texture of it—maybe something that might sometimes be a slight surprise.

Alex: I think you are opening yourself up to a lot of surprise with generative music or art. I think that surprise is always good in creative exploration—it's your means of pushing the boundaries.

Ernest: Has that got something to do with what you said earlier about it all gets too sorted out, or it gets boring and you want to move onto the next thing? Is that maybe because you're not getting enough surprises?

Alex: Yes, definitely. There are people like Dan Stowell, though, who are doing beatboxing and live coding at the same time, so managing to engage both with the instantaneous sound, then sampling that, and then adding filters and things by live coding.

There's ways of also working with instrumentalists at the same time, so having a guitarist making music while you're live coding. Different approaches but still managing to collaborate.

Ernest: Can you have two live coders interacting with one another on the same piece?

Alex: Yes, that's what I usually do, actually. It works well to have more than one because then you still get pace of change, you get people exchanging ideas, and it becomes more much more engaging, for me at least.

Ernest: So that pace of change is another issue because in the improvisational world it's particularly slow. Do you regret that, or do you foresee that as a positive?

Alex: I think it's something I work hard to improve, so I suppose in a way I wouldn't say regret, but yes I basically agree with you. I think through practicing live coding and

developing new languages it can be reduced, and that has to be a positive thing, that little bit of latency. I started live coding with Perl and then moved to Haskell to make Tidal and found my rate of change was reduced from maybe a minute to maybe ten seconds or less.

Ernest: In some different contexts I'm aware of people's saying that they value that thinking time, and if the latency is reduced, they lose it and in a way that's not always a good thing.

Alex: Yes. I suppose though a traditional improviser would still have thinking time while they are playing. So maybe it's the same for a live coder except they don't have to physically continue playing around the current theme while they think, because the computer does it for them.

Ernest: Technically how does your system work? What is the structure of your system? Are you operating a text file that's being constantly interpreted?

Alex: I've got my Tidal language running in a text editor, and I'm just sending blocks of code to the interpreter which is updating some mutable variables, global variables I suppose you could call them, which a separate thread is then turning into trigger messages for a synthesizer. I'm just working on the compositional level in that I don't do any synthesis really. It's just triggering samples and transforming patterns.

Ernest: So you're working on these blocks of code. If we're watching you do it on a projected screen, we're watching you add that text and then at some point you submit it to the interpreter.

Alex: Yes. So I'll do a particular control sequence and then you see the screen flash around the code I'm sending, and then the music would change.

Ernest: So it's an update of the file, an update of the system, and then we've got a new revised system.

Alex: I call Tidal a pattern language, in that you just define sequences or functions like sine waves and then add functions that manipulate that—for example, rotating that sequence every third repetition, or adding something to it every now and then, or some kind of transformation using some preprepared algorithm. You're just stringing together functions, really. Tidal is getting increasingly simple the more I develop it, which I think is positive for live coding.

Ernest: Let me just understand this a bit more. There is a block of code that the interpreter is interpreting that it's using all the time.

Alex: Yes.

Ernest: If you do nothing that's what it'll do?

Alex: Yes.

Ernest: And when you do something you're basically updating that code in some way, adding new function or redefining one that's there already.

Alex: Redefining, yes. I'll have a pattern, which is itself a function, and I'm just redefining the patterns all the time.

Ernest: So you're changing the program. Do you sometimes also change the data, like maybe some list it's using, that you might in addition—I don't mean instead of— sometimes turn that list round or something?

Alex: I'd quite often start off with a simple sequence and then add functions to that, so I might go back and change that sequence. And while the sequence looks like a list, it is in fact represented as a function from time to events. In my current system I have it so I can have arbitrary subdivisions of time, so I'm not constrained by sixteen beats to the bar, which I have been until a few months ago. I am now getting interested in more varied time signatures, embedded time signatures.

Ernest: Obviously, writing code is completely integral with this work. What I'm trying to explore is what the range of aesthetic issues are that are affected by the code? Could you conceive of now making music that wasn't generated from code?

Alex: I think if I did, it would probably sound fairly similar. I think it wouldn't be live; it would have to be presequenced music. I'd probably still be following algorithms but manually.

Ernest: So the whole concept of computation and code influences everything really pretty much about the work?

Alex: Yes. It's the way of thinking about it. Code is the most suitable way of thinking about music in that way. You could do it just with writing out by hand but…

Ernest: It would take forever to do.

Alex: Yes.

Ernest: How do you find it in terms of the world you live in, in terms of getting performances or being commissioned to do anything? Is it hard, do you find?

Alex: Well, it's mostly within the academic world, I suppose, and art festival world that I've played. I've played in quite major venues and major festivals like Sonar and STRP Festivals and Ars Electronica and this kind of thing. It's not mainstream, though.

Ernest: All these are places where computers are accepted in some sense? What do you think is the most successful thing so far in terms of exposure? What are you most pleased with?

Alex: Don't know. I did some really good performances at Sonar. I think the most successful thing's been when people dance.

Ernest: What's your next big thing? What are you looking forward to?

Alex: Well the fellowship, just spending two years developing my ideas and collaborations. The PhD was fantastic, actually. I was trying to get away from live coding then, I was trying to branch out and expand my horizons. I found out I expanded them but then narrowed them back down to live coding again.

Ernest: Good luck with that. Thanks very much.

Index